# ADDING FEMINISM TO LAW
The Contributions of Justice Claire L'Heureux-Dubé

EDITED BY ELIZABETH SHEEHY

Adding Feminism to Law: The Contributions of Justice Claire L'Heureux-Dubé
© Elizabeth Sheehy, 2004

All rights reserved. No part of this publication may be reproduced, stored in a retrieval system, or transmitted, in any form or by any means, without the prior written permission of the publisher or, in the case of photocopying or other reprographic copying, a licence from Access Copyright (Canadian Copyright Licensing Agency), 1 Yonge Street, Suite 1900, Toronto, Ontario, M5E 1E5.

Published in 2004 by
Irwin Law
347 Bay Street
Suite 501
Toronto, Ontario
M5H 2R7
www.irwinlaw.com

Design: Sonya V. Thursby, Opus House Incorporated

ISBN: 1-55221-085-3

**Library and Archives Canada Cataloguing in Publication**

Adding feminism to law : the contributions of Justice Claire L'Heureux-Dubé / edited by Elizabeth Sheehy.

Includes bibliographical references.

ISBN 1-55221-085-5

1. Feminist jurisprudence—Canada.  2. Women's rights—Canada.
3. L'Heureux-Dubé, Claire.  I. Sheehy, Elizabeth A.

KE8248.L44A8 2004      349.71'082      C2004-904696-9
KF345.Z9L44A33 2004

The publisher gratefully acknowledges the generous assistance of the Claire L'Heureux-Dubé Fund for Social Justice and the University of Ottawa's Human Rights Research and Education Centre. The editor wishes to thank the Social Sciences and Humanities Research Council and the Shirley E. Greenberg Professorship for their support of the "Adding Feminism to Law" conference.

The publisher acknowledges the financial support of the Government of Canada through the Book Publishing Industry Development Program (BPIDP) for its publishing activities.

Printed and bound in Canada.

1 2 3 4 5    08 07 06 05 04

# Contents

## Introductory Materials

### One
**Foreword** ... 1
CHIEF JUSTICE BEVERLEY MCLACHLIN

### Two
**Introduction** ... 5
ELIZABETH SHEEHY

Bibliography ... 35

### Three
**Tribute** ... 39
JUSTICE ROSALIE SILBERMAN ABELLA

## The Enterprise of Judging

### Four
**A Feminist View of the Supreme Court from the Anti-Rape Frontline** ... 45
LEE LAKEMAN

### Five
**The Era of Concealed Underlying Premises Is Over: L'Heureux-Dubé J.'s Contribution to Statutory Interpretation** ... 49
RUTH SULLIVAN

### Six
**Claire L'Heureux-Dubé: Reflections from Down Under** ... 81
REG GRAYCAR

### Seven
Être le miroir de son époque : la primauté du droit, la critique égalitaire, et la contribution de Madame la juge L'Heureux-Dubé ... 109
NATHALIE DES ROSIERS

### Eight
Backlash and the Feminist Judge: The Work of Justice Claire L'Heureux-Dubé ... 133
HESTER LESSARD

### Nine
Bars, Breasts, Babies: Justice L'Heureux-Dubé and the Boundaries of Belonging ... 143
REBECCA JOHNSON

## Shaping Substantive Law

### Ten
Contextualizing the Best Interests of the Child: Justice L'Heureux-Dubé's Approach to Child Custody and Access Law ... 165
SUSAN B. BOYD

### Eleven
*Baker* revisité : le contrôle judiciare de décisions humanitaires où l'intérêt de l'enfant est en cause ... 189
YVES LE BOUTHILLIER

### Twelve
The Social Phenomenon of Handicapping ... 209
ENA CHADHA

### Thirteen
Taxing Times at the Supreme Court of Canada: The Contributions of Justice L'Heureux-Dubé to a Better Understanding of the Application of the *Charter* to the Income Tax System ... 229
CLAIRE F.L. YOUNG

### Fourteen
Justice L'Heureux-Dubé and Canadian Sexual Assault Law: Resisting the Privatization of Rape ... 247
ELIZABETH SHEEHY AND CHRISTINE BOYLE

## Committing to Equality

### Fifteen
Travels with Justice L'Heureux-Dubé: Equality Law Abroad ... 287
MARGOT YOUNG

### Sixteen
Inequalities and the Social Context ... 303
MARY JANE MOSSMAN

### Seventeen
Personalizing the Political and Politicizing the Personal: Understanding Justice McClung and his Defenders ... 313
SHEILA MCINTYRE

### Eighteen
Outside/In: Lesbian and Gay Issues as a Site of Struggle in the Judgments of Justice Claire L'Heureux-Dubé ... 347
SHELLEY A.M. GAVIGAN

### Nineteen
Rooms with "Traditional Views": Justice L'Heureux-Dubé and the Expansion of Interpretative Principles Related to Equality in the Context of Indigenous Rights ... 367
TRACEY LINDBERG

### Twenty
Justice L'Heureux-Dubé: Dimensions of a Quintessential Judicial Leader ... 379
JUSTICE CORRINE SPARKS

Contributors ... 385

Introductory Materials

# One

## Foreword

CHIEF JUSTICE BEVERLEY MCLACHLIN

Justice Claire L'Heureux-Dubé is invariably described as a "feminist." And although the label has not always been intended as a compliment, it is one she bears with pride. *Adding Feminism to Law: The Contributions of Justice Claire L'Heureux-Dubé* appropriately celebrates Justice L'Heureux-Dubé's feminism and her contribution to the advancement of women's legal and social equality. This fascinating and insightful collection of papers offers a comprehensive analysis of the various ways in which Justice L'Heureux-Dubé's work and jurisprudence have advanced the cause of gender equality.

To this compendious work I can only add some brief thoughts derived from the years we spent together as colleagues and friends on the bench of the Supreme Court of Canada. Among the many qualities Justice L'Heureux-Dubé brought to the task of judging, two related ones stand out in my mind—her human compassion and her ability to see and understand the lived reality of people's lives.

Compassion is at the core of Justice L'Heureux-Dubé's judicial philosophy. She consistently approached the task of judging with consideration for the hardships experienced by others. As a judge, she was always attentive to the plight and situation of individuals and groups that have traditionally been disadvantaged in our society. Justice L'Heureux-Dubé's compassion has produced in her a near pathological intolerance for injustice and unfairness. As

many of the papers collected here so ably demonstrate, Justice L'Heureux-Dubé views the law as a powerful instrument for redressing injustice and unfairness. Compassion and concern for the vulnerable, disenfranchised, and marginalized is thus a theme woven throughout her remarkable jurisprudence in all areas of the law.

Compassion, like the law, does not exist in some abstract vacuum, but is inextricably linked to concrete experience. Justice L'Heureux-Dubé's human compassion is combined with an extraordinary ability to become engaged in the experiences of others and see the world from their perspectives. As Justice Bertha Wilson noted, judges must earnestly attempt to "enter into the skin of the litigant and make his or her experience part of [their] experience and only when [they] have done that, to judge."[1] Justice L'Heureux-Dubé has the rare ability to connect to the experiences and perspectives of others—particularly the experiences and perspectives of members of vulnerable and disadvantaged groups.

In this regard, Justice L'Heureux-Dubé championed the technique of contextual decision- making, which requires judges to examine issues in their full social context and with awareness to how they impact on people's lives. Thus Justice L'Heureux-Dubé has emphasized the importance of examining the concrete effects of norms and decisions as a central element of the decision-making process. In short, and to borrow a phrase from Aharon Barak, President of the Supreme Court of Israel, Justice L'Heureux-Dubé has always strived to bridge the "gap between law and life."[2]

In her jurisprudence, Justice L'Heureux-Dubé has certainly bridged the gap between law and the lived reality of women's lives. She has helped to demonstrate that purportedly "neutral" norms are often not at all neutral, but adopted from a particular, and usually male, perspective. Such norms may not recognize the distinct reality and validity of women's experiences and circumstances. Justice L'Heureux-Dubé has demonstrated the falsity of myths and assumptions prevalent in various areas of the law. She has shown how these myths and assumptions have unjustly operated to the disadvantage of women, thereby undermining equality.

These qualities of compassion and openness to the experience of others inform all of Justice L'Heureux-Dubé's jurisprudence, from her emphasis on human dignity as the concept at the core of the *Charter*'s guarantee of substantive equality to her use of equality as an overarching value in the devel-

opment of criminal law and family law. Justice L'Heureux-Dubé's jurisprudence stands as a vibrant model for judges and lawyers of both sexes and all backgrounds. It instructs us to be open to the experience and perspectives of others and to approach our calling with compassion and empathy for those whose lives are affected by our work. This collection of papers in honour of Justice L'Heureux-Dubé's feminism stands as a fitting testament to a great judge who has made an immense contribution to Canadian jurisprudence and who has worked tirelessly for justice and equality for all members of the human family.

The Right Honourable Beverly McLachlin, P.C.
*Chief Justice of Canada*

### Endnotes

1 B. Wilson, "Will Women Judges Really Make a Difference?" (1990) 28 Osgoode Hall L. J. 507 at 521.
2 A. Barak, "A Judge on Judging: The Role of a Supreme Court in a Democracy," (2002) 116 Harv. L. Rev. 16 at 35.

Two

## Introduction

ELIZABETH SHEEHY

My actions clearly signal that women have a major role to play in all facets of our national life, and this is a further indication of the genuineness of our commitment[1]

These were the words of then Prime Minister Brian Mulroney on his decision in 1987 to appoint Claire L'Heureux-Dubé to the Supreme Court of Canada. Justice L'Heureux-Dubé took on this responsibility with her characteristic joy and dedication of purpose.[2] From her first dissent on the Dickson Court in *R. v. Martineau*[3] in 1990, in which she was the only justice to question the "subjectivist orthodoxy"[4] that ultimately led the Court to declare unconstitutional most of our *Criminal Code* formulations of murder, to her many other fiercely independent judicial opinions on such matters as the constitutionality of legislation and practices that undermine the rights of women who have been raped, that exclude gays and lesbians from human rights protections, and that criminalize child pornography, L'Heureux-Dubé J. has turned her "major role" into one of mythic proportions. Her productivity is legendary, and it is fair to say that her keen sense of the challenge ahead fuelled her remarkable output in terms of hours worked, judgments meticulously researched and penned, articles published, and speeches delivered. She became, during her fifteen years on the Supreme Court, more, not less, outspoken on human rights and women's issues in her judgments and in her scholarship. Instead of experiencing isolation, she gained an ever-larger circle of colleagues in Canada, South Africa, the United States, Australia, New Zealand, India, and other countries, who collaborated with and supported her

work as a judge, and admired her intellect and profound humanism.

Feminists in and out of the legal profession absorbed Justice Claire L'Heureux-Dubé's announced retirement from the Court in July 2002 with great sadness, knowing that it would be years before another self-proclaimed feminist was appointed to our highest court. At the same time, we knew that it was critical to attempt to capture and assess the contribution that this one woman had made to furthering a feminist analysis of the law in Canada. With the assistance of the Shirley E. Greenberg Professorship in Women and the Legal Profession and the Social Sciences and Humanities Research Council, the University of Ottawa Faculty of Law convened a conference on the 27th of September 2002 devoted to examining L'Heureux-Dubé J.'s doctrinal, methodological, and leadership interventions that have enhanced women's access to justice. The majority of the papers is included in this volume; others have been published in a special issue of the *Canadian Journal of Women and the Law/Revue femmes et droit*.[5]

Claire L'Heureux was the oldest of four daughters, raised by a mother who lived with multiple sclerosis and spent forty years of her life in a wheelchair. She was clearly an accomplished student in her undergraduate work, where she graduated *magna cum laude* with her B.A. in 1946 and received the Lieutenant Governor's Medal. Her application to law school in 1948 required her to convince the Secretary General of the University that she did not wish to study social sciences. When eventually admitted that same year to the Université de Laval, she was ineligible for scholarships despite her academic merit and financial need because these awards were reserved for men.

Claire L'Heureux was one of two women in her law school class. Both women were "excused" from classes for the week in which rape law was discussed. In spite of her exclusion from this aspect of her criminal law class, she won the prize for this course, underlining, as she recently commented,[6] the profound lack of interest in this crime against women. She also received recognition for her academic excellence in the form of special awards for Civil and Labour Law. Claire L'Heureux received her LL.L. *cum laude* in 1951 despite the constraints that women law students laboured under at that time.

Upon graduation, she had trouble finding an articling position but was finally hired by Sam Schwarzbard (also known as Sam Bard), one of two Jewish lawyers in Quebec City at that time. Justice Claire L'Heureux-Dubé has frequently paid tribute to him for the space he gave her to develop a family

law expertise, which in time became an acknowledged field of legal practice, and the mentoring that he provided as a lawyer who served the public and pursued human rights with vigour (for example he argued *Saumur v. Quebec*[7]). She began publishing in 1969, the same year that she was made a Queen's Counsel. While achieving these distinctions, she also married Professor Arthur Dubé in 1957 and raised two children. This was at a time when other law firms would not even hire women, let alone accommodate their lives as mothers.

By the time of Claire L'Heureux-Dubé's first judicial appointment in 1973, her twenty-one years at the bar had earned her the positions of President of the Family Law and Family Court Committees of the Quebec Civil Code Revision Office, Vice President of the Vanier Institute of the Family, and Counsellor of the Bar of Quebec, as well as recognition for her expertise as a family law lawyer, lecturer, and law reformer. She was the first woman appointed to the Quebec Superior Court, and she was immediately confronted by the resistance of her new colleagues when the daughter of a neighbour, a judge of that court, excitedly told her: "Guess what, a woman has been appointed to the court and my dad says she's a nobody!"[8] Not long after, she was named the commissioner of the inquiry into alleged questionable practices at Montréal's immigration office, the findings of which were published in *Report of the Commission of Inquiry Relating to the Department of Manpower and Immigration in Montréal* (1976). Her second judicial appointment came in 1979, when she became the first woman appointed to the Quebec Court of Appeal.

In 1987, on the five-year anniversary of the proclamation of the *Charter*, celebrated as "Law Day," L'Heureux-Dubé J. received her third judicial appointment and was elevated to the Supreme Court of Canada. This appointment made her the second woman ever to sit at this level of court and the first woman from Quebec to reach this position. By this time, she had become Chair of the Editorial Committee of the Canadian Bar Review, President of the Quebec Association for the Study of Comparative Law, and Vice President of the International Society of Family Law. She had already served as the former President of the Canadian section of the International Commission of Jurists and Vice President of the Canadian Consumer Council. The press reported that she was a "canny" choice for Prime Minister Mulroney because she had no political ties to him and came from the same

city, Quebec City, as Justice Julien Chouinard, whom she replaced on the Court.⁹

She started at the Court when many members were experiencing low morale due to the "labour pains" associated with the Court's *Charter* rulings.¹⁰ She was warned by her friend Justice William McIntyre, "you will not be welcomed [on the Court],"¹¹ and she reports having initially found Chief Justice Brian Dickson to be "cool and peremptory."¹² Yet to the press, Dickson C.J. acknowledged her merit, her reputation as a hard worker, and her effectiveness as a judge.¹³ Dickson C.J.'s biography reports that "she had earned a reputation as an extremely hard-working appellate judge who grilled counsel with tough questions."¹⁴

She received a warm welcome from the first woman on the Court, Justice Bertha Wilson, but was confronted with the fact "that the Supreme Court of Canada was still pretty much a boys' club."¹⁵ Wilson J.'s biography points out that the women were often not included in judicial conferencing on the issues raised by the appeals.¹⁶ "[L'Heureux-Dubé J.] took Wilson's advice and resigned herself to the necessity (despite her six years as a trial judge and eight years as an appellate judge) of proving herself all over again."¹⁷

Within a year of L'Heureux-Dubé J.'s appointment, the Chief Justice indicated that "he respected her remarkable ability to get her work done" and told her, "If everybody were like you, it would be a pleasure to be here."¹⁸ She gives warm credit to the forty-two clerks she had over fifteen years at the Court; she says they were "the heart and soul of my chambers."¹⁹ Of her indefatigable work ethic, one of her former clerks says, "No matter how early I arrived at the Court she was already there, and no matter how late I left she was still in the office. ... [W]e all marvelled at her energy and her sheer force of will. No matter what the circumstances, Madame Dubé continued to put in hours and hours of effort."²⁰ She participated in over 600 *Charter* decisions while on the Court, and she dissented in one in ten, approximately. This means that she wrote about seven dissents per year,²¹ often on significant and politically-charged issues such as the legal definition of equality, Aboriginal title, and the rights of gays and lesbians.

L'Heureux-Dubé J. wept when Dickson C.J., whom she describes as "the greatest feminist our court ever had,"²² announced his retirement. She experienced the same loss when Wilson J. made her intention to retire known, for "the two of them had created breathing space for everyone and she knew that an era was coming to an end."²³

In the ensuing years on the Court, Justice L'Heureux-Dubé continued to serve in leadership positions: in 1998 she became the first woman and the first Canadian elected International President of the International Commission of Jurists; this mandate was extended in 2001 for another term. L'Heureux-Dubé J. was one of the founders as well as an active member of the International Association of Women Judges and has, since her retirement, been honoured with a lifetime membership in this organization. She was an honourary member and participant in the International Society of Family Law and a participant in innumerable conferences, such as those hosted by the Canadian Association of Black Lawyers. Justice L'Heureux-Dubé has been awarded thirteen honorary degrees, the Order of Canada in 2003 (Companion), and the National Order of Quebec in 2004 (Grand Officer).

Her retirement seems to have slowed her down not one bit: although she is the judge in residence at the Université de Laval Faculté de Droit, she has been solidly booked with conferences, speaking engagements, and writing commitments in the years since she stepped down from the Bench. Most recently, she has been appointed to sit on the External Advisory Committee to the Office of the Privacy Commissioner of Canada; she has also accepted a number of *pro bono* commitments such as Ombudsman of Quebec City and President of La Maison de Justice de Quebec.

This book celebrates Claire L'Heureux-Dubé's judicial career and considers the unique ways in which her work as a judge of the Supreme Court of Canada has enhanced women's equality and a feminist analysis of law, and thus concretely, the quality of life for Canadian women. The papers in this book suggest several themes that stand out from Justice Claire L'Heureux-Dubé's more than two decades on the bench. The first theme is her contribution to the enterprise of judging and its relationship to democracy. Her methodological approach to judgment writing reflects her intellectual curiosity and respect for academic research as well as for the grassroots experience of community groups and organizations. No other judge has so ably demonstrated a facility with a contextual approach to legal analysis or as long a reach to comparative law sources. She has shown leadership to other women in the profession, as well as judges, by her intellectual honesty and courage in unmasking judicial "neutrality" and taking unpopular positions in her judgments.

The second theme looks at L'Heureux-Dubé J.'s substantive contributions to specific areas of law. This theme traces the doctrinal shifts that her

judgments aspired to, sometimes as carefully-negotiated majority opinions, sometimes as powerful dissents that were so persuasive to the public that they later reappeared in the form of federal law reforms, and sometimes in lone dissents whose promise has yet to be realized. In this part of the book, the essays interrogate her judgments in the areas of family law, human rights law, the law governing taxation, immigration law, and the law of sexual assault.

The third theme examines Claire L'Heureux-Dubé's commitment to women, to substantive equality in our society, and to other rights-seeking groups. This commitment was evidenced by her invocation of substantive equality as the touchstone for almost every legal issue that she analyzed. Here the authors comment upon L'Heureux-Dubé J.'s reliance upon understandings of substantive over formal equality, the backlash that her judgments have generated, the influence of her analytical approach in equality jurisprudence on other nations, as well as the advances her judgments marked in the areas of access to justice, lesbian and gay rights, and Aboriginal rights in Canada.

### The Enterprise of Judging

Justice L'Heureux-Dubé is unique for having imbued the art of judging with scholarship; intellectualism; fresh and forthright approaches to statutory interpretation; contextual, interdisciplinary, and comparative methodologies; overt allegiance to the rule of law; and challenges to the public/private divide. With respect to scholarship, few Canadian judges have published as prolifically as Claire L'Heureux-Dubé. Her engagement in this regard has deep roots, for she began publishing long before her first judicial appointment and was reputed to be a reform-oriented practitioner. She has since published almost fifty articles in both French and English, most in Canadian legal periodicals,[24] and has co-authored a family law text with Justice Rosalie Abella.[25]

Her prolific publishing record makes manifest L'Heureux-Dubé J.'s intellectual development as well as her efforts to grapple with the unique role and responsibility of judges in a democratic society. For example, one of her publications written soon after joining the Supreme Court, "The Length and Plurality of Supreme Court of Canada Decisions,"[26] addressed criticism levied at the Court by placing judicial reasons for decision and *per curiam* decisions in historical context. She was keenly aware that judges are not only decision-makers but must "shape the law of tomorrow" and educate the citizens of a

country.[27] Plural opinions and even lengthy decisions have pedagogical functions: "As a court we sometimes have to allow new arguments to be distilled and gradually come to be accepted by the community. The successful adoption of a particular doctrine may take years, and many visits to the Court."[28]

Justice L'Heureux-Dubé's subsequent articles take up other aspects of the judicial enterprise, including the role of the Supreme Court in adjudicating *Civil Code* cases appealed from the Quebec Court of Appeal,[29] the status and contributions of women on the bench,[30] reliance upon the doctrine of judicial notice in judicial decisions,[31] the significance of dialogue and comparative law approaches among judges from different countries and legal traditions,[32] and the democratic and dynamic function of dissenting judgments.[33]

L'Heureux-Dubé J.'s scholarship also reveals her increasingly sophisticated grasp of substantive equality analysis and her deepening interest in international rights instruments and human rights issues. Susan Boyd's commentary on the Justice's family law scholarship notes that, as early as 1983, Justice L'Heureux-Dubé recognized that equality rights would be a treacherous and complex terrain for mothers in the face of the rise of the fathers' rights movement and their distortion of equality discourses. In the same vein, Shelley Gavigan credits her writing for recognizing that the language of equality can be manipulated and must therefore be tested against outcomes. The articles published by L'Heureux-Dubé J. examine the trajectory of equality jurisprudence from the Persons Case to date,[34] map out the relationship between judicial impartiality and equality,[35] and frame equality as a human rights issue of international significance.[36]

Her civilian law training, wherein the writings of legal scholars have paramount importance,[37] may help to explain why Justice L'Heureux-Dubé reviewed and integrated the scholarly literature in every substantial judgment that she wrote while at the Court. To cite one example, Sheila McIntyre points out that in *Canada v. Mossop*,[38] Lamer C.J. for the majority relied on three cases and no secondary sources, whereas L'Heureux-Dubé J. in her dissent referred to fifty-four cases and forty-three secondary sources. In *Mossop*, L'Heureux-Dubé J. concluded that the human rights prohibition on family status discrimination applied to a man denied bereavement leave for his male partner's father's funeral.

While most of the research that Justice L'Heureux-Dubé relied on was Canadian, she also engaged enthusiastically with emerging legal scholarship

from the United States, Australia, South Africa, and the United Kingdom. Shelley Gavigan credits her judgments with introducing a generation of critical feminist legal and extra-legal scholarship to Canadian judges, lawyers, law students, and readers, while displaying considerable sophistication in deploying analytic constructs such as ideology as part of her reasoning.

Justice L'Heureux-Dubé's judgments relied not only upon traditional scholarship and concepts published by recognized authors and refereed journals, but also upon knowledge generated by grassroots women's organizations and government bodies. She consistently attempted to enrich her knowledge of the experience of the "other" by reading and integrating material from such sources in order to craft sounder legal doctrine. Lee Lakeman highlights the significance of this effort to ground Canadian law in women's lived experience. L'Heureux-Dubé J. gave activists reason to believe that they should not abandon legal struggle altogether: her dissents reflected Canadian women's just demands and provided an incentive to engage in public legal debate and education.

Furthermore, Lee Lakeman's tribute to Justice L'Heureux-Dubé marks her as one of those rare judges who wrote her decisions in a way that all women could understand. This is, in part, because she adjudicated by articulating the values, conflicts, assumptions, and consequences of legal rules for real people's lives, as opposed to reasoning only by reference to case precedents and constitutional principles as if they arose in a historical and political vacuum. Although L'Heureux-Dubé J.'s decisions, and particularly her dissents, were often much longer than the opposing opinions, her direct writing style and willingness to address the "why" behind the rule showed that she wrote not only for lawyers and judges, but most importantly, for an informed citizenry.

Justice L'Heureux-Dubé's judgments were accessible to many segments of the public in part because of her innovative legal methodologies. Ruth Sullivan suggests that she made major advancements in the reading and application of legislation, constitutions, and common law doctrine by rejecting the plain meaning rule as a first principle of statutory interpretation in the *2747-3174 Quebec v. Quebec*[39] decision. This rule, argued L'Heureux-Dubé J., conceals the normative function of the judiciary in declaring particular words or phrases in a statute to be so "plain" that no interpretation is needed, while others are declared "ambiguous," requiring resort to interpretive principles. Sullivan demonstrates that she consistently avoided invoking the plain

meaning rule in her judgments and instead interpreted the contested language contextually in cases as diverse as *Charter* challenges to criminal law reforms (*R. v. Seaboyer*[40]), the interpretation of business corporations legislation (*Barrette v. Crabtree Estate*[41]), and *Charter* challenges to income tax principles (*Symes v. Canada*[42]).

By eschewing rigid and obfuscating interpretive rules and instead interrogating context in all of these decisions, L'Heureux-Dubé J. simultaneously expanded the breadth and depth of the sources used in the interpretive exercise. For example, in cases involving the interpretation of ministerial powers under the *Immigration Act*[43] and a municipality's authority to pass a by-law restricting pesticide use,[44] she treated *Charter* principles and international law as the normative context in which legislative language must be read. Justice L'Heureux-Dubé invoked comparative law approaches to interpretation that involved surveying the law in other jurisdictions while remaining attentive to the unique principles and coherence of Quebec's *Civil Code*. Beyond expanding the legal context, she also enlarged the external context, which consists of the circumstances in which legislation was passed, to include social science evidence regarding these circumstances and the legislation's actual operation in the legal and social world.

No other judge has so clearly exposed the inevitability of judicial choice through interpretation, given the ambiguity embedded in language and the criticality of context to meaning. Justice L'Heureux-Dubé stated explicitly in her judgments that all meaning is based upon embedded assumptions. Therefore, in pursuit of judicial integrity, she urged judges to identify and interrogate their own assumptions and to be honest enough to expose their premises in their reasons for judgment.

Her commitment to openness and accountability in the exercise of the judicial function is perhaps most evident in her concurring opinion in *R. v. R.D.S.*,[45] co-authored with McLachlin J., as she was then called. *R.D.S.* was significant in being only the second time that the Supreme Court of Canada had been called upon to directly address the test for reasonable apprehension of bias on the part of a judge. In this case, Youth Court Judge Corrine Sparks' acquittal of an African-Canadian youth on three charges of assaulting and resisting a police officer was challenged by the prosecutor on the basis that it raised a reasonable apprehension of bias: she had commented during adjudication that police had been known to mislead the court and overreact, par-

ticularly when dealing with non-white groups. The Supreme Court concluded, in a 7:2 decision on the analysis and a 6:3 decision on the application to the facts, that Judge Sparks' remarks did not raise a reasonable apprehension of bias—although two of the six justices held that her generalized remarks came very close to the line because they were not linked by evidence to the individual police officer who arrested R.D.S.

The judgment of L'Heureux-Dubé and McLachlin JJ., one of several gender splits in the Court's opinions, drew on a substantive equality perspective by eschewing "judicial neutrality" and particularizing the test for bias. The women justices agreed with the majority's test that asks whether a reasonable person, informed by the relevant social reality, including race and gender bias, would have seen the judge as partial. However, they endowed the reasonable person with respect for constitutional principles, including the equality value protected by section 15 of the *Charter*, and took judicial notice of systemic racism against African-Canadians. Furthermore, their judgment challenged the myth of judicial neutrality by stating baldly that no judge is neutral: instead judges must strive to be impartial by becoming cognizant of their own values and assumptions and by enlarging their understanding of the relevant social context in which the legal dispute is situated. Finally, their opinion is differentiated from the majority opinion in the conclusion that Judge Sparks' remarks were not even close to provoking a "reasonable apprehension of bias:" "In alerting herself to the racial dynamic in the case, she was simply engaging in the process of contextualized judging which, in our view, was entirely proper and conducive to a fair and just resolution of the case before her."[46]

Following her judgment in *R.D.S.*, L'Heureux-Dubé J. published several articles explaining her views on the responsibility of judges to be impartial as opposed to neutral. It is this specific contribution that prompted Australian judges to step off the dais and into public discourse, writes Regina Graycar. The paucity of women judges in Australia, and the even fewer numbers of feminist judges, has meant that Justice L'Heureux-Dubé's interpretation of the judicial function has triggered debate in that country. Graycar points out that Australian judges continue to hold on to the mantle of "judicial neutrality" in spite of the double standard embedded in the dominant conceptualizations of judicial "bias" versus "expertise." The comments of the two Australian judges discussed by Graycar reveal that some judges remain

unpersuaded by L'Heureux-Dubé J.'s view that judges should strive for self-awareness and informed reasoning over self-reflecting "objectivity." Nonetheless, *R.D.S.* remains a rich source for judges who choose to be thoughtful about their role as both judges and individuals with life experiences and particular values and beliefs.

L'Heureux-Dubé J.'s analysis of judicial bias has also been influential in other jurisdictions. For example, in an astonishing case in which the respondent challenged the entire bench of the Constitutional Court of South Africa for apprehended bias, that country's highest court followed the lead of *R.D.S.* and acknowledged that absolute neutrality is an impossibility. Quoting from the judgment of L'Heureux-Dubé and McLachlin JJ., it approved the proposition that the reasonable person would expect the judges' diversity of backgrounds, experiences, and perspectives to further, not hinder, impartial justice.[47]

Justice L'Heureux-Dubé's self-conscious and transparent judicial style has, moreover, re-invigorated the rule of law. Nathalie Des Rosiers argues that her judgments have reflected the pressing social issues of the era and reduced the gap between the law and its lived reality, thereby contributing to public respect for the law. In its narrowest formulation, the rule of law requires that no one is above the law. However, essential to even this formulation of the rule of law are equality and access to justice, which require that judges provide public reasons for their decisions and conform to just and articulable rationales. L'Heureux-Dubé J.'s judgments consistently live up to these requirements. This implementation of the rule of law is one of her most important contributions to Canadian law and, indeed, Canadian society.

Des Rosiers uses the verb "to reflect" to do justice to the ways in which Justice L'Heureux-Dubé has vitalized the rule of law. First, she reflected the rule of law by capturing the realities of our society in her judgments in the tradition of the legal realist movement, incorporating multi-disciplinary research and scholarship and expanding the sources of law's knowledge to include the lived experience of those historically excluded. Des Rosiers points out, for example, that law that recognizes the realities of only the privileged cannot contribute to a culture of democratic justification. Second, L'Heureux-Dubé J. reflected the rule of law by transmitting this knowledge in every aspect of her judgments, wherein she summarized the history of the conflict between the parties, their versions of the facts, and their arguments and positions. Des Rosiers emphasizes that this aspect of the judicial function

is critical to law's legitimacy not only for the litigants, but for society at large. Third, Justice L'Heureux-Dubé reflected the rule of law when deliberating on the role of equality in a democratic society and articulating judicial reasons by reference to egalitarian discourses. The promise of the rule of law, Des Rosiers argues, cannot be fulfilled by abstractions alone: it must be reflected in rational justification that is both grounded in social realities and aimed at reducing inequalities.

L'Heureux-Dubé J.'s approach to judging challenges the public/private divide as evidenced by the substantive content of her judgments. Her concurring opinion in *R. v. Ewanchuk*,[48] in which the majority of the Court in effect adopted her earlier judgments on the *actus reus* and *mens rea* for sexual assault and the parameters of the mistake of fact defence, is used by Hester Lessard to illustrate that challenge. The *Ewanchuk* judgment is a vivid example of the theory of judging that attempts to reflect a plurality of perspectives and to be alive to the relationship between power and the ability to "know" and to name. While the majority judgment did not address the sexism obviously displayed in the lower court judgment, L'Heureux-Dubé J. considered it her responsibility to break the silence. She articulated the assumptions and beliefs that undergirded Justice McClung's allusions to the complainant's clothing, marital status, and responses to the assault, and thereby laid bare the complexities of gender relations as they affect sexual assault adjudication. McClung J.'s personal attack on both Justice L'Heureux-Dubé and the complainant in the media in response to her judgment, accompanied by the chorus of public howling by defence lawyers as described by Sheila McIntyre, illustrates the rage that is unleashed when the power to name and to judge is publicly exposed as illegitimate.

Claire L'Heureux-Dubé also blurred the demarcation between public rights and private lives in her judicial decisions. Lessard suggests that she was attentive to the ways in which public rights of citizenship are circumscribed by familial relations, and conversely, how our understandings of citizenship depend upon the privatization of familial relations. An example is found in the case of *New Brunswick v. G.*,[49] in which the majority judgment held that section 7 of the *Charter* guaranteed legal representation to an indigent mother who faced a permanent wardship application by the Children's Aid Society for custody of her child. In this case, L'Heureux-Dubé J.'s concurring opinion directly confronted the relationship between positive and negative rights and the ways in which judicial interpretations of these rights moderate women's

experience of public citizenship.

L'Heureux-Dubé J.'s concern for public citizenship emerged in her daily actions as well as in her judgments. Rebecca Johnson recounts that her own exclusion from a licensed establishment because her nursing infant was "underage" was protested vigorously as a human rights violation by her dining companion, Justice L'Heureux-Dubé. L'Heureux-Dubé J. recognized that the construction of public space implicates citizenship rights and belonging. Her protest linked the issue to the moral regulation of parents, most often mothers, and to the protection of other adults from the discomfort caused by the presence of women with children and babies in certain establishments. Public space is inherently political: access and denial to particular spaces shapes our identities, for example, through colonization and *de facto* racial segregation. L'Heureux-Dubé J.'s insistence that law attend to the corporeal—to the realities of social existence—leads Johnson to posit that women's connections to the world of reproduction precludes them from unrestricted access to all public spaces and thus from aspects of citizenship. If we foreground the nursing mother as belonging and bearing the rights of citizens, as Claire L'Heureux-Dubé challenges us to do, Johnson suggests that we will see the connectedness of the needs of others and confront the fact that while we are symbolically committed to children, social spaces are inhospitable not only to mothers but also to children.

All of these aspects of the enterprise of judging in which L'Heureux-Dubé J. has engaged—scholarship; public education; development of interpretive, comparative, and contextual methodologies; critical reflection on impartial judging; furtherance of the rule of law; and challenging the public/private constructions invoked by legal discourse—speak to her role as an agent of social change. Ursula Franklin's "earthworm theory," invoked by Johnson to discuss the ways in which this judge has prepared the ground to nourish and sustain seeds of change as part of the project of nation-building, allows us to speculate that Claire L'Heureux-Dubé's multi-faceted contributions to shifting the paradigm of judicial leadership will bear fruit in the future.

### Shaping Substantive Law

The judgments of Justice L'Heureux-Dubé have effected doctrinal change in several areas of law that are critical for Canadian women. Among these are family law, criminal law, human rights law, constitutional law, refugee law,

and the law governing Aboriginal rights. In some of these areas, her majority judgments have changed the course of the law, making women's interests more central to the doctrinal core. In others, her dissenting judgments have prompted the legislature to respond with new laws that have effectively adopted the framework from her opinion. In still others, her dissenting judgments have, over the long term, come to be adopted by the Court. There remain, of course, dissenting judgments penned by L'Heureux-Dubé J. that have received neither majority adoption nor legislative implementation. These are perhaps her most enduring contributions to legal change, for their radical vision shows us how very far away we remain from realizing women's substantive equality.

Justice L'Heureux-Dubé's substantive contributions to family law doctrine are most apparent in her decisions on spousal support, such as *Moge v. Moge*.[50] In this case, following the lead of Dickson C.J. in *Murdoch v. Murdoch*,[51] she developed a compensatory model for determining support obligations in order to address the economic losses incurred by women who, unpaid, run households and raise children. These innovations have been adopted by the majority of the Supreme Court and have been discussed elsewhere.[52] In this book, Susan Boyd examines her less-recognized judgments on custody and access. As well, she attempts to square her support decisions with her custody decisions and explain why L'Heureux-Dubé J. was able to carry a majority of the Court with her on support, but not on the resolution of custody and access issues.

Boyd analyzes Justice L'Heureux-Dubé's approach to child custody and access issues, arguing that it is a nuanced one that cannot easily be captured by those who label her either conservatively deferential or radically interventionist. Her deference to the fact-finding of trial judges in family law matters, where there is no evidence of bias or error, shows a keen appreciation of the challenges inherent in weighing evidence and a modesty about the limits of appellate intervention. Her interventionist approach of insisting that the children's needs, best protected by preserving the authority of their custodial parents, should prevail over the *Divorce Act* principle of maximum contact between a child and both parents, is simply a well-informed application of the best interests of the child test.

While finding majority support among the justices at the Court in a 1993 decision *P. (D.) v. S. (C.)*,[53] L'Heureux-Dubé J.'s other judgments in the

area of child custody and the rights and obligations of custodial and access parents have lost majority support, such that by the time of her judgment in *Gordon v. Goertz*[54] in 1996, she was writing only for herself and La Forest J. At the same time, her judgments became increasingly sophisticated in developing the best interests of the child test. Justice L'Heureux-Dubé carefully read the research and the literature evaluating the effects of custody and access models on children, and analyzed custody and access questions from a child-centred approach, putting the needs of children above those of their parents. She recognized that children's needs are furthered by providing legal support and authority to their custodial parents and limiting access parents' rights when they interfere with the children's needs and well-being, particularly in situations involving ongoing conflict between the separated partners.

As was typical of L'Heureux-Dubé J., she invoked a multi-disciplinary approach to determining children's needs and was particularly drawn to the primary caregiver presumption that posited that children's interests are best served by placing them with the parent who has been primarily responsible for caring for their physical and emotional needs. She urged reliance on social science data to assist judges in predicting the impact of their decisions on children over the long term. More importantly, Boyd points out that she used a collectivist approach to custody litigation that included the interests of the individuals before the court as well as those of the family and the larger society. This approach entailed a feminist examination of the gendered nature of the custody/access split, the ongoing tasks and responsibilities borne by custodial mothers, the weaker economic position of these mothers, and the disturbance caused for parent and child by rendering custodial authority vulnerable to litigation.

Justice L'Heureux-Dubé's decisions in this area of law tell us much about current public policy shifts and the role of the state in constructing the private sphere. By looking at the larger social policy shifts that have occurred in social welfare schema in Canada in the last twenty years, Boyd argues that we can understand why L'Heureux-Dubé J.'s support decisions have been embraced by both her judicial colleagues and federal policy-makers whereas her custody and access decisions have not. Her approach of imposing support obligations on men is consistent with the increased re-privatization of economic responsibility and the corresponding diminishment of social programs. However, the move towards "shared parenting," which is overtly justi-

fied by reference to fathers' support obligations, is also consistent with the enhancement of private obligations in general. This shift in the approach to custody marks a rising credibility for the fathers' rights movement, but also further submerges and re-privatizes male violence against women and children in families. Thus activists, lawyers, and judges who hope to see L'Heureux-Dubé J.'s custody and access framework gain majority acceptance will need to strategize around these structural and ideological constraints.

Her unwavering focus on the best interests of children has translated into substantive law change in immigration law. Justice L'Heureux-Dubé's majority decision in *Baker* reached beyond immigration law to administrative law and incorporated international law on the protection of children's rights into domestic law. In *Baker*, for the first time, the Court invoked humanitarian grounds to permit a woman to apply for permanent residence from within Canada on the basis that the immigration officer had failed to give sufficient weight to the best interests of her Canadian-born children, who would have had to either follow their mother to a foreign country or lose her had she been deported. Yves Le Bouthillier argues that L'Heureux-Dubé J. shifted the focus of consideration away from the applicant alone to encompass the impact of the decision upon her children. She re-cast the reach of judicial review of administrative decisions to include those where the interests of the children were not considered; where they were given insufficient weight; where, although referred to in the decision-maker's reasons, the children's interests were in fact not evident in the outcome; and where those interests were outweighed by other factors that were themselves inadequately explained. At the same time, she preserved the discretionary function of administrative officers by holding that children's best interests are not determinative of the issue of humanitarian grounds.

After *Baker*, the gains made for a thoughtful and balanced approach to judicial review of administrative decisions on humanitarian grounds remain unstable, despite L'Heureux-Dubé J.'s strong reasoning and reliance upon international law principles. The decisions by the Federal Court of Appeal in *Canada v. Legault*[55] and the Supreme Court in *Suresh v. Canada*[56] both suggest that the reviewing court cannot intervene solely on the basis that inadequate weight was given to a particular factor, and it must accept the weight accorded to each factor by the initial decision-maker. This return to not differentiating children's interests from other factors undermines Justice L'Heureux-

Dubé's direction that considerable weight be given to the children's interests and raises the bar once again on the standard that must be met for judicial review. At the same time, Le Bouthillier points out that her language and conceptualization in *Baker* has been incorporated in the new legislation,[57] which expressly requires consideration of the "superior interest of the child" in several contexts in the legislation, including decisions made on humanitarian grounds. Thus, even if the courts have retreated from the strength of her judgment in *Baker*, the legislature has adopted her approach in statutory form.

In the area of human rights law, Justice L'Heureux-Dubé displayed leadership on the legal recognition of discrimination against gays and lesbians, as discussed below in the section "Committing to Equality." She also authored a significant dissent in a decision involving a claim against an all-male club. Her dissent deferred to the initial finding of discrimination by the Board of Adjudication and found the activities of preserving and publishing the history of the Yukon to be a "service" within a large and liberal construction of human rights laws.[58]

Also in the area of human rights law, Ena Chadha interrogates L'Heureux-Dubé J.'s decision in *Quebec v. Montreal*[59] (the *Mercier* decision), wherein the Court was called upon to decide whether persons who lost employment on the basis of health conditions could claim disability discrimination when, in fact, their conditions did not amount to functional impairment. Chadha argues that she grasped the complex nature of disability: it is both subjectively experienced by the person and simultaneously externally constructed by society. Thus L'Heureux-Dubé J. proposed a flexible, contextual understanding of "handicap" that does not require actual limitations, includes health impairments, and accounts for biomedical, technological, and social factors, including attitudes and stereotypes. Because the purpose of human rights statutes is to protect human dignity and equality, claimants must be protected against discrimination based upon their perceived disabilities.

Justice L'Heureux-Dubé steered the Court to a social context theory of disability over a biomedical theory and adopted Jerome Bickenbach's understanding of the "social phenomenon of handicapping," whereby social views of a person's "abnormality" and the refusal to accommodate the person's needs create the experience of disability. This theory, posits Chadha, adopts a universalist approach to disability such that all persons will experience some form of impairment over their lifetimes. L'Heureux-Dubé J. also held that the

burden of proving actual functional limitations falls on the employer, not the person whose subjective experience may be to the contrary. In other words, the respondent must demonstrate that his or her adverse decisions were undertaken in response to the claimant's actual limitations.

The significance of this doctrinal shift cannot be overstated: in the United States, rights claimants who may have managed to cope with or minimize their disabilities must instead prove to the courts how incapacitated they are in order to succeed in discrimination claims. L'Heureux-Dubé J.'s approach to defining disability has already been followed in another decision of the Supreme Court: in *Granovsky v. Canada*,[60] the Court concentrated on the social construction of the claimant's disability as created by the social and economic systems, as opposed to treating it as if it existed objectively.

Justice L'Heureux-Dubé's judgments have not been as successful in the area of tax law, yet Claire Young argues that she leaves behind a significant challenge to the view that the tax system is solely, or even mainly, a revenue-raising instrument through her judgments framing it as a social and economic policy tool that must be fairly subjected, like all other legislation, to section 15 of the *Charter*. In her dissents in two important section 15 *Charter* challenges, joined by Justice McLachlin, L'Heureux-Dubé J. implicitly drew upon the theoretical understandings of tax expenditure analysis, which Young argues lays the groundwork for any future investigation of the equality implications of the tax system.

In both of these cases, she undertook a contextual analysis that scrutinized the actual operation of the tax system in the lived reality of women's and men's social and economic lives. In *Symes*, L'Heureux-Dubé J. asserted that the relegation of childcare expenses to the private realm of the childcare expense deduction, as opposed to the public realm of the business expense, can only be explained by the male paradigm that has informed judge-made definitions of business expenses. She was prepared to re-cast the common law definition of business expense to include the costs of childcare in order to reflect the current reality that women lawyers such as Beth Symes are three times more likely to rely on paid childcare than are male lawyers.

In *Thibaudeau v. Canada*,[61] in contrast to the majority, she refused to water down her section 15 analysis just because the tax system is built upon drawing distinctions. Justice L'Heureux-Dubé found that the tax treatment of child support, which at that time was categorized as taxable income to the

payee and was permitted as a deduction from the payor's income, discriminated against women and ignored the needs of children. She disagreed with the majority's view that divorced men and women constitute a "post-divorce family unit" for the purpose of "sharing" the advantage offered by the inclusion/deduction scheme, and she rejected the idea that the family law system could somehow re-adjust the unfairness created by the tax treatment of child support.

Young argues that Justice L'Heureux-Dubé's legacy provides the framework for critical analysis of the current deduction/inclusion system for spousal support. Agreeing with L'Heureux-Dubé J. that no special deference is owed to the tax system where it violates section 15 of the *Charter*, Young demonstrates the inappropriateness of reliance on the "post-divorce family unit" as a conceptual model; she places the tax treatment of spousal support in the context of other government systems, arguing that, overall, women do not receive the spousal support that they should; and she suggests that section 1 of the *Charter* cannot save the scheme because the claimed purpose behind the deduction/inclusion arangement is thwarted by the unequal distribution of its benefits.

Criminal law is arguably the area of law where L'Heureux-Dubé J. has made her biggest imprint. Her dissent in *Martineau* and her defence of objective standards for determining moral fault or *mens rea* have, over time, come to represent a majority view for most crimes.[62] Although she is frequently portrayed as politically conservative by the criminal defence bar, her positioning is more complex than this. She consistently attempted to factor the interests of the collectivity—the groups affected by criminal acts, the accused themselves, and society at large—into her analyses. Thus, Justice L'Heureux-Dubé dissented in *R. v. Sharpe*,[63] on the basis that she would not have exempted—from the criminal prohibition on child pornography—materials that do not involve actual children, do not depict criminal activity, and are intended for private use only. She emphasized the difficulties in law enforcement created by the Court's exceptions and the importance of protecting children and society against the pernicious idea that children are appropriate sexual partners. On the other hand, in her dissents in several cases involving young offenders who had committed serious, violent crimes, L'Heureux-Dubé J. urged that a stringent test be applied before youth could be tried as adults[64] under the legislative regime that prevailed until 2002. Her deep concern to

protect the well-being and potentiality of children and young persons is perhaps a better explanation for these cases than is a particular orientation towards the state and its use of the criminal law power.

Christine Boyle and Elizabeth Sheehy focus on Justice L'Heureux-Dubé's most well-publicized criminal law decisions—those in the area of sexual assault law. They argue that the doctrinal developments in the substantive and procedural law of sexual assault pursued through her decisions have contributed to resisting the privatization of rape. Through linguistic choice, legal methodology, fact determinations, and doctrinal interpretations, she has insisted that the legal treatment of the crime of rape has implications for women's full participation in social, political, and economic life. Sexual assault is not simply an individualized crime, but rather one whose legal boundaries define men's rights over women and women's rights to their physical and sexual autonomy. L'Heureux-Dubé J.'s judgments in this area of law have been marked by her stance that individual accused's rights must be balanced against women's group-based rights, as well as broader social interests in truth-seeking and public confidence in a criminal justice system. Some of her famous sexual assault law dissents, such as *R. v. Cuerrier*,[65] have failed to gain support from either the full Court or Parliament. In *Cuerrier*, she alone would have ruled that any lie told deliberately to secure another's consent to sexual contact should render the contact non-consensual and thus criminal.

Many other of Justice L'Heureux-Dubé's dissents have, over time, gained majority acceptance or been enacted as law reforms subsequent to her judgments. Thus, while her dissenting decision in *Seaboyer*, asserting the fundamental irrelevance of women's sexual histories to the question of whether they consented to sexual contact with specific men, has not been made law, Bill C-49, in part fuelled by her powerful dissent, was passed in 1992.[66] It blunted some of the damage caused to women's equality rights by the ruling in *Seaboyer* by re-defining central concepts of the crime of sexual assault and legislating criteria by which judges must publicly justify their decisions on the relevance of women's sexual history. Justice L'Heureux-Dubé's doctrinal interpretations of the *actus reus* and *mens rea* elements for sexual assault and, perhaps most importantly, her interpretations of the parameters of the mistake of fact defence in earlier cases such as *R. v. Osolin*,[67] have ultimately achieved majority adoption in the more recent decisions of *R. v. Park*[68] and *Ewanchuk*. Her dissent in *R. v. O'Connor*,[69] on the disclosure and production

of women's counselling and therapy records in sexual assault prosecutions (repeated substantially in the subsequent cases of *A. (L.L.) v. B. (A.)*[70] and *R. v. Carosella*[71]) was adopted almost wholesale in Bill C-46, passed in 1997.[72] Sheehy and Boyle argue that her sexual assault decisions have succeeded in creating public space for women as fact-finders in their capacity as jurors and judges, as well as ensuring that the crime of rape and the consequent costs borne by women do not escape the public condemnation of criminal law.

Many of the substantive legal doctrines and shifts pursued by Justice L'Heureux-Dubé's judgments are incremental changes, the acceptance of which, by majority decisions or legislative implementation, cannot be fully gauged until the passing of another decade of judicial interpretation. Even the gains made for women by majority decisions like *Baker* remain tentative, as Le Bouthillier illustrates. However, the power of her dissents in the areas of child custody, the tax treatment of childcare and child support, child pornography, and sexual assault highlight her vision and courage in staking out new substantive law mirroring feminist aspirations for law that in turn reflect the interests of our most vulnerable citizens.

### Committing to Equality

A reliable consistency in the judicial decisions of Claire L'Heureux-Dubé is her attention to the equality value, whether through explicit reliance upon section 15 of the *Charter* or as an interpretive principle informing the development of the common law and the reading of statutes. In fact, almost every case discussed in this book underlines this point, as her judgments on judicial bias and impartiality, matrimonial support, child custody, the tax treatment of childcare costs and child support, the understanding of disability, and the substantive and procedural law of sexual assault are all grounded in an assumption that adherence to substantive equality principles must undergird all law in a democracy. Beyond this notable feature of her judgments are many specific contributions to equality law: the test for equality forged by her judgments; her re-interpretation of other *Charter* rights, such as section 7, in light of section 15; her willingness to brave the hurricane of backlash that her decisions unleashed; and her ability to re-conceptualize the "family" and lesbian and gay interests and to meet the challenge of looking at Canadian legal principles from an Aboriginal standpoint.

Margot Young traces L'Heureux-Dubé J.'s imprint on the framework for a section 15 equality claim pursuant to the *Charter* both in Canada and in South Africa. Justice L'Heureux-Dubé's focus on looking for discriminatory impact in light of the nature of the group and the interest affected—using a subjective/objective test of the reasonable person in the shoes of the affected person and emphasizing human dignity as the essential value protected by the equality guarantee—emerged initially in her judgments in the Trilogy cases (*Miron v. Trudel*,[73] *Egan v. Canada*,[74] and *Thibaudeau*), where she wrote in dissent. However, the Supreme Court's unanimous *Law v. Canada*[75] decision accepted these elements of Justice L'Heureux-Dubé's analysis.

In several key decisions,[76] the Constitutional Court of South Africa has adopted L'Heureux-Dubé J.'s section 15 benchmarks of the protection of dignity and the examination of impact on the group and the interest at issue. Noting this legal development, Young suggests that the emphasis on dignity as the key to equality may be inadequate to the task of radical social transformation that South Africa's constitution demands. South African commentators argue that this inadequacy arises because dignity can be framed as an individual experience, undermining group-based claims of inequality and distracting us from examining material disadvantage. In light of the fact that the test from *Law* has been used frequently in subsequent cases to deny section 15 claims, Young argues that Canadian equality jurisprudence would be enriched by South African concepts like *ubuntu*. This concept links human dignity and worth to collective concerns like material position, and thus, much more closely captures Justice L'Heureux-Dubé's search for a model that aspires to substantive equality.

L'Heureux-Dubé J.'s commitment to substantive equality and to the rights of women and children is examined by Mary Jane Mossman's chapter on the *G.* decision. In *G.* the Court as a whole ruled that indigent parents who face child protection hearings in which they may lose the custody of their child have a constitutional right to state-funded legal assistance, pursuant to section 7 of the *Charter*. Justice L'Heureux-Dubé's judgment in this case went further than the majority decision by recognizing, as a component of "security of the person" protected by section 7, a right to meaningful participation in decisions, such as wardship applications, that affect one's life in a significant way. In addition, her broad casting of the "liberty" interest protected by section 7 carries the potential for unrepresented litigants in other family law contexts involving

unequal litigants to assert a substantive right to state-funded counsel.

Most importantly perhaps, her separate judgment in *G.* interpreted section 7 through the lens of section 15's equality guarantee, emphasizing that unrepresented litigants in this context are usually single mothers and members of visible minority groups who have substantive claims to representation as an aspect of access to justice. However, any determination of a right to state-funded counsel in the broader family law context must take account of the research that suggests that men in family litigation without lawyers are more likely to be self-represented (as recreational or vexatious litigants) in contrast to women, who are more likely to be unrepresented. Mossman argues that in order to avoid further entrenchment of women's inequality in light of many men's use of litigation to harass, and in light of their ability to represent themselves, the future application of the *G.* case requires careful attention to social context for which L'Heureux-Dubé J. is recognized.

Sheila McIntyre examines in depth the anti-feminist attack on Justice L'Heureux-Dubé that erupted upon the release of her concurring judgment in the *Ewanchuk* decision. McIntyre argues that the attack relied upon the right-wing strategy of naming substantive equality theory and advocacy as "political correctness" and denouncing the advocates and their scholarship. She suggests that L'Heureux-Dubé J. stood as a proxy for all feminists and for institutions, such as the Supreme Court of Canada, which some claim have been "hijacked" by feminists. She draws numerous parallels to illustrate the anti-"political correctness" tradition of fact-distortion, anti-intellectualism, and resistance to social change as invoked by Justice McClung of the Alberta Court of Appeal, lawyers, academics, and the media as they converged in the attack on this one woman justice.

McIntyre demonstrates that beneath the rhetoric lies deep opposition to substantive equality and denial of the realities and significance of systemic inequalities. The intellectual challenge so willingly taken on by Claire L'Heureux-Dubé of upgrading her legal knowledge and analytical tools through engagement with scholarly research and the legal traditions of other jurisdictions is repudiated by these members of the profession. McIntyre speculates as to what her retirement will mean for substantive equality if L'Heureux-Dubé J.'s significant legal work can be discredited as "feminist extremism."

In the area of lesbian and gay rights, L'Heureux-Dubé J.'s twelve decisions and the voluminous commentary demonstrate her remarkable achieve-

ment, which has been to "[bring] the outside in." Shelley Gavigan shows how she faithfully commenced the legal inquiry with the experience of those excluded from law's paradigms and used this standpoint to inform and craft new legal interpretations. Gavigan credits her with courage, complexity, and consistency in her treatment of lesbian and gay claims to equality across a multiplicity of legal contexts such as work benefits, social benefits, human rights protections, and family law. Her decisions commenced with her dissent in 1993 in *Mossop*, joined by now Chief Justice McLachlin, and culminated in *M. v. H.*[77] in 1999, where Justice L'Heureux-Dubé's analysis prevailed, albeit in a majority opinion written by Cory and Iacobucci JJ. Gavigan places particular emphasis on her sophisticated grasp of significant analytical concepts that inform modern understandings of the family as shaped by the relationship between law and society and her challenge to the content of "family values."

L'Heureux-Dubé's dissent in *Trinity Western University v. British Columbia Teachers' College*[78] holds lessons for the legal profession as a whole, and particularly for legal educators, in living out the values of substantive equality. In this decision she examined the concrete experience of lesbian and gay students in a hostile learning environment and took seriously their entitlement to an equal education. In her academic publications, she has further suggested that law schools must be a starting point for instilling values like respect and compassion in law students. Gavigan argues that while lesbian and gay law students see themselves respected and valued in Justice L'Heureux-Dubé's judgments, we must take up her challenge of recognizing and supporting the "outside" in the legal academy itself.

Finally, Justice L'Heureux-Dubé has evinced her commitment to equality by expanding the interpretive principles of Canadian laws and systems so as to render them meaningful for Indigenous communities. Tracey Lindberg suggests that she has invoked the notion of inclusiveness as an aspect of equality, in such a way that difference can be celebrated. This understanding is critical for Indigenous peoples given the role of the legislature and the judiciary in creating and enforcing discrimination against their communities. Lindberg argues that L'Heureux-Dubé J. recognized that equality must extend to the right to name discrimination and inequality, to create the standards by which these claims are assessed, and to adjudicate upon them. The interpretive approach that she used in *Vriend v. Alberta*,[79] *Egan v. Canada*,[80] *Moge*, and *Thibaudeau* opens the possibility of mutual respect between Indigenous

communities and the Canadian legal system. Thus, these cases are of significant value to Indigenous communities thanks to Justice L'Heureux-Dubé's willingness to give equal weight to the different contributions that men and women make to a family, to take judicial notice of the "formerly unnoticeable," to recognize group-based rights, to refashion the reasonable person test, and to find discrimination when the vulnerability of a group is increased by the law, even though not every member of the group is adversely affected.

More particularly, her dissent in *R. v. Adams*,[81] following on her dissent in *R. v. Van der Peet*,[82] shows the early signs of her ability to integrate context, history, and inclusiveness into legal decision-making. She eschewed a "frozen rights" approach to determining Indigenous rights to hunt and fish, instead looking to post-contact relations and ways of living as the guide to recognizing rights. Her decision one year later in *Delgamuukw v. British Columbia*,[83] with La Forest J., marks a turning point in Canadian jurisprudence by preferring traditional Indigenous accounts and understandings of Aboriginal title to territories over judicial accounts based on statutes, case law, proclamations, and regulations. Lindberg suggests that an opportunity for mutual respect and dialogue was created by this judgment. More recently, in *Corbière v. Canada*,[84] Justice L'Heureux-Dubé adjudicated the question of off-reserve voting rights for Indigenous peoples by relying upon an historical, cultural, and legal perspective and using the modified reasonable person test to ask whether, from the perspective of off-reserve Indigenous peoples, the denial of voting rights violates principles of equality and fairness.

Despite what equality advocates identify as trends in recent Supreme Court decisions that suggest a retreat from substantive equality and the analysis pursued by L'Heureux-Dubé J.'s judgments[85] on equality claims, it may be impossible for the courts to retrench on Aboriginal rights. Given the international reception of her analyses of these rights claims,[86] as well as the attention by legal scholars in Canada to both her judgments and those of McLachlin C.J.,[87] it seems likely that our courts will move towards, not further away, from frameworks that validate Aboriginal understandings of rights in relation to land, forest, and water. It also seems clear that her approach to reading other *Charter* rights, an approach shaped by a section 15 analysis, will resonate in future rights litigation in the criminal law area, particularly in cases involving rights against unreasonable search and seizure and arbitrary detention and the right to reasonable bail. It is more difficult to predict Justice

L'Heureux-Dubé's impact in terms of the probable target of her decision in G.: access to legal aid for women in family law disputes. Legal aid has been further retrenched for family law matters in almost every province, and the trend to privatization and informal dispute resolution in this area may be too strong even for the persuasive jurisprudence of L'Heureux-Dubé J.

### Conclusion

In 1990, Canada's first woman on the Supreme Court of Canada, Justice Bertha Wilson, asked "will women judges really make a difference?"[88] While the question may be unanswerable when posed in such a broad manner, the answer is clearer when we ask whether a feminist judge makes a difference to the realization of women's equality rights. L'Heureux-Dubé J.'s many contributions to de-mystifying and contextualizing the enterprise of judging, her doctrinal innovations across different areas of law, and her persistent invocation of equality as a touchstone for all legal issues make her a judge who has indisputably made a difference to women's lives in Canada.

Claire L'Heureux-Dubé was not only a great judge; she was, most importantly for feminists in Canada, a woman judge—one of those most difficult contradictions. There is ample literature on the subject of the uneasy fit between women and authority, the feminine and the authoritative.[89] There is also a growing body of work on the experiences of women judges and the pressures to gain dominion by eschewing feminism, denying the relevance of sex to questions of law, and conforming to the status quo.[90] Although no woman judge is immune from attack because of her sex, regardless of her adherence to precedent or loyalty to power, judges who identify unabashedly with feminism, children's interests, and human rights open themselves knowingly to contempt and challenge.[91]

It is highly significant, therefore, that Justice L'Heureux-Dubé has shown leadership—and not only to other women judges—as Her Honour Judge Corrine Sparks observes in this book. In her tribute, Judge Sparks writes of Claire L'Heureux-Dubé's profound humanism, her admirable work ethic, and the support and encouragement that she unwaveringly provided to other women judges throughout her career. Justice L'Heureux-Dubé has also been a model for all women in law and for women who hold power in other social and economic domains, on how to assume authority with dignity and

with humility: she has refrained from entering the fray in the public domain even when viciously and personally demeaned; she has also spoken freely about how much she has learned, and has yet to learn, from those who are disenfranchised in Canadian society. Therefore, she must be celebrated, as Lee Lakeman suggests, for refusing to hide her womanliness, her hurt, and her joy and for displaying courage and dignity as a public and successful woman under constant scrutiny and attack. Justice L'Heureux-Dubé must also be thanked for the rich legacy in law that she leaves women in and out of the legal profession in Canada.

### Endnotes

1 "Supreme Court appointment brings praise" *The [Montreal] Gazette,* 16 April 1987, A2.
2 "I love life. I love my work: That's my life," quoted in Ken McQueen, "Second woman named to Supreme Court" *The Ottawa Citizen,* 16 April 1987, A1.
3 [1990] 2 S.C.R. 633.
4 Rosemary Cairns Way, "Constitutionalizing Subjectivism: Another View" (1990) 79 C.R. (3d) 260.
5 (2003) 15:1 C.J.W.L./R.F.D
6 Speech to the Australian Attorney General's Crime Prevention Division.
7 [1953] 2 S.C.R. 299.
8 Claire L'Heureux-Dubé, "Outsiders on the Bench: The Continuing Struggle for Equality" (2001) 16 Wisconsin Women's L.J. 15 at 15.
9 *Supra* note 2.
10 Ellen Anderson, *Judging Bertha Wilson: Law as Large as Life* (Toronto: The Osgoode Society, 2001) at 274.
11 Robert J. Sharpe and Kent Roach, *Brian Dickson: A Judge's Journey* (Toronto: The Osgoode Society, 2003) at 300.
12 *Ibid.*
13 *Supra* note 1.
14 Sharpe and Roach, *supra* note 12 at 300.
15 Anderson, *supra* note 11 at 431, n. 4.
16 *Ibid.* at 328.
17 *Ibid.* at 431, n. 4.
18 Sharpe and Roach, *supra* note 12 at 300.
19 Speech on the Occasion of the Retirement of the Honourable Claire L'Heureux-Dubé, 2002, Supreme Court of Canada, Ottawa, Canada.

20 Andrew J.F. Lenz, "Clerking for Madam Justice L'Heureux-Dubé: A memoir." A Tribute by the International Commission of Jurists (Canadian Section).
21 Roger Philip Kerans, Public comments (24 June 2002), online: www.kerans.ca/op-ed/claire.htm.
22 *Supra* note 7.
23 Anderson, *supra* note 11 at 328.
24 See Bibliography.
25 Rosalie S. Abella and Claire L'Heureux-Dubé, eds., *Family Law: Dimensions of Justice* (Toronto: Butterworths, 1983).
26 (1990) 28 Alberta L. Rev. 581.
27 *Ibid.* at 585.
28 *Ibid.* at 586.
29 "By Reason of Authority or By Authority of Reason" (1993) 27 U.B.C. L. Rev. 1.
30 *Supra* note 9.
31 "Re-Examining the Doctrine of Judicial Notice in the Family Law Context" (1994) 26 Ottawa L. Rev. 551.
32 "The Importance of Dialogue: Globalization and the International Impact of the Rehnquist Court" (1998) 24 Tulsa L.J. 15.
33 "The Dissenting Opinion: Voice of the Future" (2000) 38 Osgoode Hall L.J. 495.
34 "The Legacy of the "Persons Case": Cultivating the Living Tree's Equality Leaves" (2000) 63 Sask. L. Rev. 389.
35 "Beyond the Myths: Equality, Impartiality, and Justice" (2001) 10 J. Social Distress and the Homeless 87.
36 "The Search for Equality: A Human Rights Issue" (2000) 25 Queen's L.J. 401.
37 *Supra* note 30 at 8.
38 [1993] 1 S.C.R. 554.
39 [1996] 3 S.C.R. 919.
40 [1991] 2 S.C.R. 577.
41 [1993] 1 S.C.R. 1027.
42 [1993] 4 S.C.R. 695.
43 *Baker v. Minister of Citizenship and Immigration*, [1999] 2 S.C.R. 817.
44 *114957 Canada Ltée v. Hudson*, [2001] 2 S.C.R. 241.
45 [1997] 3 S.C.R. 484.
46 *Ibid.* at para. 59.
47 *President of the Republic of South Africa v. South African Football Union*, [1999] 4 S.A. 147.
48 [1999] 1 S.C.R. 330.
49 [1999] 3 S.C.R. 46.
50 [1992] 3 S.C.R. 813.

51 [1975] 1 S.C.R. 423.
52 E. Llana Nakonechny, "Spousal Support Decisions at the Supreme Court of Canada: New Model or Moving Target?" (2003) 15 C.J.W.L./R.F.D. 102.
53 [1993] 4 S.C.R. 141.
54 [1996] 2 S.C.R. 27.
55 [2002] F.C.J. No. 457 (C.A.).
56 [2002] 1 S.C.R. 3.
57 *Immigration and Refugee Protection Act*, S.C. 2001, c. 27.
58 *Gould v. Yukon Order of Pioneers*, [1996] 1 S.C.R. 571. McLachlin J. also wrote a significant dissent in this case.
59 [2000] 1 S.C.R. 665.
60 [2000] 1 S.C.R. 703.
61 [1995] 2 S.C.R. 627.
62 Rosemary Cairns Way, "Culpability and the Equality Value: The Legacy of the *Martineau* Dissent" (2003) 15 C.J.W.L./R.F.D. 53.
63 [2001] 1 S.C.R. 45.
64 See her dissents in *R. v. J.E.L.*, [1989] 2 S.C.R. 510 and *R. v. S.H.M.*, [1989] 2 S.C.R. 446.
65 [1998] 2 S.C.R. 371.
66 *An Act to Amend the Criminal Code (sexual assault)*, S.C. 1992, c. 38.
67 [1993] 4 S.C.R. 595.
68 [1995] 2 S.C.R. 836.
69 [1995] 4 S.C.R. 411.
70 [1995] 4 S.C.R. 536.
71 [1997] 1 S.C.R. 80.
72 *An Act to Amend the Criminal Code (production of records in sexual offence proceedings)*, S.C. 1997, c. 30.
73 [1995] 2 S.C.R. 418.
74 [1995] 2 S.C.R. 513.
75 [1999] 1 S.C.R. 497.
76 *President of the Republic of South Africa v. Hugo* (1997), C.C.T. 11/96; *Harksen v. Lane*, [1998] 1 S.A. 300 (C.C.).
77 [1999] 2 S.C.R. 3.
78 [2001] 1 S.C.R. 772.
79 [1998] 1 S.C.R. 493.
80 [1995] 2 S.C.R. 513.
81 [1996] 3 S.C.R. 101.
82 [1996] 2 S.C.R. 507.
83 [1997] 3 S.C.R. 1010.

84 [1999] 2 S.C.R. 203.
85 *Gosselin v. Quebec,* [2002] 4 S.C.R. 429; *Trociuk v. British Columbia,* [2003] 1 S.C.R. 835; Daphne Gilbert, "Unequalled: L'Heureux-Dubé J.'s Vision of Equality and Section 15 of the *Charter*" (2003) 15 C.J.W.L./R.F.D. 1.
86 For an account of the strengths of L'Heureux-Dubé J.'s approach see Janice Gray, "O Canada! —*Van Der Peet* as Guidance on the Construction of Native Title Rights: The *Gladstone* Decision" [1997] Aust. Indigenous L.R. 10.
87 Leonard Rotman, "Creating a Still-life Out of Dynamic Objects: Rights Reductionism at the Supreme Court of Canada" (1997) 36 Alta. L. Rev. 1; John Borrows, "The Trickster: Integral to a Distinctive Culture" (1997) 8 Constitutional Forum 27.
88 Justice Bertha Wilson, "Will Women Judges Really Make a Difference?" (1990) 28 Osgoode Hall L. J. 507.
89 Margaret Thornton, *Dissonance and Distrust: Women in the Legal Profession* (Melbourne: Oxford University Press, 1996); Lorraine Code, "Credibility: A Double Standard," in Lorraine Code, Sheila Mullet, and Christine Overall, eds., *Feminist Perspectives: Essays on Method and Morals* (Toronto: University of Toronto Press, 1988) 64.
90 Thornton, *ibid.* at 201–09, "Women on the Woolsack."
91 See Constance Backhouse, "The Chilly Climate for Women Judges" (2003) 15 C.J.W.L./R.F.D. 167. For an account of resistance even without a feminist target, see Anne Boigeol, "Male Strategies in the Face of the Feminisation of a Profession: The Case of the French Judiciary," in Ulrike Schultz and Gisela Shaw, eds., *Women in the World's Legal Profession* (Oxford and Portland Oregon: Hart Publishing, 2003) 401.

# Bibliography

### Articles

"A Conversation About Equality" (2000) 29 Denv. J. Int'l L. & Pol'y 65–75.

"A Response to Remarks by Dr. Judith Wallerstein on the Long-Term Impact of Divorce on Children" (1998) 36 Family and Conciliation Courts Rev. 384–91.

"L'arrêt *Bibeault* : une ancre dans une mer agitée" (1994) 28 R.J.T. 731–60.

"L'arrêt *'Poirier c. Globensky'* sous les feux du droit comparé" (1985) 87 R. du. N. 435–37.

"Au-delà des mythes : justice" (1994) 7 C.J.W.L./R.F.D. 1–14.

"Beyond the Myths: Equality, Impartiality, and Justice" (2001) 10 J. Social Distress and the Homeless 87–104.

"Bijuralism: A Supreme Court of Canada Justice's Perspective" (2002) 62 La. L. Rev. 449–69.

"By Reason of Authority or By Authority of Reason" (1993) 27 U.B.C. L. Rev. 1–18.

"Canadian Justice: Celebrating Differences and Sharing Problems" (1995) J. Supreme Court History 5–10.

"Changing Face of Equality: The Indirect Effects of Section 15 of the *Charter*" (1999) 19 Canadian Woman Studies 30–36.

"Conversations on Equality" (1999) 26 Man.L.J. 273–98.

"The Dissenting Opinion: Voice of the Future?" (2000) 38 Osgoode Hall L.J. 495–517.

"Droit de la famille à l'aube du 20$^e$ siècle : la marche vers l'égalité" (1997) 28(2) R.D.U.S. 3–18.

"Le droit de ne pas divorcer" (1969) 10 C. de D. 121–66.

"Les droits des minorités religieuses—Introduction" (1986) 27 C. de D. 53–55.

"Economic Consequences Of Divorce: A View From Canada" (1994) 31 Hous. L. Rev. 451–98.

"Equality and the Economic Consequences of Spousal Support: A Canadian Perspective" (1996) 7 U.Fla. J.L. & Pub. Pol'y 1–39.

"It Takes a Vision: The Constitutionalization of Equality in Canada" (2002) 14 Yale J.L. & Feminism 363–81.

"La garde conjointe : concept acceptable ou non?" (1979) 39 R. du B. 835–61.

"The Importance of Dialogue: Globalization and the International Impact of the Rehnquist Court" (1998) 34 Tulsa L.J. 15–40.

"In Memoriam: Bernard Schwartz" (1998) 33 Tulsa L.J. 1041 at 1045.

"Introduction" (2000) 46 McGill L.J. 109–11.

"The Legacy of the 'Persons' Case: Cultivating the Living Tree's Equality Leaves" (2000) 63 Sask. L. Rev. 389–401.
"The Legal Profession in Transition" (1992) 13 N. Ill. U.L. Rev. 93–103.
"The Length and Plurality of Supreme Court of Canada Decisions" (1990) 28 Alta. L. Rev. 581–88.
"Making a Difference: The Pursuit of Compassionate Justice" (1997) 31 U.B.C. L. Rev. 1–15.
"Making Equality Work in Family Law" (1994) 14 Can. J. Fam. L. 103–27.
"La marche vers l'égalité" (1995) 8 C.J.W.L./R.F.D. 275–89.
"La nomination des juges : une perspective" (1994) 25 R.G.D. 295–306.
"Nomination of Supreme Court Judges: Some Issues for Canada" (1991) 20 Man. L.J. 600–24.
"Les opinions dissidentes : voix de l'avenir" (2000) C. du Cons. Const 85–94.
"Outsiders on the Bench: The Continuing Struggle for Equality" (2001) 16 Wis. Women's L.J. 15–30.
"The Quebec Experience: Codification of Family Law and a Proposal for the Creation of a Family Court System" (1984) 44 La. L. Rev. 1575–640.
"Recent Developments in Family Law" (1993) 6 C.J.W.L./R.F.D. 259 at 269–77.
"Les récents développements en droit familial" (1993) 6 C.J.W.L./R.F.D. 259–68.
"Re-Examining the Doctrine of Judicial Notice in the Family Law Context" (1994) 26 Ottawa L. Rev. 551–77.
"The Search for Equality: A Human Rights Issue" (2000) 25 Queen's L.J. 401–15.
"Vers un droit familial nouveau" (1974) 4 Info-Inter 8–31.
"Volatile Times: Balancing Human Rights, Responsibilities and Resources" (1996) 25 C.H.R.R. c/1–c/5.
"What a Difference a Decade Makes: The Canadian Constitution and the Family Since 1991" (2001) 27 Queen's L.J. 361–73.

### Books and Chapters in Books

*Albert Mayrand : l'homme et son oeuvre* (Montreal: Éditions Themis, 1998).
"Applying Women's International Human Rights," in *Developing Human Rights Jurisprudence: The Domestic Application of International Human Rights Norms* (London: Commonwealth Secretariat, 2001) at 25–40.
"Appreciation: Madame Justice L'Heureux-Dubé," in I. Cotler, ed., *Nuremberg Forty Years Later: The Struggle against Injustice in Our Time* (Montreal: McGill University Press, 1995) at 23–25.
"Comments," in *Women's Rights are Human Rights* (UNPAC, Manitoba, 1999).
"Deciding Child Custody: New Developments in Quebec," in Ian F.G. Baxter and Mary A. Eberts, eds., *The Child and the Courts* (Toronto: Carswell, 1978) at 121–27.
In cooperation with Rosalie S. Abella, eds., *Family Law: Dimentions of Justice* (Toronto: Butterworths, 1983).
"Introduction: Same-Sex Partnerships in Canada," in R. Wintermute and M. Andenaes, eds., *Legal Recognition of Same-Sex Partnerships* (Oxford: Hart, 2001) 211.

"Judicial Activism and the Rule of Law: Doing Away with *Terra Nullius* Once and for All," in *Democracy and the Law* (London: Australian Bar Association Conference, 1998) at 49–68.

"Le défi de la magistrature : s'adapter à son nouveau rôle," in M.J. Mossman and G. Otis, eds., *La montée en puissance des juges : ses manifestations, sa contestation/ The Judiciary as Third Branch of Government: Manifestations and Challenges to Legitimacy* (Montreal: Thémis, 1999) at 455–68.

"L'égalité en droit de la famille : une perspective canadienne," in Marie-Thérèse Meulders-Klein, *Droit comparé des personnes et de la famille* (Brussels: Bruylant, 1998) at 399–416.

"Pour la primauté du droit," in *Concours Fondation Rougier Commission internationale de juristes (Canada)* (Montreal: Université de Montréal, 1995) at 6–8.

"The Hague Convention on the Civil Aspects of International Child Abduction," in A-M Trahan, ed., *Proceedings of the 4th Biennial International Conference of the International Association of Women Judges: A New Vision for a Non-Violent World: Justice for Each Child/ Actes de la 4e conférence biennale internationale des femmes juges : justice pour chaque enfant : vision nouvelle d'un monde sans violence* (Montreal: Yvons Blais, 1990) at 227.

"The Importance of Dialogue: Globalization, the Rehnquist Court, and Human Rights," in M.H. Belsky, ed., *The Rehnquist Court: A Retrospective* (New York: Oxford University Press, 2002) at 234–52.

"Two Supreme Courts: A Study in Contrast," in M.C. McKenna, ed., *The Canadian and American Constitutions in Comparative Perspectives* (Calgary: University of Calgary Press, 1993) at 149–65.

### Other Material

In cooperation with Jean-Louis Baudouin, "La situation juridique de la femme dans le droit civil de la Province de Québec" (Paper presented to the IXe Congrès de l'Institut international de Droit d'expression francaise, Tunis 1974), I.D.E.F, Paris, 1975.

*Rapport de la Commission d'enquête relative au ministère de la main-d'œuvre et de l'immigration à Montréal/ Report of the Commission of Inquiry Relating to the Department of Manpower and Immigration in Montreal* (Ottawa: Information Canada, 1976).

"Relationship Recognition: The Search for Equality" (Seminar Paper in a Discussion Forum on Relationship and the Law, Sydney, Australia, 7 July 2000) New South Wales Law Reform Commission, online: http://www.lawlink.nsw.gov.au/lrc.nsf/pages/seminar.

Three

Tribute

JUSTICE ROSALIE SILBERMAN ABELLA

There are many legacies of Claire L'Heureux-Dubé: the international conversions to equality she inspired; the domestic and gender-neutral nurturing of colleagues committed to gender neutrality; the public record of an unswerving devotion to human rights; and her private loyalty to family and friends. But of all the memorable achievements of this memorable judge, none is more profound than the jurisprudence she tenaciously developed during her fifteen years on the Supreme Court of Canada. She took the torch lit by Brian Dickson and Bertha Wilson into her firm grasp and never let that light stop glowing for human rights.

L'Heureux-Dubé has explained her passion for compassion as springing from what she learned from her mother's courage at home and from her profession's insularity when she decided to become a lawyer. The personal and professional environments were exceptional incubators for the judge she grew into, teaching her to overcome obstacles and opposition with grace and grit. In return, she found generosity and respect.

The juristic phenomenon this forged can really only be understood if one remembers the climate in which her most important judgments were produced. Judicially, L'Heureux-Dubé found herself for a full decade on a court in which the jurisprudential trajectory was criminal law. This concentration, perhaps an inevitable second chapter to the human rights-oriented

*Charter* story launched by Chief Justice Dickson, exponentially expanded the rights of the accused and held the state to stricter account. It was not a comfortable philosophical environment for a judge whose sympathies lay openly with victims and the protection of the public. Her dissents or concurring opinions in this period unabashedly exposed her perplexed frustration with what she perceived to be an ideological unwillingness to appreciate that the presumption of innocence was rebuttable.

And so, with an increasingly powerful pen, she made the case for a different governing perspective. In a trail leading from her astonishment in *Seaboyer*,[1] that prior sexual history could ever be relevant to a complainant's consent; her outrage in *O'Connor*[2] and *Osolin*[3] that a complainant's privacy rights could so easily yield to a fishing expedition in search of an elusive "gotcha" thought or statement; and her astonishment in *Park*,[4] *Ewanchuk*,[5] and *Livermore*[6] that a complainant's clothes and demeanour could so cavalierly be characterized as sexually inviting, all reflect her indomitable resistance to what she saw as a judicial flow of indifference to the rights of the victims of crimes.

It is no accident that the Rubicon in criminal law for Justice L'Heureux-Dubé was sexual assault, where complainants were mostly women. Throughout her jurisprudence, she consistently introduced the woman's voice to the judicial conversation, resisting tradition and demanding attention to the uniqueness of women's experience. She was unapologetic in her loyalty to this voice. In family law, an area in which the Supreme Court seemed to curtail its transformative reach after detonating *Rathwell*,[7] she raised it to operatic levels. In *Moge*,[8] she paid judicial tribute to the economic sacrifice most wives paid on marriage; in *Willick*[9] and *Young*,[10] she elevated the rights of children to pre-eminent status; and in *Gordon v. Goertz*[11] she gave custodial parents, mostly women, a sense of entitlement to the possibility of integrating reality with parental responsibility.

In a national media and political climate dramatically more conservative in the 1990s than it had been for almost two decades, L'Heureux-Dubé dared to protect gay rights in *Mossop*;[12] eschew historic male entitlements in *Yukon Order of Pioneers*;[13] limit administrative power in *Baker*;[14] challenge discriminatory tax structures in *Thibaudeau*[15] and *Symes*;[16] add dignity to equality in *Egan*;[17] and, with Chief Justice McLachlin, to build a wall between bias and neutrality in *R.D.S.*[18]

In some sense, she paid the price for refusing to be guided by the prevailing winds. She was demonized by the right and by the defence bar, a vilification willingly stoked and fuelled by the press. On the other hand, her singularly steadfast commitment to the rights of women, children, and minorities earned her a place in history. Without her insistent insinuation of her unique judicial principles into a contrary philosophy, those principles would never have achieved the centrality they did by virtue of being endorsed by a Supreme Court judge.

Judging from the grateful academic, judicial, and public tributes swirling around her retirement, L'Heureux-Dubé will always be remembered for judicially protecting, sometimes at a huge cost to her reputation, values which, while not always in "political" favour, always seemed to resonate comfortably with the public. This, in the end, is why her jurisprudence is so supremely relevant: it connects private lives to the law, rather than contradicting them. Hers is, in short, the judicial triumph of common sense. No small feat.

*Rosalie Silberman Abella*
Court of Appeal for Ontario

### Endnotes

1 *R. v. Seaboyer*, [1991] 2 S.C.R. 577.
2 *R. v. O'Conner*, [1995] 4 S.C.R. 411.
3 *R. v. Osolin*, [1993] 4 S.C.R. 595.
4 *R. v. Park*, [1995] 2 S.C.R. 836.
5 *R. v. Ewanchuk* (1999), 131 C.C.C. (3d) 481 (S.C.C.).
6 *R. v. Livermore*, [1995] 4 S.C.R. 123.
7 *Rathwell v. Rathwell*, [1978] 2 S.C.R. 436.
8 *Moge v. Moge*, [1992] 3 S.C.R. 813.
9 *Willick v. Willick*, [1993] 3 S.C.R. 670.
10 *Young v. Young*, [1993] 4 S.C.R. 3.
11 *Gordon v. Goertz*, [1996] 2 S.C.R. 27.
12 *Canada (Attorney General) v. Mossop*, [1993] 1 S.C.R. 554.
13 *Gould v. Yukon Order of Pioneers*, [1996] 1 S.C.R. 571.
14 *Baker v. Canada (Minster of Citizenship and Immigration)*, [1999] 2 S.C.R. 817.
15 *Thibaudeau v. Canada*, [1995] 2 S.C.R. 627.

16 *Symes v. Canada*, [1993] 4 S.C.R. 695.
17 *Egan v. Canada*, [1995] 2 S.C.R. 513.
18 *R.D.S. v. The Queen*, [1997] 3 S.C.R. 484.

The Enterprise of Judging

Four

## A Feminist View of the Supreme Court from the Anti-Rape Frontline

LEE LAKEMAN

I am not a lawyer and neither are any of the women who work in my Vancouver Rape Relief and Women's Shelter. Nor do lawyers work in the many Canadian Association of Sexual Assault Centres of anti-violence activity across the country. In fact, when young women who are attending law school want to volunteer with us we feel obliged to warn them off. They probably should not do so because it is still impossible to work effectively in a rape crisis centre or a transition house and not be breaking Canadian law on a regular basis. Partly thanks to you, Justice L'Heureux-Dubé, we will be breaking the law a little less often.

I trust I am the only woman here who has not read all your decisions. But I have read enough to know that I can read them. There is something in your writing, your manner, your self-revelations that makes it clear to us, the non-lawyers, that you mean for us to understand.

We women in the anti-rape centres are not quick to believe that the law or our current legal institutions are the route to freedom and justice for women. Rather, we accept that it is necessary for us to commit acts of civil disobedience in which we refuse to submit to and comply with unjust laws and procedures. Hiding records or destroying records will be one act you know about; there is also immigration law, the obligation to report crimes, and the need to hide prostitutes and wives and daughters. There are the wel-

fare frauds necessary to feed children and the probation orders that must be ignored to survive.

But we are often before the courts because the women who call us cannot usually choose their engagement with law. They are desperate for protection, they are stripped of agency, and they are impoverished by social policy. Our experience, the experiences of women in courts, whether as lawyers, witnesses, complainants, or accused, are still a shame on the state, and still denied. Overall, the courts are of very little help to women facing down sexism either as individuals or as a group.

We anti-rape workers may not believe in law but we know that you do. When we do appeal to the courts, our efforts can seem to fall on deaf ears. We have often been left to worry that we had not made ourselves clear. But sometimes because of you we heard back that we had been heard and understood. And so sometimes we knew unequivocally that the problem was not argument. We had sometimes been refused justice. But even then we could take some comfort in a minority position, a question, or a comment. We could improve our tactics and strategies. Those acts of yours have sometimes made us less likely to abandon legal strategies altogether.

Young women often argue to us that they plan to go to law school as the effective way to be a feminist. I never encourage this. We have a greater need for the political and social activism that will drive legal change. But we do believe we have a critical mass of legal scholars and practitioners and students now. That mass is critical to anything that can be done through law and you were and are still part of the knife-edge, which made the numbers, and the philosophy of law that accumulated into that mass. Women see themselves as becoming lawyers because of your integrity. Yours is a professional and social achievement of barrier breaking and tone changing and substance giving. It was and is a refusal to accept ceilings and notions of the rightful place for women.

We understand that you have made these achievements in ways that opened choices for other women. We admire not only your professional work but also the way you have conducted yourself as a public woman. Your judicious manner and personal discretion was expected. Your skill and discipline in transcending personal identity was terribly important to a public scandalized by too many self-serving public figures. But you have also been sensual and funny and charming and very, very personally tough. No princess and the pea stories about you! You have repeatedly revealed how the attacks have

shaped your life as well as the kudos. That you were viciously attacked is not a surprise, but that you were so open in your resistance was.

You have made it clear that you knew you were breaking ground that belonged to all women of achievement. We know that you have been hurt and we know that you possess great joy. It is a gift to us that you reveal both. Most of us grew up with the notion that, while some women might achieve great things, their achievement would be punished by isolation and loneliness. You have not hidden your womanly existence behind judicial robes pretending to be an almost-man. This too has been an important example.

The rape crisis centre women were barely aware of the fight to achieve the *Charter*. The fight to establish the inclusion of women as a group in need of protection from and by government was won largely by more educated and privileged women. But that critical mass of women in law, and particularly some of the feminist lawyers in this room, have introduced us to the promise of the *Charter*. Often they did so by pointing to you.

It is not hopeless, they tell us; it is possible to add the promise of the *Charter* to the promise of international agreements. It is possible to have equality interpreted to mean something of substance. It is possible to bring a justice that can be of benefit to poor women and women of colour, to lesbians and mothers who dared to leave their marriages. It is possible to have that interpreted by a sensible, fair-minded judge and thereby to move towards justice. We have learned that even if we cannot get full satisfaction before the Supreme Court, it has been possible for some measure of our reality to be reflected in the decisions of the Court through minority positions, even through question and comment. We have learned to claim, as our own, concepts of substantive equality and compounding inequalities. You have helped to fuse hope into our demands.

This year virtually all rape crisis centre workers have been involved in a national discussion about rape law and records, rape law and assault law, rape law and damages, rape law and poverty law, rape law and international human rights. Almost every rape crisis centre and transition house has been engaged and has hosted a discussion of rape law and the rights of the accused. I believe that public legal education would not be going on if the Court had not had you to give it some credibility to women.

We as activist feminists have been trying to establish the rights of women, not victims' rights. We have been trying to establish the prize of free-

dom, not the prize of vengeance. We have been asserting our judgment that it is the role of governments to interfere with inequality, and to contribute to the movement towards equality and justice. You have played a significant part in raising our expectations that women have a right to the rule of law and that the rule of law in Canada includes government protection from the violence that takes advantage of and also imposes an unequal status on women.

But to use the *Charter* in the courts takes a lifetime. I remember when I first considered Justice Thurgood Marshall of the United States Supreme Court and realized that he schooled and coordinated three generations of lawyers to fight American race segregation before he could even assess his tactic. We are in our first generation of legal struggle using the *Charter*. But to dare to use such a tool, progressives have to have some realistic expectation that the court is a venue for meaningful and rational discourse.

I have heard women say that they fear that they will never see the likes of you again. I can promise you that I will be among the women expecting those in that critical mass to live up to your example and I will be among those to demand from Supreme Court judges the attention to the condition of women, all women, that has been your credit.

Perhaps we are most grateful for the use you made of your right to dissent. Surely this is the first job of any woman in any position of influence or power: to refuse to be silent or compliant on matters of equality and justice. And of course it is among the most difficult of things to do. To dare to articulate a new legal understanding of the social and political imperatives, to assert a version of reality and logic and fairness that confronts the world in which we live, and to demand that it begin to live up to our humanity—at least to the extent we have won that expression in law—are challenges that frontline women must step up to meet every day.

# Five

## The Era of Concealed Underlying Premises Is Over: L'Heureux-Dubé J.'s Contribution to Statutory Interpretation

RUTH SULLIVAN

### Introduction

In 2000 Justice L'Heureux-Dubé delivered the Rubin Lecture at the Louisiana State University Law Center on the topic of bijuralism. She began by quoting some remarks of John Sexton, the dean of New York University Law School, on the merits and implications of intellectual self-examination:

> Discovering a premise that unconsciously shaped one's thinking is a dramatic moment intellectually, and the repetition of such discoveries should instill intellectual humility and a reluctance to assume that there is a single right answer.[1]

It is not surprising that L'Heureux-Dubé J. opened her presentation with a reference to unconscious premises that shape one's thinking, for drawing attention to such premises and their impact on interpretation is one of her most important contributions to Canadian law. As she notes in *R. v. Seaboyer*, the impact of unconscious premises can be pernicious:

> Whatever the test [of relevance], be it one of experience, common sense or logic, it is a decision particularly vulnerable to the application of private beliefs. Regardless of the definition used,

the content of any relevancy decision will be filled by the particular judge's experience, common sense and/or logic. For the most part there will be general agreement as to that which is relevant and the determination will not be problematic. However, there are certain areas of inquiry where experience, common sense and logic are informed by stereotype and myth ...[2]

In a report prepared for the Ontario Women's Directorate in 1988, by Informa Inc., "Sexual Assault: Measuring the Impact of the Launch Campaign", the prevalence among Ontario residents of a number of stereotypical and discriminatory beliefs was measured. The results indicate that similar stereotypes are held by a surprising number of individuals, for example: that men who assault are not like normal men, the "mad rapist" myth; that women often provoke or precipitate sexual assault; that women are assaulted by strangers; that women often agree to have sex but later complain of rape; and the related myth that men are often convicted on the false testimony of the complainant; that women are as likely to commit sexual assault as are men and that when women say no they do not necessarily mean no. This baggage belongs to us *all* ...[3]

The *Seaboyer* case was not about statutory interpretation; it involved a *Charter* challenge to *Criminal Code* provisions that excluded certain types of evidence in trials for sexual assault. The passage set out above is nonetheless relevant, because it draws attention to the hazards of establishing factual conclusions through inference, an activity that lies at the heart of all interpretation. Interpreting a perceived event is not very different from interpreting a text. Both are responses to sensory inputs that the mind strives to organize in a meaningful way by drawing on its knowledge of the world. This knowledge constitutes the context in which legislation is read.

Here is what Dan Sperber and Deidre Wilson, two leading scholars in linguistics, have to say about the concept and role of context in interpretation:

> The set of premises used in interpreting an utterance ... constitutes what is generally known as the context. A context is a psychological construct, a subset of the hearer's assumption about

the world. It is these assumptions, of course, rather than the actual state of the world, that affect the interpretation of an utterance. ... [E]xpectations about the future, scientific hypotheses or religious beliefs, anecdotal memories, general cultural assumptions, beliefs about the mental state of the speaker, may all play a role in interpretation.

While it is clear that members of the same linguistic community converge on the same language, and plausible that they converge on the same inferential abilities, the same is not true of their assumptions about the world ... Differences in life history necessarily lead to differences in memorised information. Moreover, it has been repeatedly shown that two people witnessing the same event—even a salient and highly memorable event like a car accident—may construct dramatically different representations of it, disagreeing not just on their interpretation of it, but in their memory of the basic physical facts. While grammars neutralise the differences between dissimilar experiences, cognition and memory superimpose differences even on common experiences.

... A central problem for pragmatic theory is to describe how, for any given utterance, the hearer finds a context which enables him to understand it adequately.[4]

At the heart of Justice L'Heureux-Dubé's work is the recognition that people construct different representations of the world from their experience and different meanings from texts. All interpretation depends on context, and the context an interpreter brings to an experience or a text inevitably varies with his or her cultural and personal "baggage." As a francophone and civilist in an English-speaking, common law continent and as a woman in a patriarchal society, Justice L'Heureux-Dubé was well placed to notice the gap between the underlying premises of the dominant group and the underlying premises of an outsider, rooted in a different cultural and personal experience. Dominant groups dominate, in part at least, by equating their underlying premises with truth, common sense, and logic. It follows that their premises must be accepted by anyone who is truthful, sensible, and logical. Because

these premises have the feel of inexorable truth, they are not easily challenged. In practice, the burden of challenge falls on the outsiders. They bring a different context to interpretation and are therefore well placed to recognize the contingent character of the dominant group's underlying premises. If courts are to rely on these premises, they need to justify them—ideally on a basis that both groups can accept, but in any event on some explicit basis. As Justice L'Heureux-Dubé repeatedly insists in her reasons for judgment, courts must expose the underlying premises on which they rely and open them up for debate.

Justice L'Heureux-Dubé also contributed to statutory interpretation by adopting an expansive conception of the context in which legislative provisions should be interpreted. For her, context includes not only the statutory context—the "Act-as-a-whole" or the "statute-book as-a-whole"—but also the social, economic, and cultural context in which the legislation was enacted and in which it continues to apply. In effect, she brings the enriched concept of context developed in connection with *Charter* litigation to the interpretation of ordinary statutes. Her understanding of legal context is also expansive in that it includes *Charter* norms, international law, and the law of other jurisdictions.

Justice L'Heureux-Dubé was also sensitive to the troubled relationship among the rhetoric of statutory interpretation that governs judicial reasons for judgment, the theory of statutory interpretation in which judicial rhetoric is grounded, and judicial practice in particular cases. She points out that during the 1990s the Supreme Court of Canada waffled between competing theories of interpretation, sometimes adopting a textualist approach while at other times emphasizing intention and total context.

Finally, Justice L'Heureux-Dubé contributed to statutory interpretation by showing how the exercise is enriched by drawing on the bilingual and bijural resources of the federal statute book. These themes are explored below, looking first at her contribution to interpretation theory, then at her understanding of context, and finally (though very briefly) at her use of comparative law.

### Interpretation Theory

Judges and lawyers working within the common law tradition generally have little interest in legal theory. For most common law jurists, the life of the law

is experience, and experience is integrated into law through judicial responses to individual cases. Fortunately, Canada benefits from a different attitude towards theory in its civil law tradition. Civil law jurists recognize that both the interpretive practice of courts and the rhetoric relied on to justify particular outcomes are grounded in theory—a theory of the judicial task in interpretation and a theory of how meaning is derived from a text. If these basic theories are faulty or inadequate, then judicial practice or judicial rhetoric, or both, may be deficient.

Within statutory interpretation, the primary theoretical concern is legitimizing what courts and tribunals do to resolve interpretation disputes. According to official theory, in a democracy such as Canada it is the legislature (consisting of the elected representatives of the people) that makes the law while the role of courts (an undemocratic institution, but possessed of legal expertise) is to verify in doubtful cases the content of the law enacted by the legislature and to apply it to particular facts. Crucially, this theory presupposes that it is possible to "embody" the law intended by the legislature in the language of the legislative text—in other words, that the law enacted by the legislature can be equated with the meaning of the words that declare it, that meaning is a stable entity captured by and preserved in the fixed words of a text. On this approach, ironically, judicial expertise consists not in superior knowledge of the law but in linguistic competence—the ability to extract meaning from a text. Judges regularly purport not only to declare the meaning of legislative texts but also whether that meaning is plain or ambiguous, based on their own linguistic intuitions. Judges routinely assume that their personal understanding of a text is the meaning that any competent reader would share and therefore the meaning that must have been intended by the legislature.

Among appellate court judges, Justice L'Heureux-Dubé was unusually forthcoming in acknowledging the weaknesses in the official theory of statutory interpretation and the realities of judicial practice. In her concurring judgment in *2747-3174 Quebec v. Quebec (Régie des permis d'alcool)*,[5] she took on the task of establishing a sound theoretical basis for statutory interpretation and indeed for interpretation generally. As she makes clear in a number of her judgments, for her the basic methodology of interpretation is the same regardless of whether the text to be interpreted is a contract, a statute, or a Charter of Rights.[6]

In the *Régie* case, she begins by pointing out that the interpretation of legislative texts is primarily a judicial responsibility that entails the development of appropriate interpretive norms:

> Even if, according to the principle of parliamentary sovereignty, the judiciary does not legislate and merely applies the substantive law to specific cases, it retains a residual normative jurisdiction derived from the common law. In areas of law outside substantive law, this jurisdiction relates, for example, to the rules of practice of the adversary process and, in so far as it is not codified, the law of evidence. In my view, the methodology of legal interpretation is one of those areas of the law in respect of which the judiciary must exercise its normative jurisdiction.[7]

She also points out that during the 1990s the Supreme Court of Canada waffled between competing norms and approaches. At least some of the time the Court embraced the plain meaning rule and method, but at other times it embraced what Justice L'Heureux-Dubé calls the modern interpretive approach. In her view, such waffling is unacceptable because it undermines the rule of law:

> The fact that this Court is wavering at random between the former "plain meaning" method and the "modern" contemporary method introduces uncertainty into the law ... If the courts randomly choose one of the two interpretative methods depending on the desired result, then the activity of legal interpretation is reduced to an arbitrary exercise whose result is unpredictable ... A Humpty-Dumpty-like interpretation exercise is actually nothing more than an interpretation based on random or vague rules or solely on intuition or unrationalized impressions, or one that fails to consider the underlying premises of legal reasoning.[8]

Under the plain meaning rule, a court is bound to give effect to the text as written if its meaning is clear and unequivocal. Only if the text is judged to be vague or ambiguous may courts resort to interpretive techniques such as purposive or consequential analysis or reliance on extrinsic aids. This

FIVE • THE ERA OF CONCEALED UNDERLYING PREMISES IS OVER   55

approach to interpretation is rooted in the *Sussex Peerage* case, decided in 1844, in which Lord Tindall said:

> My Lords, the only rule for the construction of Acts of Parliament is, that they should be construed according to the intent of the Parliament which passed the Act. If the words of the statute are in themselves precise and unambiguous, then no more can be necessary than to expound those words in their natural and ordinary sense. The words themselves alone do, in such case, best declare the intention of the lawgiver. But if any doubt arises from the terms employed by the legislature, it has always been held a safe means of collecting the intention, to call in aid the ground and cause of making the statute, and to have recourse to the preamble, which, according to Chief Justice Dyer, is "a key to open the minds of the makers of the Act, and the mischiefs which they intend to redress."[9]

In 1994, in *R. v. McIntosh*,[10] a majority of the Supreme Court of Canada strongly endorsed this approach to interpretation and spelled out its implications. *McIntosh* concerned the self-defence provisions of the *Criminal Code*. The Court was asked to determine whether section 34(2) could be relied on by a person who had provoked the assault from which he then sought to defend himself. Section 34(1) is available to anyone "who is unlawfully assaulted, not having provoked the assault ..."; section 34(2) is available to anyone "who is unlawfully assaulted ... ." Section 35 expressly applies to persons who have provoked the assault from which they subsequently defend themselves. Unlike sections 34(1) and (2), it imposes a duty to retreat. Despite the absence of any reference to provocation in section 34(2), there was strong evidence that in 1892 Parliament intended to codify the common law rule, which imposed a duty to retreat in cases of provoked assault, and that subsequent changes in the wording of the relevant text were inadvertent and did not reflect an intention to change the law. Lamer C.J. felt obliged to disregard this evidence. He wrote:

> I take as my starting point the proposition that where no ambiguity arises on the face of a statutory provision, then its clear

words should be given effect. This is another way of asserting what is sometimes referred to as the "golden rule"[11] of literal construction: a statute should be interpreted in a manner consistent with the plain meaning of its terms. Where the language of the statute is plain and admits of only one meaning, the task of interpretation does not arise (*Maxwell on the Interpretation of Statutes* (12th ed. 1969) at p. 29).[12]

Later he wrote: "Only where a statutory provision is ambiguous, and therefore reasonably open to two interpretations, will the absurd results flowing from one of the available interpretations justify rejecting it in favour of the other."[13] The notion that one can distinguish between plain and ambiguous texts and the further notion that all or some contexts should be looked at only if the text is ambiguous is the hallmark of the plain meaning rule.

In *Régie*, Justice L'Heureux-Dubé repudiates the plain meaning rule. Her repudiation, as is typical in her judgments, is scholarly and thorough, drawing on American and British sources as well as Canadian ones. She first of all points out that the plain meaning rule artificially divides the process of interpretation into two stages, one in which the text is merely read and the other in which it is interpreted. If the meaning seems clear based on a stage-one reading, then there is no reason to proceed to a stage-two interpretation. In effect, Justice L'Heureux-Dubé states, the rule "functions as a sort of methodological estoppel that seeks to prevent the legal interpretation process from beginning."[14]

She also notes that the plain meaning rule ignores the inevitable ambiguity of language and the essential role of context in constructing meaning from a text. On this point, she quotes a number of authorities:[15]

> It should not be forgotten that research in semantics has shown that words only take on their real meaning when placed in context. The meaning of words and sentences is crystallized by the context, and in particular by the purpose of the message.[16]

> The most fundamental objection to the rule is that it is based on a false premise, namely that words have plain, ordinary meanings apart from their context.[17]

> ... the interpreter's own context, including her situatedness in a certain generation and a certain status in our society, influences the way she reads simple texts.[18]

To these criticisms she adds her own:

> In my view the principal failing of the "plain meaning" process is the following: it obscures the fact that the so-called "plain meaning" is based on a set of underlying assumptions that are concealed in legal reasoning. In reality, the "plain meaning" can be nothing but the result of an implicit process of legal interpretation.[19]

> In light of the evolution of our law following the passage of the charters[20] and given the growing recognition that there are many different perspectives—the aboriginal perspective, for example —*I believe that the era of concealed underlying premises is now over. In my view, those premises must be brought to the surface in order to promote consistency in our law and the integrity of our judicial system.*[21]

Justice L'Heureux-Dubé here touches on a fundamental point, namely the integrity of the judicial system. For her, judicial integrity is grounded in both effort and honesty. Judges must be willing to identify and evaluate the assumptions on which they rely (which can involve considerable effort) and to expose them in reasons for judgment (which requires honesty). It is no accident that Justice L'Heureux-Dubé associates exposing concealed premises with the Quebec and Canadian Charters of Rights. If such rights are to be meaningfully protected, the real impact of the law must be examined and hidden sources of discrimination must be exposed.

Having shown why the plain meaning rule must be rejected, Justice L'Heureux-Dubé then turns to her preferred approach, an approach she used throughout her period at the Court. Again, she invokes American, Canadian, South African, and British authorities on statutory interpretation, all of which emphasize the multi-faceted character of interpretation and its unavoidable dependence on context. She concludes:

> What Bennion calls the "informed interpretation" approach is called the "modern interpretation rule" by Sullivan and "pragmatic dynamism" by Eskridge. ... I will here use the term "modern approach" to designate a synthesis of the contextual approaches that reject the "plain meaning" approach. According to this "modern approach", consideration must be given at the outset not only to the words themselves but also, *inter alia*, to the context, the statute's other provisions, provisions of other statutes in *pari materia* and the legislative history in order to correctly identify the legislature's objective. It is only after reading the provisions with all these elements in mind that a definition will be decided on. This "modern" interpretation method has the advantage of bringing out the underlying premises and thus preventing them from going unnoticed, as they would with the "plain meaning" method.[22]

Having set out her theory of interpretation, Justice L'Heureux-Dubé then qualifies it with two "methodological caveats." The first concerns William Eskridge's advocacy of dynamic pragmatism. While Justice L'Heureux-Dubé is prepared to adopt a pragmatic approach to interpretation, one which draws on and balances many considerations, she rejects certain aspects of Eskridge's dynamic approach.

In *Dynamic Statutory Interpretation*, Eskridge argues that courts have a mandate to respond not only to the intention of the legislature but also to evolving social circumstances. He advocates what he calls an Aristotelian approach:

> An Aristotelian approach to statutory interpretation is suggested by the American pragmatic tradition. Pragmatism argues that there is no "foundationalist" (single overriding) approach to legal issues. Instead, the problem solver should consider the matter from different angles, applying practical experience and factual context before arriving at a solution. Practical experience in both Europe and the United States suggests that when statutory interpreters apply a statute to specific situations, the interpreter asks not only what the statute means abstractly, or even

on the basis of legislative history, but also what it ought to mean in terms of the needs and goals of our present day society.

> ... [A] statute is relatively abstract until it is applied to a specific situation. Especially over time, the circumstances will not be ones that the statute or its drafters contemplated, and any application of the statute will be dynamic in a weak sense, going beyond the drafters' expectations. Sometimes the circumstances will be materially different from those contemplated by the statutory drafters, and in that event any application of the statute will be dynamic in a strong sense, going against the drafters' expectations, which have been negated because important assumptions have been undone.[23]

Justice L'Heureux-Dubé distances herself from Eskridge's "pragmatic dynamism" because she fears that on his approach the judiciary is given too much freedom. "In my view," she writes, "Eskridge's 'pragmatic dynamism' provides the judiciary with a justification for manufacturing interpretations that are diametrically opposed to the clear purpose of a statute."[24]

This cautious side of Justice L'Heureux-Dubé comes out in a case like *Barrette v. Crabtree*,[25] where the issue was whether the directors of a bankrupt corporation were personally liable for a judgment against the corporation ordering it to pay employees damages in lieu of notice of dismissal. Normally directors are not liable for the debts of the corporation; they are distinct persons and it is a well-established common law principle that no one is liable for the debts of another. Under section 114(1) of the *Canada Business Corporations Act*, however, the "[d]irectors of a corporation are jointly and severally liable to employees of the corporation for all debts not exceeding six months wages payable to each such employee for services performed for the corporation while they are such directors respectively." In the circumstances, Justice L'Heureux-Dubé could not bring herself to find that the damages awarded in lieu of notice were a debt for services performed. She wrote:

> On the pretext of a broad interpretation, this Court cannot add to the text of the provision words which it does not contain.
>
> ...

> However much sympathy one may feel for the appellants, who have here been deprived of certain benefits resulting from the contract of employment with their employer, that does not give a court of law the authority to confer on them rights which Parliament did not intend them to have. ... Only Parliament is in a position, if it so wishes, to extend these benefits after weighing the consequences of so doing. This, in the final analysis, remains a political choice and cannot be the function of the courts.[26]

Justice L'Heureux-Dubé's second methodological caveat concerns the interpretation of fiscal legislation. She writes:

> It is clear that the "plain meaning" method, with its methodological estoppel that prevents the initiation of legal reasoning, can be used in situations in which it is justified and does not have undesirable side effect. I am thinking, for example, of the area of tax law, in which our case clearly establishes that the basic approach is that involving the "plain meaning" rule ...
>
> ...
>
> From the standpoint of the methodology of legal interpretation, it must be borne in mind that tax law is a technical field that has a language of its own, since it is, along with accounting and management, part of what may generally be called "the business world."
>
> ...
>
> Since the business world occupies such an important place and has such profound ramifications in our society, there are a great many terms of business language that have already been precisely defined by those working in the field. In fact, taxation terms often have definitions that have been clearly established through empirical means, that are generally recognized and accepted or that have been standardized by various bodies ...
>
> ...
>
> It is thus the business world itself that develops its own contextualized definitions based on what is here being called the "modern" method. This Court then uses those definitions as what it

views as the "plain meaning" generally accepted in the business world. The "plain meaning" in taxation relies on methodological estoppel, which prevents us from initiating any reasoning on legal interpretation because those working in the field have already carried out the relevant analyses.... In situations in which there is no "plain meaning" or there is ambiguity, this Court must then define the term in question by engaging in legal interpretation.[27]

With this caveat, Justice L'Heureux-Dubé brings Humpty Dumpty back into statutory interpretation. In my view, this reasoning confounds *technical* language—the language of accounting or business—with *plain* language, which is language judged to be unambiguous by the reader of a text. More importantly, it precludes the court from engaging in the work of interpretation, which properly includes the exposure and evaluation of concealed premises. If in regulating or taxing an industry a legislature uses terms of art developed by that industry, courts may presume that the legislature intended to adopt the technical meaning of those terms. However, this presumption is rebuttable and in any case intended word meaning is only one of the factors that must be taken into account under Justice L'Heureux-Dubé's modern approach.

In my view, the two caveats proposed by her are ill-conceived and they are belied by her own practice of statutory interpretation. This discrepancy between theory and practice is most dramatically apparent in her judgment in *Symes v. Canada*.[28] The issue in *Symes* was whether childcare expenses incurred by a female lawyer could be deducted as a business expense within the meaning of section 18(1)(a) or alternatively were properly considered to be a non-deductible personal expense within the meaning of section 18(1)(h). The relevant legislation provided:

> 18(1) In computing the income of a taxpayer from a business or property no deduction shall be made in respect of
> (a) an outlay or expense except to the extent that it was made or incurred by the taxpayer for the purpose of gaining or producing income from the business or property;
>
> ...
>
> (h) personal or living expenses of the taxpayer except travelling expenses ....

In her dissenting judgment, Justice L'Heureux-Dubé rejected well-established understandings of business expense and of personal or living expense and ruled that Ms. Symes's childcare costs should be deductible as an expense incurred for the purpose of gaining income from a business. In my view, her reasons in support of this conclusion offer an excellent illustration of what Eskridge advocates under the rubric of pragmatic dynamism; and they also demonstrate quite powerfully why the plain meaning approach to interpretation is always wrong, even in the context of fiscal legislation.

On the issue of business expense, she writes:

> The definition of "business expense" was shaped to reflect the experience of businessmen, and the ways in which they engaged in business. ...
>
> As Cullen J. recognized, the world of yesterday is not the world of today. In 1993, the world of business is increasingly populated by both men and women and the meaning of "business expense" must account for the experiences of all participants in the field ... [C]hild care is vital to women's ability to earn an income.[29]

On the issue of personal or living expense, she writes:

> If we survey the experience of many men, it is apparent why it may seem intuitively obvious to some of them that child care is clearly within the personal realm. The conclusion may, in many ways, reflect many men's experience of child care responsibilities. In fact, the evidence before the Court indicates that, for most men, the responsibility of children does not impact on the number of hours they work, nor does it reflect their ability to work. Further, very few men indicated that they made any work-related decisions on the basis of child-raising responsibilities. The same simply cannot currently be said of women.[30]

The historical understandings of business expense and personal expense are good examples of what Justice L'Heureux-Dubé refers to in the *Régie* case as plain meaning—instances where the business world has devel-

oped its own contextualized definitions based on its own experience and interests. Applying the plain meaning rule to such terms prevents the court from initiating an examination of premises relied on by businessmen in developing their understanding of these terms. Despite her remarks in the *Régie* case, it is obvious in *Symes* that Justice L'Heureux-Dubé is prepared to examine underlying premises even in the case of fiscal legislation.

A second criticism of Justice L'Heureux-Dubé's theory of statutory interpretation is that it does not do justice to her own very innovative practice. I suspect that most members of the Supreme Court of Canada, and Canadian courts generally, would have no problem accepting her version of the "modern approach" as set out above. Yet many would refuse to concur in her judgments. This is because Justice L'Heureux-Dubé's formulation of the modern approach in the *Régie* case fails to highlight what I take to be her most important contribution to statutory interpretation, namely her emphasis on and expanded conception of context and its crucial role in interpretation. Moreover, her formulation in the *Régie* case does not explain *how* the modern approach facilitates exposure of the concealed premises that underlie interpretation. These are themes I explore below.

### Justice L'Heureux-Dubé's Conception of Context

Historically, courts have recognized three categories of context that are relevant to interpretation of a legislative provision. First, there is the statutory context consisting of the Act in which the provision appears, related legislation (which may include the legislation of other jurisdictions), and most expansively, the entire statute book of the enacting jurisdiction. Second, there is the supplementary legal context consisting of the common law and in Quebec, in private law matters, the *Civil Code*. And finally, there is external context consisting of the circumstances existing at the time of enactment which are presumed to be known to the legislature.

Justice L'Heureux-Dubé's conception of context is innovative in several respects. First, and most importantly, she expands the category of external context to include social science evidence of both the circumstances in which legislation was enacted and the circumstances in which it operates. In particular, she establishes and relies on what L. Walker and J. Monahan call "social framework facts."[31] It is through consideration of social framework facts that concealed underlying premises are brought to light in her judgments and

their validity assessed. L'Heureux-Dubé J. also expands the category of legal context to include both the *Charter* and international law, particularly international human rights law. While these materials were consulted in the past, they were not regarded as an essential part of every interpretive exercise. Finally, on occasion at least, she relies on comparative law methodology in resolving interpretation issues and in doing so introduces yet another dimension to statutory interpretation. In cases where it is warranted, she looks to both common law and civil law responses to particular problems in an effort to devise the best possible solution to the interpretive problem at hand. Her judgments are often lengthy because they contain so much social and legal scholarship. To use Francis Bennion's language, hers is a truly "informed interpretation."[32]

*Social Context*

In 1994 Justice L'Heureux-Dubé published an article in the *Ottawa Law Review* entitled "Re-examining the Doctrine of Judicial Notice in the Family Law Context."[33] This is a remarkable piece in that it reveals, outside the context of reasons for judgment, where L'Heureux-Dubé J. was coming from as a Supreme Court judge, and it highlights in particular her own conception of judicial integrity. The article is a gloss on the many judgments in which she relied on social science data to challenge faulty or inadequate assumptions about women and their role in society.

Justice L'Heureux-Dubé begins the article with K.C. Davis's important distinction between legislative and adjudicative facts[34] and its refinement by Monahan and Walker,[35] who developed the hybrid category of social framework facts. As she explains,

> Social framework facts refer to social science research that is used to construct a frame of reference or background context for deciding factual issues crucial to the resolution of a particular case. ... An example of social science research used for the purposes of establishing social framework is evidence on the battered woman syndrome, which may be important background to the more fact-specific determination of whether a woman accused of killing her husband was "reasonably" acting in self-defence.[36]

Justice L'Heureux-Dubé goes on to point out that the broader the issue before the court, the more inadequate are the facts of the individual case as a basis for decision. When courts decide a broad issue it affects many people, not just the litigants before them. Social framework facts ensure that the reality of those others is factored into the particular decision.

She also astutely observes that by recognizing the role of legislative facts and social framework facts in interpretation, the courts implicitly acknowledge their own law-making role. In her view, "[t]he more courts acknowledge their active contribution to lawmaking, the greater becomes both their duty and their need to lay bare the policy assumptions upon which their decisions are based. ... [I]f courts deny their lawmaking role, then they deny our judicial system the ability to monitor that role."[37]

Justice L'Heureux-Dubé is especially concerned with monitoring "those very basic facts that the average factfinder possesses regarding the world in which we live, and that must be used in the drawing of inferences, the judging of a witness's credibility, or the evaluation of evidence."[38] As she explains,

> These fundamental facts comprise a prism of personal experience and understandings through which judges and jurors, as factfinders, perceive and interpret that which is put before them. ... [W]hile the prism held by most factfinders may constitute a perfectly adequate analytical framework in most situations, in certain contexts it may not accord with reality. ... In cases such as these, social framework evidence can play both a meaningful and a necessary role in re-aligning that prism with reality.[39]

Reliance on assumptions about reality cannot be avoided by judges. After all, they bring their fully furnished minds with them when appointed to the bench. It follows that judicial integrity cannot consist in being opinionless, but must consist in being willing to look for the premises underlying interpretation, subject them to scrutiny, and reveal their role in judicial reasoning. Justice L'Heureux-Dubé both explains and models this conception of judicial integrity in numerous cases, including *Hills v. Canada*,[40] *Canada v. Mossop*,[41] *Symes*,[42] *R v. Chartrand*,[43] *Moge*,[44] and *Willick v. Willick*.[45]

In *Moge*, for example, the issue was the basis on which support orders can be made under section 17 of the *Divorce Act*, 1985. The appellant argued

that the section embodies a self-sufficiency model of spousal support. In rejecting this analysis, Justice Heureux-Dubé points out that the self-sufficiency model "has generally been predicated upon the dichotomy between 'traditional' and 'modern' marriage,"[46] a dichotomy she characterizes as a "mythological stereotype."[47] She writes:

> That Parliament could not have meant to institutionalize the ethos of deemed self-sufficiency is ... apparent from an examination of the social context in which support orders are made. In Canada, the feminization of poverty is an entrenched social phenomenon.[48]

In support of these claims, she relies on dozens of review articles in Canadian and American journals as well as monographs and collections of essays published in Belgium, the United Kingdom, and Australia. The academic sources are supplemented by reports of departments of justice, law reform commissions, and Statistics Canada. As she explains, "these socio-economic observations ... provide background information useful in determining the intent of the legislators."[49] She concludes:

> It would be perverse in the extreme to assume that Parliament's intention in enacting the Act was to financially penalize women in this country. And, while it would undeniably be simplistic to identify the deemed self-sufficiency model of spousal support as the sole cause of the female decline into poverty, based on the review of the jurisprudence and statistical data set out in these reasons, it is clear that the model has disenfranchised many women in the court room and countless others who may simply have decided not to request support in anticipation of their remote chance of success.[50]

In *Moge*, Justice L'Heureux-Dubé not only relies on social science data to support her own interpretation of section 17, but also urges the courts of first instance that deal with spousal support issues to test their intuitions of what is fair against such data. She writes:

> Based upon the studies which I have cited earlier in these reasons, the general economic impact of divorce on women is a phenomenon the existence of which cannot reasonably be questioned and should be amenable to judicial notice.
>
> . . .
>
> In all events, whether judicial notice of the circumstances normally encountered by spouses at the dissolution of a marriage is to be a formal part of the trial process or whether such circumstances merely provide the necessary background information, it is important that judges be aware of the social reality in which support decisions are experienced …[51]

*Legal Context*

Justice L'Heureux-Dubé relies on legal context as well as social context in justifying her interpretations. She treats legal context as including not only the common law and the *Civil Code* but also the *Charter of Rights and Freedoms* and international law. In the past, of course, these sources of law have been available to and heavily relied on by interpreters in a range of cases. In the past, however, access to these sources has been effected primarily through the so-called presumptions of legislative intent. It is presumed, for example, that the legislature intends to comply with natural justice and the rule of law, with Canada's entrenched constitution, including the *Charter*, and with Canada's obligations at international law. The presumptions of legislative intent are embedded in judge-made common law and, as the legal realists pointed out some seventy years ago, their originating impulse is not to discover the actual intention of the legislature, but rather to control it or at least guide it in what the court takes to be a kinder and gentler direction.

Presumptions of legislative intent are criticized on a number of grounds. First, insofar as they purport to describe legislative (as opposed to judicial) intent, they are a legal fiction that is capable of abuse. There is no doubt that applying a presumption of legislative intent may influence the scope of legislative rules or the operation of a legislative scheme so as to distort the actual intentions of the legislature. Historically, common law presumptions were

invoked on more than one occasion to undermine socially progressive legislation in Commonwealth jurisdictions as well as the United States.[52] Modern courts are sensitive to this history and take pains to assure their public that their goal is to effect, not thwart, the intentions of the legislature.[53] Once established, however, presumptions are factored into legislative policy development and taken into account by legislative drafters. The legislature knows that it must use clear, explicit language if it wants to contradict the intentions imputed to it by the courts. Given this shared understanding, the failure to use such language arguably becomes a legitimate basis for inferring that the legislature actually intended what the courts impute to it.[54]

A second criticism of the presumptions of legislative intent is that they have been rendered obsolete by the *Canadian Charter of Rights and Freedoms*, which sets out a definitive and exhaustive set of norms for the control of legislative initiatives. These norms are interpreted and applied by the courts in the context of direct review—review that establishes the validity or invalidity of an enactment. Arguably, entrenched constitutional norms displace the common law norms historically relied on by courts in the context of indirect review—review that establishes the true legal meaning of an enactment having regard to presumed intent.

While this criticism may be cogent, it has not caught on. The courts continue to invoke common law presumptions both in lieu of *Charter* norms and as a supplement to *Charter* norms. Partly this is a matter of cost and convenience. A *Charter* challenge is subject to notice and evidentiary requirements that do not arise in a simple case of statutory interpretation. It is much cheaper for a party to invoke a presumption of legislative intent than to launch a *Charter* challenge. Another factor is ideological. The *Charter*, for example, does not protect private property rights, yet for many judges private property is an important constitutional value and the presumptions designed to protect it continue to play an important role in interpretation.

A third criticism of the presumptions, and the one that is most commonly voiced, is their relation to the plain meaning rule. In the seventeenth and eighteenth centuries, British courts had little compunction about invoking common law values to control what they took to be ill-conceived legislative initiatives. This was the era of strict construction in which courts openly stated their reluctance to enforce legislation that deprived subjects of their

life, liberty, or property. However, in response to the *Reform Act* of 1832, which made Parliament a more democratic institution, and the development of regulatory legislation written in what came to be known as the common law style (detailed, precise, and leaving nothing to the imagination), courts were moved to pay more respect to the intention of the legislature as revealed by the language of the enacted text. This gave rise to the plain meaning rule, with its fundamental distinction between plain and ambiguous texts.

Even though the plain meaning rule has been repudiated by the Supreme Court of Canada, the impulse to classify texts as plain or ambiguous has not disappeared. This distinction is still being used as a way to limit access to particular sources of legislative meaning. In classic applications of the plain meaning rule, the court purports to limit itself to the "literal" meaning of the words or the provision to be interpreted, isolated from any context.[55] Resort may be had to context only if the literal meaning is ambiguous. This classic approach has been rejected by the Supreme Court of Canada in *Rizzo v. Rizzo Shoes Ltd.*[56] However, under a more modern version of the rule, the court purports to read the words to be interpreted "in context"—including the statutory context and aspects of the legal and external context as well, but excluding resort to so-called extrinsic aids or the presumptions of legislative intent. These latter sources of legislative meaning or intent may be consulted only if the text, having been read in (partial) context, remains ambiguous.

There are two problems with this more modern formulation of the plain meaning rule. First, it presupposes that it is possible to distinguish in a principled way between plain and ambiguous texts. Second, it presupposes that the values and assumptions embodied in the presumptions of legislative intent play no role in reading, that is, in the initial determination of the meaning of a legislative text. Both suppositions are false.[57] Justice L'Heureux-Dubé avoids these false suppositions by treating constitutional and international law as part of the context in which legislation is read. This allows interpreters to acknowledge the role that internalized constitutional and international law norms play in understanding the meaning of a text and to assign a weight to those norms that is appropriate in the circumstances.

The evolution of this approach to international law is well illustrated by *Baker v. Canada*,[58] *114957 Canada Ltd. v. Hudson (Town)*,[59] and *Suresh v. Canada*,[60] decided in 1999, 2001, and 2002 respectively. In *Baker*, the issue was

the proper exercise of discretion conferred on the Minister of Citizenship and Immigration to exempt a person from a regulation made under the *Immigration Act* or to facilitate a person's admission to Canada "owing to the existence of compassionate or humanitarian considerations." One of the questions considered by the Court was whether this discretion to exempt or admit was constrained by the *Convention on the Rights of the Child*,[61] a convention ratified by Canada but not implemented at either the federal or provincial level. Section 3.1 of the Convention provides:

> 3.1 In all actions concerning children, whether undertaken by public or private social welfare institutions, courts of law, administrative authorities or legislative bodies, the best interests of the child shall be a primary consideration.

The question was whether the minister, in deciding the fate of the appellant on humanitarian and compassionate grounds, was obliged to treat as a primary consideration the impact of her deportation on her children. Speaking for a majority of the court, Justice L'Heureux-Dubé writes:

> I believe that the failure to give serious weight and consideration to the interests of the children constitutes an unreasonable exercise of the discretion conferred by the section.[62]
>
> ...
>
> [An] indicator of the importance of considering the interests of children when making a compassionate and humanitarian decision is the ratification by Canada of the *Convention on the Rights of the Child*, and the recognition of the importance of children's rights and the best interests of children in other international instruments ratified by Canada. International treaties and conventions are not part of Canadian law unless they have been implemented by statute ...
>
> Nevertheless, the values reflected in international human rights law may help inform the contextual approach to statutory interpretation and judicial review.[63]

FIVE • THE ERA OF CONCEALED UNDERLYING PREMISES IS OVER    **71**

In *Hudson*,[64] the issue was the validity of a municipal by-law restricting the use of pesticides within the municipality. In upholding the by-law, Justice L'Heureux-Dubé relies on a number of factors, including international law. She writes:

> I note that reading s. 410(1) to permit the Town to regulate pesticide use is consistent with principles of international law and policy.
>
> The interpretation of By-law 270 contained in these reasons respects international law's "precautionary principle". ... Canada advocated inclusion of the precautionary principle during the Bergen Convention negotiation. ... The principle is codified in several items of domestic legislation. ...
>
> Scholars have documented the precautionary principle's inclusion "in virtually every recently adopted treaty and policy document related to the protection and preservation of the environment". ...[65]

In neither *Baker* nor *Hudson* was the legislation to be interpreted an implementation of an international law convention or an attempt to give effect to customary international law. International law functions in these cases in the way common law functions—as a source of values, norms, and principles. These values, norms, and principles are more or less relevant and receive more or less weight depending on the terms of the legislation and the facts of the particular case. That is how context works.

Justice L'Heureux-Dubé's understanding of international law as context was accepted by the entire Court in *Suresh*.[66] The case concerned section 53(1) of the *Immigration Act*. The issue was first whether section 53(1) violates section 7 of the *Charter* and second, whether, assuming it to be valid, the discretion conferred on the minister by section 51(1)(b) was properly exercised. Section 53(1)(a) provides that certain classes of persons cannot be deported from Canada to a country where their life or freedom would be threatened. However, section 53(1)(b) creates an exception to the non-deportation rule that is dependent on a number of conditions, including whether "the Minister is of the opinion that the person constitutes a danger to the security of Canada." A unanimous Court wrote:

> The provisions of the *Immigration Act* dealing with deportation must be considered in their international context. ... Similarly, the principles of fundamental justice expressed in s. 7 of the *Charter* and the limits on rights that may be justified under s. 1 of the *Charter* cannot be considered in isolation from the international norms which they reflect. A complete understanding of the Act and the *Charter* requires consideration of the international perspective.[67]

This perspective was established through a wide range of international law materials, which led the Court to conclude as follows:

> Although this Court is not being asked to pronounce on the status of the prohibition of torture in international law, the fact that such a principle is included in numerous multilateral instruments, that it does not form part of any known domestic administrative practice, and that it is considered by many academics to be an emerging, if not established peremptory norm, suggests that it cannot easily be derogated from. ...[68]

Justice L'Heureux-Dubé's enlarged concept of context, along with the scholarship that informs her judgments, often features a comparative law approach to interpretation. In *Gordon v. Goertz*,[69] for example, she reviews case law and legislation from the common law provinces, Quebec, England, Australia, France, and the United States in determining whether a right to custody conferred under the *Divorce Act* includes the right to determine where the child shall live. In *Hills*,[70] to determine whether laid-off union workers should receive unemployment insurance benefits during a strike, she looks at the history and evolution of the relevant provision in Canada, the United Kingdom, and the United States.

This comparative approach is probably grounded in her experience as a lawyer and judge in Quebec. Quebec is a mixed jurisdiction in that the basic law of property and civil rights is civilist, whereas public law, including criminal law, is grounded in the common law. Thus, anyone who practises law in Quebec is exposed to both systems and comparisons are inevitable. However, as Justice L'Heureux-Dubé points out, comparison is not the same as assimilation.

## Enhancing and Defending Civil Law

During its first century, the Supreme Court of Canada did not do a good job of interpreting Quebec's codes—the *Civil Code* of Lower Canada and the *Code of Civil Procedure*. As France Allard reminds us, the Supreme Court of Canada was created as part of the movement to establish national institutions for Canada and more particularly to establish, as much as possible, a uniform law for the whole of Canada. Until recently, uniformity was largely understood to entail the imposition of common law principles and precedents on Quebec's civil law. As Allard explains,

> At the time [of its establishment], the court was seen as a means of developing a unified national legal system. During its early years, this role was generally expressed by giving preference to the common law in the interpretation of the civil law. However, in reaction to the threat of assimilation of civil law by common law and the fact that the common law undermined the internal consistency of civil law, a movement to defend the integrity of civil law emerged. This movement would further the establishment of civil law as a system that was autonomous from the common law.[71]

The evolution to which Allard refers is reviewed by Justice L'Heureux-Dubé in her Rubin Lecture.[72] Like many Quebec jurists, she approves the benefits of comparative law analysis in interpreting and applying the law of Quebec. She recognizes the diverse origins of Quebec's two codes and is open both to the solutions and the analytical methods of other jurisdictions. At the same time, however, she is clear that the integrity of the civil law as embodied in its codes must be respected.

In *Caisse populaire des deux rives v. Société mutuelle d'assurance contre l'incendie de la vallée du Richelieu*,[73] for example, the Court had to consider a standard clause in an insurance contract, which provides that, if a loss occurs, the indemnity is payable to the hypothecary creditor despite the acts or neglect of the owner of the insured property. The issue was whether this clause was contrary to article 2563 of the *Civil Code*, which provides that, notwithstanding any agreement to the contrary, an insurer is not liable for loss arising from the insured's intentional fault.

Justice L'Heureux-Dubé begins her comparative analysis with the following observations:

> The hypothecary clause originates from the insurance contracts developed in the State of New York in the second half of the 19th century. These clauses spread throughout North America, with the result that virtually identical clauses (apart from a few words) have been interpreted by courts in other jurisdictions. Without giving these interpretations the force of precedent, it is nonetheless worthwhile to examine the solutions adopted by the courts in those jurisdictions, in particular in France, in the U.S., and in the common law provinces of Canada, if only as an exercise in comparative law.[74]

While comparative analysis may be helpful, she warns that it must not be relied on inappropriately:

> ... [T]his apparent similarity of the fundamental rules [of insurance in France, the U.S. and common law Canada] should not cause us to forget that the courts have a duty to ensure that insurance law develops in a manner consistent with the rest of Quebec civil law, of which it forms a part. Accordingly, while the judgments of foreign jurisdictions, in particular Britain, the United States, and France, may be of interest when the law there is based on similar principles, the fact remains that Quebec civil law is rooted in concepts peculiar to it, and while it may be necessary to refer to foreign law in some cases, the courts should only adopt what is consistent with the general scheme of Quebec law.[75]

In *Vidéotron Ltée c. Industries Microlec Produits Électroniques Inc.*,[76] the issue was whether a person charged with contempt of court under article 761 of the *Code of Civil Procedure* could be compelled to testify at his or her trial for contempt of court. In her dissenting judgment, while acknowledging the common law origin of the article, Justice L'Heureux-Dubé refused to rely on common law principles of contempt to assist in its interpretation:

> There is nothing unusual about the fact that contempt of court is a concept borrowed from English law. Quebec private law includes a wealth of rules of law drawn from foreign sources ... . The common law principles cannot simply be applied to these rules, in my opinion, without first directly addressing the question of whether those principles are even compatible with the recipient law ... . Finally, such an approach seems particularly inappropriate where, as here, it is used in connection with provisions which form part of the general structure of a code ... .[77]

Here, L'Heureux-Dubé J. makes a point that is echoed by many Quebec jurists, especially those with an interest in comparative law. Comparison is one thing; assimilation is another. Examining the law of other jurisdictions can yield useful insights, particularly if the foreign law has influenced the formation of one's own legislation. But however influential a foreign idea may be, it must be adapted to fit the fundamental principles and institutions of the receiving legal system. This is especially true of civil law jurisdictions, which generally place a high premium on the integrity and internal coherence of the law.

Conclusion

In my view, during her stint on the Supreme Court of Canada, Justice L'Heureux-Dubé was a heroine. She voiced iconoclastic and unpopular opinions, she was isolated and attacked for doing so, and yet she persisted in expressing her convictions. She exemplified judicial integrity at its best.

In terms of her contribution to statutory intepretation, she must be applauded, first, for drawing attention to a fundamental issue in all legal interpretation, namely the role played by concealed underlying assumptions, and second, for attempting to devise ways within the "rules" of statutory interpretation to bring those assumptions to light. Once they are exposed, there is at least the possibility of subjecting them to critical scrutiny.

Third, Justice L'Heureux-Dubé must be applauded for introducing a form of judgment writing that is at once both scholarly and iconoclastic. If the era of concealed underlying premises really is over, then "reasons for judgment" must take on a new significance. For the future, lawyers and judges must produce different kinds of legal analysis and justification. They must

make an effort to expose their own assumptions, expose the assumptions of others, and back them up or attack them with appropriate evidence and argument. The category of appropriate evidence will have to be expanded to include the sort of social framework evidence relied on by Justice L'Heureux-Dubé in many of her judgments. When it comes to disputes about the meaning of a text, it might also be expanded to include expert opinion evidence by linguists.[78]

In the *Régie* case, Justice L'Heureux-Dubé perhaps missed an opportunity to reject what Pierre-André Côté calls the official theory of interpretation—the theory that says that rules of law are fixed by democratically elected legislatures and the role of unelected judges is simply to apply those rules as embodied in the text of duly enacted legislation.[79] According to the official theory, judges are mere carriers of wood and drawers of water. They have no role to play in completing or adjusting the legal rules enacted by the legislature; they are neutral automatons. In perpetuating this official theory, courts cause a great deal of trouble for themselves. In particular, they invite criticism of the sort that has become commonplace in the editorial pages of Canadian newspapers, namely that courts are inappropriately "activist," that they are overstepping their role.

In fact, it is impossible for judges not to be active in their response to a legal text. They necessarily bring their minds to the bench, and their minds are stuffed full of assumptions (valid or invalid) that are brought to bear on constructing meaning from a text, inferring legislative intent, and assessing the acceptability of outcomes. Moreover, cases that wind up before the courts tend to be hard: the meaning of the text or the intention of the legislature is obscure or there are conflicts between the apparent meaning, the apparent intention, and well-established legal or cultural norms.

Properly understood, the role of judges in a statutory interpretation case is to mediate between the text, the context, and the facts of the particular case so as to produce a result that balances the relevant competing considerations. These are as follows:
- legislative intent (grounded in the sovereignty of the legislature),
- legislative text (grounded in the rule of law), and
- acceptable consequences (grounded in the norms of the evolving legal tradition).

In hard cases, such mediation inevitably involves choice. The issue for

courts is whether to deny and attempt to hide this part of their practice or to acknowledge it, explain why it is unavoidable, and attempt to justify their choices as they are made in particular cases. Clearly, and admirably, Justice L'Heureux-Dubé preferred the latter approach.

The theory of interpretation that acknowledges and explores the mediating role of judges is generally known as pragmatism. As noted above, in the *Régie* case Justice L'Heureux-Dubé was unwilling to fully embrace the pragmatic account of interpretation as explained by Eskridge, its leading advocate in the United States. Nonetheless, she was an exemplary practitioner of that approach. And her practice highlights an aspect of pragmatism that has received insufficient attention, namely the role of effort and honesty in interpretation. Given the necessity of choice, judicial integrity requires both. It requires judges to challenge the official account of interpretation described above and to reflect critically on the personal and professional assumptions (concealed or not) that inform their own interpretations. If further requires judges to justify those assumptions with reference to evolving social, cultural, and legal norms. It would be difficult to overstate the energy, discipline, and humility this conception of integrity entails. Clearly these are high standards, but Justice L'Heureux-Dubé's career shows that it is possible for a judge to meet them. We are all in her debt.

### Endnotes

1 John Sexton, "Thinking About the Training of Lawyers in the Next Millennium," NYU Law School Magazine, Autumn 2000, 34 at 41, quoted by the Honourable Claire L'Heureux-Dubé in "Bijuralism: A Supreme Court of Canada Justice's Perspective" (2002) 62 Louisiana L. Rev. 449 at 450.
2 *R. v. Seaboyer; R. v. Gayme*, [1991] 2 S.C.R. 577 at para. 679.
3 *Ibid.* at para. 659.
4 Dan Sperber and Deirdre Wilson, *Relevance: Communication and Cognition*, 2d ed. (Oxford: Blackwell, 1995) at 15–16.
5 [1996] 3 S.C.R. 919 [*Régie*].
6 See, for example, *Manulife Bank of Canada v. Conlin*, [1996] 3 S.C.R. 415 at para. 40.
7 *Supra* note 5 at para. 151.
8 *Ibid.* at paras. 170–71.
9 (1844), 11 Cl. & F. 85, 8 E.R. 1034 (H.L.).

10 [1995] 1 S.C.R. 686.
11 Lamer C.J. perhaps means to refer to the plain meaning rule here; the so-called golden rule (in most of its formulations at least) permits courts to *depart* from the literal or plain meaning of a text.
12 *McIntosh, supra* note 10 at para. 18.
13 *Ibid.* at para. 36.
14 *Supra* note 5 at para. 153.
15 *Ibid.* at paras. 153–57.
16 Pierre-André Côté, *The Interpretation of Legislation in Canada*, 2d ed. (Cowansville, Que.: Yvon Blais, 1991) at 241–42.
17 Michael Zander, *The Law-Making Process*, 4th ed. (London: Butterworths, 1994) at 121–27.
18 William Eskridge, *Dynamic Statutory Interpretation* (Cambridge, Mass.: Harvard University Press, 1994) at 41.
19 *Régie, supra* note 5 at para. 154.
20 *Canadian Charters of Rights and Freedoms,* Part 1 of the *Constitution Act, 1982,* being Schedule B to the *Canada Act 1982,* (U.K.), 1982, c. 11; *Charter of Human Rights and Freedoms,* R.S.Q. c. C-12.
21 *Régie, supra* note 5 at para. 158.
22 *Ibid.* at para. 160.
23 Eskridge, *Dynamic Statutory Interpretation, supra* note 18 at 50, quoted by Justice L'Heureux-Dubé *ibid.* at para. 173.
24 *Régie, supra* note 5 at para. 175.
25 [1993] 1 S.C.R. 1027.
26 *Ibid.* at 1052.
27 *Régie, supra* note 5 at paras. 179–82.
28 *Symes v. Canada,* [1993] 4 S.C.R. 695 [*Symes*].
29 *Ibid.* at paras. 201–2.
30 *Ibid.* at para. 205.
31 See L. Walker and J. Monahan, "Social Frameworks: A New Use of Social Science in Law" (1987) 73 Va. L. Rev. 559, discussed at length in Justice L'Heureux-Dubé's own article, "Re-examining the Doctrine of Judicial Notice in the Family Law Context" (1994) 26 Ottawa L. Rev. 551.
32 See Francis Bennion, *Statutory Interpretation,* 3d ed. (London: Butterworths, 1997) at 449–51.
33 *Supra* note 31.
34 See K.C. Davis, "An Approach to Problems of Evidence in the Administrative Process" (1942) 55 Harv. L. Rev. 364.
35 In addition to "Social Frameworks," *supra* note 31, see L. Walker and J. Monahan, "Social Authority: Obtaining, Evaluating and Establishing Social

Science in Law" (1986) 134 U. Pa. Law Rev. 477; L. Walker and J. Monahan, "Social Facts: Scientific Methodology as Legal Precedent" (1988) 76 Cal. L. Rev. 877; L. Walker and J. Monahan, "Empirical Questions without Empirical Answers" (1991) Wis. L. Rev. 569.

36 *Supra* note 31 at 556.
37 *Ibid.* at 558.
38 *Ibid.* at 559.
39 *Ibid.*
40 *Hills v. Canada (Attorney General)*, [1988] 1 S.C.R. 513 [*Hills*].
41 *Canada (Attorney General) v. Mossop*, [1993] 1 S.C.R. 554.
42 *Supra* note 28.
43 *R. v. Chartrand*, [1994] 2 S.C.R. 864.
44 *Moge v. Moge*, [1992] 3 S.C.R. 813 [*Moge*].
45 *Willick v. Willick*, [1994] 3 S.C.R. 670.
46 *Moge, supra* note 43 at para. 35.
47 *Ibid.* at para. 41.
48 *Ibid.* at para. 55.
49 *Ibid.* at para. 61.
50 *Ibid.* at para. 63.
51 *Ibid.* at paras. 91–92.
52 See J.A. Corry, "Administrative Law and the Interpretation of Statutes" (1936) 1 U.T.L.J. 286.
53 See, for example, *New Brunswick v. Estabrooks Pontiac Buick Ltd.* (1982), 44 N.B.R. (2d) 201 at 210.
54 The presumptions, it should be noted, are the primary source of modern administrative law, which imputes to legislatures the intention to observe rule of law, natural justice, and fairness.
55 Linguists have shown that in practice all meaning occurs in a context, whether acknowledged or not. See Georgia Green, *Pragmatics and Natural Language Understanding*, 2d ed. (Mahweh, New Jersey: Lawrence Ehrlbaum, 1996) at 59.
56 [1998] 1 S.C.R. 27.
57 For a full critique of these suppositions see R. Sullivan, "Statutory Interpretation in the Supreme Court of Canada" (1998–99) 30 Ottawa L. Rev. 175.
58 *Baker v. Canada (Minister of Citizenship and Immigration)*, [1999] 2 S.C.R. 817 [*Baker*].
59 *114957 Canada Ltée v. Hudson (Town)*, [2001] 2 S.C.R. 241 [*Hudson*].
60 *Suresh v. Canada (Minister of Citizenship and Immigration)*, [2002] 1 S.C.C. 3 [*Suresh*].
61 Can. T.S. 1992 No. 3.
62 *Baker, supra* note 56 at para. 65.

63 *Ibid.* at paras. 69–70.
64 *Hudson, supra* note 57.
65 *Ibid.* at paras. 30–32.
66 *Supra* note 58.
67 *Ibid.* at para. 59. See also *R. v. Sharpe*, [2001] 1 S.C.R. 45 at paras. 175–76 and *R. v. Beaulac*, [1999] 1 S.C.R. 768 at para. 20.
68 *Suresh, supra* note 58 at paras. 65–66.
69 [1996] 2 S.C.R. 27 at para. 72 & ff.
70 *Supra* note 39 at 542 & ff.
71 France Allard, "The Supreme Court of Canada and Its Impact on the Expression of Bijuralism," online: canada.justice.gc.ca/en/dept/pub/hfl/fasc3/fascicule_3a.html (accessed 20 July 2004).
72 *Supra* note 1.
73 [1990] 2 S.C.R. 965.
74 *Ibid.* at 1016.
75 *Ibid.* at 1004.
76 [1992] 2 S.C.R. 1065.
77 *Ibid.* at 1097.
78 See C.D. Cunningham and D.J. Fillmore, "Using Common Sense: A Linguistic Perspective on Judicial Interpretation of 'Use A Firearm'" (1995) 73 Washington Univ. Law Q. 1159.
79 See Côté, *Intepretation of Legislation in Canada, supra* note 16, ch. 1.

Six

# Claire L'Heureux-Dubé: Reflections from Down Under

REG GRAYCAR

Introduction

In 1997 a Federal Court judge in Australia opened a speech she was giving to a group of women lawyers by telling an anecdote that she had heard at a recent function to celebrate the appointment of a member of the New South Wales (NSW) bar to the state's Supreme Court. What was said on the occasion was to this effect: "X's appointment to the Supreme Court, while most welcome, took us all by surprise: after all he is a male, heterosexual, came from the inner Bar, and he knows something about the law having practised it for many years."[1] Of course, as the judge went on to point out, the story is not so simple. It never is. The figures the judge referred to later in her speech made it very clear that in Australia, a woman on a superior court is about as rare a phenomenon as a flying pig or a fish riding a bicycle.[2] By comparison with Canada, Australia still has a judiciary that is overwhelmingly white, male, Anglo, heterosexual, able-bodied, and—dare I use the word because it is so contentious—unrepresentative.[3]

How does all this relate to Justice L'Heureux-Dubé? When I set about reviewing the impact of her work in Australia, I came across a range of disparate references in various judicial forums. As feminist judges are even rarer in Australia than women judges, Justice L'Heureux-Dubé's work has not yet had an overt influence on Australian judgments. In this paper, I will therefore

examine the impact of her judgments on judicial discourse outside the courtroom setting in Australia. In particular, I will use her joint judgment with now Chief Justice Beverly McLachlin in *R.D.S.*[4] and her elaborated views on neutrality and impartiality as a case study. What particularly intrigues me is that her judgment in *R.D.S.* is the only thing that has actually provoked two judges in Australia to step, at least metaphorically, off their benches and venture into the law journals to engage with her.[5] Having had a long-standing interest in "bias" and "perspective," how these tags are frequently attached to "outsider judges," and the complicated issue of whether "women judges make a difference,"[6] it seemed fitting to revisit these issues by examining the responses to Justice L'Heureux-Dubé's work expressed by these judges.

In what follows, I will first briefly review *R.D.S.* I will then discuss the responses to it by two Australian judges (Justices Ipp and Mason). In particular, I focus on the criticism that they (at least, Justice Ipp) make of judges like Justice L'Heureux-Dubé, who analyse equality claims from a premise of widespread inequality. I also briefly consider whether the absence of an entrenched constitutional guarantee of equality limits the ability of judges in Australia to engage with these issues. I conclude by highlighting the contributions that Justice L'Heureux-Dubé has made to exposing the partiality of the orthodoxy of judicial neutrality and by highlighting her effort to bring the knowledges and perspectives of outsiders into her work of judging.

### *R.D.S.*

The facts of the *R.D.S.* case are reasonably well known, at least in Canada. Judge Corinne Sparks, a provincial court trial judge in Nova Scotia, was hearing the case of a fifteen-year-old African Canadian youth who was alleged to have interfered with the arrest of another youth. He was charged with unlawfully assaulting and resisting a police officer. While delivering an oral judgment dismissing the charge, having found that the prosecution had not proved its case beyond a reasonable doubt, the judge stated:

> The Crown says, well, why would the officer say that events occurred the way in which he has relayed them to the Court this morning. I am not saying that the Constable has misled the Court although police officers have been known to do that in the past.

I am not saying that the officer overreacted, but certainly police officers do overreact, particularly when they are dealing with non-white groups. That to me indicates a state of mind right there that is questionable. I believe that probably the situation in this particular case is the case of a young police officer who overreacted. I do accept the evidence of [RDS] that he was told to shut up or he would be under arrest. It seems to be in keeping with the prevalent attitude of the day.[7]

The Crown successfully argued in the Nova Scotia Supreme Court that these comments gave rise to a reasonable apprehension of bias,[8] a decision confirmed by a majority of the Nova Scotia Court of Appeal.[9] The Supreme Court of Canada overturned this decision.[10] In their joint judgment, Justices L'Heureux-Dubé and McLachlin stated:

In our view, the test for reasonable apprehension of bias established in the jurisprudence is reflective of the reality that while judges can never be neutral, in the sense of purely objective, they can and must strive for impartiality. It therefore recognizes as inevitable and appropriate that the differing experiences of judges assist them in their decision-making process and will be reflected in their judgments, so long as those experiences are relevant to the cases, are not based on inappropriate stereotypes, and do not prevent a fair and just determination of the cases based on the facts in evidence.[11]

In order to apply... [the test for bias], it is necessary to distinguish between the impartiality which is required of all judges, and the concept of judicial neutrality. [They referred to the work of Benjamin Cardozo, *The Nature of the Judicial Process* (1921), who] ... affirmed the importance of impartiality, while at the same time recognizing the fallacy of judicial neutrality.

... Cardozo recognized that objectivity was an impossibility because judges, like all other humans, operate from their own perspectives. As the Canadian Judicial Council noted in

*Commentaries on Judicial Conduct* (1991), at p. 12, "[t]here is no human being who is not the product of every social experience, every process of education, and every human contact". What is possible and desirable, they note, is impartiality:

> ... True impartiality does not require that the judge have no sympathies or opinions; it requires that the judge nevertheless be free to entertain and act upon different points of view with an open mind.[12]

### Judicial Discourse in Australia on *R.D.S.*

#### Justice Ipp

In 2000, Justice Ipp, a judge of the Supreme Court of Western Australia,[13] gave a paper engaging with the *R.D.S.* judgment to an annual judges' conference.[14] He was followed the next year by Justice Keith Mason, president of the NSW Court of Appeal, who also spoke about the case at a subsequent judges' conference.[15]

Justice Ipp's article commences with considerable dramatic flourish: "A post-modern phenomenon of some significance has made its appearance in North America. This is a movement that stands for the proposition that while judges should be impartial, they should not be neutral."[16] In the same paragraph, he asserts: "this movement is closely allied to the view that judges should be representative of the community and is concerned about how judges should behave once they have been appointed in effect as representatives of a particular section of the community."[17] He claims that the concept of judicial neutrality has ancient roots going back to biblical writing but now, courtesy of *R.D.S.*, "precepts that were regarded as eternal truths have been challenged."[18] He refers extensively to Richard Devlin's article, "We Can't Go on Together with Suspicious Minds,"[19] which, of course, predates the decision of the Supreme Court, and caricatures it as presenting a simple either/or approach: you are either a formalist or a realist. He argues, in Devlin's terminology, that "formalists has a negative connotation while realists is a term of approval."[20]

Justice Ipp also criticizes the article by Jennifer Nedelsky, "Embodied Diversity and the Challenges to Law,"[21] which he quotes from, albeit selec-

tively. For example, he asserts that Nedelsky argues that "the conventional notion of impartiality entails a denial of difference."[22] Actually, Nedelsky was describing philosopher Iris Young's essay, "Impartiality and the Civic Public,"[23] and her intention was to explicate the implications for legal decision-making of Young's comments about universality and impartiality (and of the work of a number of other scholars, including Hannah Arendt). Ipp's one-paragraph summary of Nedelsky's discussion concludes that she is arguing that judges "should not be neutral but should instead be instruments of social justice, applying relative values and taking into account at all times the manifold differences between individual human beings."[24]

But the real target of Justice Ipp's critique is Justice L'Heureux-Dubé herself. Noting that she is president of the International Commission of Jurists, he reports on an article she published in that organization's Yearbook, in which she reiterated the proposition that impartiality does not necessarily mean judicial neutrality.[25] She said: "impartiality does not demand that judges close their eyes to the reality of the society in which legal disputes occur but rather that they remain open-minded to the possibilities for deeper understanding that differing viewpoints and experiences can provide."[26] After detailing extracts of the judgment in *R.D.S.*, Ipp goes on to make his own critique. Drawing on Devlin's observations that the Canadian judiciary has been selected from a relatively small cross-section of the community, specifically, as he says, privileged white males, calls have been made for broader appointment processes involving gender and race. But Ipp asks, "what is the true purpose of appointing judges from particular segments of the community? Are judges who are so appointed expected to behave with true impartiality or neutrality? And, if so what is the point of group identity as a criterion of judicial selection? Or should judges be appointed with the aim that they should actually represent the interests of their constituencies?"[27]

It is important to note that these questions are only ever raised when we are discussing the appointment of people outside the dominant power group of privileged, white, male, heterosexual, Anglo, English-speaking, able-bodied men.[28] The word "representativeness" has, at least until recently, been as absent from judicial appointments debates as have the words "gender" or "race," which tend to be reserved for discussions of those who are other than male, or who are racialized.[29] Justice Ipp might be astonished by the proposition that white, male, able-bodied, heterosexual judges may be perceived as

representing the interests of *their* community in their approach to the world in their judgments.

Justice Ipp concludes his discussion with three basic objections to the position that judges should not be "neutral" and to the notion of contextualized judging more broadly. First, he claims that there is a "lack of objectivity in determining the context," thereby treating objectivity as if it were an unproblematic phenomenon.[30] Next, he asks rhetorically, how does contextualized judging work in practice? Was it relevant in *R.D.S.*, for example, that there was racial prejudice in Halifax, Nova Scotia? In other words, could evidence have been led to this effect? His answer, not surprisingly, is that it could not have been.[31] Thirdly and finally, he says that underlying contextualized judging is a proposition that in individual cases, judges must be instruments to right perceived social wrongs and to remedy broad inequalities in society. Yet he regards this view of a court's function as "essentially inimical to true justice."[32]

Had he paid closer attention to Professor Nedelsky's discussion, he might have engaged with her response to these concerns. She argues: "What makes it possible for us to genuinely judge, to move beyond our private idiosyncrasies and preferences, is our capacity to achieve an 'enlargement of mind.' We do this by taking different perspectives into account."[33]

Nedelsky then refers to the work of philosopher Hannah Arendt who, she argues, "makes it clear that impartiality is not some stance above the fray, but the characteristic of judgments made by taking into account the perspectives of others in the judging community."[34] She continues:

> Arendt's insight shows that those who claim that a representative judiciary would destroy judicial autonomy, and create instead interest-group partiality, misunderstand the requirements of impartial judgment. To understand judicial impartiality we must ask who judges are, and with whom they imagine themselves to be in conversation as they make their judgments. Whom do they imagine persuading and on whom do they make claims of agreement? If their attention is turned to only a narrow group (white, middle-class males), then judges will surely remain imprisoned in their limited perspective. But if the faculties and student bodies of law schools, the practising bar as well

as the judiciary actually reflected the full diversity of society, then every judge would have had long experience in exercising judgment, through the process of trying to persuade (in imagination and actual dialogue) people from a variety of backgrounds and perspectives. This would better prepare judges for judging situations about which they had no first- or even second-hand knowledge. It would vastly decrease the current likelihood of a single set of very limited perspectives determining the judgment.[35]

*Justice Mason*

Considerably less polemical than the arguments of Justice Ipp is the discussion by Justice Mason, who has clearly reflected on the issues at greater length. According to Justice Mason, the furor created by the case would not have occurred if the issue involved something less sensitive than racism.[36] As he describes it, the real point of disagreement seemed to lie "in the application of the doctrine of judicial notice to racism and police conduct in Canadian society and the impropriety of *trial* judges deciding credibility issues by reference to generalisations about how classes of people behave."[37] As Justices L'Heureux-Dubé and McLachlin did in their judgment, he too quotes the statement of the Canadian Judicial Council, derived from Cardozo, that "True impartiality does not require that the Judge have no sympathies or opinions; it requires that the Judge nevertheless be free to entertain and act upon different points of view with an open mind."[38]

Justice Mason goes on to describe as "much more controversial" the extra-judicial suggestion of Justice L'Heureux-Dubé that "Judges should not aspire to neutrality. When Judges have the opportunity to recognise inequalities in society, and then to make those inequalities legally relevant to the disputes before them in order to achieve a just result, then they should do so."[39]

Unlike Justice Ipp, who rejects this proposition out of hand, Justice Mason acknowledges that

> Such an *aspiration* becomes debatable if it is taken outside of a context like Canada, where broad equality rights are Constitutionally entrenched. It is one thing to recognise human

differences in outlook, experience and vulnerability and to apply such perception in the neutral application of legal rules. It is another to see the judicial *function* as directly concerned with reversing inequalities except when there is a clear pre-existing mandate. Judges must do right to all manner of people. Nevertheless fresh insights may reveal or confirm (compare *Garcia v. National Australia Bank Limited*)[40] the unintended discrimination of facially neutral legal principles. The Judge who shuts his or her eyes to such revelation may merit criticism for failing to give effect to higher legal principles posited upon true equality.

In other words, he appears to concede that the existence of the *Charter of Rights and Freedoms* and its entrenchment of equality rights makes it legally possible and indeed perhaps appropriate to rely upon such a guarantee (in Canada) to address inequality.

Unfortunately, Justice Mason goes on to muddy the waters somewhat, as follows:

If, in a judgment, a hypothetical female Aboriginal magistrate gives effect to her attitudes about police behaviour or systemic violence to women, we tend to sit up and take notice. The media will usually ensure publicity and there will be no lack of critical commentators. Similarly, a hypothetical white male judge who betrays a now controversial attitude about female sexual complainants can expect to be taken to task by a different section of the public also feeding off the publicity of judicial proceedings.[41]

He suggests that in the "court of *judicial* opinion," which he contrasts with the "court of *public* opinion," "the same forces are at work in each situation (regardless of our approval or disapproval of the suppositions revealed in the remarks of the two hypothetical judicial officers)."[42] This idea—that expressing a point of view that engages with issues of equality, whether it is for or against equality values, is inherently problematic—is the point with which I want to take issue.

As Canadian readers know only too well, the *Charter of Rights and Freedoms* entrenches certain values. Moreover, the jurisprudence that has

developed under the *Charter* has given a particular content to those values. So, for example, equality is understood not as merely formal equality—treating everybody the same without reference to any distinction—but as a much more substantive notion based on a recognition of the history and consequences of disadvantage and an aspiration to the recognition of human dignity and equal worth.[43] It is in that context that Justices L'Heureux-Dubé and McLachlin in *R.D.S.* held that the recognition of racism is an important part of understanding issues of inequality within the constitutional context of Canada. They were not alone in this: while not agreeing with their judgment in all respects, Cory J. (with whom Iacobucci J. agreed) did point out in his judgment in *R.D.S.* that "the reasonable person [*whose perception is at the core of the issue when apprehension of bias is the question*] should also be taken to be aware of the social reality that forms the background to a particular case, such as societal awareness and acknowledgement of the prevalence of racism or gender bias in a particular community."[44]

Justice Mason's proposition that acknowledging and drawing attention to pervasive racism, or to the systemic disadvantages experienced by women, is equivalent to, or the same thing as (and equally impermissible for judges as) exhibiting sexism or racism, has been characterized by Constance Backhouse as the "peas in a pod" approach.[45] She elaborates upon this point in an article published in a forum discussing a number of aspects of the decision in *R.D.S.*[46]

Much of Backhouse's comment is focused on the appropriate attention (or lack thereof) given to the racial identities of the parties in the case and indeed, of the make-up of the courtroom: it appears that the fact that most of the personnel in the courtroom were African Canadian had an impact on the perception of the prosecutor at trial.[47] For Backhouse, the erasure of racial identity in the judgments makes it easier to slip into this "peas in a pod" approach, that is, to treat a bias complaint about racism as the same thing as a bias complaint about anti-racism. And the same applies to gender. Thus "racism and anti-racism, sexism and feminism, are all treated as identical peas in a pod":

> This is a false parallelism, unless one assumes that we inhabit a world that is scrupulously egalitarian. If our society did treat all races and genders equally, then it would be manifestly unfair for judges and adjudicators to take either race or gender into

account. However, ... [w]e live in a society in which there is a great deal of documented evidence to suggest that, at least systemically, whites continue to hold a position of dominance over people of colour, and men continue to hold a position of dominance over women. When judges are perceived to possess perspectives that support and reinforce these imbalances, you have a problem. When judges are perceived to possess perspectives that consider such imbalances to be improper and needing alteration, you have something quite different.[48]

To illustrate her point, Backhouse refers to a number of government-sponsored inquiries, Royal Commission reports and the like, into racism and sexism in parts of the Canadian justice system including, of course, the Royal Commission on the Donald Marshall Jr. prosecution in Nova Scotia, which was referred to in the judgment of the Supreme Court in *R.D.S.* While perhaps not as numerous, there are many counterparts to these reports in Australia.[49] But surely if racism and anti-racism and sexism and anti-sexism were equally bad and equivalent as social problems, we would have a shelf-full of reports and inquiries into anti-racism, and into the problematic nature of equality-seeking activities more broadly. In fact, not only are there no such reports, but as Backhouse points out only too clearly, a contemporaneous development with the documenting of the disadvantage of some groups within the justice system is the tendency to challenge those small number of "outsider" decision-makers, such as Judge Sparks, who have been appointed to the judiciary, on the grounds of "bias."[50]

Backhouse documents the now-infamous collection of bias challenges against those seen as jurisprudential outsiders, including herself,[51] and draws attention to comments made by Derrick Bell, a distinguished African American jurist, who points out the unselfconscious way in which challenges have been made to racialized judges about the perceived difficulty of their being impartial in race discrimination cases.[52] Once again, white male privilege is not seen as a position or a perspective, just as whiteness is not a race and maleness is not a gender.[53] These attributes are only used when we apply them to other-ized characteristics.[54] It is presumed that gender does not feature in an all-male environment, and that race is only relevant when the decision-maker is not white. Backhouse concludes:

Within a racist and sexist social framework, racism and sexism masquerade as "common sense." Discriminatory statements by white, able-bodied, heterosexual males pass for "normality." When anti-racist activists, feminists, disability advocates, and gay men and lesbians try to explain their own sense of reality, their statements appear unconventional, aberrant and askew.[55]

In her contribution to the forum, Professor Marilyn MacCrimmon discusses the role of contextual information in judicial decision-making.[56] Drawing on the work of Professor William Twining, MacCrimmon points out: "it is generally agreed that fact determination in judicial decision-making involves ordinary practical reasoning. The trier of fact necessarily draws on general experience and common sense beliefs about the behaviour of people. Fact determination is a product of the interaction between the evidence and the background and experience of the trier of fact."[57]

MacCrimmon also engages with the "false symmetry" argument, most clearly illustrated by the minority judges, where Major J., speaking for himself, Lamer C.J. and Sopinka J., suggested that referring to how white police in Nova Scotia deal with non-white youths was as much an impermissible stereotype as making assumptions about sexual assault victims or prostitutes. In Major J.'s words, "[i]t can hardly be seen as progress to stereotype police officer witnesses as likely to lie when dealing with non-whites. This would return us to a time in the history of the Canadian justice system that many thought had past. This reasoning, with respect to police officers, is no more legitimate than the stereotyping of women, children or minorities."[58]

The dissenting minority justices, according to MacCrimmon,

> hold race as immaterial and irrelevant unless there is specific evidence that a particular witness is racist. In effect, the fact determiner is to start with the generalisation that a black youth would be treated the same as a white youth by a white police officer in Halifax. In my view it would be illegitimate for trial judges to rely on this generalisation expressly and they should not be encouraged to do so implicitly. Not only would it be unfair to the accused not to take into account what is known by well informed members of the community, it is likely to distort the fact determination process.[59]

MacCrimmon draws on the Ontario Government's *Report on Systemic Racism in the Justice System*[60] to suggest that reliance on negative stereotypes should be distinguished from instances in which reference to race or ethnic origin can "displace assumptions which implicitly adopt white cultural behaviour."[61] She continues:

> A White person who does not think of themselves as belonging to a racial group may unconsciously judge others by reference to a standard that is implicitly White. The point is that there is no such thing as an empty mind. Persons cannot be abstracted from their race. ... Non-discriminatory fact determination should recognize that unequal and hierarchical social relations are constructed on the basis of race.[62]

She goes on to point out that we must treat generalizations based on race with great caution, just as we must challenge discriminatory generalizations about sexual assault victims, battered women, or child witnesses. But this does not necessarily mean that recognition of racial or gender dynamics will never be appropriate: "Generalizations that distort the fact determination process and have a discriminatory effect are not analogous to generalizations that recognize that the process of racialization may affect how people are treated."[63]

So how are we to identify when it *is* appropriate to take race or ethnic origin and gender into account? As Justice Mason noted, L'Heureux-Dubé and McLachlin JJ. were able to draw on *Charter* values, in particular, the principle of equality, to address this question in their judgment:

> The reasonable person ... is an informed and right-minded member of the community, a community which, in Canada, supports the fundamental principles entrenched in the Constitution by the *Canadian Charter of Rights and Freedoms* ... The reasonable person must be taken to be aware of the history of discrimination faced by disadvantaged groups in Canadian society protected by the *Charter*'s equality provisions. These are things of which judicial notice may be taken.[64]

## Equality Rights in Australia?

To return to Australia, Hilary Charlesworth recently presented a series of public lectures on human rights and the Australian Constitution in which she drew attention to some of the consequences of Australia's being the last Western democracy not to entrench constitutional recognition of rights.[65] One of the examples she gave is a case that involved a challenge by a group of Aboriginal women to the building of a bridge in an area they claimed was sacred to the women of their community.[66] They argued that the building of the bridge was a breach of existing laws that protected Aboriginal heritage.[67] In response, the Commonwealth (Federal) Government passed legislation overriding the heritage protection legislation to enable the bridge to be built. The Aboriginal owners of the land challenged that law under a section of the federal constitution that gives the Commonwealth Parliament the power to legislate with respect to "the people of any race for whom it is deemed necessary to make special laws."[68]

The issue before the High Court was whether the so-called race power in the constitution could permit "the making of a special law which is detrimental to, and discriminates adversely against, a group of Aboriginal Australians solely by reference to their race."[69] That is, did the scope of the power extend to the ability to pass laws that treated one racial group less favourably than another? The Commonwealth Government, supported by the governments of the Northern Territory, South Australia, and Western Australia, argued that the legislative power was not limited to enabling Parliament to pass laws only for the benefit of indigenous Australians.[70] During the course of argument, Justice Kirby of the High Court asked the Commonwealth Solicitor-General:

> Can I just get clear in my mind, is the Commonwealth's submission that it is entirely and exclusively for the Parliament to determine the matter upon which special laws are deemed necessary or whatever the words say or is there a point at which there is a justiciable question for the Court? I mean, it seems unthinkable that a law such as the Nazi race laws could be enacted under the race power and that this Court could do nothing about it.

> MR GRIFFITH: Your Honour, if there was a reason why the Court could do something about it, a Nazi law, it would, in our submission, be for a reason external to the race power. It would be for some wider over-arching reason.[71]

The validity of the law was upheld, with Justice Kirby dissenting.[72]

The High Court seems to be suggesting that, in the absence of some express prohibition on laws that disadvantage people of minority racial groups (here, indigenous Australians), there is no basis for finding such a law invalid. In effect, there is no need to consider issues of substantive equality in Australian law.[73] But this is a view that others have questioned.[74] And to return to Justice Mason's discussion, while he acknowledges the centrality of the *Charter* (and its equality provisions) to the judgment of Justices L'Heureux-Dubé and McLachlin, he expressly refers to the possibility of giving "effect to higher legal principles posited upon true equality." Although he did not elaborate on the circumstances in which such principles might apply, or what their content might be in a jurisdiction such as Australia, where there is no constitutionally based principle of equality, his comments suggest that there may be some room for the recognition of equality rights in Australia.

However, even in the absence of a Charter that explicitly authorizes judicial intervention, are Australian judges at liberty to re-think traditional notions of "neutrality" and reasonable apprehension of judicial "bias?"[75] In his discussion, Justice Mason gives the example of a judge sitting on a child murder case who might have had a child murdered and presents as unproblematic the view that this would obviously disqualify such a person. And what, he asks, would be the situation of a person who suffered directly at the hands of Hitler's genocidal policies who was asked to be a judge at Hitler's hypothetical trial?[76]

I would want us to consider some more questions in thinking about how to understand the issue of "bias." For example, what of a judge of the Family Court of Australia who had been divorced, or had been involved in a dispute over a child or over property? What of a judge in a civil action for damages arising out of a road accident who him- or herself had been tortiously injured and compensated (or, who had been a defendant in such a case)? What of a judge who had been the subject of unwanted sexual advances (probably every woman who has ever been appointed to a court) sitting on a

sexual harassment trial? Should a judge who had been the victim of a sexual assault be allowed to sit on a criminal trial? What of a male judge whose daughter had been the victim of a sexual assault (this is, of course, a far more likely demographic)? What of a judge who had perpetrated a sexual assault? Given the low reporting rates and the even lower charge and conviction rates,[77] it is perfectly feasible that there are within our own profession some who have perpetrated rape. What of a judge who, like Glanville Williams, wrote extensively about his belief that women lie in sexual assault matters?[78] What about a judge who, in an earlier life as an academic lawyer, expressed a view that the law perpetuated myths of that kind?[79] And what of a judge, known to be a practising Catholic, who announces to the court his personal acquaintance with the representatives of a Catholic organization seeking leave to intervene in a case and who then uses a casting vote to grant that organization's application?[80]

In "Embodied Diversity," Jennifer Nedelsky applies her arguments about embodied reasoning to the issue of how we decide who would appropriately sit on a tribunal of fact. She takes the example of a sexual harassment case:

> Traditional notions of impartiality might suggest that because of the emotional nature of the issue, we would want to exclude women who had been victims of sexual harassment and perhaps men who had been accused or found guilty of sexual harassment. But if our goal is not traditional impartiality—based on a presumed unity of selves stripped of their affective, experiential and bodily differences—then we will think about such past experiences differently.[81]

She goes on to suggest that a woman who has experienced sexual harassment is more likely to be attuned to the complex nuances involved in such a case. Nedelsky then argues that because there are so many different and conflicting perspectives, there should ideally be a panel of judges with different backgrounds including men, preferably one of whom has had an experience with sexual harassment as well. "I would choose a man who had sexually harassed a woman and had come to understand why his actions constituted harassment and what kind of harm they had done."[82] This perspective, which rec-

ognizes and values the lived experiences and knowledge of those who judge, is very far removed from that presented by Australian commentators.

Conclusion

I want to conclude by returning to Justice L'Heureux-Dubé's contributions to re-conceptualizing judicial expertise, authority, and impartiality. In an article called "Outsiders on the Bench: The Continuing Struggle for Equality,"[83] Justice L'Heureux Dubé draws attention to the number of bias challenges to herself and other women judges and makes the point that they all involve challenges to the legitimacy of the outsider as judge.[84] "[T]he attack on the impartiality of judges seems to be characterised by impugning the neutrality of those who do not fit the white male paradigm of what it means to be a judge." She elaborates:

> The key issue is what types of experience are accepted and what types are considered illegitimate. Society does not value the experience of the outsider: the woman, the member of a minority group. Our experiences are not considered legitimate. By their anatomy, their skin pigmentation, or their accent, these outsiders are brandished as biased, not to be trusted as judges and not to be accepted as members of our judicial community.

But as she goes on to point out, the experience of the insider is valued. Indeed, it is celebrated. She asks rhetorically: "Can you imagine a party moving to recuse a judge from a tax case because that judge is a tax expert"?[85]

Another example of our preoccupation with insider/outsider status and "knowledge" is illustrated by a colleague who works in the area of dispute resolution. Hilary Astor has written about her experience at an Australian law teachers' conference some years ago.[86] At that conference, she used a storytelling method to raise the issues of violence in mediation at a general (plenary) session (not at an "interest group" on "mediation" or indeed, on "gender" or "violence"). She told the fictitious story of Elizabeth, a lawyer, who was severely beaten by her husband and who left him after his violence had caused her to have a miscarriage. She wanted to get the audience to reflect on whether Elizabeth might end up in mediation in the resolution of her dis-

putes with her husband about property and about the children, and how Elizabeth might fare in a mediation process. The second part of her published article reflects on the audience reaction to her paper. All through morning teatime, which followed the presentation, people were speculating on who Elizabeth "really" was. I heard one legal academic announce that he knew Elizabeth: he had actually taught her. Others simply assumed the story was autobiographical.[87] Someone else claimed that the paper was unlike others at the conference: "It was emotional! The author must have a barrow to push—perhaps she is talking about herself!"[88] Astor comments:

> One does wonder whether, when an academic gives a paper on bankruptcy, there is speculation about whether that academic has personal experience of bankruptcy. Or whether, if one used a storytelling method to illustrate the dilemmas faced by a bankrupt in the legal system, one would be seen as pushing a "barrow." Speculations that Elizabeth's story was polemic motivated by autobiography are disturbing in that they do not do justice to the issues raised, which are an important part of legal scholarship and the law school curriculum.[89]

Until we and, in particular those who exercise power, recognize the choices made when experiences are either valued or discounted, depending on their proximity to the stock stories of the powerful, outsiders, even legally trained outsiders, will remain just that. Justice L'Heureux-Dubé's work, in judgments such as *R.D.S.* and in articles such as the one I have quoted from, have helped to challenge the orthodoxy of judicial neutrality and to point towards ways of seeing the world a little differently.

### Endnotes

1 Justice Catherine Branson, speech to NSW Women Lawyers Association, "Running on the Edge," October 1997, online: www.wlansw.asn.au/branson.htm (accessed 10 February 2003).

2 Women are very poorly represented on Australian courts, at both state and federal levels. There has only ever been one woman appointed to the High Court of Australia, and since her departure on 10 February 2003, no woman sits on this court. A national newspaper pointed out that, since Justice Gaudron's

retirement, the first case to be presided over by an all-male High Court bench, in February 2003, involves women's reproductive rights (*Melchior v. Cattanach*, an appeal from the Supreme Court of Queensland, [2001] Q.C.A. 246, concerns a claim for damages for the costs of raising a child born as a result of a doctor's negligence). See *The Australian (7* February 2003) at 11. The Federal Court of Australia has four women out of a total of forty-eight judges. In the state and territory Supreme Courts, the statistics are equally telling: New South Wales has four out of forty-six; Victoria four out of thirty-two; Queensland six out of twenty-three; Western Australia two out of seventeen; South Australia one out of fourteen; Tasmania none of seven; Northern Territory one out of seven; Australian Capital Territory none of twelve. On the Family Court of Australia there are fourteen women justices out of a total of fifty judges (data current for February 2003).

3 For some judicial discussions of the notion of "representativeness" from the U.S. Supreme Court and the Supreme Court of Canada respectively, see *J.E.B. v. Alabama ex rel TB*, 511 U.S. 127 (1994) and *R. v. Biddle*, [1995] 1 S.C.R. 761. Compare the discussion by Jennifer Nedelsky, "Embodied Diversity and the Challenges to Law" (1997) 42 McGill L.J. 91, esp. at 107–8.

4 *R.D.S. v. R.*, [1997] 3 S.C.R. 484 [*R.D.S.*]. The judgment was a joint judgment of Justices L'Heureux-Dubé and McLachlin, with which Justices La Forest and Gonthier agreed.

5 D.A. Ipp, "Judicial Impartiality and Judicial Neutrality: Is there a Difference?" (2000) 19 Austl. Bar Rev. 212; and Justice Keith Mason, "Unconscious Judicial Prejudice" (2001) 75 Austl. L.J. 676.

6 Cf Justice Bertha Wilson, "Will Women Judges Make a Difference?" (1990) 28 Osgoode Hall L.J. 507. See my "The Gender of Judgments: An Introduction," in Margaret Thornton, ed., *Public and Private: Feminist Legal Debates* (Melbourne: Oxford University Press, 1995) at 262; and "The Gender of Judgments: Some Reflections on 'Bias'" (1998) 32 U.B.C. L. Rev. 1 ["Reflections on Bias"].

7 *R.D.S.*, *supra* note 4 at para. 4: cited by Major J., his emphasis omitted.

8 *R.D.S. v. R.*, [1995] N.S.J. No. 184 (S.C.).

9 *R. v. R.D.S.* (1995), 145 N.S.R. (2d) 284 (C.A.).

10 Cory and Iacobucci JJ. also allowed the appeal, although Cory J. wrote a separate judgment in which Iacobucci J. joined; La Forest and Gonthier JJ. endorsed the joint reasons of L'Heureux-Dubé and McLachlin JJ.; Lamer C.J., Sopinka, and Major JJ. dissented.

11 *R.D.S.*, *supra* note 4 at para. 29.

12 *Ibid.* at paras. 34–35.

13 Most recently, he has been an acting judge of the Supreme Court of New South Wales. In 2002, he chaired a "Panel of Eminent Persons" established by the fed-

eral government to respond to what was perceived as a "crisis" in the public liability system, directed at limiting liability and imposing caps on personal injury damages. In the opening paragraphs, the committee asserts that there is a widely held view in the Australian community that "[d]amages awards in personal injuries cases are frequently too high" and that it is increasingly easy to sue. The committee claimed that it was not their job to test the accuracy of these perceptions, but rather to take them as a starting point: see www.revofneg.treasury.gov.au/content/review2.asp at paras. 1.4–1.6 (accessed 10 February 2003).

14 Ipp, "Judicial Impartiality," *supra* note 5.
15 Mason, "Unconscious Judicial Prejudice," *supra* note 5.
16 Ipp, "Judicial Impartiality," *supra* note 5 at 212.
17 *Ibid.*
18 *Ibid.* at 213.
19 Richard Devlin, "We Can't Go on Together with Suspicious Minds: Judicial Bias and Racialised Perspective in *R. v. R.D.S.*" (1995) 18 Dalhousie L.J. 408.
20 Ipp, "Judicial Impartiality," *supra* note 5 at 214.
21 Nedelsky, "Embodied Diversity," *supra* note 3.
22 Ipp, "Judicial Impartiality," *supra* note 5 at 214.
23 Nedelsky, "Embodied Diversity," *supra* note 3 at 94–96, discussing Iris Marion Young, "Impartiality and the Civic Public: Some Implications of Feminist Critiques of Moral and Political Theory," in Seyla Benhabib and Drusilla Cornell, eds., *Feminism as Critique: On the Politics of Gender* (Minneapolis: University of Minnesota Press, 1987).
24 Ipp, "Judicial Impartiality," *supra* note 5 at 214, citing Nedelsky, "Embodied Diversity," *supra* note 3 at 101.
25 Claire L'Heureux-Dubé, "Reflections on Judicial Independence, Impartiality and the Foundations of Equality" (1999) 7 C.I.L.J. Yearbook 95.
26 *Ibid.* at 106.
27 Ipp, "Judicial Impartiality," *supra* note 5 at 220.
28 Of course, the very use of these adjectives is a marker: we rarely refer to white male judges, but a woman judge, or a racialized judge, is frequently marked by the use of an adjective as "other." See my "Reflections on Bias," *supra* note 6 at 2–3 where I suggest that, when we talk about judges, adjectives are almost invariably used only to indicate that a judge is NOT white, male, or heterosexual; we rarely use those descriptions, while "women," "Afro-Canadian," "Aboriginal," or "gay" are commonly used indicators of "difference." For a graphic illustration, note the newspaper report of a successful application for special leave to appeal to the High Court of Australia by an applicant for refugee status claiming that his sexuality was the cause of persecution, under the headline "Kirby grants gays a hearing," referring to the only openly gay

member of the High Court of Australia: Benjamin Haslem "Kirby grants gays a hearing" *The Australian* (24 October 2002) at 3. I have yet to see a headline stating, "Male heterosexual judge grants convicted rapist a hearing."

29 The concept of racialization, i.e., the way ascriptions (or in some cases the erasure) of racial identities is used is discussed by Constance Backhouse in her "Bias in Canadian Law: A Lopsided Precipice," in Christine Boyle et al., "*R. v. R.D.S.*: An Editor's Forum" (1998) 10 C.J.W.L. 159 at 172–74.

30 Ipp, "Judicial Impartiality," *supra* note 5 at 221.

31 Here he is at odds with not only the judgment of L'Heureux-Dubé and McLachlin JJ. (with whom two other judges agreed, not one as he suggests) but also with the other members of the majority, Cory and Iacobucci JJ.

32 Ipp, "Judicial Impartiality," *supra* note 5 at 221.

33 Nedelsky, "Embodied Diversity," *supra* note 3 at 107.

34 *Ibid.* at 107, citing Hannah Arendt, *Lectures on Kant's Political Philosophy*, ed. R. Beiner (Chicago: University of Chicago Press, 1982); Hannah Arendt, *Between Past and Future: Six Exercises in Political Thought* (London: Faber and Faber, 1961).

35 *Ibid.* at 107–8.

36 Mason, "Unconscious Judicial Prejudice," *supra* note 5 at 678. This may well be so, and while he rightly points out that there are other attitudes that might equally deny equality to, for example, women (such as views about the appropriateness of paid work for women) (at 679), this does not really answer how we work to expose and ultimately change those attitudes. For a discussion of some of the attitudes and stereotypes that influence personal injury assessments for women, see my "Hoovering as a Hobby and Other Stories: Gendered Assessments of Personal Injury Damages" (1997) 31 U.B.C. L. Rev. 17.

37 Mason, "Unconscious Judicial Prejudice," *supra* note 5 at 678.

38 CJC, Commentaries on Judicial Conduct, 1991.

39 Mason, "Unconscious Judicial Prejudice," *supra* note 5 at 678–79, quoting L'Heureux-Dubé, "Reflections on Judicial Independence," *supra* note 25 at 106.

40 (1998), 194 C.L.R. 395. This is a decision of the High Court of Australia, reaffirming a special "wives' equity" in cases involving third-party guarantees: see for discussion, Reg Graycar and Jenny Morgan, *The Hidden Gender of Law*, 2d ed. (Sydney: Federation Press, 2002) at 121–25; Kristie Dunn, "Yakking Giants: Equality Discourse in the High Court" (2000) 24 Melbourne U.L. Rev. 427.

41 Mason, "Unconscious Judicial Prejudice," *supra* note 5 at 680.

42 *Ibid.* Of course, in Australia, there is only one such easily identifiable woman, though there are probably many more of the latter type of judicial officer.

43 As the Court noted in *Law v. Canada (Minister for Employment and Immigration)*, [1999] 1 S.C.R. 497, "Equality analysis under the *Charter* must be

purposive and contextual" (para. 6); "A flexible and nuanced analysis … is preferable because it permits evolution and adaptation of equality analysis over time in order to accommodate new or different understandings of equality as well as new issues raised by varying fact situations" (para. 3). The Court elaborated on the proper approach to equality, building on developments since *Andrews v. Law Society of British Columbia,* [1989] 1 S.C.R. 143. The Court stressed that an important focus must be remedying disadvantage. As Iacobucci J. (for the unanimous Court) explained in *Law*: "[P]robably the most compelling factor favouring a conclusion that differential treatment imposed by legislation is truly discriminatory will be, where it exists, pre-existing disadvantage, vulnerability, stereotyping, or prejudice experienced by the individual or group" (at para. 63). Some of the significant "post-*Andrews*" jurisprudence, discussed by the Supreme Court in *Law,* includes *Symes v. Canada,* [1993] 4 S.C.R. 695; *Egan v. Canada,* [1995] 2 S.C.R. 513; *Miron v. Trudel,* [1995] 2 S.C.R. 418; *Thibaudeau v. Canada,* [1995] 2 S.C.R. 627; *Eldridge v. British Columbia (Attorney General),* [1997] 3 S.C.R. 624; and *Vriend v. Alberta,* [1998] 1 S.C.R. 493.

44  *R.D.S., supra* note 4 at para. 111.

45  Backhouse, "Bias in Canadian Law," *supra* note 29 at 175. While in the text I have referred to Justice Mason's assimilation of these phenomena, Justice Ipp goes a considerable step further in his deployment of this type of reasoning. In his discussion of *R.D.S.,* he writes, "For example, it would be thought to be quite wrong for a judge to disbelieve a red-headed person and give, as the reason, 'In my personal experience red-headed persons usually lie about blondes'" (at 213). This suggests a parallel with the police officer/ non-white youth scenario in *R.D.S.* In this assimilationist strategy, to discriminate against redheads is the same as to discriminate against whites—which is the same as to discriminate against non-whites. All are suggested to be "the same," and equally pernicious. In this way, the actual racialized identities at play in *R.D.S.*—and the fact that a significant power disparity (between a white police officer and a "non-white" youth) was involved—are swept away and made irrelevant. To paraphrase Backhouse, "by this logic, anti-racism becomes as objectionable as maintaining an unsupportable bias against redheads."

46  Boyle, et al., "*R. v. R.D.S.*: An Editor's Forum," *supra* note 29. Christine Boyle, at 160, opened the discussion: "At a time when some, albeit limited, progress is being made in diversifying the bench, the decision provides food for thought on theories of judicial impartiality as well as on the role of 'the other' and, in particular, the racialized 'other' in perceptions of impartiality. It invites consideration of judicial notice, the appropriate use of generalizations in assessments of credibility, the meaning of 'evidence', the role of storytelling in the construction of 'facts', and the values that construct the reasonable person."

47 Backhouse, "Bias in Canadian Law," *supra* note 29 at 172, quoting Devlin, "We Can't Go on Together with Suspicious Minds," *supra* note 19 at 411.
48 Backhouse, "Bias in Canadian Law," *supra* note 29 at 174–75.
49 On the disadvantage of women in the Australian legal system, see, e.g., Australian Law Reform Commission, *Equality Before the Law: Women's Access to the Legal System*, Interim Report No. 67 (Sydney: ALRC, 1994); Australian Law Reform Commission, *Equality Before the Law: Justice for Women*, Report No. 69, Part I (Sydney: ALRC, 1994); Australian Law Reform Commission, *Equality Before the Law, Women's Equality*, Report No. 69, Part II (Sydney: ALRC, 1994); *Gender Bias and the Judiciary*, Report by the Senate Standing Committee on Legal and Constitutional Affairs (Canberra: Australian Government Publishing Service, 1994). Note also non-government initiatives, such as Law Society of NSW, *Getting Through the Door is Not Enough: An Examination of the Equal Opportunity Response of the Legal Profession in the 1990s* (1993); *Equality of Opportunity for Women at the Victorian Bar* (Victorian Bar Council, 1998). See Rosemary Hunter and Helen McKelvie, "Gender and Legal Practice" (1999) 24 Alternative L.J. 57; Keys Young, *Research on Gender Bias and Women Working in the Legal Profession*, Report Prepared for the Department for Women, 1995 and NSW Ministry for the Status and Advancement of Women, *Gender Bias and the Law: Women Working in the Legal Profession in NSW*, summary report, March 1995. On racism, see e.g., Commissioner Ronald Wilson, *Bringing Them Home: Report of the National Enquiry into the Separation of Aboriginal and Torres Strait Islander Children From Their Families* (Sydney: Australian Government Publishing Service, 1997), online: www. austlii.edu.au/au/special/rsjproject/ rsjlibrary/hreoc/stolen/; Chris Cunneen/ Aboriginal and Torres Strait Islander Commission, *Submission to the Senate Legal and Constitutional References Committee re Senate Inquiry into the Human Rights (Mandatory Sentencing of Juvenile Offenders) Bill 1999*, online: www.atsic.gov.au/issues/Law_and _Justice /mandatory_sentencing/mandatory_sentencing_juveniles/default.asp; and Commissioner Elliott Johnston, *National Report: Royal Commission into Aboriginal Deaths in Custody* (Canberra: Australian Government Publishing Service, 1991), online: www.austlii.edu.au/au/special/rsjproject/rsjlibrary/ rciadic/. Note also conferences and events such as Beyond Tolerance: A National Conference on Racism, convened by the Human Rights and Equal Opportunity Commission (HREOC), Sydney Opera House, 12 and 13 March 2002, speeches and papers reproduced online: www.hreoc.gov.au/racial_ discrimination/beyond_ tolerance/index.html.
50 Her article outlines the spate of "lopsided" challenges against decision-makers presumed to be biased because of their racialization, or their purported "feminism": Backhouse, "Bias in Canadian Law," *supra* note 29 at 178–83. See also

Maryka Omatsu's discussion, "The Fiction of Judicial Impartiality" (1995) 8 C.J.W.L. 528; and my "The Gender of Judgments: Some Reflections on 'Bias,'" *supra* note 28, 1. Interestingly, a number of white male judges have drawn attention to the existence of racism without incident: for some examples see *R. v. Parks* (1993), 15 O.R. (3d) 324 at 342 (C.A.) (per Doherty J.A.) and from Australia, *B and R and Separate Representative* (1995), F.L.C. 92–636 (Family Court, Full Court). The present Chief Justice of the High Court of Australia, Gleeson C.J., once endorsed criticism of the defence of provocation on the grounds that, with respect to this defence, "the law's concession to human frailty was very much, in its practical application, a concession to male frailty": *Muy Ky Chhay* (1994), 72 A. Crim. R. 1 at 11 (NSW Court of Criminal Appeal).

51 Backhouse recounts how in 1993, when she held a part-time appointment as a human rights adjudicator, she was successfully removed from a sex discrimination case for bias because she had been one of 120 complainants in a systemic discrimination case against a university: *Great Atlantic & Pacific Co. of Canada v. Ontario (Human Rights Commission)* (1993), 13 O.R. (3d) 824 (Gen. Div.). She further notes that "bias challenges for 'feminist' perspectives have also affected the Supreme Court of Canada," given that in the early 1990s both Justice Bertha Wilson and Justice Beverley McLachlin had complaints of bias lodged against them by the conservative women's organization, REAL Women of Canada. In both instances, "feminist perspective" or "feminist ideology" were said to negate the judge's "impartiality" or to undermine "the integrity of the court": Constance Backhouse, "Bias in Canadian Law," *supra* note 29 at 180. Note also the controversy that followed the decision of the Supreme Court of Canada in *R. v. Ewanchuk*, [1999] 1 S.C.R. 330; Ed Ratushny, "Speaking as Judges: How Far Can They Go?" (2000) 11 N.J.C.L. 293 at 387–401 provides an excellent overview of the vituperative response (particularly on the part of Justice McClung) that followed Justice L'Heureux-Dubé's judgment in *Ewanchuk*. In April 1999, the Canadian Judicial Council (CJC) dismissed REAL Women's complaint against L'Heureux-Dubé: CJC, News Release, "Council Releases Response to REAL Women of Canada," online: www.cjc-ccm.gc.ca/english/news_releases/1999_04_01.htm (accessed 17 February 2003). In May 1999, the Council went on to issue its determination on the twenty-four complaints it had received against Justice McClung, expressing "strong disapproval" of his conduct: CJC, News Release, "Panel Expresses Strong Disapproval of McClung Conduct," online: www.cjc-ccm.gc.ca/english/news_releases/1999_05_21.htm (accessed 17 February 2003).

52 Backhouse quotes Bell on the fact that there exists "a wide-spread assumption that blacks, unlike whites, cannot be objective on racial issues, and will favour their own no matter what." Bell argues that in the American context: "Black

judges hearing racial cases are eyed suspiciously and sometimes asked to recuse themselves in favour of a white judge—without those making the request even being aware of the paradox in their motions." Constance Backhouse, "Bias in Canadian Law," *supra* note 29 at 179, quoting Derrick Bell, *Faces at the Bottom of the Well: The Permanence of Racism* (New York: Basic Books, 1992) at 113. Similarly, the late Justice Leon Higginbotham once remarked when asked to recuse himself from a race discrimination case, "[B]lack lawyers have litigated in the federal courts almost exclusively before white judges, yet they have not urged that white judges should be disqualified on matters of race relations": *Pennsylvania v. Local Union 542, International Union of Operating Engineers*, 388 F. Supp. 155 at 177 (E.D. Pa., 1974) per Higginbotham J.

53 On the problematic construction of whiteness as a non-position, and for an examination of how this is linked to white privilege, see Richard Dyer, *White* (London and New York: Routledge, 1997).

54 The use of adjectives is not symmetrical: while we use an adjective of gender for women in power roles—i.e., "woman judge," "woman premier"—in that context, the adjective serves to disempower what would otherwise be a position of power. But "male" is never itself an adjective of empowerment or disempowerment. Other adjectives, such as "poor," or "black," or "gay," are used to disempower men. And see generally Lorraine Code, *What Can She Know? Feminist Theory and the Construction of Knowledge* (Ithaca: Cornell University Press, 1991) at 175–76.

55 Backhouse, "Bias in Canadian Law," *supra* note 29 at 181. For a detailed discussion of this phenomenon, and in particular, the epistemological processes by which the voices of the powerless are rendered inaudible while those with power continue to define "reality," see Kim Lane Scheppele, "Manners of Imagining the Real" (1994) 19 Law and Social Inquiry 995. Scheppele relies here on Pierre Bourdieu's notion of "habitus," or the "way things are": Pierre Bourdieu, *Outline of a Theory of Practice* (Cambridge: Cambridge University Press, 1977).

56 Marilyn MacCrimmon, "Generalizing about Racism," in Boyle et al., "Editor's Forum," *supra* note 29 at 184.

57 *Ibid.* at 185.

58 *R.D.S.*, *supra* note 4 at para. 18.

59 MacCrimmon, "Generalizing About Racism," *supra* note 56 at 194.

60 *Report of the Royal Commission on Systemic Racism in the Ontario Criminal Justice System* (Ottawa, 1995).

61 MacCrimmon, "Generalizing About Racism," *supra* note 56 at 196, quoting *Report on Systemic Racism* at 43.

62 MacCrimmon, "Generalizing About Racism" at 196.
63 *Ibid.* at 197.
64 *R.D.S., supra* note 4 at para. 46.
65 Hilary Charlesworth, *Writing in Rights: Australia and the Protection of Human Rights* (Sydney: University of NSW Press, 2002).
66 *Kartinyeri v. The Commonwealth* (1998), 195 C.L.R. 337. For a detailed discussion of some of the issues that arose out of this controversy, see Joanna Bourke, "Women's Business: Sex, Secrets and the Hindmarsh Island Affair" (1997) 20 U.N.S.W.L.J. 333.
67 *Aboriginal and Torres Strait Islander Heritage Protection Act* 1984 (Cth).
68 S. 51 (xxvi).
69 *Kartinyeri, supra* note 66 per Kirby J. at 38.
70 In 1967, nearly 90 percent of voters, with majorities in every state, approved a proposal to enable the Commonwealth to legislate with respect to Aboriginal people. This remains the most overwhelmingly successful referendum in Australia's history, attracting over 10 percent more "yes" votes than any other referendum before or since. See Tony Blackshield and George Williams, *Australian Constitutional Law and Theory*, 3d ed. (Sydney: Federation Press, 2002) at 1306 for a precise breakdown of voting patterns.
71 *Kartinyeri and ANOR v. The Commonwealth of Australia* A29/1997 (5 February 1998), transcript online: www.austlii.edu.au/au/other/hca/transcripts/1997/A29/3.html. This exchange is extracted in Charlesworth, *Writing in Rights, supra* note 65 at 32, referring to George Williams, *A Bill of Rights for Australia* (Kensington: UNSW Press, 2001) at 8.
72 It was a 5:1 decision; only six judges sat rather than seven, as Callinan J. had recused himself. For a discussion of this, see Sydney Tilmouth and George Williams, "The High Court and the Disqualification of One of its Own" (1999) 73 Austl. L.J. 72.
73 There have been some, extremely limited, discussions of "equality" in Australian constitutional law: see, e.g., *Kruger v. Commonwealth of Australia* (1997), 190 C.L.R. 1; *Kable v. Director of Public Prosecutions for NSW* (1996), 189 C.L.R. 51; *Leeth v. Commonwealth of Australia* (1992), 174 C.L.R. 455; *Street v. Queensland Bar Association* (1989), 168 C.L.R. 461. See also Jenny Morgan, "Equality Rights in the Australian Context: A Feminist Perspective," in Philip Alston ed., *Towards an Australian Bill of Rights*, (Canberra: HREOC/CIPL, 1984).
74 See Jenny Morgan, "Provocation Law and Facts: Dead Women Tell no Tales, Tales Are Told About Them" (1997) 21 Melbourne U.L. Rev. 237 esp. at 272, n. 176. See also Christine Boyle, "The Role of Equality in Criminal Law" (1994) 58 Sask. L. Rev. 203.

75 Note that Backhouse points out that both in the challenge to her role as a human rights adjudicator (*Great Atlantic Pacific Company of Canada Ltd. v. Ontario (Human Rights Commission)*, *supra* note 51 and the challenge to Judge Sparks, the cases were put more strongly, that is, claims were made of "actual bias": Backhouse, "Bias in Canadian Law," *supra* note 29 at 182–83.

76 Mason, "Unconscious Judicial Prejudice," *supra* note 5 at 680. Noted Hungarian filmmaker, Istvan Szabo, has engaged with this question in a recent film. *Taking Sides* (2001) looks at the "de-Nazification process" in Germany after the Nuremberg Trials. One of the key characters is a Jewish man whose family had left their native Germany for the United States shortly before the war. This character, David, is one of those involved in determining whether celebrated conductor Wilhelm Furtwängler should be viewed as a war criminal. He is presented as having a much more nuanced, indeed more open, approach to the question, perhaps due to his "German-ness," which involved considerable respect for the conductor, a respect not shared by his American superior officer. So does his Jewishness automatically rule him out of dealing with trials of Nazis (other than Hitler)?

77 For an overview of the data on sexual assault, see Julie Stubbs, "Sexual Assault, Criminal Justice and Law and Order," paper delivered to Sexual Assault: Prevention and Practice conference, 12 February 2003, online: www.lawlink.nsw.gov.au/cpd.nsf/pages/stubbs. On reporting rates, see Australian Bureau of Statistics, *Women's Safety Australia* (Canberra: Australian Bureau of Statistics, 1996), Cat. no. 4128.0 at 28 (and see also tables 4.5 and 4.6); on charge rates, see NSW Bureau of Crime Statistics and Research, (2002) *NSW Recorded Crime Statistics 2001* at 37–38, online: www.lawlink.nsw.gov.au/bocsar1.nsf/files/rcs01.pdf/$FILE/rcs01.pdf; and on conviction rates, see NSW Bureau of Crime Statistics and Research, NSW Criminal Courts Statistics 2001 report at 83, online: www.lawlink.nsw.gov.au/bocsar1.nsf/files/CCS01.pdf/$FILE/CCS01.pdf. This latter shows that while the rate of conviction for all cases in the higher courts was 77.4 percent, for sexual offences, some two-thirds of cases did NOT result in convictions.

78 In the first edition of his *Textbook of Criminal Law* (London: Stevens & Sons, 1978) Williams states at 196: "Many complaints of rape are false, since the woman in fact consented." By the second edition this had become: "Some (we do not know how many) complaints of rape are false, since the woman in fact consented." Glanville Williams, *Textbook of Criminal Law*, 2d ed. (London: Stevens & Sons, 1983) at 238.

79 For more illustrations of such scenarios, see Graycar and Morgan, *The Hidden Gender of Law*, *supra* note 40 at 65.

80 This is not a hypothetical: it was the situation in *CES v. Superclinics*, an appeal from the decision of the NSW Court of Appeal (1995), 38 N.S.W.L.R. 47. When the matter was heard in the High Court of Australia, there were only six (rather than the full seven) members hearing the application as Kirby J. did not sit: he had been a member of the NSW Court of Appeal when it decided the case under appeal. When the application for leave to intervene was made, then Chief Justice Brennan said: "I have asked the Senior Registrar to inform counsel that I know Father McKenna, a deponent to one of the affidavits in support of the application to intervene, or to appear amicus curiae, and a number of members of the Australian Catholic Bishops' Conference," *Superclinics Australia Pty Ltd. v. CES and ors*, in the High Court of Australia, No. S88 of 1996, Transcript of Proceedings, 11 September 1996 at 4, online: www.austlii.edu.au/au/other/hca/transcripts/1996/S88/1.html (accessed 10 February 2003). The judges split 3:3 on this application and it was granted on the casting vote of the Chief Justice. The case subsequently settled.
81 Nedelsky, "Embodied Diversity," *supra* note 3 at 109–10.
82 *Ibid.* at 110.
83 (2001) 16 Wisconsin Women's L.J. 15 (part of a symposium and workshop on judging at U.C.L.A., Berkeley, Spring 2000).
84 *Ibid.* at 27.
85 *Ibid.* This resonates with a wonderful comment made many years ago by Christine Boyle in "Sexual Assault and the Feminist Judge" (1986) 1 C.J.W.L. 93 at 102, n. 39, where she noted that she appeared in a graduate seminar course outline "under the heading of 'Legal Scholarship for a Cause,' while a male tax lawyer spoke under the heading 'Conventional Legal Research.'"
86 Hilary Astor, "Elizabeth's Story: Mediation, Violence and the Legal Academy" (1997) 2 Flinders J.L. Ref. 13.
87 I was also a participant at this conference.
88 Astor, "Elizabeth's Story," *supra* note 86 at 27.
89 *Ibid.* at 29.

## Seven

## Être le miroir de son époque : la primauté du droit, la critique égalitaire, et la contribution de Madame la juge L'Heureux-Dubé

NATHALIE DES ROSIERS*

La justice, c'est l'invention des gens chanceux[1].

Il est clair que l'art. 15 a pour objet de garantir l'égalité dans la formulation et l'application de la loi. *Favoriser l'égalité emporte favoriser l'existence d'une société où tous ont la certitude que la loi les reconnaît comme des êtres humains qui méritent le même respect, la même déférence et la même considération*[2].

Plusieurs personnes ont écrit[3] et continueront d'écrire sur la contribution de la juge L'Heureux-Dubé au droit canadien. Le présent texte constitue modeste contribution et vise à décrire certains aspects de la vision de la juge L'Heureux-Dubé et à les analyser en fonction du respect du principe de la primauté du droit. Je ne prétends pas présenter ici «la» pensée de l'honorable juge[4], je ne suis pas si brave; je veux simplement examiner un élément de sa pensée, l'interpellation de la critique égalitaire[5], qui me paraît, à moi et à d'autres[6], significatif.

Ma thèse est que la vision de la juge comporte une volonté d'appliquer pleinement le principe de la primauté du droit. Il s'agissait donc pour elle de réduire l'écart entre le droit et la réalité et de répondre aux critiques égalitaires adressées aux tribunaux. Ce qui a sans doute identifié Claire L'Heureux-Dubé à la critique égalitaire, c'est le fait non pas qu'elle en a fait un axe de réflexion, mais plutôt qu'elle a pris les arguments au sérieux, les a écoutés, et y a répondu. En cela, ses propos reflètent bien les préoccupations de notre époque. J'utilise donc la métaphore de la réflexion pour illustrer le projet de la juge L'Heureux-Dubé et je ne cherche aucunement à minimiser son rôle de leader. Claire L'Heureux-Dubé n'a pas seulement réfléchi sur son époque, elle l'a aussi modelée. Malgré tout, je tente ici de démontrer comment une réflexion bien articulé par le pouvoir judiciaire, des idées et des enjeux d'une

époque est primordiale pour une société qui reconnaît la primauté du droit. Je reprends d'abord certaines interprétations du principe de la primauté du droit pour suggérer que l'élimination (ou à tout le moins le rétrécissement) de l'écart entre le droit et la réalité est essentiel pour l'établissement du principe de la primauté du droit, puis je décris le rôle de la juge L'Heureux-Dubé dans ce contexte.

## I – Réfléchir sur son époque et sur la primauté du droit

La primauté du droit[7] est une «expression haute en couleur»[8] et constitue certainement un concept fluide[9]. H.W. Arndt dit que la primauté du droit «has meant different things to many different people»[10].

Pour certains, la primauté du droit requiert avant tout l'assujettissement de l'exercice d'un pouvoir public[11] au droit et la nécessité d'un ordre juridique[12]. Les critères énoncés par le professeur Fuller[13] (les lois doivent être générales, prospectives, claires, publiques, logiques, diriger l'exercice de la discrétion gouvernementale, respectueuses de la justice naturelle, et prévoir un recours pour leur mise en application par un tribunal indépendant) sont souvent associés au principe de la primauté du droit[14]. Plus récemment, on a voulu donner une définition moins formaliste du principe et on l'associe à une exigence de justification raisonnée[15], publique, qui ne soit pas «injuste»[16]. C'est la suggestion de Tremblay[17]. Selon Dysenhaus, le «justificatory exercise of reason-giving» est essentiel au principe de la primauté du droit[18]. La juge en chef McLachlin retient l'expression «culture de justification»[19]. Webber parle aussi de rationalité substantive[20].

Il serait possible de rapprocher l'interpellation par la juge L'Heureux-Dubé de la critique égalitaire de la conception du principe de la primauté du droit axée sur l'accès à la justice, telle qu'elle est défendue par certains, ou même du concept d'égalité souvent inclus dans ce même principe[21]. En effet, certaines décisions prennent en compte la notion d'accès (à tout le moins physique) aux tribunaux[22]. De plus, selon certains auteurs, T.R.S. Allan entre autres, la primauté du droit comporte une notion d'égalité, à tout le moins formelle. On pourrait considérer la place de la critique égalitaire dans les décisions de la juge L'Heureux-Dubé sous cet angle, en y voyant une extension du principe d'égalité d'Allan, l'égalité formelle étant remplacée par l'égalité réelle. J'adopte ici un point de vue un peu différent qui insiste sur le caractère de justification raisonnée, pratique et contemporaine de ce principe

dans une société délibérative. C'est non seulement parce que le principe de la primauté du droit englobe l'égalité devant la loi que la critique égalitaire devait être examinée, mais aussi parce qu'il s'agissait de préserver un cadre de rationalité pratique et pertinent à l'argumentation juridique. C'est pour des raisons de justification (inhérentes au principe de primauté du droit) que la critique égalitaire devrait avoir sa place dans les cours de justice.

Essentiellement, le principe de la primauté du droit exige de la part de la juge qu'elle décide de questions concrètes et actuelles au regard des principes juridiquement admis[23]. Même dans les conflits les plus banals, il s'agit de traduire les principes juridiques dans le cadre de faits impliquant un rapport concret entre des personnes. Même dans les décisions qui font intervenir l'application de principes juridiques reconnus, et non la question de la validité des lois promulguées par le législateur, la juge s'applique à réduire l'écart entre le droit et la réalité et à traduire les valeurs du droit pour la résolution du conflit et le développement des rapports entre les participants. Le droit s'exerce donc dans une situation déterminée et concerne des personnes réelles. De plus, la société demande souvent aux juges de se prononcer sur les grandes questions de notre époque. En effet, presque tous les grands conflits de valeurs ont trouvé à s'exprimer devant les tribunaux : l'avortement, l'euthanasie, les politiques à l'égard des gens économiquement vulnérables, la transformation de la famille. Les juges sont des témoins privilégiés des tensions sociales et leur tâche consiste à défendre les valeurs démocratiques et juridiques dans des cas concrets. Les juges doivent donc actualiser, dans tous les sens du mot[24], le droit dans la société. C'est peut-être ce que signifie la célèbre métaphore de la constitution comme «arbre vivant»[25]. L'établissement de la primauté du droit suppose donc son actualisation dans la résolution des conflits sociaux. Un État de droit qui tient à assurer la primauté du droit s'attache à faire respecter les valeurs du droit dans les rapports personnels, sociaux, économiques, et politiques[26]. Le droit doit parler pour tous et s'exprimer de façon convaincante dans le langage d'aujourd'hui.

En effet, le principe de la primauté du droit implique aussi que, pour être légitime, le droit doit parler raisonnablement et non pas seulement de façon autoritaire[27]. Dans ses applications les plus récentes, le principe de la primauté du droit est soumis à l'impératif de justification[28].

J'utilise l'expression «être le miroir de son époque» pour décrire le rôle du juge dans le processus d'actualisation justifiée décrit plus haut, que j'ai associé au principe de la primauté du droit. Cette expression me semble

appropriée pour expliquer la corrélation entre la «justification actualisée» inhérente au principe de la primauté du droit et les fonctions de juge. Je développe plus loin la métaphore du reflet en décrivant trois rôles pour les juges : capter la réalité, la retransmettre, et stimuler la délibération.

## II – La réflexion en action

Selon moi, la contribution de l'honorable L'Heureux-Dubé a stimulé la croissance d'un État de droit fort et a raffermi le respect de la société canadienne à l'égard du principe de la primauté du droit. D'une certaine façon, je maintiens, contrairement à certains commentateurs, que l'Honorable L'Heureux-Dubé a contribué à consolider le principe de la primauté du droit et non pas à l'affaiblir[29]. Dans la présente section, je considère son action et son rôle de captatrice (A) et de «transmettrice»[30] (B).

### A. Capter la réalité

Le réflexe au droit qui caractérise nos sociétés démocratiques se fait dans un contexte où le droit est lui-même un espace contesté. Sans aucun doute, il y a toujours eu des critiques acerbes du rôle du droit dans la société. Ce qui frappe néanmoins c'est que la critique égalitaire prédomine depuis la fin des années 1970. Depuis le mouvement *legal realism* jusqu'aux critiques féministes et à la *critical race theory*, le droit est regardé comme un fait social. Le droit n'apparaît plus comme une série de mesures objectives, mais comme un système qui distribue ou justifie le pouvoir social. Cette critique profonde de notre droit et de sa place dans la société a marqué profondément notre époque. C'était inévitable dans une société démocratique qui réfléchit sur les notions de justice, d'égalité, et d'imputabilité. Le droit sert souvent à justifier l'exercice d'un pouvoir coercitif, et la critique égalitaire fait partie d'une demande d'imputabilité à l'endroit de l'exercice de ce pouvoir. Que cette critique égalitaire ait atteint le judiciaire était inévitable, mais le phénomène est aussi très sain. Le refus d'entendre les critiques égalitaires à l'endroit du rôle du droit ne pouvait pas servir une société défendant la primauté du droit. Il n'aurait servi qu'à miner la légitimité du droit et aurait rendu le droit étranger aux progrès sociaux, et le droit n'aurait pu ni apprendre d'eux ni influer sur eux. Le maintien du principe de la primauté du droit exigeait donc précisément qu'on interpelle ces critiques et que celles-ci soient réfléchies dans la

décision judiciaire. L'État de droit ne peut ignorer ni la réalité sur laquelle il s'appuie ni les distorsions qu'il crée. Se réfugier derrière une cloison de technocrate plutôt que de reconnaître le caractère de cette réalité est inacceptable à long terme pour le projet démocratique. Il est impossible que le droit survive s'il ne défend pas sa légitimité en répondant à la critique fondamentale que les mouvements féministes, la *critical race theory*, et autres en ont faite. Certainement, c'est une des contributions majeures de l'honorable L'Heureux-Dubé que d'avoir donné une place à la critique égalitaire dans la jurisprudence canadienne.

À mon avis, la réponse à la critique égalitaire de la juge L'Heureux-Dubé a consisté à justifier le rôle du droit afin de pouvoir maintenir le principe de la primauté du droit. Elle s'est articulée autour de deux approches méthodologiques : la réceptivité à un savoir pluridisciplinaire et la diversification des sources de savoir, c'est-à-dire le désir de mieux comprendre la réalité en se mettant à l'écoute du point de vue des exclus.

1. La réceptivité au savoir pluridisciplinaire

Dans son article «Re-examining the Doctrine of Judicial Notice in the Family Law Context»[31], la juge L'Heureux-Dubé rend compte de l'utilisation qu'elle fait des acquis des sciences sociales :

> If historical context constitutes relevant authority to the interpretation of historical documents, then does it not follow that contemporary social context constitutes relevant authority to interpreting the mischief that Parliament seeks to address by way of statute?[32]

Elle estime que l'approche est essentielle pour remédier aux limites du savoir :

> In family law, more than in almost any other field, judges are called upon to interpret provisions that will profoundly affect people's daily lives. Most judges will not have had personal experiences akin to those whom their decisions will affect. Fewer still are the primary caregivers in their family. Moreover, unless they themselves have gone through a divorce as a custodial parent, they may be just as inclined as the custodial parent to underestimate the costs of raising a child on one's own. It has

> been noted earlier that interpretation always takes place through the finder of fact's own prism, and that in certain cases this prism may not be appropriate to reflect suitably the realities of those affected. *For this reason, social framework evidence can play an important role in combating popular misconceptions touching upon the fact-finding exercise, and in helping to bring the beliefs and understandings of the trier of fact into congruence with social reality* [nos italiques][33].

Elle cherche aussi à réduire l'écart entre les présomptions du droit et leur impact dans la réalité : «It promotes judicial awareness of the context in which support awards are *experienced*, rather than merely contemplated.»[34]

La critique[35] du recours au savoir des sciences sociales comme source d'information pour la décision judiciaire fait état de la difficulté pour les juges de définir les limites du savoir présenté.

Évidemment, tout savoir est partiel et est toujours susceptible de s'accroître. Sans aucun doute, comme toutes les disciplines, le savoir des sciences sociales n'est pas neutre ni exempt de critique. Il est souvent le produit de l'organisation des universités et des organismes subventionnaires. Malgré tout, en se privant de l'apport d'un tel savoir dans la décision judiciaire contribue à élargir le fossé entre la réalité et le droit. Edward Robinson disait déjà en 1935: «Men [sic] who resolve to think about human affairs without recourse to psychology never actually succeed in avoiding psychology; they simply make up a crude, uncritical psychology of their own.»[36] Le droit est rempli d'assertions en matière d'organisation sociale et de psychologie qui n'ont pas été vérifiées, ne sont pas vérifiables ou qui, si elles se vérifiaient par le passé, sont maintenant dépassées et désuètes. Mentionnons simplement, à titre d'exemple, certains dogmes de notre système juridique : de longues peines d'emprisonnement dissuadent les criminels, les parties demander et défenderes son égale devant la juge, une personne donne toujours un consentement valable et éclairé à la suite de conseils juridiques, la vérité se fait jour après des contre-interrogatoires serrés, il est toujours possible de refuser de donner son consentement à son médecin traitant, etc. Il est souvent nécessaire pour le droit de présumer certains faits pour pouvoir remplir certains objectifs d'efficacité. On pourrait aussi donner comme exemple la quantité de palissades où le droit présume des états de fait parce qu'ils servent à la fois

d'assises conceptuelles faciles ou parce qu'on n'a pas trouvé mieux. Sans cesse, des études s'attachent à comprendre les assises de notre droit[37]. Sans aucun doute, les organismes de réforme du droit tentent de déterminer si les catégorisations du droit continuent de bien servir les justiciables ou si elles occultent leur réalité[38].

Le savoir des sciences sociales est donc utile pour mettre en lumière certaines illusions du système juridique. Pourquoi se priver d'une telle source de connaissance? D'autant que le savoir des sciences sociales peut aussi servir à déceler certains préjugés des décideurs. C'est une des utilités mentionnées à maintes reprises par la juge L'Heureux-Dubé dans ses écrits et décisions.

Il s'agit donc d'utiliser le savoir avec circonspection. Sa mise au rancart contribuerait encore à masquer la réalité par le droit. Il vaut mieux s'en servir en mesurant bien les dangers et les incertitudes. Je pense qu'on peut affirmer que la juge L'Heureux-Dubé a une approche prudente :

> Given that support and custody decisions are inherently prospective, evidence that sheds light on what may happen once the parties leave the court can therefore be of great importance to those who must make these decisions. *The guidance that such evidence may give does not in any real way restrict the judge's discretion—it merely provides a more rational basis upon which that discretion may be exercised* [39].

Et plus loin :

> It is important to avoid the temptation to rely on it (social science evidence) for too much. It cannot, for instance, take the place of evidence on the actual advantages and disadvantages stemming from the marriage and its breakup. It cannot take the place of the parties' actual financial statements. It cannot replace evidence on the actual relationships between each of the parents and their child[40].

L'argument selon lequel les juges n'ont pas la compétence nécessaire pour utiliser les données des sciences sociales milite en faveur de l'octroi d'une aide appropriée prenant la forme soit de témoignages d'experts.

À mon avis, l'utilisation prudente du savoir des sciences sociales visait aussi à justifier la décision judiciaire à deux niveaux. Premièrement, elle permettait au moins d'engager la discussion avec des penseurs souvent exclus du processus judiciaire, à savoir les sociologues, les économistes, et les criminologues qui étudient souvent l'impact du droit sur la société. Elle permet donc à un auditoire élargi de participer au travail de justification. Deuxièmement, il s'agissait aussi de justifier le droit en tenant compte de son impact et non pas en en faisant abstraction avec des critères élargis. Solliciter l'apport critique des sciences sociales permet d'étendre le potentiel de justification du droit : il invite des perspectives autres à se pencher sur la justification du droit en employant des critères qui vont au-delà des critères traditionnels du droit, tels que ceux de cohérence et de certitude[41]. Une justification qui dépasse les sources traditionnelles du droit (c'est-à-dire la bonne personne, en suivant le bon processus, a édicté la règle suivant une conception procédurale de la primauté du droit) et qui vise une justification pasée sur des critères différents (c'est-à-dire une décision qui est bonne parce qu'elle aura des résultats appropriés compte tenu d'objectifs sociaux légitimes) me semble conforme aux critères de justification dans le cadre de la primauté du droit dans une société délibérative[42]. Je suis d'avis qu'on devrait associer cet élargissement des modes de justification du droit et des catégories d'évaluateurs à une démocratisation de ce processus. Évidemment, il ne suffit pas d'élargir le cercle des spécialistes qui sont en mesure de participer à la justification, il faut également rejoindre les citoyens ordinaires et ceux qui sont souvent exclus des mécanismes de participation démocratique.

2. La perspective de l'exclu

> We can choose to know the lives of others by reading, studying, listening, and venturing into different places[43].

L'interprétation du principe de la primauté du droit que j'ai donnée plus haut[44] implique la nécessité d'avoir accès (à tout le moins physique) aux tribunaux[45]. L'accessibilité financière aux tribunaux commence à être reconnue comme principe constitutionnel[46]. Il faut aussi se soucier de l'accessibilité intellectuelle[47]. On ne peut parler d'accès physique ou financier sans répondre aux préoccupations réelles des démunis. En effet, il ne sert à rien d'appliquer le principe de primauté du droit assorti du libre accès au tribunal si les

commentaires, les réflexions, les questions, et les discussions ne tiennent aucunement compte de la réalité de ceux pour qui on a prévu l'accès. L'accès à la justice exige aussi qu'on entende le point de vue des gens invités à participer.

Une des conséquences les plus heureuses de l'adoption du principe de la primauté du droit a été d'assujettir les forts et les puissants au contrôle juridique. L'arrêt *Roncarelli* c. *Duplessis*[48] en est la preuve. Dans quelle mesure le principe de la primauté du droit assure la participation réelle des plus faibles aux enjeux du droit? En effet, étant donné qu'en vertu du principe de la primauté du droit, la règle de droit doit s'appliquer à tous, tous doivent se voir concernés par son application. Dans le contexte d'inégalité économique qui caractérise nos sociétés, présumer de l'égalité des chances et de l'absence de rapports inégalitaires de pouvoir contribue à accroître le caractère abstrait du droit. Cela signifie non pas que le constat d'inégalité doive faire écarter d'autres objectifs du système juridique : par exemple, on peut vouloir préserver la stabilité des contrats comme valeur et donc considérer l'annulation d'un contrat pour dol ou à cause de l'exploitation d'une partie par l'autre que dans des circonstances exceptionnelles. Il importe cependant qu'on évalue vraiment les avantages et les inconvénients ainsi que les conséquences des choix entre les valeurs. La juge L'Heureux-Dubé affirme d'ailleurs : «You have no justification to ask the cost of justice when you haven't figured out the cost of injustice.»[49]

Dans une société où le droit dit vrai, on doit se préoccuper de l'impact sur ceux et celles qui ont le moins de chances d'être entendus aussi bien par les systèmes politiques que par les systèmes judiciaires. Les exclus et les marginalisés se font mal entendre[50], et il faut donc que les décideurs fassent un effort pour bien reconnaître, par-delà des divers préjugés que nous entretenons, l'impact réel du droit sur leurs vies. Il ne peut y avoir de culture de justification démocratique si la justification ne sert qu'à donner raison à une classe sociale. Il ne s'agit pas de privilégier une rationalité plutôt qu'une autre mais d'être ouvert à l'expression et à la critique.

C'est encore une fois dans ses écrits et dans ses décisions que la juge L'Heureux-Dubé explique l'importance pour elle de mesurer l'impact du droit du point de vue des marginalisés. À mon avis, son approche favorise un discours égalitaire qui permet l'expression par les marginalisés de leurs expériences et de leurs besoins. Le discours égalitaire est donc non pas créé d'en haut par les tribunaux, mais permet à ceux et celles qui ont besoin de

parler en toute égalité de le faire[51]. Par exemple, dans sa dernière intervention concernant l'article 15 de la *Charte* canadienne, la juge déclarait : «L'examen d'une demande fondée sur l'art. 15 doit toujours être centré sur la partie demanderesse en l'instance et sur la façon dont une législation l'affecte»[52]. Elle insiste souvent sur la nécessité d'avoir une approche pratique qui donne des résultats : «Nous ne réglerons jamais complètement le problème de la discrimination et nous ne réussirons pas à la démasquer sous toutes ses formes si nous continuons d'insister sur des catégories abstraites et des généralisations plutôt que sur des effets précis.»[54]

Elle s'efforce donc de présenter l'impact réel des décisions, bien qu'elle soit consciente du peu qu'on peut savoir de l'autre :

> These cases [*Moge c. Moge*[54] et *R. c. Lavallée*[55]] and others like them, show that thinking about equality is more than just analyzing discrimination claims or interpreting human rights codes. Rather, its pursuit requires an understanding of the historical disadvantages experienced by members of some groups, an awareness of groups' differences and unique experiences, and a sensitivity to the fact that much of the law has been designed around and for those with power and privilege. It requires that in the analysis we undertake in nearly every area of law, we consider various perspectives, think about the experiences and realities of disadvantaged groups, and examine the assumptions on which our laws and jurisprudence are based[56].

Les auteurs s'accordent pour dire que cette capacité d'accueil à l'égard des exclus est une des caractéristiques de la philosophie de la juge. Comme le dit Mimi Liu, «Madam Justice L'Heureux-Dubé's personal philosophy focuses on seeing others' perspectives, acknowledging what is behind the legal doctrine and the immediate facts of the case, and understanding what's *really* going on»[57]. Diane Pask note aussi cet aspect de la philosophie de la juge : «*Moge* stands as an example of how different voices and different opinions can be heard and find expression at the highest levels of Canadian Family Law Jurisprudence.»[58]

Une fois la réalité captée, elle doit être reflétée. Il s'agit donc maintenant de décrire le travail de traduction que les juges doivent faire de même que la charge qui leur incombe d'expliquer la réalité auprès des intervenants et du grand public.

## B. Transmettre la réalité

Les juges disent le droit[59]. Ils disent aussi davantage : ils racontent les histoires des parties, résument leur position et leurs arguments, confrontent leur vision des faits ou du droit avec celle de l'autre partie. Ce processus de traduction et d'explication passe souvent inaperçu, mais il est capital. Non seulement les parties se voient à travers le filtre de la décision ou de l'intervention judiciaire, mais aussi le grand public les perçoit aussi à travers cette intervention.

Le processus justificatif est expression. Il y a transmission d'idées, de valeurs, mais aussi d'images et de perceptions des enjeux et des personnes. La compréhension des enjeux sociaux dépend souvent de leur caractérisation juridique, et même de la caractérisation qui en est faite par les juges. Il ne fait aucun doute que les juges expliquent les enjeux, les positions, voire les attitudes des parties l'une à l'égard de l'autre. Les juges expliquent aussi les enjeux pour le bénéfice du grand public.

Dans ce contexte de représentation et de retransmission de la réalité sociale, il y a des choix à faire. Il y a des voix qui sont peu présentes dans les discours juridiques, qui ont souvent été oubliées, ou mal entendues. Il est impossible que notre société continue de se développer si des efforts de compréhension et de rapprochement ne sont pas consentis. Un droit ne peut représenter la réalité s'il ne véhicule que l'expression des voix dominantes, s'il ne correspond qu'à une vision de la réalité. Que ce soit dans une perspective de justification auprès de la citoyenneté ou celle d'une actualisation des promesses du droit, la contribution des juges à l'évolution des rapports sociaux par la voie de la description de la réalité est significative. En effet, la justification et son acceptation ne se font que dans un contexte particulier. Ce n'est que parce que les voix des femmes se sont fait entendre que le discours juridique relatif à l'agression sexuelle a un peu changé. On ne pourrait parler de mariage de personnes de même sexe s'il n'y avait pas eu une démystification progressive de l'orientation sexuelle dans les médias comme dans le discours juridique.

La représentation par le judiciaire d'une réalité sociale fait partie du contexte dans lequel les rapports sociaux évoluent. Il ne suffit pas pour avoir une justice actualisée de disposer d'un droit formel explicite si la culture qui entoure l'expression formelle de ces droits en décourage l'exercice ou la personne qui cherche à s'en prévaloir[60]. Il est donc important pour les juges d'avoir égard non seulement au raisonnement qu'ils veulent élaborer, mais aussi à l'idée qu'ils se font de la réalité dans laquelle le droit se vit. Il leur faut

réfléchir à la logique de l'argumentation et aussi à la façon dont celle-ci contribue à accoître à notre compréhension des enjeux, des personnes, et des groupes concernés.

Je souligne ici cet aspect parce que je pense que la juge L'Heureux-Dubé s'est donnée pour rôle de faire état de préoccupations qui étaient absentes du débat. Ce qui explique ses dissidences fréquentes. Je pense que ce désir de défendre des intérêts absents s'est fait sentir, entre autres, dans deux domaines[61]. Il me semble que Claire L'Heureux-Dubé a souvent tenté d'expliquer aux hommes le point de vue des femmes qui travaillent ou qui veulent se protéger contre l'agression sexuelle. Elle a aussi tenté de présenter une image respectueuse des couples de même sexe qui vivent dans une société souvent homophobe.

1. La voix des femmes

*Pour les femmes, la vie professionnelle et la vie familiale ne sont pas si distinctes et, dans de nombreux cas, une telle distinction est tout à fait irréelle puisque la capacité même d'une femme d'entrer sur le marché du travail peut dépendre entièrement de sa capacité d'obtenir des services de garde.* La décision d'obtenir des services de garde d'enfants fait inextricablement partie de la décision de travailler, en affaires ou autrement [nos italiques][62].

Dans l'arrêt *Symes c. Canada*[63], la juge l'Heureux-Dubé a émis ces commentaires dissidents. C'est une décision lourde de conséquences puisqu'elle oppose la conception du travail pour les hommes et les femmes et fait ressortir les différences de traitement entre employés et travailleurs autonomes. Pour décrire brièvement l'affaire, Mme Symes, avocate et travailleuse autonome, demande de déduire comme dépense d'affaires ses frais de garde d'enfant. Les frais de garde sont des frais considérés comme personnels. Les employés et les travailleurs autonomes peuvent les déduire jusqu'à concurrence d'un montant déterminé. Ce maximum est souvent inférieur aux frais réels engagés surtout pour quelqu'un qui travaille plus que quarante ou cinquante heures par semaine ou dont le travail est irrégulier. La cause Symes a soulevé beaucoup de controverses même chez les féministes parce qu'elle met en opposition une analyse féministe et une certaine analyse des classes

sociales. En effet, la distinction entre employés et travailleurs autonomes qui n'était pas remise en cause dans l'affaire permet à certaines catégories de citoyens de maintenir leurs avantages économiques[64]. Mme Symes n'était donc pas, aux yeux de plusieurs, suffisamment marginalisée pour pouvoir bénéficier de la protection de l'article 15(1) de la *Charte* canadienne. Néanmoins—et c'est le point qui est soulevé par la juge L'Heureux-Dubé ainsi que par la juge McLachlin—l'analyse de la discrimination sur la base du sexe oblige à supprimer une distinction établie par le droit. La distinction entre les dépenses d'affaires et les dépenses personnelles résulte des usages et des contumes propres à un monde des affaires sexiste : pourquoi déduire les memberships aux clubs de golf et les dîners d'affaires et non les frais de gardienne? Il ne fait aucun doute qu'il y avait dans l'extension de la catégorie des dépenses d'affaires de grandes possibilités d'abus qui allaient devoir être empêchées en fixant des limites. Malgré tout, la dissidence de Mme L'Heureux-Dubé a servi à mettre en lumière à la fois le caractère déraisonnable de la distinction, ses limites au point de vue conceptuel quant au travail des femmes et la nécessité de lier au travail de ces dernières la question de l'accès à de services de garde. Depuis la décision *Symes*, le montant maximal de la déduction personnelle de frais de garde, applicable à tous les travailleurs, a été haussé.

Dans le domaine de rapports sexuels, la juge L'Heureux-Dubé a également fait preuve d'audace :

> La force de ces arguments est liée à la notion que les femmes consentent à avoir des rapports sexuels, selon des considérations accessoires comme l'endroit, la race, l'âge ou la profession du prétendu agresseur ou d'autres éléments comme la nature de l'acte sexuel. *Bien qu'il paraisse quelque peu bizarre de devoir énoncer explicitement cette proposition, le consentement se rattache à la personne et non à une circonstance.* L'utilisation des expressions "mode de comportement" ou "faits similaires" ne tient pas compte de cette réalité. Ces arguments se fondent implicitement sur la notion que les femmes, dans les circonstances appropriées, donneront leur consentement à quiconque et, plus fondamentalement, que les femmes de "moeurs faciles" auront une propension à consentir [nos italiques][65].

C'est, entre autres, dans ses dissidences célèbres dans l'arrêt *Seaboyer*[66] et dans ses opinions formulées dans les arrêts *O'Connor*[67] et *Ewanchuk*[68] que la juge L'Heureux-Dubé tentera d'expliquer parfois avec une certaine impatience, pourquoi la dénonciation de l'agression sexuelle doit respecter la dignité des femmes, respect qui comporte au moins deux principes fondamentaux, qui devraient paraître évidents :

- les femmes ne sont pas des objets sexuels mais des agentes de leur sexualité ;
- ce n'est pas parce qu'une femme a accepté d'avoir une relation sexuelle avec une personne qu'elle est plus susceptible d'accepter d'avoir des relations sexuelles avec une autre.

L'établissement d'une éthique de l'égalité dans le contexte des rapports sexuels hétérosexuels dans un monde inégalitaire continue de susciter des questions complexes. C'est un terrain de contestation jonché de victimes et de conflits : d'un côté, l'égalité et la dignité des femmes et de l'autre, une criminalisation des hommes provenant souvent des classes pauvres ou marginalisées. À long terme, c'est la transformation des opinions et des mœurs qu'il faut viser pour venir à bout de la violence sexuelle et du harcèlement. Les textes, opinions, dissidences, et articles de la juge L'Heureux-Dubé auront contribué à cette transformation.

2. La voix des couples gais et des couples de lesbiennes

Dès les premières affaires traitant de discrimination sur la base de l'orientation sexuelle, la juge L'Heureux-Dubé a montré l'impact de la discrimination à l'égard des couples de même sexe :

> Bien que tous ne structurent pas leurs relations familiales de la même façon, il existe de toute évidence des problèmes communs. À l'heure actuelle, les familles de toutes sortes sont en proie à des pressions souvent accablantes. Vu les changements dans l'économie, la plupart des familles estiment avoir besoin du salaire de deux travailleurs adultes. Par ailleurs, la famille doit souvent prodiguer des soins aux enfants, aux personnes âgées et aux malades, sans vraiment recevoir d'aide de l'ensemble de la collectivité. *Bien que ces problèmes soient communs à tous les types de famille, ils sont exacerbés dans les familles dont le*

*caractère légitime est mis en doute. Étant donné ces pressions et responsabilités, il semblerait être dans l'intérêt de la société d'améliorer les conditions pour permettre aux familles de fonctionner le mieux possible, sans être victimes de discrimination* [nos italiques][69].

On peut être en faveur de la famille sans rejeter pour autant les types de familles moins traditionnels. Ce n'est pas attaquer la famille que d'appuyer la protection des familles non traditionnelles[70].

La «normalisation»[71] de la famille gaie ou lesbienne ne se fera pas sans heurts[72], mais on peut considérer que les opinions de la juge L'Heureux-Dubé énoncées dès les premières heures témoignent d'un respect de la dignité qui se retrouvera dans plusieurs décisions ultérieures de la Cour suprême et des tribunaux inférieurs[73].

Je cite ces exemples bien connus pour montrer que la démarche judiciaire ne se borne pas à décider qui gagne et à justifier cette décision. Souvent, on est forcé de reconnaître que l'impact d'une décision judiciaire est minime sans que d'autres forces viennent l'appuyer. Il est rarement suffisant d'obtenir gain de cause dans le cadre d'une bataille judiciaire pour modifier des rapports sociaux discriminatoires. Les tribunaux peuvent modifier les rapports de forces entre les parties en captivant l'imagination des lecteurs. Le langage utilisé par la juge L'Heureux-Dubé transcende très souvent la décision judiciaire et force les lecteurs à reconnaître une réalité peut-être différente de la leur. On sous-estime souvent l'impact de la représentation ainsi faite. Les juges sont évidemment cités par d'autres juges, mais de plus en plus leurs idées sont reprises ailleurs. Leur action sert à la justification et à la diffusion des valeurs juridiques dans la société. La description éloquente de la réalité vécue par les autres est une des contributions de la juge L'Heureux-Dubé.

### Conclusion : Réfléchir la réalité

J'ai mis en évidence dans ce chapitre certains aspects méthodologiques des décisions de la juge L'Heureux-Dubé : son intérêt pour les acquisitions des sciences sociales ainsi que la place faite à la réalité des exclus (capter la réalité). J'ai aussi tenté de donner des exemples d'une langue judiciaire qui vise la

justification à l'égard de tous et qui participe d'un processus explicatif entre différents groupes sociaux (transmettre la réalité). En guise de conclusion, je veux donner un certain nombre d'exemples de l'expansion du raisonnement juridique en regard de la critique égalitaire. En effet, on peut imaginer qu'un juge veuille entendre les exclus, qu'elle s'attache à expliquer leur réalité et qu'elle conclut malgré tout que cette réalité n'est pas pertinente pour les fins de la décision judiciaire. Ce ne sera pas le cas de la juge l'Heureux-Dubé.

La juge a su donner plus de force aux arguments égalitaires. Tout d'abord, elle a attribué plus de place à la critique et elle l'a proposé comme une dimension fondamentale de la justification constitutionnelle.

En effet, alors que la question de l'égalité était évacuée, la juge l'Heureux-Dubé l'a remise à l'ordre du jour[74] :

> Les droits garantis par l'art. 7 doivent être interprétés à travers le prisme des art. 15 et 28 afin que l'importance d'une interprétation de la Constitution qui tienne compte des réalités et des besoins de tous les membres de la société soit reconnue.

Lorsque les discours égalitaires étaient minimisés, elle les réexpliquait avec force analogies et exemples[75]. Sa contribution au développement de l'argumentation égalitaire et ses efforts pour briser le carcan où cette argumentation était enfermée continuent d'être salués.

Claire L'Heureux-Dubé a répondu aux critiques égalitaires en leur faisant une place dans le discours juridique. Elle a probablement contribué à faire du prisme égalitaire une mesure tout aussi fondamentale pour notre droit que la liberté. Il ne s'agit pas d'avoir une égalité sans liberté, mais la liberté sans l'égalité est tout aussi opprimante, surtout pour les plus vulnérables dans la société. Parce qu'elle a fait entrer la question de l'égalité dans notre discours juridique, elle s'est placée au centre des grands débats de notre société. Une société démocratique qui se veut délibérative doit avoir un droit qui, à tout le moins, soulève tous les enjeux. Claire L'Heureux-Dubé a participé à la prise de conscience de nos sociétés face à l'égalité.

Une société de droit ne peut se contenter d'un renvoi rhétorique aux droits enchâssés. Elle ne peut tolérer que le droit écrit dise une chose et que la réalité en dise une autre, que le droit justifie les actions des riches et non celles des pauvres, celles des hommes, et non celles des femmes ou que des groupes

de citoyens soient entièrement exclus du processus de délibération. Dans ce chapitre, j'ai considéré certains aspects du principe de la primauté du droit et tenté de les appliquer aux écrits de la juge L'Heureux-Dubé.

Entre autres, j'ai voulu démontrer comment la justification rationnelle du principe de la primauté du droit débouche sur le recours aux acquisitions des sciences sociales et aux efforts pour donner une voix aux exclus du système juridique qui sont des caractéristiques de la jurisprudence de la juge L'Heureux-Dubé. Mon argumentation visait à établir qu'en réfléchissant bien les enjeux de son époque, plutôt qu'en les ignorant, la juge a aidé à renforcer le principe de justification.

J'ai aussi voulu montrer que le principe de la primauté du droit vise à mettre en oeuvre les promesses du droit et qu'encore une fois la critique égalitaire ne peut être laissée de côté. Si la primauté du droit suppose la concrétisation des promesses du droit pour tous les citoyens, il faut continuer de valoriser les personnes qui s'efforcent de réaliser ces dernières. On peut être en désaccord sur l'efficacité du passage par le judiciaire pour faire admettre les valeurs constitutionnelles, ou même sur la façon dont les conflits entre ces valeurs sont résolus, mais on ne doit pas minimiser les efforts déployés pour traduire concrètement les promesses du droit. Tous les citoyens devraient avoir confiance dans leur système de justice et dans sa capacité de résoudre les difficultés qui surgissent. Ils ne devraient pas simplement conclure que la justice est affaire de chance[76]. Réfléchir son époque : la représenter et bien la penser, c'est la fonction des juges et des juristes. Nous devons honorer cette fonction ainsi que ceux et celles qui s'en acquittent avec sagesse et courage. Les juges doivent s'assurer que la primauté du droit signifie quelque chose pour les plus démunis et les marginalisés. La véritable primauté du droit n'est pas dans l'abstraction des problèmes contemporains, mais bien dans sa résonance pour leur résolution justifiée, juste et équitable. Je pense que c'était un peu cette vision que l'honorable Claire L'Heureux-Dubé voulait véhiculer. On doit l'en remercier.

### Endnotes

* Une première version de ce texte a été livrée à Toronto, le 6 mai 2002 dans le cadre d'un symposium sur la contribution de la juge L'Heureux-Dubé. J'ai beaucoup bénéficié des commentaires faits dans le cadre de ce colloque. Je

remercie les organisatrices de m'y avoir invitée. Je voudrais aussi remercier les professeurs Louise Langevin et Roderick A. Macdonald pour leurs commentaires sur le texte et Mme Audrey Boctor pour ses commentaires et son aide dans la recherche pour cet article. Les propos tenus ici n'engagent pas la Commission du droit du Canada. Ils sont le fruit d'une réflexion personnelle.

1 André Langevin, dans G. Forest, *Dictionnaire des citations québécoises*, Montréal, Québec-Amérique, 1994.

2 Le juge McIntyre, dans l'arrêt *Andrews c. Law Society of British Columbia*, [1989] 1 R.C.S. 143 à la p. 171, cité par la juge l'Heureux-Dubé dans *Egan c. Canada*, [1995] 2 R.C.S. 513 à la p. 543. C'est la juge L'Heureux-Dubé qui souligne.

3 Voir, entre autres, Mimi Liu, «A "Prophet With Honour": An Examination of the Gender Equality Jurisprudence of Madam Justice Claire L'Heureux-Dubé of the Supreme Court of Canada» (2000) 25 Queen's L.J. 417.

4 C'est vraiment minimiser son œuvre que ne pas mentionner les transformations qu'elle a amenées, entre autres, en droit administratif et dans la définition des concepts d'imputabilité, de justification et d'équité élaborés dans la décision *Baker c. Canada (Ministre de la Citoyenneté et de l'Immigration)*, [1999] 2 R.C.S. 817.

5 J'utilise l'expression «l'interpellation de la critique égalitaire» pour désigner ce que je considère comme une prise au considération des arguments des groupes qui décelaient un traitement discriminatoire ou inéquitable dans certaines décisions.

6 Plusieurs symposiums ont été organisés en 2002 et 2003 à l'occasion de la retraite de la juge L'Heureux-Dubé. J'ai participé à plusieurs, et les idées présentées ici ont été inspirées des interventions faites par d'autres. Je remercie entre autres les professeures Michelle Boivin et Louise Langevin pour leurs commentaires sur la méthodologie féministe dans le cadre des décisions de la juge L'Heureux-Dubé.

7 Je préfère l'expression «primauté du droit» pour traduire «*rule of law*», plutôt que d'utiliser la traduction littérale «règle de droit» employée dans certaines décisions plus anciennes de la Cour suprême du Canada (voir *Renvoi relatif à la modification de la Constitution du Canada*, [1981]1 R.C.S 753 à la p. 805).

8 *Renvoi relatif à la modification de la Constitution du Canada*, ibid. à la p. 805. La version anglaise est plus explicite : «the rule of law is a highly textured expression.»

9 «La "règle de droit" est une expression haute en couleur qui, sans qu'il soit nécessaire d'en examiner ici les nombreuses implications, communique par exemple un sens de l'ordre, de la sujétion aux règles juridiques connues et de la responsabilité de l'exécutif devant l'autorité légale», dit la Cour suprême dans

*Renvoi relatif à la modification de la Constitution, supra* note 7. Depuis, *Renvoi : Droits linguistiques au Manitoba*, [1985] 1 R.C.S. 721, a approfondi cette notion tout comme *Renvoi relatif à la sécession du Quebec*, [1998] 2 R.C.S. 217; voir aussi *Renvoi relatif à la rémunération des juges de la Cour provinciale de l'I.-P.-E.; Renvoi relatif à l'indépendance et à l'impartialité des juges de la Cour provinciale de l'I.-P.-E.*, [1997] 3 R.C.S. 3. J. Magnet, *Constitutional Law of Canada*, 8e éd., Edmonton, Jurliber, 2001, c. 4 décrit les différentes conceptions et expressions jurisprudentielles canadiennes du principe de la primauté du droit. Voir aussi l'article de Douglas Simsovic, «No Fixed Address: Universality and the Rule of Law» (2001) 35 R.J.T. 739 au para. 46, qui présente le principe de la primauté du droit comme une théorie politique qui implique au minimum la centralité de l'individu et son désir d'être protégé des abus du gouvernement. À mon avis, les nouvelles conceptions de la primauté du droit, et certainement celle de la juge L'Heureux-Dubé, sont moins réservées.

10 H.W. Arndt, «The Origins of Dicey's Concept of the Rule of Law» (1957) 31 Austl. L.J. 117.

11 La démonstration la plus célèbre du principe de la primauté du droit au Canada a été l'affaire *Roncarelli* c. *Duplessis*, [1959] R.C.S. 121, où le premier ministre de la province de Quebec a été assujetti en vertu de ce principe au droit de la responsabilité extra-contractuelle pour abus de pouvoir. Dans *Renvoi concernant la modification de la constitution, supra* note 7, la Cour se réfère à cette affaire. Voir aussi James A. Hodgson, «What Is the Rule of Law» *The Advocates Brief* 8 : 5 (décembre 1996) 1.

12 *Renvoi : Droits linguistiques au Manitoba*, [1985] 1 R.C.S. 721.

13 L.L. Fuller, *The Morality of Law*, New Haven, Yale University Press, 1969. *The Morality of Law* a été abondamment discuté depuis sa publication. Citons simplement J. Raz, *The Authority of Law : Essays on Law and Morality*, Oxford, Oxford University Press, 1979 et une mise en application moderne des principes de Fuller, R.A. Macdonald, «La législation, science normative» dans *La législation en question : Mémoires du concours Perspectives juridiques 1999*, en ligne : la Commission du droit du Canada www.lcc.gc.ca/fr/opportunity/contracts/research/ldi1999.asp.

14 Voir aussi la liste des deuze principes plutôt formalistes décrits par G. Walker, *The Rule of Law : Foundation of a Constitutional Democracy*, Carlton, Australia, Melbourne University Press, 1988 aux pp. 23–42, cité par l'honorable Beverley McLachlin, «Rules and Discretion in the Governance of Canada» (1992) 56 Sask. L. Rev. 167.

15 D. Dysenhaus, «Form and Substance in the Rule of Law: A Democratic Justification for Judicial Review?» dans C. Forsyth, dir., *Judicial Review and the*

*Constitution*, Oxford, Hart Publishing, 2000 à la p. 141.

16 T.R.S. Allan, *Constitutional Justice: A Liberal Theory of the Rule of Law*, Oxford, Oxford University Press, 2001. Voir les commentaires de Mark D. Walters, «Common Law, Reason, and Sovereign Will» (2003) 53 Univ. of Toronto L.J. 65, et la critique de F.C. DeCoste, «Redeeming the Rule of Law» (2002) 39 Alta. L. Rev. 1004.

17 Luc B. Tremblay, *The Rule of Law, Justice, and Interpretation*, Montréal, McGill-Queen's University Press, 1997.

18 D. Dyzenhaus, «Constituting the Rule of Law: Fundamental Values in Administrative Law» (2002) 27 Queen's L.J. 445 au para. 120.

19 B. McLachlin, «The Roles of Administrative Tribunals and Courts in Maintaining the Rule of Law» (1999) 12 C.J.A.L.P. 171.

20 Jeremy Webber, «The Rule of Law Reconceived» dans K. Kulcsar et D. Szabo, dir., *Dual Images: Multiculturalism on Two Sides of the Atlantic*, Budapest, Royal Society of Canada and Hungarian Academy of Sciences, 1996.

21 Patricia Hughes estime que le concept substantif d'égalité est un principe inhérent à notre arrangement constitutionnel. Voir Patricia Hughes, «Recognizing Substantive Equality as a Foundational Constitutional Principle» (1999) 22 Dal. L.J. 5. Allan, *supra* note 16, qui affirme que les distinctions entre personnes et groupes doivent respecter le principe de l'*equal citizenship* (que je traduis par la citoyenneté égalitaire), les distinctions doivent être compatibles avec la dignité et l'autonomie morale des individus. Walters, *supra* note 16, est d'avis que la conception de l'égalité exprimée par Allan est beaucoup plus étroite que celle qui est admise par le droit canadien. La citoyenneté égalitaire d'Allan serait moins «substantive» que procédurale aux yeux de Waters; voir à ce sujet les commentaires à la note 84.

22 Voir *Terre-Neuve (Procureur général) c. N.A.P.E.*, [1988] 2 R.C.S. 204, où la Cour suprême statue que l'accès physique aux tribunaux est inclus dans le principe de la primauté du droit.

23 Voir les travaux de Luc Tremblay, «La démocratie délibérative et la protection des intérêts fondamentaux» dans André Duhamel, Daniel Weinstock, et Luc Tremblay, dir., *La démocratie délibérative en philosophie et en droit : enjeux et perspectives*, Montréal, Thémis, 2001, en particulier, p. 172 et sq., où le professeur Tremblay explique la nécessité du pedigree démocratique des raisons juridiques qui justifient la décision judiciaire.

24 J'emploie ici le terme «actualiser» dans son premier sens, celui de «passer de la puissance à l'acte». Il est symptomatique de mon propos que le deuxième sens du mot actualiser est «donner un caractère d'actualité, c'est-à-dire moderniser» [Josette Rey-Deboue et Alain Rey, dir., *Le Petit Robert : dictionnaire de la langue*

*française*, Paris, Dictionnaires Le Robert, 1996.].
25 *Edwards c. Canada (A.G.)*, [1930] A.C. 124 (P.C.). Voir aussi D. Bright, «The Other Woman: Lizzie Cyr and the Origins of the "Persons Case"» (1998) 13 : 2 Can. J. L. & Soc. 99; K. Lahey, «Legal "Persons" and the *Charter of Rights*: Gender, Race and Sexuality in Canada» (1998) 77 Can. Bar Rev. 402; C. L'Heureux-Dubé, «The Legacy of the "Persons Case": Cultivating the Living Tree's Equality Leaves» (2000) 63 Sask. L. Rev. 389–401.
26 La liste de ces rapports est tirée des travaux de la Commission du droit du Canada (voir la description en ligne : www.cdc.gc.ca consulté le 15 juin 2003). Je pense qu'elle rend bien compte de l'aspect dynamique et concret dans lequel le droit se vit. Voir aussi pour une description de ce point de vue sur le rôle du droit dans la société R.A. Macdonald, «Law Reform and Its Agencies» (2000) 79 Rev. Barreau Canadien 99; Nathalie Des Rosiers, «Réformer ou repenser le droit? L'expérience canadienne de la réforme du droit» (2 août 2003), en ligne : www. lcc.gc.ca/fr/pc/speeches/20000629.asp.
27 On peut penser que, dans une société où la déférence est en déclin, l'impératif de justification acquiert plus d'importance; voir Neil Nevitte, *The Decline of Deference: Canadian Value Change in Cross-National Perspective*, Toronto, Broadview Press, 1996. Pour une discussion du rapport du juge au justiciable dans un contexte de transformation de la relation à l'autorité, voir N. Des Rosiers, «Les tribunaux dans une démocratie délibérante : savoir poser les bonnes questions» (2 août 2003), en ligne : www.lcc.gc.ca/fr/pc/speeches/20010424.asp.
28 Voir Allan, *supra* note 16; Dysenhaus, *supra* note 15; Tremblay, *supra* note 17; et l'honorable McLachlin, *supra* note 19.
29 Voir Robert Martin, «Our Judges Are Enemies of Judicial Independence» *The Lawyers Weekly* 13 : 35 (28 January 1994), où la juge L'Heureux-Dubé est décrite comme un magistrat «who has abandoned any notion of being constrained by the law».
30 *Le Petit Robert*, *supra* note 24, ne donne pas de féminin au mot transmetteur, «technicien travaillant dans les services de transmissions». Je me suis permise de le féminiser.
31 (1994) 26 : 3 Ottawa L.R. 551 aux pp. 561–62 [«Judicial Notice»]. Voir aussi C. L'Heureux-Dubé, «Equality and the Economic Consequences of Spousal Support: A Canadian Perspective» (1995) 7 U. Fla. J.L. & Pub. Pol'y 1; C. L'Heureux-Dubé, «Economic Consequences of Divorce: A View From Canada» (1994) 31 Hous. L. Rev. 451; C. L'Heureux-Dubé, «Making Equality Work in Family Law» (1997) 14 Can. J. Fam. L. 103.
32 «*Judicial Notice*», *supra* note 31 aux pp. 561–62.
33 *Ibid.* à la p. 564.

34 *Supra* à la p. 576.
35 La profeseur Danielle Pinard a beaucoup réfléchi à cette question; voir D. Pinard, «La preuve des faits sociaux et les *brandeis briefs* : quelques réserves» (1996) 26 R.D.U.S. 497; D. Pinard, «La notion traditionnelle de connaissance d'office des faits» (1997) 31 R.J.T. 87; D. Pinard, «La connaissance d'office des faits sociaux en contexte constitutionnel» (1997) 31 R.J.T. 315.
36 Edward S. Robinson, *Law and Lawyers*, New York, Macmillan, 1935.
37 Voir tout le mouvement de l'approche thérapeutique du droit qui tente de dégager les prémisses psychologiques de certaines notions juridiques (David Wexler et Bruce Winick, «Introduction», dans *Law in a Therapeutic Key*, Durham, Carolina Academic Press, 1996 à la p. xvii); concernant l'approche économique du droit, voir Posner, *The Economic Analysis of Law*, 4e éd., Boston, Little Brown, 1992, qui en examine les fondements économiques.
38 Tous les organismes canadiens de réforme du droit ont comme mission de moderniser le droit. On reconnaît qu'il s'agit non seulement de mettre à jour les législations pertinentes mais aussi de repenser, dans certains cas, le rôle du droit, de formuler de nouveaux concepts de droit, et d'engager tous les acteurs à poursuivre leur réflexion. Voir R.A. Macdonald, *supra* note 26; Nathalie Des Rosiers, *supra* note 26.
39 «*Judicial Notice*», *supra* note 31 à la p. 566.
40 *Supra* à la p. 564.
41 Fuller, *supra* note 13.
42 Dans ce cadre, je trouve très utiles les distinctions que le professeur Tremblay fait entre la théorie du fondement rationnel et celle du fondement légitime. Voir Luc B. Tremblay, «La justifications des restrictions aux droits constitutionnels : la théorie du fondement rationnel» (1999) 44 McGill L.J. 39–110.
43 M. Matsuda, «When the First Quail Calls: Multiple Consciousness as Jurisprudential Method» (1992) 14 Wom. Rts. L. Rep. 297 à la p. 299, cité dans C. L'Heureux-Dubé, «Conversations on Equality» (1999) 26 Man. L.J. 273 à la p. 294. (L'exergue est tiré de «Conversations on Equality»).
44 *Supra* note 22.
45 *Ibid*.
46 Pour une discussion de l'extension du droit constitutionnel à l'aide juridique prônée par la juge L'Heureux-Dubé, voir *Nouveau-Brunswick (Ministre de la Santé et des Services communautaires) c. G. (J.)*, [1999] 3 R.C.S. 46.
47 La complexité de la question de l'accès à la justice est bien cernée par R.A. Macdonald, *Community Based Legal Services in the Third Millennium—Diagnosis and Prognosis,* à paraître.
48 *Supra* note 11.
49 *Lawyers Weekly* 16 : 07 (21 juin 1996).

50 Voir à ce sujet l'excellent chapitre de John Gibbons : «Language and Disadvantage before the Law» dans J. Gibbons dir., *Language and the Law*, London, Longman, 1994.

51 La juge L'Heureux-Dubé tempère un peu ce point de vue en supposant une personne raisonnable dans les circonstances de la demanderesse (voir la dissidence dans *Egan c. Canada*, [1995] 2 R.C.S. 513 [*Egan*]).

52 *Gosselin c. Quebec (Procureur général)*, 2003, C.S.C., par. 103.

53 *Egan*, supra note 51.

54 *Moge c. Moge*, [1992] 3 R.C.S. 813.

55 *R. c. Lavallee*, [1990] 1 R.C.S. 852.

56 C. L'Heureux-Dubé, «Conversations on Equality» supra note 43.

57 Liu, supra note 3, aux pp. 429–30. C'est l'auteure qui souligne.

58 E.D. Pask, «Canadian Family Law and Social Policy: A New Generation» (1994) 31 Hous. L. Rev. 499 à la p. 504, cité dans Mimi Liu, «A "Prophet With Honour": An Examination of the Gender Equality Jurisprudence of Madam Justice Claire L'Heureux-Dubé of the Supreme Court of Canada» (2000) 25 Queen's L.J. 417 à la p. 462.

59 Même ceux qui s'opposent au supposé activisme des juges doivent reconnaître qu'en appliquant le droit, les juges doivent l'appliquer. C'est dans ce sens que l'expression «dire le droit» doit être entendue ici.

60 Kent Roach explique très bien ce point de vue : «One of the greatest dangers of judicial review may be the idea that we can rely on the courts to protect rights. In a democracy […] you always need more than the Court on your side» (*The Supreme Court on Trial: Judicial Activism or Democratic Dialogue*, Toronto, Irwin Law, 2001 à la p. 9).

61 On pourrait aussi mentionner ses interventions en faveur des personnes souffrant de handicaps : en mettant l'accent sur la dignité humaine, le respect et le droit à l'égalité, plutôt que sur la condition biomédicale tout court, cette approche reconnaît que l'opinion publique influe sur la perception d'un «handicap». *Ainsi, une personne peut n'avoir d'autre limitation dans la vie courante que celles qui sont crées par les prejuges et les stéréotypes.* Voir *Quebec (Commission des droits de la personne et des droits de la jeunesse) c. Montréal (Ville); Quebec (Commission des droits de la personne et des droits de la jeunesse) v. Boisbriand (Ville)*, [2000] 1 R.C.S. 665.

62 *Symes c. Canada*, [1993] 4 R.C.S. 695 à la p. 800.

63 *Supra* note 62.

64 Les travailleurs autonomes ne sont pas tous riches cependant; voir Judy Fudge, Eric Tucker, et Leah Vosko, *Le concept légal de l'emploi : la marginalisation des travailleurs*, étude pour le compte de la Commission du droit du Canada, 2002.

65 *R. c. Seaboyer; R. c. Gayme*, [1991] 2 R.C.S. 577 aux pp. 685–86.
66 *Supra* note 65.
67 [1995] 4 R.C.S. 411.
68 *R. c. Ewanchuk*, [1999] 1 R.C.S. 330.
69 [1993] 1 R.C.S. 554.
70 *Ibid.*; voir aussi *Egan, supra* note 51.
71 Je donne ici au terme de normalisation le sens d'«acceptation générale» par la société.
72 Au moment d'écrire ce texte (été 2003), la question du mariage des couples de même sexe fait la une des journaux au Canada. Pour une description complète des hauts et des bas des tentatives de la part des groupes représentant les gais et lesbiennes de porter devant les tribunaux la discrimination à leur endroit voir le site de EGALE, www.egale.ca/.
73 Voir, entre autres, *Halpern c. Canada* (2003), 65 O.R. 161 (C.A.).
74 *Nouveau-Brunswick (Ministre de la santé et des services communautaires) c. G. (J.)*, [1999] 3 R.C.S. 46; [1999] 3 S.C.R . 46. Voir aussi sa dissidence dans *M.A. c. Ryan*, [1997] 1 R.C.S. 157.
75 *Egan, supra* note 51.
76 Voir la pensée du romancier André Langevin au début du texte.

Eight

## Backlash and the Feminist Judge: The Work of Justice Claire L'Heureux-Dubé

HESTER LESSARD*

In thinking about the path marked out by Justice Claire L'Heureux-Dubé, I found myself drawn to the dramatic points of challenge and resistance that have marked her judicial career. These flashpoints seem emblematic of the larger phenomenon of political backlash against the project of social justice and all things even faintly feminist that has taken over the public mood. The swirl of controversy that erupted in the wake of Justice L'Heureux-Dubé's decision in *R. v. Ewanchuk*,[1] for example, reveals how severe the costs can be for those who seek to open up the spaces of legal discourse to women's lives. In *Ewanchuk*, a case dealing with a criminal prosecution for sexual assault, Justice L'Heureux-Dubé's concurring reasons drew attention to the sexist stereotypes that have shaped the law of sexual assault.[2] In particular, she pointed to the imagery of the wily deceitful seductress and the earnest befuddled romantic male that underpinned, she argued, Justice McClung's conclusion at the Alberta Court of Appeal that the accused in the case had innocently mistaken resistance for consent to sexual advances or, to put it more bluntly, had mistaken "no" said three times over for "yes." Justice McClung reacted to the Supreme Court of Canada's unanimous overturning of his decision by lambasting in the press, not the majority reasons, but Justice L'Heureux-Dubé's concurrence, suggesting that she had misused her position on the Supreme Court of Canada to advance her personal and political agen-

da as a feminist.³ Justice L'Heureux-Dubé, was ultimately vindicated but only after being subjected to a long and invasive investigation by both the media and the Canadian Judicial Council.⁴

The *R. v. Ewanchuk* debacle gives us a powerful graphic: feminist brilliance and courage thrown into sharp relief by patriarchal curmudgeonry. However, I want to trouble that picture for a moment because, like any tale of backlash, it both distorts and obscures the radical nature of Justice L'Heureux-Dubé's trajectory as a judge.⁵ Let me start by urging that we think of backlash as a construct rather than as a force let loose when pent-up rage reaches its tipping point, or as the dictionary would have it, a "violent, usually hostile reaction" or "sudden recoil."⁶ In our mental mapping of the way the world works, the image of a mechanical chain of response and reaction places backlash in the same list of natural catastrophes as tidal waves and avalanches. I would ask that we resist the term's metaphoric power for a moment and, instead, examine backlash as a narrative structure that organizes our understanding of law and social change in a particular way.

In thinking about how the backlash construct shapes the world by shaping the story, I recalled some lessons I had learned in a long ago, earlier life as a painter. I remembered discovering, as I struggled to capture the effervescence of light in paint, that the middle zone or half-light—the place where figures and shapes curve very gently into shadow—is the place of depth, texture, and pure vibrating colour. I learned that the eye is drawn to points of high contrast but that those points succeed because of the movement, depth, and richness contained in the less visibly arresting middle zone. It seemed to me at the time that as viewers, if we register that middle zone complexity and richness at all, it is usually unconsciously. Out of this came an important practice or technique, not just for painters but for observers of the world. The practice entails moving your eye away from the point of contrast and cultivating an awareness of the otherwise overlooked territories of deep colour and textural improvisation that lie partially submerged in shadow.

Backlash, in configuring politics as patterns of pressure, change, and violent recoil, captures on a visceral level what feminists experience as the unexpected and disproportionate vehemence of conservative resistance in the face of modest demands. As well, backlash in feminist critical analysis has come to function as useful shorthand for the pattern of inversions that characterizes conservative backlash discourse, namely, the portrayal of powerful

social groups as victims and of marginalized groups as demonic and powerful oppressors.[7] However, as in painting, the focus on ambush and contest can sometimes work to hide and even misrepresent the complexities of social and historical change.

The *Ewanchuk* furor is a particularly good example of this phenomenon, of how backlash trope becomes sleight of hand. Indeed, the tale of *Ewanchuk* and the clamour around Justice McClung's tirade has unusual power and attraction because the story it tells is a relatively rare instance of the feminist seeming to get the last word. After all, Justice L'Heureux-Dubé emerged from the skirmish as the victor. The Canadian Judicial Council found she had done nothing more than use "strong words" to make her point. It was Justice McClung who, in the end, was described as biased and reprimanded for his injudicious resort to the media to attack Justice L'Heureux-Dubé's analysis of his reasons.[8] But even here the backlash narrative of victor and vanquished allowed Justice McClung to define the key issue, to indirectly shape the character of the opposing side, and to shunt aside the complexities of context in favour of a simplified cartoon of feminist excess, conservative curmudgeons, and the rational, objective, liberal middle ground. Indeed, in the rush to restore the liberal middle ground and to locate Justice L'Heureux-Dubé within its safe perimeter, the radical quality both of Justice McClung's surprise at being called biased and, of course, of Justice L'Heureux-Dubé's courage in speaking out rather than simply signing the majority's less disruptive reasons, is too hastily smoothed over.[9]

This is not to suggest that Justice McClung was justified in lashing out as he did. However, his outburst landed all of us, not just himself, on the lurching terrain of a crisis over the concept of reason and objectivity in a heterogeneous, culturally complex, socially diverse political community rather than on the expected firm ground of the orthodoxies of judicial common sense. It is that lurching terrain that occupies the middle zone, that threatens to fade into quiet invisibility as we tend to the astonishing histrionics of Justice McClung's outpourings. In short, Justice L'Heureux-Dubé's willingness to explore the conceptual and institutional foundations of judicial review tends to get bracketed, minimized, or overlooked in the backlash story.

To counter that momentum, I propose to pull into the foreground the radical quality of Justice L'Heureux-Dubé's work as a judge, in particular, two interconnected facets. The first is her theorizing with respect to the work of

judging itself. Here she exhibits a keen awareness of the ties between social justice and the practices and norms of judging. The second is the manner in which the substantive content of her judgments repeatedly impels us to question the orthodoxies of the public/private split. Finally, I think these two threads in her work—the close attention to both the methodological and the substantive requirements of realizing social justice—are intertwined; they nourish each other and, in some sense, one is not possible without the other.

### Feminism, Concealed Premises, and the Art of Judging

A number of feminists, in the wake of critiques of feminism's first and second waves, have cautioned that we should resist and reject demands to present feminism as a theoretical unity, that grounding for female agency and feminist politics should not be sought in "an homogenous psychology of identity alone ... but through a politics of organization and strategy which takes into account the myriad differences and loyalties that criss cross women's lives with conflicting passions."[10] That injunction, to reject a unified conceptual ground for action and instead simply to act through and in response to concrete social, historical, and cultural differences, places the feminist judge in a seemingly impossible position given the habits and customs of judicial practice. Judges ply their craft within a set of rigid institutional and ideological constraints that demand a separation of law and politics and a commitment to reason, or rather Reason, understood as a universal, unified, and fundamental norm of rationality.[11] Justice L'Heureux-Dubé's work as a judge addresses directly these constraints. Reason confronts diversity in her work and is reconceived as "reasons," namely "an open minded, carefully considered, and dispassionately deliberate investigation of the complicated reality of each case ... ."[12] Justice L'Heureux-Dubé explicitly linked her conception of the normative basis of judging to the pluralist nature of Canadian society in *2747-3174 Quebec Inc. v. Quebec (Régie des permis d'alcools)*:

> [I]n light of the evolution of our law following the passage of the charters and given the growing recognition that there are many different perspectives—the aboriginal perspective, for example—I believe that the era of concealed underlying premises is now over. In my view, those premises must be brought to the

surface in order to promote consistency in our law and the integrity of our judicial system ... .[13]

The recognition of a plurality of perspectives in the name of consistency and integrity, values that traditionally have been invoked to discount difference in favour of a unified objective truth, reflects an awareness that judges, perhaps more than other actors in the arenas of liberal legalism, are poised at the point where epistemology becomes politics, where the criteria for what counts as reasoned and impartial adjudication determines the texture and meaning of membership in the political community. Justice L'Heureux-Dubé's work is distinctive in its awareness of this folding together, within the task of adjudication, of knowledge and power. Perhaps nowhere is this more evident than in her concurring reasons with Chief Justice McLachlin in *R. v. R.D.S.*[14]

*R. v. R.D.S.* concerned the acquittal at trial of a young African Canadian on two counts of assaulting a police officer and one count of resisting an officer in the lawful execution of his duty. The central issue on appeal was whether the trial judge, Judge Corrine Sparks, at the time the only African Canadian female judge in Canada, displayed bias during the trial proceedings. The charge of bias rested on the fact that Judge Sparks explicitly incorporated her knowledge of the highly racialized nature of local relations between police and the African Canadian community into her assessment of conflicting testimony from a white police officer and the accused. The concurring reasons signed by Justice L'Heureux Dubé and Chief Justice Beverly McLachlin vindicated Judge Sparks's handling of the evidence and asserted the propriety of Judge Sparks's reliance on her personal knowledge of race relations in the local community.

Together with the Chief Justice, Justice L'Heureux-Dubé outlined an approach to judging that concedes the multiplicity of common senses in a socially complex society and asserts the impossibility of judicial neutrality while preserving a reconceived notion of judicial impartiality. As they put it, "judges in a bilingual, multiracial, and multicultural society will undoubtedly approach the task of judging from their varied perspectives."[15] They went on to insist that reasonableness should be elaborated not simply in relation to the Canadian community, a construct that presumes a unified homogenous view of reason, but in relation to myriad local communities.

The extended nature of the debate over Judge Sparks's impartiality—through several levels of appeal and in multiple law review articles—reveals the difficulty of distinguishing between racism and anti-racism within the discourses and institutional norms of liberal legalism. Justice L'Heureux-Dubé and the Chief Justice, however, recognized in the furor over Judge Sparks's remarks the link between the constructed nature of reason and the lived experience of power and its lack. Their judgement urges other judges to travel into that terrain of uncertainty and creativity, that middle zone of experimentation and diversity, and to craft a set of adjudicative norms and practices more reflective of the plural social worlds we inhabit. A judge, they wrote,

> must be taken to possess knowledge of the local population and its racial dynamics, including the existence in the community of a history of widespread and systemic discrimination against black and aboriginal people, and high profile clashes between the police and the visible minority population over policing issues ... The reasonable person must thus be deemed to be cognizant of the existence of racism in Halifax, Nova Scotia. It follows that judges may take notice of actual racism known to exist in a particular society.[16]

Indeed, one might argue that to fail to integrate one's knowledge of the local dynamics of racism in the name of an adjudicative ideal of impartiality—understood as the aperspectival view from nowhere—is to conceal the premises ensuring that the somewhere of racial privilege remains systemically entrenched.

### Seeing Beyond Public and Private

How does the way in which Justice L'Heureux-Dubé navigates new territory with respect to the art of judging relate to the substantive features of her work as a judge? Depending on your main interest, you can trace in Justice L'Heureux-Dubé's work a thread that pursues the project of rewriting the family discourse of privacy, privatization, and gender hierarchy—the case *Moge v. Moge*[17] is an important benchmark in this regard—and the thread that pursues the project of rewriting the rights discourse of liberal freedom and equality—the 1995 Equality trilogy[18] is key here. Both of these threads are

important in Justice L'Heureux-Dubé's work. Both illustrate the originality, courage, and depth of her contributions. Both also, within their frameworks, challenge the ideological and structural boundaries of the public/private split. However, these two threads—familial privacy and familial hierarchies on the one hand and liberal freedoms and equality on the other—often remain in separate rooms because of the nature of litigation and of adjudication. They unfold within the four corners of the issue as defined by the case, with no interconnections, although we may intuitively understand, and often posit as a matter of theory, that they are tightly interlocked.

Justice L'Heureux-Dubé's work, however, insists on the interconnections and on contextualizing the issues in order to expand what we think of as the "four corners." This often occurs in the family thread whether or not a *Charter* argument has configured the issue as a "freedom" issue or "equality" issue,[19] and it occurs in the rights thread despite the immense normative and ideological pressures to view rights holders as unencumbered, unconnected, and interchangeable individuals.[20] Justice L'Heureux-Dubé's methodological insistence on contextualization brings into focus sets of relations that are usually submerged or literally inaccessible because of the structure of litigation. In short, she exposes the manner in which "private" familial relations mediate the material, political, and social dimensions of "public" citizenship and, at the same time, the way in which dominant notions of liberal citizenship—understood as the meaning and texture of political membership rather than its formal entitlements—are premised on the privatization of familial and sexual relations.

The split in *New Brunswick (Minister of Health and Community Services) v. G. (J.) [J.G.]*,[21] a case in the rights thread, between Justice L'Heureux-Dubé's concurring reasons and the majority reasons by Chief Justice Lamer, illustrates my point. In *G. (J.)*, Jeanette Godin, a single mother on welfare, challenged the denial of legal aid benefits to assist her in proceedings concerning the continued apprehension of her three children by child protection authorities. In order to get at the legal aid issue, she argued under section 7 of the *Charter* that the removal of her children constituted an interference with her parental rights and that the denial of legal aid to assist her in re-establishing her custody of her children was inconsistent with fundamental justice. Chief Justice Lamer's majority reasons treated Jeanette Godin's claim to parental rights in classical terms of a negative right to be left alone and undisturbed within the sovereign sphere of parental authority over children. In

contrast, Justice L'Heureux-Dubé's concurrence worked against the tide of the negative construction of section 7 rights by giving central significance in the opening sections of her judgment to the intersecting equality concerns raised by the child protection context, in particular the fact that most child protection defendants are female, lone parents, impoverished, disproportionately racialized, sometimes performing their parenting work despite disabilities, and in many instances coping with the wider social impacts of colonialism.

In this way, Justice L'Heureux-Dubé made it clear that the liberty of the citizen, namely the classical values that stand behind section 7, must be viewed through the lens of the particular social and historical features of disadvantage that converge within the child protection regime under challenge. The texture and content of citizenship was thus directly tied to a set of familial arrangements and ideologies that intersect with other axes of systemic subordination. Conversely, the premises concealed by the majority's construction of parental rights as negative rights brandished against the state assumed the contextual features of social privilege necessary for such an exercise of individual, materially secure, and fortress-like sovereignty and thereby obscured the social textures and meanings so alive and central in Justice L'Heureux-Dubé's analysis.[22]

The fact that Justice L'Heureux-Dubé's reasons in G. (J.) were a concurrence, that her path takes her to the same disposition of the case as the majority, is, as it is in *Ewanchuk*, potentially misleading. The divide between majority and concurrence in G. (J.) is not a hairsplitting doctrinal disagreement but rather is rooted in a theoretically and radically different way of observing and understanding the world. Crucially, the difference is directly attributable to Justice L'Heureux-Dubé's practice of the art of judging, her willingness to address rather than avoid the crisis of objectivity, and to start the conversation about perspectivity and particularity in the work of judging.

### Conclusion

Many of Justice L'Heureux-Dubé's concurrences and dissents occupy the middle zone, the half-light, in the public discourse of judicial reasoning. They underpin and throw into relief the authoritative statements of the majority reasons, but often do so invisibly. In fact, we often deliberately edit them out of our casebooks and media reports. In *Ewanchuk*, the pattern was disrupted

momentarily when Justice L'Heureux-Dubé's willingness in her concurring reasons to open up space within the adjudication of sexual assault charges to examine the broader complexities of gender and the social relations of violence sparked Justice McClung's virulent outburst. However, and somewhat ironically given her ultimate vindication, the opportunity to broaden public and legal awareness of the radical quality of Justice L'Heureux-Dubé's engagement in the substantive, institutional, and methodological dimensions of the struggle for social justice was foreclosed by the tropes of backlash.

In conclusion, I would like to borrow once more from the repertoire of visual practices aimed at sharpening our grasp of the relations between light, colour, and perception and urge us to retrain our eyes to look at the broader landscape we must navigate in the struggle for progressive social change. Justice L'Heureux-Dubé's work shows us how to do that. In particular, she shows us how to foreground the complex textures and colours of life in a stratified, fluid, and heterogeneous society and give them a vivid and irresistible presence.

### Endnotes

* I would like to thank the Social Sciences and Humanities Research Council for providing research funds to explore the theme of backlash against legal reforms aimed at improving women's social equality.
1. [1999] 1 S.C.R. 330.
2. Justice Major wrote the majority reasons with the support of Chief Justice Lamer and Justices Cory, Iacobucci, Major, Bastarache, and Binnie. Justice L'Heureux-Dubé agreed generally with the majority's reasons but went on to add her comments on the reasoning in the courts below. Justice Gonthier signed Justice L'Heureux-Dubé's concurring reasons. Justice McLachlin stated her agreement both with the majority's analysis and with Justice L'Heureux-Dubé's assertion that "stereotypical assumptions lay at the heart of what went wrong in this case" and that such assumptions "no longer find a place in Canadian law." *Ibid.* at 379–80 per McLachlin J.
3. *National Post, 26* February 1999, A19.
4. The Council's analysis of the propriety of both Justice McClung's and Justice L'Heureux-Dubé's conduct in relation to *R. v. Ewanchuk* is contained in Council File 98-129, 31 March 1999.
5. I have pursued this analysis of *Ewanchuk* and backlash at greater length in "Farce or Tragedy?: Judicial Backlash and Justice McClung" (1999) 10

Constitutional Forum 65. My purpose here is to return to this theme as an occasion to look at Justice L'Heureux-Dubé's contributions, both substantive and methodological, to the art of judging and to social justice.

6 Della Thompson, ed., *The Oxford Dictionary of Current English*, 2d ed. (Oxford: Oxford University Press, 1993).

7 For a close analysis of how these inversions succeed in public discourse, see Dorothy Smith, "Politically Correct: An Ideological Code," in Stephen Richer and Lorna Weir, eds., *Beyond Political Correctness: Towards an Inclusive University* (Toronto: University of Toronto Press, 1995) at 23–50.

8 Canadian Judicial Council, *supra* note 4.

9 As I pointed out in "Farce or Tragedy?", the public debate over Justice McClung's outburst implied that feminist analysis and argument in fact do receive serious consideration in judicial decision making, a view that is belied by the record, especially in the area of sexual assault prosecutions. *Supra* note 5 at 69.

10 Ann McClintock, *Imperial Leather: Race, Gender and Sexuality in the Colonial Contest* (New York: Routledge, 1995) at 312.

11 For an insightful and extended exploration of the conceptual implications of social diversity for the principles and processes of legal decision making, see Jennifer Nedelsky, "Embodied Diversity and the Challenges to Law" (1997) 42 McGill L. J. 91.

12 *R. v. R.D.S.* (1998), 10 C.R. (5th) 1 at 23 (S.C.C.) per Justice L'Heureux-Dubé and Chief Justice Beverly McLachlin.

13 [1996] 3 S.C.R. 919 at 1001.

14 *Supra* note 12.

15 *Ibid.* at 22.

16 *Ibid.* at 24.

17 [1992] 3 S.C.R. 813.

18 *Miron v. Trudel*, [1995] 2 S.C.R. 418; *Egan v. Canada*, [1995] 2 S.C.R. 513; and *Thibaudeau v. Canada*, [1995] 2 S.C.R. 627.

19 See e.g. Justice L'Heureux-Dubé's dissenting reasons in this regard in *Willick v. Willick*, [1994] 3 S.C.R. 670 at 705–7.

20 See discussion *infra* at notes 21–22.

21 [1999] 3 S.C.R. 46. Chief Justice Lamer wrote the majority opinion, which was agreed to by Justices Gonthier, Cory, McLachlin, Major, and Binnie. Concurring reasons were written by Justice L'Heureux-Dubé and agreed to by Justices Gonthier and McLachlin.

22 I have developed this analysis in greater detail in "The Empire of the Lone Mother: Parental Rights, Child Welfare Law, and State Restructuring" 2001 (39) Osgoode Hall L.J. 717.

Nine

## Bars, Breasts, Babies: Justice L'Heureux-Dubé and the Boundaries of Belonging

REBECCA JOHNSON

> Social change will not come to us like an avalanche down the mountain. Social change will come through seeds growing in well-prepared soil—and it is we, like the earthworms, who prepare the soil. We also seed thoughts and knowledge and concern. We realize there are no guarantees as to what will come up. Yet we do know that without the seeds and the prepared soil nothing will grow at all. — Ursula Franklin[1]

Ursula Franklin's "earthworm theory" reminds us of the crucial roles played by those who prepare the soil, those who sow the seeds of new thoughts and concerns. In this paper, I would like to share with you some of my observations about Justice L'Heureux-Dubé as "earthworm"—about some of the visible and not so visible ways she has participated in preparing and seeding the soil for change. I am particularly interested in her actions in those struggles for change involving the complex processes of construction, the processes of building: of building categories, of building communities, of building nations. And, there is of course another set of processes embedded in that business of building: the business of excluding. As a starting point for thinking about Justice L'Heureux-Dubé and these earthworm struggles over construction, I would like to share with you one of my experiences as a breastfeeding mother.

### The Experience

In 1998, I found myself "with child." Still believing that children need not lead to a whole scale reorganization of one's life, I continued making plans as usual. I finished teaching, got my marking done and grades submitted, did a final check of my email, drove myself to the hospital, got admitted, and had a

baby. A few weeks later, I hopped on a plane with my little Alex, and flew to Bristol, England, to join my husband, who had left the week after the birth to take up an eight-month contract there. (Hindsight makes it clear to me that postpartum disconnection was interfering with my usual processes of rational thought, but that is another story.)

Shortly after my arrival, I found out that Madame le juge was scheduled to speak at a conference in Bristol a few weeks later. I had clerked for her several years earlier, and was delighted at the prospect of catching up with her. So, on the appointed day, I packed up the baby, and headed off to the conference. I did worry about the propriety of showing up with a baby, but, given that my entire support network was back in Canada, I had no alternative. If I were to go, Alex would have to come with me. To my relief, Alex was a perfect baby, sleeping most of the time. I happily spent the afternoon sitting beside the judge, and listening to the presentations. At the end of the day, she suggested that my husband and I meet up with her for dinner at a great restaurant she had found, one that had very nice pub-style food. We arrived at the scheduled time, and sat at a table in the nearly empty restaurant. Because there was plenty to talk about, we did not initially note that the service was slow, particularly given the lack of crowd. Finally, a waiter did approach. But he did not take our order. Instead, he told me that I could not be served, and to leave. The problem? The eight-week-old baby I had been oh-so-discreetly nursing. He was under fourteen. Their liquor licence was clear: no minors.

To say that I was shocked and humiliated would be to under-tell the tale. I was stunned and completely unable to form a coherent response. But in that moment of my darkest trauma, Madame le juge drew herself up to her full height (which is an imposing 5'1"), and blurted out in a French-accented tone of outrage, "You can't kick her out! That is a violation of her human rights!" But, as sometimes happens, Justice L'Heureux-Dubé was in dissent: we found ourselves out on the street.

Yet the human spirit is resilient. We walked the streets until we found a kinder, gentler restaurant with a different liquor licence, and a pleasant evening was had by all, full of scintillating and witty conversation. At least, I *hope* my part in the conversation was that. Because, to be honest, I can't recall any details of the subsequent conversation. What I do recall vividly was the intense and nearly overwhelming sense of gratitude I felt for the response of the judge at my moment of expulsion. Her response had repelled and dis-

placed attention from me and my supposed failures, displaced assertions that I had behaved badly, that I had shown myself to be a bad mother by taking my child into an inappropriate place. If there were any blame to be laid, she argued, it lay not with me, nor with my presence or behaviour, but with a legal rule that would deny me and my infant the ability to sit at the same table with her in a public space, and enjoy a plate of "bangers and mash," maybe even with a beer. The problem was with them, and not with me.

Her intervention salvaged what was a situation of incredible humiliation and alienation for me. The day after, I did manage to write a letter to the local authority to complain because, as a Canadian, that is what I tend to do in moments of outrage, but then I wrote the experience off as being a bizarre British thing.

Two or so years later, another baby arrived on the scene, coincidental with yet another cross-country move. And so, leaving two-year-old Alex at home with his dad, I packed my five-week-old baby Duncan on a plane, and flew across the country on a house-hunting trip, managing to see thirty houses in three days. And again, I met up with a friend, who offered to take me out to dinner at the end of a long and exhausting day. We drove to the Cowichan Valley, and headed for her favourite restaurant on the harbour. And once again, on a lovely spring day, the law stood between me and a much-desired plate of food. No, we could not come in the restaurant: Duncan was under nineteen.

Auditory flashback. I could just hear those French accented words resonating in the back of my mind: "That's a violation of her human rights!" This time, I was prepared to do battle! But though better prepared, I was no more successful. The waitress was unmoved by my assertion that I was being denied a service customarily available to the public on the basis of unjust discrimination rooted in my sex, or alternatively, my family status. She was similarly unmoved by my assertion that, as a matter of statutory interpretation, my five-week-old baby was not really "a child" within the meaning of the regulations. Indeed, he was really more like a vacuum attachment. Once again, I found myself standing out on the street with a baby, trying to find someplace (other than McDonald's) to sit and get a bite to eat.

On the event of my first expulsion, back in Bristol, I had been a stranger in a strange land. But this second time, in Duncan, British Columbia (with my child Duncan, a strange irony), I felt very much a stranger in my *own* land.

I found myself questioning the meaning of citizenship, wondering about the status of the breast-feeding woman as rights holder.[2] This second time, I was left reflecting more seriously on the words that Claire L'Heureux-Dubé had blurted out: "That is a violation of her human rights." While I had loved her invocation of "human rights" in that pub in Bristol, I had not taken it completely seriously. I had been deeply touched by the intervention, but had seen in it primarily a generous move designed to deflect blame, to minimize my feelings of vulnerability and humiliation. Now I found myself wondering if Justice L'Heureux-Dubé had not in fact been speaking very seriously about the content of human rights, if she had not indeed been making a most profound intervention in the ongoing social and legal debates about inclusion, exclusion, and the boundaries of belonging. For me, the seed she had sown several years earlier had finally begun to germinate.

At this point, before returning to the question of Justice L'Heureux-Dubé's comment about the content of human rights, a few comments on "the law" may be in order. Here, I would like to comment on three things: the substance of the liquor licensing law that denied me access to a meal, the policy behind the law, and the law's effects.

### Liquor and the Law

Both experiences of exclusion had to do with liquor licensing legislation. In British Columbia (as in most places), one must be licensed to sell liquor. At the time I was denied access to the restaurant in the Cowichan Valley, the British Columbia regime had nine different categories of liquor licence.[3] Two of those categories are relevant to this piece of storytelling: the restaurant[4] and the public house.[5] It is the distinction between them that kept me hungry both in Bristol and Duncan, B.C. Children may be present in restaurants, but are prohibited from entry to the public house. In both Bristol and British Columbia, in my quest for a meal, I had attempted to take my child across the threshold of the public house.

What then is the distinction? Both places serve food, and both serve liquor. Indeed, public houses are *required* to serve food in order to serve liquor. According to the legislation, unless an exemption has been granted, at any public house, "hot foods, wrapped sandwich snacks, soft drinks, fruit and vegetable juices shall be available at reasonable prices to customers."[6]

Restaurants too are required to serve food in order to serve liquor, though the restaurant licence does exact greater standards of variety from the proprietor, requiring the establishment to offer "a reasonable selection of menu items including appetizers and entrees, or their equivalent."[7] But, of course, the length of the menu, and the distinction between "appetizers and no-appetizers" are not at the centre of my story of expulsion.

At the heart is the question of "purpose." While both restaurants and public houses may generate significant profits from both their food and liquor sales, the restaurant licence is available only if one's purpose is to be "*primarily* engaged in the service of *food* during all hours of operation."[8] That is, where food and liquor are sold in the same place, children can be present only if the establishment's primary purpose is the food part of the equation.

Now from my perspective, as a hungry nursing woman with a baby in arms, the matter was tricky. If all I wanted was a sandwich or a burger and fries, I could get that at either establishment. How was I to know which was which from the outside? At the time I was denied entry to the pub in Duncan, the ratio of restaurant to public house licences was around two-thirds/one-third. Using those odds, I should expect to be denied access in only one-third of my attempts to sit down for a burger with a baby.

When I spoke with a representative of the Liquor Commission, and indicated my concern about the difficulty of telling from the outside what kind of licence the establishment had, she agreed. Indeed, she stated there were a great number of places with restaurant licences that were not legitimately serving food as their primary purpose. That is, from her perspective, these establishments had acquired restaurant licences, but did not "really" have food service as their primary purpose: their licences should be revoked, and children should *not* be there.[9] It was, she noted, largely a problem of enforcement. I was coming at things from the other direction, but it was clear that we agreed on one thing: the difficulty of telling from the outside what the "primary purpose" of the establishment is.

A question one might ask is this: what is the policy rationale? Why can children be present in a licensed restaurant, but not in a public house? According to the Liquor Licensing Operating Manual,

> The reasons behind these sections of the Act and the policies that support them are public interest concerns about the effects

of alcohol abuse on growing young bodies and developing minds, and the effects on individuals and society of irresponsible drinking behaviours learned at an early age. The Act reflects a generally held view in our society that early exposure to alcohol consumption and the teaching of appropriate drinking behaviours are best provided in the home under the guidance of parents or guardians.[10]

So, then, there are two related public interest concerns: the effects of alcohol abuse on young children and the social costs of irresponsible drinking behaviours. Both concerns can be met, assumes the policy, through a regime that asserts that *parents* are responsible both for *exposing* (and for *not* exposing?) their children to alcohol, and for teaching appropriate drinking behaviours *in the home.* Note that the regulations, while prohibiting children from most licensed venues, do not prohibit the consumption of alcohol by children. Parents may give alcohol to their own child in their own homes. Further, with respect to the emphasis on "the home," were I permitted a slightly bleak and cynical aside, I might suggest that the emphasis on the "home" manages to evoke a nostalgic vision of domestic bliss at odds with a reality in which many of the most inappropriate drinking behaviours are acquired in the home under the guidance of parents.[11]

But, as a starting point, assuming one accepts the policy statement uncritically and without cynicism, one might note a possible issue of overbreath in the relationship between the expressed concerns and the regulations, given the exclusion of *all* minors: teens, children, and infants.[12] In the case of small infants, the exclusion does not seem to advance the purpose. Surely there is no concern that an infant will be accidentally served a drink, or manage to sneak a surreptitious sip while a parent's back is turned. And when it comes to observing and modelling responsible drinking behaviours, neither of *my* infants appeared the *least* interested in my drinking behaviour (or eating behaviour for that matter). Indeed, *their* independent unreasonable drinking behaviours were the reason why I was seldom able to finish my own meal while it was still warm.

And there is another interesting aspect of the policy's emphasis on the importance of both "parental guidance" and "the home": parents are not completely restricted to the home as a venue for a child's education in alcohol

consumption. Children *are* allowed into the licensed restaurant. Presumably, this reflects a belief that restaurants are not locations of irresponsible drinking behaviour. However, keep in mind that a parent could presumably order an identical meal/beverage combination in either restaurant or public house (and, indeed, could order just food in the public house, without a beverage). Despite this, a parent is still prohibited from bringing a child into a public house. It would seem, then, that the emphasis on parental guidance is only a small piece of the picture here. It would appear that, whatever a parent's thoughts to the contrary, responsible drinking behaviour cannot be taught from within the public house.

Is the public house, by definition, necessarily a site of inappropriate drinking behaviour? While momentarily finding myself caught up in an imaginary location of pulsing music, smoke, vice, and iniquity, I am drawn back to a recollection of the actual physical spaces from which I was concretely expelled. Dens of iniquity they were not. I am reminded of my conversation with the Liquor Control Representative, who agreed that the distinction between restaurant and public house is often a fine one. And yet, the regulations code the public house in such a fashion as to make it a site of danger or contagion for a child.

Although it proclaims the parent to be responsible for educating his or her child, I find myself wondering if the policy does not also aim to educate the parent: it directs the parent to understand that the public house is *not* a location for a child. Either there is something about the public house that makes it more likely that the child will somehow be able to consume alcohol even though the parent is present, or the things that happen in such a space are inappropriate for the child to see. In either case, one wonders if the licensing regulations function partly as a form of moral regulation—foreclosing the unruly behaviour of those undisciplined parents who would teach "inappropriate drinking behaviours" through their presence with children in certain establishments.

It may be that there is another set of policy rationales that remain unarticulated, but which influence the shape of the regulations. This is a set of rationales that are often raised when I talk about this material with friends and colleagues. Perhaps the policy reflects less a concern with what the child might *see*, than with the child *being seen*. That is, perhaps the regulations and policy are really a set of justifications explaining a felt sense of discomfort

with children (and perhaps particularly with mothers and small children) in what are deemed to be adult spaces? Spun from the other direction, should not there be spaces where adults can go to be *free* from children?

I suspect that this latter set of reasons is operational more frequently than is acknowledged. That is, I suspect that my arguments about legal interpretation were unsuccessful in part because the pub owners were just as happy *not* to have my child and me in the space. And, I will say, that I find the rationale compelling in part. There is no denying that children can be noisy, they can be messy, and they can interfere with the pleasure one finds in a space. As the mother of two small children, I have *often* longed for a space, a place of temporary freedom from the intransigent demands of a child. However, arguments concerning the comfort of adults should be distinguished from arguments that purport to rest on justifications related to the welfare of children. Further, a rule that unilaterally excludes children from certain spaces has implications for the access of parents of children to those spaces. And this leads me to a consideration of the effects of the regulation.

There is a first set of effects that can and should be identified using the language of gender neutrality. The licensing regime excludes "children" from the public house. Although the primary target is the child, the effect is the exclusion of any adult who is accompanied by a child. Even in the shock of my Bristol expulsion, the genderless dimension of the rule was clear to me: in many ways, the fact that I was a nursing mother was completely irrelevant. The pub that denied me entry would also have denied entry to my sister, bottle-feeding her adopted daughter. So, too, the doors would have been closed to my brother, travelling with his little boy. And further, I doubt that my parents would have any greater success had they been out for a day with the grandchildren. Thus, part of the story here is one of a gender-neutral adverse effect on parents or caregivers.

But of course, in our contemporary society, many questions about the burdens suffered by "parents" continue to be inflected with the clear accents of gender. In the society not of our dreams but of our daily lives, the current design of the work/family dyad continues to create different headwinds for men and women—headwinds that push and tug men in the direction of "the ideal worker" and women in the direction of "domesticity."[13] The results of these headwinds are so well known that the Supreme Court took judicial notice of the fact that women disproportionately bear the social costs of child-

care.[14] Thus, even though it is important to acknowledge that the rule itself is facially neutral with respect to gender, and that the rule *will* operate to punish men as well as women, it is also important to acknowledge that, to the extent that women remain more likely than men to be travelling in the company of children, the "neutral" exclusion will continue to produce gendered effects.

And in addition to adverse effects based on gender, the law generates adverse effects linked to "sex." In invoking "sex" as distinct from "gender," I should pause briefly to make explicit some of my own presuppositions. First, I do subscribe generally to Simone de Beauvoir's insight that woman is made not born.[15] I am also of the view that talk about "sex" often proceeds in a fashion that can too easily assume the matter of "nature" to be given. I agree with Judith Butler that there are important discursive limits to talk about "sex," and that there is great utility in understanding "matter" to be not so much a site or surface, but a "process of materialization that stabilizes over time to produce the effect of boundary, fixity, and surface we call matter."[16] But against this background, I still find it important to note that my own experience of exclusion was very much tied up with some complicated issues of biology. That is, while I was not kicked out *because* I was nursing,[17] the fact of my being a nursing mother put a certain kind of biological spin on the exclusion.

Not only was I nursing Duncan, I was nursing him pretty much every couple of hours. Because this child was born with violent allergies to both milk and soy, formula was not an option for him or me. If the child were to be fed, the child would need to be travelling with me. Where he could not travel, neither could I. And the "biological" reminder functioned on two levels. It was not simply that Duncan, with his allergies, needed to remain close by to satisfy his voracious appetite. I, too, needed to remain proximate to Duncan. I already understood too well that I was not just "The Edible Woman" (to steal Margaret Atwood's title); I was also "The Leaky Woman." Even were I granted access to the restaurant sans enfant, I would have a limited amount of time available before (without access to my vacuum-attachment-like child), I would be a very wet and milky woman.[18] I needed to remain proximate to my child in order to minimize the physical discomfort of engorgement and the ever-present possibility of social embarrassment due to my ever-leaky body.

In foregrounding some questions of biology, I am in no way proceeding on the assumption breast-feeding is simply a question of "nature." Certainly,

I am not making any argument concerning whether women should or should not breast-feed, nor about the meaning breast-feeding does or does not have. Answers to such questions are in any event socially constructed, not simply found in nature.[19] But if the meanings and manners of breast-feeding are largely socially constructed, there remains nonetheless a lingering kernel of "the real"—an intransigent issue of biology that simply cannot be imagined away. And thus it is that a seemingly gender-neutral regulatory liquor licensing regime designed to exclude children from the "public house" has effects that implicate gender and sex, disproportionately excluding genderless caregivers, mothers, and nursing women.[20]

### The Pub as Site of Human Rights?

Let us return to the streets of Bristol, and the seed that was sown there. Here, I pose some of the questions that I have asked myself, and that have been asked of me. Even if the liquor-licensing regime has an adverse impact on parents, mothers, or women, is the invocation of human rights in the context going overboard? While it may be irritating to be denied entry to a pub, does the cry of "human rights" here not risk trivializing the notion of rights itself? After all, what is really involved: the right to purchase food and drink in the location of one's choice? Is *this* a matter of human rights? And even if there *were* such a right, does economic class perhaps not play a more significant role in the denial of access? Am I suggesting that the discourse of human rights can be invoked any time someone cannot afford to eat in an expensive restaurant?

Queries such as these rest in part on the presumption that space itself is inert or apolitical, and that it may therefore mean little to be excluded from it. Invoking the discourse of human rights, Justice L'Heureux-Dubé launched an explicit challenge to this presumption. Her comments reflected an understanding of a central insight of critical geography: that space is fully political.[21] But if one is prepared to acknowledge the political character of space, one must also take seriously the exclusion of certain kinds of bodies from certain kinds of space. Space is, indeed, a piece of what *makes* us who we are. Space, and the terms upon which we occupy it, is fundamentally related to the materiality of the body itself. To draw again on Butler, the materiality of sex is constructed through a ritualized repetition of norms.[22] These norms deter-

mine not only what bodies come to matter and why, but also *where* and *how*. That is, we come to *be* in certain ways, and our place in space is part of what tells us (and makes us) who we are. As Sherene Razack puts it, "bodies are produced in spaces and … spaces produce bodies."[23]

Where the relationship of body and space is theorized as fully political, the language of human rights has quite different purchase. Certainly, it reveals that the invocation of rights in the context of "the pub" is neither trivial nor of tangential significance. Renisa Mawani has demonstrated the crucial role that exclusionary liquor legislation played in creating racialized colonial spaces in British Columbia,[24] and Richard Thompson Ford has documented the ways that inattention to space will perpetuate racialized segregation even in the absence of racial animus.[25] What is true of racialized spaces is no less true of the gendered dimensions of political space. Inattention to the political character of the public house can perpetuate a certain kind of gendered segregation in our society, again even in the absence of any gender animus. If Ludwig Wittgenstein is partly right that a picture holds us captive,[26] then our gendered spaces are part of this picture. They contribute to our gendered imaginations and gendered understandings of the possible.[27] They are a piece of the picture that holds us in place.

In the jurisprudence of Justice L'Heureux-Dubé, there is an attention to space and the spatial, to the corporeal, to the bodies in which lives are actually lived. Hers is a jurisprudence that has long asked us to consider what human rights might look like in a world that attended to the needs of the embodied, and to the geographical spaces in which those humans live and experience themselves and those around them. Her jurisprudence has served as a reminder of the importance of looking at bodies and spaces in order to answer questions about how we construct the boundaries of belonging: who is drawn in and who is drawn out.

That summer evening, on the streets of Bristol, she spoke out against my exclusion from a pub using the language of human rights. In so doing, she took seriously the relationship of bars, breasts, and babies. She planted in my mind the seed of a thought: what are the spaces appropriate for the exercise of human rights? Does space matter only in Parliament and in the prison? Is denial of the vote the lynchpin for disenfranchisement, or are the full indicia of citizenship and its rights constructed in more wide-ranging locales? Her assertion required me to think carefully about the exclusion and the emotions

it generated in me. From *what* was I being excluded, and what was the source of my distress?

I was inconvenienced by having to seek a meal elsewhere. But my anger was rooted in my sense that my expulsion was linked to my responsibilities as a mother. Certainly, it was not enough, for me, to be reminded that I could enter the space anytime w*ithout* my children. Indeed, such comments served only to indicate that my connections to the world of reproduction disentitled me from full access to public spaces.[28] Further, such comments indicated a social determination that I, as a mother, could not be trusted to make decisions about how my children would occupy space with me.[29] And some of my distress was rooted in a sorrowful acknowledgement of the ways in which I had limited access and on limited terms to the spaces where social capital is developed and accumulated.[30] There was also grief about the limited ways in which I felt acknowledged and recognized as being a full part of the larger polity.[31]

At this point, one might protest and say, "But is there not a space where adults can be free from the insistent demands and insurgent noisy messiness of children?" I have uttered those words myself. But the claim that there should be a space of adult refuge is a much different claim than one that asserts the impropriety of children in certain licensed spaces. This latter claim is one that employs the rhetoric of moral regulation in ways that maintain and police the boundaries of gendered behaviour and gendered space.[32] And if the effect of that claim is indeed to construct a certain kind of space for "adults," the construction of that space has exclusionary implications for those who are linked to the reproduction and care of the young. A focus on "human rights" may lead us to think more carefully about the exclusions that flow from the ways we construct and make available the spaces of social contact.

If we take seriously Justice L'Heureux-Dubé's challenge, and use the body of the breast-feeding mother to think about the exclusion of the nursing child (and mother) from certain social spaces, a different horizon stretches before us. I would emphasize that in foregrounding the breast-feeding mother, I am in no way asserting that she has an "essential meaning." I am asking rather what might it mean for our discussions of human rights were we to take seriously the embodiment of the breast-feeding mother, and her location in physical space.[33] First, her body is a reminder of corporeality, of the ways that life is lived through the body.[34] Law and social theory might well look different were the "body" at the centre of its theorizing to be less "the

firmly boundaried able-bodied autonomous rights holder" than "the leaky woman."³⁵ Were such a body at the centre, questions about "propriety"³⁶ or "accommodation"³⁷ would sound quite different.

Further, in asking *how* and *where* the nursing mother is a citizen and holder of human rights, we may be better placed to understand the connections between her needs and the needs of others. We can see that her needs, partially embodied, resonate with the needs of the mother/father whose child is bottle-fed, or whose child is not easily left behind. With her body plainly in view, it is easier to see that many social spaces are constructed in ways that are highly inhospitable to children. Indeed, one might be led to conclude that many of our commitments to children are symbolic rather than actual, and are premised on a deep and systemic distrust of parents.³⁸

Our gendered spaces are part of the picture that contributes to our gendered imaginations, and our gendered understandings of the possible. They are part of the picture that holds us captive. On a summer evening in Bristol, several years ago, Justice L'Heureux-Dubé was doing what she so often does: she was tilling the soil, and planting new seeds, seeds that hold the potential to germinate into something that challenges the strength of the picture that purports to hold us captive. On the streets of Bristol, looking for another place to eat, I was conscious of my good fortune to have been able to work for a time alongside such a woman, a woman who presses for social change not only in the sterile air of the courtroom, but also in the routine and quotidian spaces of day-to-day life. This is a woman who remains alert to justice, inequality, and the boundaries of civic space even when dealing with an issue as seemingly mundane as an attempt to order a burger and a beer.

What did she ask me to reimagine that day? What does she ask us all to reimagine? She asks us to note that bodies matter, and that space matters. She reminds us to remain mentally alive to the narratives that shape how we imagine justice,³⁹ and to consider the linkages in life: between space, expression, and equality; between workplace rules and the shape of family life; between law and society; between legal categories and the possibility of justice. She urges us to reimagine ourselves as full participants in the project of constructing an invigorated and increasingly inclusive civil society, to rethink our vision of the boundaries of belonging. She invites us to join in the project of re-visioning, of challenging the picture that holds us captive. That is a vision indeed.

## Endnotes

1 Ursula Franklin, *The Real World of Technology* (Toronto: CBC Enterprises, 1990) 120–21.

2 There are some difficulties in deploying the language of citizenship here. Citizenship, while a language of inclusion, is also premised on a prior exclusion. See Linda Bosniak, "Citizenship Denationalized" (2000) 7 Indiana J. of Global Legal Studies 447 and Linda Bosniak, "Universal Citizenship and the Problem of Alienage" (2000) 94 Northwestern University L. Rev. 963. I take her point about the need to fundamentally rethink citizenship, both where it is located, and what its practices and experiences are. Certainly, while believing the language of citizenship to be rhetorically (and politically) powerful, I am also mindful that its use in this context is limited to the extent that it might imply that a "non-citizen" could legitimately be excluded from the public space of the bar or restaurant.

3 A caveat here: at the time I began working on this paper, there were discussions underway to streamline things, in order to reduce the current nine categories of liquor licence to two. The new regulations came into place in December of 2002, so this streamlining has since taken place: see the *Liquor Control and Licensing Regulation*, B.C. Reg. 244/2002. While the new regulation has made the system a bit less complicated, the distinction between restaurants ("food primary") and public houses ("liquor primary") stands firm. As such, even though I discuss the old rather than the new regulations, the analysis remains applicable.

The older nine categories of licence can be found in s. 17 of the *Liquor Control and Licensing Regulation*. There are special events licences (drinks at the break during the symphony or opera); licences for hotels/planes/trains/colleges; retail sales licences (B.C. Liquor Store, rural gas/grocery stores); cabaret licences (places the primary purpose of which is to provide entertainment); restaurant licences; and "public house" licences.

Minors may accompany adults into retail sales establishments. They may also accompany adults into licensed restaurants. But they are generally excluded from entering public houses, as well as areas licensed for liquor sales at special events. There are also some exceptions from the exclusion of minors: children are allowed to be in licensed areas in trains, planes, and ferries. There are also exceptions for child entertainers (who are allowed to perform in licensed facilities from which they would ordinarily be excluded).

4 Section 17(2) of the regulations sets out the criteria for the Category "B" licence (for dining establishments).

5 There are several categories of public house, each with its own licence. There is

a "D" licence for the "Neighborhood Public House," an "F" licence for the "Marine Public House," and an "I" licence for the "Restoration Public House." It is important to keep in mind that the "Public House" is not an equivalent for "The Nightclub" or "The Cabaret." The "C" licence is designed for establishments that are "primarily engaged in providing entertainment" (see s. 17(3)). I point this out only because it is common for people listening to my "I got kicked out of the bar" rants to remind me that it might not be appropriate for children to hang out in nightclubs. There is certainly a set of arguments to be made about the appropriateness of children's access to adult entertainment. But the distinction between restaurant and public house does not raise this issue. In this context I am interested in the distinction between different categories of food/alcohol establishments where any entertainment provided is to come directly from the customers themselves, over the table.

6  This is the wording used with respect to all categories of public houses, and some special events licences: See, e.g., ss. 17(4)(h), 17(5)(g), 17(6)(f), 17(9)(e).
7  See s. 17(2)(c). The legislation is more detailed, setting out the rules to govern "designated food-optional areas" where it is legitimate to serve liquor even without serving food, and children are allowed to accompany adults into this area. In short, you can do in the restaurant "food optional areas" what you would do in the public house. Or, you could do in the public house (eat) that which you could do in the licensed restaurant.
8  See s. 17(2) of the regulations.
9  The restaurant licence is procedurally easier to obtain than a public house licence. Applications for public house licences trigger a public input component that is not triggered by the application for a restaurant licence.
10 *Liquor Licensing Operating Manual*, issued July 1997, Section 10.1: Minors— General Conditions, page 1 of 12.
11 Of course, most provinces have social services legislation that purports to fill this gap by enabling social services to intervene if the amount of alcohol delivered to a child or the drinking behaviours being taught are deemed sufficiently egregious to enable the child to be labelled as "in need of protection," e.g., in British Columbia, the *Child, Family, and Community Services Act*.
12 The *B.C. Liquor Control and Licensing Act*, R.S.B.C. 1996, c. 267, s.1, is clear that the word "minor" means a person under the age of majority established by the *Act of Majority Act*, R.S.B.C. 1996, c. 7, which says in s. 4: "A person who has not reached the age of majority may be described as a minor instead of as an infant, and 'minor' means such a person."
13 See Joan Williams, *Unbending Gender: Why Family and Work Conflict and What To Do About It* (New York: Oxford University Press, 2000). She notes that the

norm of "the ideal worker" (a norm that expects the worker to be available for work at all times, and *not* to have primary responsibility for childcare) is damaging for both men and women. Certainly, it produces headwinds blowing against men who wish to participate to a greater degree in the day-to-day physical care of their children.

14 *Symes v. Canada*, [1993] 4 S.C.R. 695 at 763.
15 Simone de Beauvoir, *The Second Sex* (1952; New York: Vintage Books, 1989).
16 Judith Butler, *Bodies That Matter: On the Discursive Limits of "Sex"* (New York: Routledge, 1993) at 9.
17 For a discussion of some of the "breast-feeding cases," see Barbara Arneil, "The Politics of the Breast" (2000) 12 C.J.W.L. 345, particularly at 360–70; see also Lorna A. Turnbull, *Double Jeopardy: Motherwork and the Law* (Toronto: Sumach Press, 2001) at 92–99.
18 The fear of just such an experience is very real to any woman who has nursed a child. Lawyer Elizabeth Cusack-Walsh, then the nursing mother of a three-and-a-half-week-old baby, writes about the experience of being in a trial, and having the judge refuse her a lunch break long enough to go home and nurse her child. She writes: "By mid-afternoon I was in deep distress, mentally and physically. Milk began spurting through my clothes, all over my cross-examination notes. The courtroom was crowded with spectators. I was standing, cross-examining an RCMP scientist on a very technical point. The judge was enraged when I requested a few minutes' adjournment. When he cooled down, I explained that I was leaking milk, that my notes were wet and that I would like a few minutes to deal with the situation. The justice remembers the incident as a joke. I remember how women and motherhood were degraded." See Pamela Harris, *Faces of Feminism* (Toronto: Second Story Press, 1992) at 46.
19 There is a voluminous literature on the social construction of breast-feeding. See, e.g., Vanessa Maher, ed., *The Anthropology of Breast-Feeding: Natural Law or Social Construct* (Oxford: Berg Publishers, 1992); Rosalia Rodriguez-Garcia and Lara Frazier, "Cultural Paradoxes Relating to Sexuality and Breastfeeding" (1995) 11 J. of Human Lactation 111; Datha Clapper Brack, "Social Forces, Feminism, and Breastfeeding" (1975) 23 Nursing Outlook 556; Judith Galtry, "Lactation and the Labor Market: Breastfeeding, Labor Market Changes, and Public Policy in the United States" (1997) 18 Heath Care for Women Int'l 467; Jane Gordon, "'Choosing' to Breastfeed: Some Feminist Questions" (1989) 18 Resources for Feminist Research 10. Even the most recent Canadian government report on breast-feeding confirms that the social construction of breast-feeding (social discomfort about it) is one of the major impediments to efforts to increase the rate at which Canadian women choose to breast-feed over bot-

tle-feeding: Patrick Sullivan, "Breast-Feeding Still Faces Many Roadblocks, National Survey Finds" (1996) 154 C.Med.Ass.J. 1569.

20 For a now-classic deconstruction of the "seemingly gender-neutral standard," see Catharine MacKinnon, "Difference and Dominance: On Sex Discrimination," in *Feminism Unmodified: Discourses on Life and Law* (Cambridge, Mass.: Harvard University Press, 1987) 32.

21 Some valuable analyses of the political nature of space include Michel Foucault, "Space, Knowledge, and Power," in Paul Rabinow, ed., *The Foucault Reader* (New York: Pantheon Books, 1984) at 239–56; Doreen Massey, *Space, Place, and Gender* (Minneapolis: University of Minnesota Press, 1994); Sherene Razack, ed., *Race, Space, and the Law: Unmapping a White Settler Society* (Toronto: Between the Lines, 2002); Edward W. Soja, *Postmodern Geographies: The Reassertion of Space in Critical Social Theory* (London: Verso, 1989); Nicholas K. Blomley, *Law, Space, and the Geographies of Power* (New York: The Guilford Press, 1994).

22 Butler, *Bodies That Matter, supra* note 16. Butler, putting it in philosophical terms, argues that "sex is not what one 'has', but is one of the norms by which the 'one' becomes viable at all, that which qualifies a body for life within the domain of cultural intelligibility" (at 2).

23 Razack, ed., *Race, Space, and the Law, supra* note 21 at 17.

24 Renisa Mawani, "In Between and Out of Place: Mixed-Race Identity, Liquor, and the Law in British Columbia, 1850–1913," in Razack, ed., *Race, Space, and the Law, supra* note 21 at 49.

25 Richard Thompson Ford, "The Boundaries of Race: Political Geography in Legal Analysis" (1994) 107 Harvard L. Rev. 1841–1921.

26 Ludwig Wittgenstein, *Philosophical Investigations*, trans. G.E.M. Anscombe (New York: Macmillan, 1953) s. 115.

27 Consider the deeply gendered versions of what it means to be good enough as a mother or as a father: see Williams, *Unbending Gender, supra* note 13, particularly ch. 4. These differing versions of "good parenting" have implications for the kinds of public lives we allow to women who are also mothers. Susan B. Boyd, "Looking Beyond Tyabji: Employed Mothers, Lifestyles, and Child Custody," in Susan B. Boyd, ed., *Challenging the Public/Private Divide* (Toronto: University of Toronto Press, 1997) 253.

28 With respect to the breast-feeding side of the equation, it required me to see that part of myself as something "in excess," something inappropriate for public life, an aspect of the corporeal to be set aside in order to be part of the body politic.

29 Indeed, the rule served to establish me as firmly in a relationship of tutelage: see Jacques Donzelot, *The Policing of Families* (New York: Pantheon Books, 1979).

30 Robert Putnam's work, both in Italy and the United States, demonstrates the vital importance of social networks and social capital for economic outcomes. The pub/bar has long been one of the important locations for the development of male social capital. See Robert D. Putnam, *Bowling Alone: The Collapse and Revival of American Community* (New York: Simon & Schuster, 2000); Robert D. Putnam, with Robert Leonardi and Rafealla Y. Nanetti, *Making Democracy Work: Civic Traditions in Modern Italy* (Princeton: Princeton University Press, 1994).

31 The emotions I felt mapped fairly cleanly onto what Nancy Fraser describes as the "struggle for recognition." See her chapter 1, "From Redistribution to Recognition? Dilemmas of Justice in a 'Postsocialist' Age," in Nancy Fraser, ed., *Unruly Practices: Power, Discourse and Gender in Contemporary Social Theory* (Minneapolis: University of Minnesota Press, 1989).

32 I develop this thread more fully in Rebecca Johnson, *Taxing Choices: Class, Gender, Parenthood and the Law* (Vancouver: UBC Press, 2002), particularly in chapter 6, "Power, Constraint and the Rhetoric of Choice."

33 What I am proposing is similar to the approach taken by Zillah R. Eisenstein in *The Color of Gender: Reimagining Democracy* (Berkeley: University of California Press, 1994). There, she asks that we attempt to re-imagine what is required for democracy by starting from the body of the pregnant black woman. I am suggesting that we do the same work for human rights, using the body of the breast-feeding woman.

34 Vivian Sobchack, theorizing the body in the context of having lost a limb, argues: "it is especially important that we redeem for critical thought an understanding of the body that includes our bodies—that is, bodies not merely as they are objectively seen, but also as they are subjectively and synoptically and synesthetically lived, as they enable and contain the very meaning and mattering of matter, as they give gravity to semiotic production and circulation, and suffer as its very ground." See Vivian Sobchack, "'Is Any Body Home?': Embodied Imagination and Visible Evictions," in Hamid Naficy, ed., *Home, Exile, Homeland: Film, Media, and the Politics of Place* (London: Routledge, 1999) at 45, 47. The necessity to think about biology in the context of theory is foregrounded in Robin West, "Jurisprudence and Gender" (1988) 59 U. C. L. Rev. 83, and Robin West, "The Difference in Women's Hedonic Lives: A Phenomenological Critique of Feminist Legal Theory," in Martha Albertson Fineman and Nancy Sweet Thomadsen, eds., *At the Boundaries of Law: Feminism and Legal Theory* (New York: Routledge, 1990) 115. A powerful argument about the need to reinsert "the body" into our theorizing about sexual assault and sexual autonomy can be found in Nicola Lacey, "Unspeakable

Subjects, Impossible Rights: Sexuality, Integrity and Criminal Law" (1998) 11 C.J.L.Juris. 47.

35 On the importance (and permeability) of boundaries to selfhood, see also Jennifer Nedelsky, "Law, Boundaries and the Bounded Self" (1990) 30 Representations 162. Arguably, some of the discomfort with placing the leaky-boundaried-body of the nursing woman at the centre of the theoretical enterprise may have something to do with concepts of "disgust." Martha Nussbaum, noting that the female body has been constructed as an object of disgust and contagion, agrees with Walt Whitman that the recuperation of this body is closely linked to women's political equality. See Martha C. Nussbaum, "'Secret Sewers of Vice': Disgust, Bodies, and the Law," in Susan Bandes, ed., *The Passions of Law* (New York: New York University Press, 2001) 19 at 33.

36 In the current regime, the exposure of the breast (even a nursing breast) in public is deemed to be anywhere from improprietous to downright disgusting. See Janine Benedet, "On Indecency: *R v. Jacob*" (1998) 3 Can. Crim. L.Rev. 17. See also Marilyn Yalom, *A History of the Breast* (New York: Alfred Knopf, 1997).

37 Accommodation most often focuses on finding a way to enable the woman to nurse "in private." Such approaches, though ostensibly about workplace accommodation, still locate the problem in the woman. It is interesting to consider what the results would be were the workplace itself truly to accommodate by restructuring itself to take as a "given" the presence and/or needs of the breast-feeding woman. See Arneil, "The Politics of the Breast,"and Turnbull, *Double Jeopardy, supra* note 17.

38 Ironically, this is also co-existent with an idealization of child and family in ways that vilify, punish, and marginalize women who, for reasons of choice, nature, or fate do *not* have children. For an example of a work that treats female childlessness as something other than deviant or tragic, see Marlène Carmel, *Ces femmes qui n'en veulent pas: enquête sur la non-maternité volontaire au Quebec* (Montréal: Éditions Saint-Martin, 1990).

39 On the centrality of narratives to law, see Anthony G. Amsterdam and Jerome Bruner, *Minding the Law* (Cambridge: Harvard University Press, 2002).

Shaping Substantive Law

## Ten

# Contextualizing the Best Interests of the Child: Justice L'Heureux-Dubé's Approach to Child Custody and Access Law

SUSAN B. BOYD

By infusing family law with the social context, we ensure that the perspective and interests of all the parties involved, *men, women and children*, are taken into account.[1]

### Introduction

When Claire L'Heureux-Dubé was appointed to the Supreme Court of Canada in 1987, I knew little about her, despite the fact that she had been on the Quebec Court of Appeal since 1979 and the Cour supérieure du Quebec since 1973. This ignorance is, no doubt, directly attributable to a myopic Anglo-Canadian focus. It was Marlène Cano, a feminist family law professor in Droit Civil at the University of Ottawa who died young of breast cancer in 1994, who first pointed out to me the significance of Justice L'Heureux-Dubé's innovative approach to family law when she was on the Quebec Court of Appeal. Cano published an article making this point in 1991.[2]

Marlène Cano's article was written partly in response to suggestions that Justice L'Heureux-Dubé took a conservative (less interventionist) approach to the *Canadian Charter of Rights and Freedoms* in comparison with that of other Supreme Court justices, for instance, Justices Bertha Wilson and Antonio Lamer. Cano's response was to complicate the analysis by observing that a non-interventionist approach to the *Charter* did not necessarily correlate with a conservative approach. Cano found that, in fact, Justice L'Heureux-Dubé adopted an approach that addressed social injustices and inequalities, that was multidisciplinary, and that rejected an individualistic focus in favour of a focus on collective interests—hardly a conservative

approach, and arguably an innovative one. In the context of family law, this approach meant that in matrimonial conflicts, it was not only individual interests that were relevant, the impact of conflicts on the whole family and on the larger society had also to be considered. Justice L'Heureux-Dubé felt that the state should play a role in ensuring the interests of the family and its stability, and thus society's interest.[3] Cano pointed out that Justice L'Heureux-Dubé's family law work typically looked to the social context within which inequalities are found, particularly economic inequalities. In relation to children, Cano found that Justice L'Heureux-Dubé was preoccupied with their best interests and often suggested that the best interests of children were not sufficiently taken into account by the courts.[4] In determining what those interests were, she took a multidisciplinary approach, and also looked to social science expertise for guidance.

Cano suggested that Justice L'Heureux-Dubé's decisions affirmed that the discretionary power that judges possess under family legislation empowers them to think about formal equality in relation to social realities, with the goal of ensuring substantive equality for disadvantaged groups.[5] Interestingly, however, Cano also pointed out that Justice L'Heureux-Dubé typically limited her interventions as an appellate judge, often endorsing the opinion of the judge who had the opportunity to hear the evidence.[6] She was not, then, a particularly interventionist judge in terms of second-guessing the decisions of judges in the lower courts.

At the time Marlène Cano wrote, (1991), Justice L'Heureux-Dubé's most significant Supreme Court of Canada decisions in relation to child custody and access issues at separation and divorce had not yet been rendered. This article explores the extent to which Cano's 1991 assessment of the jurisprudence of Justice L'Heureux-Dubé holds water after another decade of work on the Supreme Court of Canada. Before discussing the key decisions related to the child custody and access law, however, I shall review her contributions to scholarly discussions of the best interests of children.

### Extra-Judicial Discourse

Unlike many judges, Justice L'Heureux-Dubé has written and published prolifically, including in the field of family law. She has also been an honorary member and an active participant in the conferences of the International

Society of Family Law. A key theme of her writing is that "if we are to be true to our commitment to enhance the quality of justice, in the family law context amongst others, the focus of legal developments and reforms should be on the notion of equality."[7] She has emphasized that the concept of equality underlies modern trends in family law, even if family law is not traditionally regarded as dealing with equality rights. In addition, she suggests that jurists must ensure that "the family law system keeps in touch with reality as it is experienced by the men, women and children who need it most."[8]

Justice L'Heureux-Dubé's direct remarks on child custody and access law are relatively few, but worthy of note. In general, they support the usual characterization of her work as taking the highly contextual approach to law that is required to make equality work.[9] Her remarks also consistently emphasize the best interests of children and that a child-centred approach is crucial.[10] Her child-centred approach takes social context carefully into account (for instance, through expansion of the doctrine of judicial notice), which sometimes involves considering gender-based dynamics such as woman abuse. For example, in the course of a discussion of academic literature on judicial decisions that fail to take the views of children into account, instead focusing on adult perspectives, she said:

> Judges often focus ... on the degree to which the parents' attitudes and beliefs conform to traditional moral values or the fairness of the custody or access order to the parents. Family law adjudicators have also been criticized for devaluing mothering by the primary caregiver, while commending fathers for even very minor interest expressed in their children. Most disturbing, in my view, is the criticism that judges may tend to ignore the effects of violence committed by fathers against children and their mothers. A recent review of a sample of family law cases involving such violence shows judicial decisions in this sample minimizing the effects of this behavior on the father's ability to parent the child, often authorizing unsupervised access or even joint custody, and this where the children were begging not to be left alone with their father. Where are the children's needs and interests taken into account in such decisions?[11]

Justice L'Heureux-Dubé went on to say that it is not sufficient to subscribe to the best interests of the child approach. Rather, one must understand what this approach implies: for her, a child-centred approach to the best interests of the child test requires a focus "at all times on the child, not the needs or interests of the parents."[12] Moreover, parental rights play no role in such decisions "except in so far as they are necessary to ensure the best interests of the child."[13] At first glance, this approach may seem to run against the stream of feminist analysis that suggests that children's interests are often interconnected with those of the caregivers, who tend to be their mothers.[14] However, as we will see below in my analysis of her actual custody decisions, and as her comments above signal, L'Heureux-Dubé was in practice attentive to the interrelationship of children's interests and those of their caregivers.

Justice L'Heureux-Dubé also demonstrated an early consciousness that equality rights might be a contested terrain in relation to child custody, particularly in relation to gender. In 1983, when still on the Court of Appeal, in a book co-edited with Rosalie Abella, Justice L'Heureux-Dubé offered the following rather prescient comments on trends in custody and access law: "In the field of child custody, the recognition of equal rights of both parents, coupled with the increasing number of women in the work force and the assertion of fathers' rights, may complicate further the delicate task of the judge in awarding custody."[15] Indeed, since the early 1980s, there have been notable shifts in child custody law, including less reliance on gender-based assumptions, greater indeterminacy concerning the best interests of the child principle, a gender-neutral approach to equality, and less recognition of the sexual division of labour related to children. At the same time, the importance of fathers to children's well-being was being elevated in social science and legal discourse, as well as touted by the fathers' rights movement.[16]

Already, then, before her appointment to the Supreme Court of Canada, Justice L'Heureux-Dubé was observing that the determination of the best interests of the child occurred within a complex and changing social context, one that included emerging equality rights discourse, socio-economic changes related to gender, and political claims by fathers to "equal" rights in relation to children. In that same 1983 article, she also noted the increasing use of experts in child custody determinations, including social workers, psychologists, and psychiatrists, as well as processes such as mediation and assessments. She identified the rising emphasis on the continuity and quality

of the relationship between the child and the custodial parent, whether biological or psychological, as reflected in the *Re Moores and Feldstein* case,[17] and noted that the access rights of non-custodial parents had been challenged.[18] She also observed that joint custody was an issue of continuing concern. These somewhat contradictory trends were to form the basis for controversial custody debates during the later 1980s and 1990s, which in turn set the scene for some of the cases that she dealt with on the Supreme Court of Canada.

In her more recent writing during the 1990s, Justice L'Heureux-Dubé emphasized that judicial notice of social science research and data might prove an invaluable tool to assist judges in "the journey towards equality" in family law.[19] She also urged that parties not be required to present expert testimony in all cases; rather, she suggested that family law judges have an obligation to inquire into and take note of relevant social data or research as they assess the evidence concerning the actual relationships of parents and children.[20] This responsibility is particularly important given that family law, in contrast to many areas of law, involves prospective rather than retrospective "evaluations of a continuum of events and interactions which extend well beyond the date of adjudication."[21] For instance, she noted that social science research can reveal the potential impact of a custody or access decision, such as a joint custody award, on the children, in a manner that an individual judge cannot predict based on an assessment of the facts alone. Her own, often lengthy, decisions that invoke scholarly literature in some detail, reflect this approach.[22] That said, Justice L'Heureux-Dubé emphasized that the use of social framework evidence was not a substitute for dealing with the evidence properly placed before a judge, nor should it dictate the judge's decision in assessment of the evidence.[23]

Justice L'Heureux-Dubé has emphasized that social science evidence is important in ensuring that jurists do not present their own vision of what is right for families as an "objective" truth. One might, of course, counter with the observation that the claims to objectivity often made by social scientists may be overrated.[24] However, in her actual decisions, she did not fall into the trap of assuming that all social science evidence generated absolute "truths." For instance, many legal experts now routinely state that social science research finds that contact with both parents is the key factor in ensuring a child's well-being after separation or divorce, and that joint custody and/or shared parenting orders are therefore to be preferred.[25] Instead, Justice

L'Heureux-Dubé referred to the more nuanced findings in the social science studies, drawing, for instance, on Dr. Judith Wallerstein's work, and emphasizing that these findings constitute a child-centred approach that "recognizes and shows equal concern for children's unique experience of their parents' separation."[26] In the following statement, she used social science knowledge to distance herself subtly, but firmly, from the suggestion of many fathers' rights advocates that equality in this field of law would mean equal numbers of custody awards to fathers and mothers:

> Rather than dictating a concentration of efforts on the fair assignment of custody and access in the period immediately following separation, the best interests principle in these cases mandates emphasis on reducing conflict between the parents, supporting primarily the caregivers, and emphasizing positive ongoing relationships with both parents in a flexible manner over the long term.[27]

As Justice L'Heureux-Dubé then said, this approach was the one she took in custody and access cases such as *Young v. Young*[28] at the Supreme Court of Canada. In a later article, she emphasized—drawing on the Supreme Court of Canada decisions in *Young v. Young* and *P. (D.) v. S. (C.)*[29] on the issue of restrictions to access based on a non-custodial parent's religious activities—that "determination of an appropriate access order is not a question of the non-custodial parent's rights, but rather of what is in the best interests of the child." She added that "a parent's own rights generally will be limited to action which does not interfere with his or her child's best interests."[30]

Justice L'Heureux-Dubé's clearest statement about the relevance of equality, social context, gender, and child custody and access was made in the course of a discussion of her minority opinion in the *Gordon v. Goertz* case[31] on relocation of custodial parents:

> Our decision in *Gordon v. Goertz* was not framed in terms of equality rights. This is not to say, however, that judges must close their eyes to the practical realities of custodial responsibilities in deciding relocation cases. A strict reading of this decision, without any regards to the frequently underestimated personal,

financial and professional sacrifices involved in raising children, might contribute to systematically disadvantage custodial parents. As the majority of custodial parents are women, they may be all the more vulnerable to judicial inattention to the disadvantage they face. An equality-oriented approach would ensure that judges remain alive to these realities when adjudicating such cases.[32]

Overall, Justice L'Heureux-Dubé's analysis of child custody and access law suggests that she felt strongly that it is impossible to consider the best interests of children in isolation from the realities of their parents' lives, especially the social and economic conditions under which their caregivers (often their mothers) operate. These conditions might include financial constraints and abuse, and Justice L'Heureux-Dubé suggested that this type of evidence was worthy of consideration, rather than adopting a more abstract approach. Her approach echoes that of two English researchers, Carol Smart and Bren Neale, who have been studying the impact of legal reforms in this field. Smart and Neale suggest that decisions or outcomes should be derived from the realities of the lives of the people involved, including who the primary caregiver has been, whether both parents have a relationship with the child, and whether there is a climate of coercion and fear. They suggest that the child be placed in a set of relationships and that the quality of those relationships—including a history of caring for the child—be taken into account. Contact should be maintained where possible, but not at the price of coercion.[33]

The scholarly writing of Justice L'Heureux-Dubé reflects the approach that Marlène Cano identified in her 1991 article. In the next section, I consider the extent to which the views expressed in her scholarly writing were reflected in Justice L'Heureux-Dubé's judicial decisions during the 1990s.

### The Supreme Court of Canada Judgments

In the 1990s the Supreme Court of Canada dealt with several highly controversial child custody cases in which Justice L'Heureux-Dubé wrote judgments. The two cases on freedom of religion and access parents decided in 1993 (*Young v. Young* and *P. (D.) v. S. (C.)*) signalled an emerging split within the Court in relation to approaches to child custody and access law, and,

indeed, in relation to the very meanings of "access" and "custody." In general, the meaning of "access" was enlarged, with a corresponding erosion of the rights associated with "custody." These trends had a gendered impact, given that mothers continued to hold custodial responsibilities in a majority of cases, despite the increase in joint custody awards.[34] Justice L'Heureux-Dubé cautioned against the trend to erode custodial authority in her judgments. During this period, her approach to child custody law began to diverge sharply from that of Justice McLachlin, in particular in relation to the impact of the "maximum contact" provision of the *Divorce Act* contained in section 16(10).[35] The emerging split within the Supreme Court became even more pronounced in the 1996 decision in *Gordon v. Goertz* on the relocation of custodial parents, by which time Justice L'Heureux-Dubé's approach was relegated to a minority opinion.

The divided and confusing judgments in the 1993 cases *Young v. Young* and its non-identical "twin" *P. (D.) v. S. (C.)* revealed differences of opinion among the justices on the extent to which access parents should be empowered in relation to custodial parents, as well as on the facts concerning the appropriateness of the non-custodial fathers' approaches to religion in relation to the best interests of their children. In the *P. (D.)* case from Quebec, Justice L'Heureux-Dubé (writing for three out of five majority justices) found that custodial parents had the parental authority to determine religious education until the child was in a position to make up his or her own mind. The access parent was not excluded from the child's life by this authority, but rather could exercise such rights as were not opposed to the exercise of custody by the custodial parent. Overall, she emphasized that the focus must be on the child, not the interests or needs of the parents, and that the right to access is a right designed primarily to benefit children, not parents. Putting strict limits on the circumstances in which it was legitimate for judges to restrict access, for instance requiring that harm to the child be found before restrictions could be made, was "not only contrary to the child's best interests but puts the burden of error on the child."[36] A majority of the Supreme Court affirmed the trial judge's imposition of restrictions on access because the child in this case was disturbed by the father's repeated references to his religious beliefs.

In *Young v. Young*, a common law case emanating from British Columbia, Justice L'Heureux-Dubé elaborated her approach to child custody

and access law in more detail, suggesting that an order of custody entails the right to exercise full parental authority. She was in dissent in her decision to uphold the trial judge's restrictions on the father's access, with Justices La Forest and Gonthier agreeing with her on the result and that the issue of access should be determined on the basis of what is in the best interest of the child. Justice L'Heureux-Dubé did not ignore the maximum contact principle, but she balanced it with other factors related to the best interests of children. While she stated clearly that she favoured generous and unrestricted access in general for non-custodial parents, in this case, the trial judge's determination that the father had crossed the line and engaged in conduct that constituted "indoctrination, enlistment, or harassment" warranted restrictions on his access.[37] As she pointed out, such restrictions would be rare and a child's exposure to different parental faiths or beliefs was generally of value. Here, it was the finding by the trial judge that continuing conflict over religion, including the father's repeated attempts to discuss religious matters with the children against their clearly expressed desires in a manner that profoundly disturbed them, that was contrary to their best interests.[38] For Justice L'Heureux-Dubé, maximum contact was not an unbridled objective but must be curtailed if the best interests of the child required it to be.

Justice L'Heureux-Dubé's most controversial statements in *Young* arose in the context of her general discussion of access. Her analysis was premised on the goal of access being "continuation of a relationship which is of significance and support to the child," but her view was that "access must be crafted to preserve and promote that which is healthy and helpful in that relationship so that it may survive to achieve its purpose."[39] Sometimes this might mean removal or mitigation of the sources of ongoing conflict that threatened the continuation of the meaningful relationship. Her most risky move was to quote a case approvingly that said that the role of the access parent is only that of a very interested observer,[40] a point that flows from her analysis of the authority of the custodial parent. Overall, she followed the lead of social science studies that show the importance of various factors in children's well-being: continuity in children's relationships, lack of conflict, and the importance to children's long-term well-being of protecting the child's relationship with the custodial parent.[41] She emphasized that the studies show that "continued contact may only be in the best interests of the child where parents are not adversarial and where interaction between the child and the

access parent is not beset by conflict."[42] These findings imply that sometimes limits on access are in the best interests of a child.

Justice McLachlin, in contrast, noted that Parliament had seen fit to single out the specific factor of contact with each parent in determining the best interests of children. Further, she stated that *only* to the extent that contact conflicted with a child's best interests should it be restricted. Justice McLachlin also noted that Parliament's decision to maintain maximum contact was amply supported by the literature, which, she said, suggested that children benefited from continued access. Justice McLachlin thus endorsed the trend in favour of the desirability of maximizing contact between the child and each parent. Her view prevailed as the 1990s wound on, notably in the *Gordon v. Goertz* decision on relocation of custodial parents.

In *Young*, Justice L'Heureux-Dubé offered her most extensive analysis of child custody law, reviewing its history and analyzing the impact of current trends such as joint custody. She endorsed the notion that the parent who bears primary responsibility for a child should be provided support by the law. To her, this custodial "right" was not for the benefit of the custodial parent, but rather was designed to enable parents with custodial responsibilities to discharge their responsibilities and obligations to children in their care.[43] Her overall analysis was deeply feminist in the sense that it took account of the complex relationship between norms with laudable ideals and how those norms might operate within the context of a social reality that reflects ongoing gendered inequalities:

> When implementing the objectives of the Act, whether considering joint custody or fashioning access orders, courts, in my view, must be conscious of the gap between the ideals of shared parenting and the social reality of custodial and childcare decisions. Despite the neutrality of the Act, forces such as wage rates, job ghettos and socialization about caregiving still operate in a manner that cause many women to "choose" to take on the caregiving role both during marriage and after divorce.[44]

To feminists such as myself, who feel that criticisms of the rush to shared parenting have too often fallen on deaf ears, both in law reform debates and in courtrooms, Justice L'Heureux-Dubé's grasp of the issue was refreshing:

A corollary of the acceptance of neutral parenting roles is the notion that children after divorce need to maintain contact with both parents. It is now widely assumed to be self-evident in the child's best interests to ensure the non-custodial parent's involvement in the life of the child. One result of these changes has been the emergence of joint custody awards which are predicated explicitly on equality of parental responsibilities and the belief that children's interests are served by maximizing the involvement of both parents in decisions concerning the child.[45]

Her cautionary argument was that

In the face of the enduring tasks and obligations of the custodial parent [*aka* the mother], courts must be wary of any expansion of the traditional rights of the non-custodial parent. The clear risk is that such changes will simply reduce the decision-making power of the custodial parent, without any parallel reduction in the responsibilities.[46]

Nor did Justice L'Heureux-Dubé leave this analysis ungendered. She continued: "This creates no benefit, and may amount to pure disturbance, both to the women who, as a rule, provide the primary care and to the children who must function within such a regime."[47] She noted the ongoing sexual division of labour under which women still perform the majority of childcare labour, even under joint custody orders,[48] and she also pointed to the gendered impact on women of "unending litigation occasioned by disputes over parental authority [which] exacts a financial cost that few custodial parents can bear. It is no secret that the vast majority of such parents are women."[49]

In the 1996 case *Gordon v. Goertz*,[50] Justice L'Heureux-Dubé built on her analysis in *Young* in relation to applications by a custodial parent to relocate geographically, typically very difficult cases because contact arrangements will have to be varied if relocation occurs. In this case, all justices agreed on the result (approving the relocation of the custodial mother), but only Justice La Forest agreed with Justice L'Heureux-Dubé's reasons in full. Justice McLachlin's approach had emerged as the dominant approach on the Court. Justices L'Heureux-Dubé and McLachlin agreed that a change of residence such as the

one in this case constituted a material change of circumstances. However, Justice L'Heureux-Dubé did not agree that once the threshold test had been passed, a reappraisal of the entire custody arrangement was necessary, which was Justice McLachlin's position. For Justice L'Heureux-Dubé, only if the original order were now irrelevant or no longer appropriate would this be so. Nor did she place the emphasis on maximum contact generally being in the best interests of the child in the way that Justice McLachlin did.[51]

This difference of opinion between Justice L'Heureux-Dubé and Justice McLachlin derived from their different approaches in the *Young* case in 1993, something that Justice L'Heureux-Dubé was quite clear about. In *Gordon v. Goertz*, however, she did not articulate a gender-based analysis, instead grounding her reasoning in relation to statutes, case law from Canada and other countries, international law, social science studies, and academic work. For her, custodial power was not a right granted for the benefit of the parent, but rather was designed to enable that parent to discharge her responsibilities to the child. Determination of residence of the child was part of that power. The onus of showing why a move was not in the best interest of the child should therefore rest on the party who opposed the move, the access parent, unless an order or agreement expressly restricted a change of residence. Justice L'Heureux-Dubé delineated several factors that would be relevant to a consideration of the best interests of the child. One such factor would be maximum contact, although she noted the experts were divided on the weight to be given to it.[52] Another factor was "a consideration of the particular role and emotional bonding the child enjoys with his or her primary caregiver" and she noted that there is a growing body of evidence that this relationship may well be the most determinative factor in relation to a child's long-term welfare.[53]

Overall, in cases such as *Young v. Young, Gordon v. Goertz,* and related cases on the *Hague Convention on the Civil Aspects of International Child Abduction*,[54] Justice L'Heureux-Dubé argued (increasingly as a minority voice on the Supreme Court) for recognition of the parental authority of the custodial parent, and is therefore often assessed as being "conservative" or traditionalist in her approach. However, I want to suggest that she adopted this approach not in order to affirm the rights of custodial parents as opposed to those of access parents, but rather from a contextualized child-centred per-

spective that suggested that it would normally be in the best interests of children to affirm the rights of their custodial parents, and thus, as a rule, their caregivers. For instance, in *Young*, she stated, referring to the limits of judicial powers and of law, that "[o]nce a court has determined who is the appropriate custodial parent, it must, indeed it can do no more than, presume that that parent will act in the best interests of the child."[55] She also noted that "[i]t is to avoid the spectre of the child as the field upon which the battle of competing parental rights is played out that the law confirms the authority of the custodial parent."[56]

This approach, which indicates a healthy scepticism about excessive use of law in social engineering, has been criticized by some family law scholars.[57] Indeed, in the context of law reform debates on child custody and access, Justice L'Heureux-Dubé's approach to custody might be characterized as "traditional,"[58] and resistant to the kinds of changes exemplified by joint custody and the (shared) parental responsibility regimes that have been introduced in jurisdictions such as England and Australia, and that are now being considered in Canada.[59]

I would suggest, however, that Justice L'Heureux-Dubé's approach in cases such as *Young* and *Gordon* was not "traditional" in a "conservative" sense, but rather took appropriate account of the social context of parenting, and that she placed the interests of children at the heart of her decisions. Her approach reflected what I have previously called a "realistic" approach to family breakdown and parenting in the "post-divorce family unit." This approach takes account of the fact that circumstances change significantly when families break down, and that the legal system cannot insulate the non-custodial parent from changes in the custodial parent's life such as relocation.[60] As an American judge has said, "Like Humpty Dumpty, a family, once broken by divorce, cannot be put back together in precisely the same way."[61] Protecting a child's relationship with both parents is not always possible. In difficult cases where parents cannot agree on a mutually convenient arrangement that also suits the children, the question is whether to give some presumptive deference to the parent with the main responsibility for the child or to prioritize contact with the other parent. Justice L'Heureux-Dubé has clearly taken the former approach, while always attending to the overriding concern of the best interests of the child. Where the custodial parent's decision is challenged by

the non-custodial parent, she feels that the emphasis must be on deferring to the decision-making responsibilities of the custodial parent, unless there is substantial evidence that those decisions impair the child's, not the access parent's, long-term well-being.

Justice L'Heureux-Dubé has written that she still disagrees with the majority decision in *Gordon v. Goertz* that, in the context of relocation, a fresh assessment of all circumstances of the child and parents was required.[62] She stands by her view that a variation order must start from the premise that the notion of custody entails the right to determine where the child shall live:

> I firmly believe that it is in the best interests of children that a variation of custody only be warranted where the non-custodial parent adduces cogent evidence that the quality of his or her relationship with the child is of such importance to the child's best interests that to prohibit the proposed move will not cause comparable or greater detriment to the child then [sic] to change custody.[63]

In developing her approach in *Young* and *Gordon v. Goertz*, which accords deference to the custodial parent, Justice L'Heureux-Dubé drew, sometimes extensively, on social science literature on the "children of divorce" and feminist and other scholarly literature on the still-gendered patterns of caregiving. While she favoured generous and unrestricted access in general for non-custodial parents, she accepted the need for limits. She endorsed the notion that the parent who bears primary responsibility for a child should be provided support by law. As well, she emphasized the importance of minimizing conflict between parents, noting that such conflict "is the single factor which has consistently been proven to be severely detrimental to children upon separation or divorce."[64] Her approach was that empowering the custodial parent as the decision-maker, rather than distributing authority between two parents, was the way to avoid conflict.

It is clear from Justice L'Heureux-Dubé's custody law decisions—whether one agrees with her or not—that she wanted law to be exercised in a way that took account of and ameliorated inequalities and problems, rather than reinforcing them. That said, her approach has not prevailed as the dom-

inant one within child custody law and law reform debates. Moreover, her decisions have been much criticized. My conclusion will examine some reasons for the negative reception of her work on child custody and access law.

## Conclusion

Justice L'Heureux-Dubé is far better known for her impact, as a Supreme Court of Canada justice, on the family law field of spousal support than for her impact on child custody and access law.[65] Her decision in *Moge v. Moge*, in particular, contributed enormously to the reshaping of spousal support norms during the 1990s, through its development of a compensatory model of support that can address the economic disadvantage often generated by the disproportionate responsibility for childcare and household labour that women carry in marriage or marriage-like relationships.[66] As with her decisions on child custody and access, Justice L'Heureux-Dubé's decisions in the support law field reflect a conscious effort to bring social context to bear on judicial decision-making. Yet her approach to custody and access law has not won the day in the same way that her contributions to the evolution of spousal support law have. Her key Supreme Court decisions on child custody and access have typically been minority opinions. Moreover, recent law reform initiatives have increasingly eroded the content of custody orders and moved towards models that make shared parental responsibilities the normative starting point for decisions about post-separation parenting. This approach tends to detract from decision-making in relation to children that takes social context (e.g., gendered caregiving dynamics) seriously, in favour of a gender-neutral, rights-based approach.[67] As Helen Rhoades has put it, the new shared parenting philosophy involves "replacement of the 'custody and access' framework with a 'symmetrical family' scenario, in which parents who live apart have equal status and are encouraged to continue their pre-separation collaboration."[68] This law reform trajectory also marks a departure from Justice L'Heureux-Dubé's approach to child custody and access law.

Despite the markedly different reception that Justice L'Heureux-Dubé's decisions on spousal support and child custody law appear to have had, her approach in cases such as *Young v. Young* and *Gordon v. Goertz* is actually quite consistent with her judgments in cases such as *Moge*. An excerpt drawn from

her 1997 article "Making Equality Work in Family Law" indicates that she saw her approach as operating consistently across these fields. Speaking about judicial notice, she said:

> In the realm of family law, evidence of social realities, which is sometimes referred to as social framework evidence, can play both a meaningful and a necessary role in combating popular misconceptions. Most importantly, more explicit resort to such evidence by scholars, lawyers and judges alike may lessen the possibility that these misconceptions take on the character of *de facto* conclusions of law, even where such conclusions defy social reality. For instance, reference to the social context may shed sensible light on questions such as the economic consequences of separation or divorce on former spouses, the monetary value of domestic work, the actual costs of raising children, *the primary caregiver's role in the family and the link between access rights and the well-being of children, the impact of parental conflict on children* or the reality of same sex relationships.[69]

Various factors explain why, despite the consistency of her contextualized approach to family law, Justice L'Heureux-Dubé's decision in *Moge* has had greater resonance than her custody decisions with other judges, commentators, and law reformers. These factors include the increasing (re)privatization of economic responsibilities during the 1990s and the relative success of the fathers' rights movement in influencing child custody law reform debates. There has been much commentary recently about the increasing trend in Canadian law and social policy to cut back on social programs and the social safety net while simultaneously downloading increased economic responsibility to the individual, and in particular, to families. The support law trends to enhance (and enforce) the private obligations of parents and former partners to provide for children and ex-partners in financial need arguably fit well within the climate of privatization and non-state responsibilities.[70] From this perspective, the Supreme Court of Canada acknowledgement in *Moge* of women's disproportionate responsibility for children and domestic labour fits as well within a fiscally conservative approach as it does within a feminist approach.

In child custody law, the dominant trend towards shared parenting also arguably supports the privatization trend, to the extent that it is believed that fathers who have more rights in relation to children may be more likely to assume financial support responsibilities for those children.[71] In fact, the Special Joint Committee on Child Custody and Access was established in direct response to Senate discussion of heightened child support obligations. During the 1997 and 1998 law reform debates, some fathers' rights advocates suggested that child support should be tied to access to children as some form of *quid pro quo*. Bill C-22, eventually introduced by the federal government in December 2002,[72] did not go this far. However, it would have eliminated the concepts of "custody" and "access" and adopted to a considerable degree a normative model of shared parental responsibilities, which is a response to the arguments of fathers' rights advocates. If the experience in jurisdictions such as Australia is any indication, the ability of mothers to draw attention in custody disputes to the significance of their responsibility for childcare would be diminished under this new parenting law. More worrying is the evidence that women would experience even more difficulty in seeking protection from violence against themselves and/or their children.[73]

I would suggest that the approach of Justice L'Heureux-Dubé—emphasizing that law should pay attention to women's disproportionate responsibility for children as well as to the prevalence of woman abuse in families, rather than adopting a gender-neutral, formal equality approach that ignores gendered patterns in pre- and post-family structures—has little cachet in the current period of parenting law reform and privatization of economic responsibilities within the family. Her approach, which tends to support the autonomy of custodial mothers in relation to their former partners, rather than reinforcing a "post-divorce family unit" that requires them to collaborate almost as though they had not separated,[74] works against the privatization discourse. The cooler reception of Justice L'Heureux-Dubé's custody and access decisions, in comparison to those on financial support obligations, may thus be explained. She was speaking against the grain in the custody and access field, while, in contrast, her judicial discourse in the financial support area resonated with the tunes of economic restructuring.

Justice L'Heureux-Dubé has been criticized specifically for a number of things in relation to her decisions on child custody and access, including being "conservative" in her emphasis on the authority of custodial parents,

wrong in her decision for the Court in *D.S. v. V.W.*,[75] "extremist and impractical" in her decision in *Gordon v. Goertz*,[76] too interventionist as a judge,[77] and for being biased against fathers. Glen How asked in his comment on Justice L'Heureux-Dubé's 1993 decisions in *Young v. Young* and *P. (D.) v. S. (C.)*: "Is this law, or a feminist social program?"[78] His comments foreshadowed similar attacks by fathers' rights groups. At least one group has lodged complaints with the National Judicial Council against the justices of the Supreme Court of Canada, as well as against Justice L'Heureux-Dubé directly, for their "feminist" slant in decisions that deny men access to children.[79] Similarly, Anne-France Goldwater has suggested that the rights-oriented language of Justice L'Heureux-Dubé in cases such as *Gordon v. Goertz* "essentially empowers mothers and disenfranchises fathers," in contrast to the majority opinion that, according to Goldwater, "soundly rejects [this model], in favour of a child-centered approach in which neither parent is viewed as second class."[80]

These criticisms indicate a shift in the critique of Justice L'Heureux-Dubé's judgments since Cano wrote.[81] In the late 1980s and early 1990s, she was criticized for her non-interventionist approach (albeit perhaps not in relation to family law), whereas now, it is apparently felt that too much intervention has occurred. I would suggest (echoing Cano) that a close examination of Justice L'Heureux-Dubé's decisions in the child custody field shows that her approach must be understood in different terms. It is a child-centered approach, which requires taking into account the gendered nature of childcare and family dynamics. She has consistently emphasized that the best interests of the child are paramount and that statutes giving broad discretion to judges in relation to the best interests principle are not contrary to the *Charter of Rights and Freedoms*. In emphasizing the best interests principle, however, she has been careful to place the interests of children in their social context. She has been willing to take note of the fact that children's interests are often inextricably linked to those of their caregivers, and that those caregivers are often women. This approach is often misunderstood by fathers' rights advocates and others as signalling an inappropriate favouring of women. In fact, it takes social realities that are relevant to children's interests into account. It is consistent with Justice L'Heureux-Dubé's tendency to respect the decisions of trial judges who are typically more able to determine the realities of a family law case because they have had the opportunity to observe the parties as witnesses (unless of course a clear error had occurred).

Overall, Justice L'Heureux-Dubé tried in her custody and access decisions, as in her other work, to redress false assumptions that social equality has already been achieved in family relations. She recognized that the quest for social equality is a long-term struggle that has a sometimes complicated relationship with powerful, but often inadequate, ideas of formal legal equality. She has consistently pointed out that "equality is a term that, in a vacuum, means nothing."[82] In other words, equality analysis must proceed in a manner that takes social context into account, and that does not require treating people who are differently situated in the same way. In the field of custody, this means that the differential positions of women and men within most families must be taken into account, including when parents cannot reach agreement about custody decisions. Otherwise the best interests of children, and of the caregivers who are responsible for them, will not be assured. We can only hope that as new wave statutes on post-separation parenting are interpreted, the insights that Justice L'Heureux-Dubé offered in her writing and in her judgments in cases such as *Young v. Young* and *Gordon v. Goertz* will not be lost.

### Endnotes

1 Claire L'Heureux-Dubé, "Making Equality Work in Family Law" (1997) 14 Can. J. Fam. L. 103 at 111 (emphasis in original).
2 Marlène Cano, "Claire L'Heureux-Dubé et le droit de la famille: Juge innovateur?... Innovatrice" (1991) 98 Queen's Quarterly 131–59.
3 *Ibid.* at 134.
4 *Ibid.* at 154, 155.
5 *Ibid.* at 155.
6 *Ibid.* at 154.
7 L'Heureux-Dubé, "Making Equality Work in Family Law," *supra* note 1 at 105.
8 *Ibid.*
9 See, e.g., Mimi Liu, "A 'Prophet With Honour': An Examination of the Gender Equality Jurisprudence of Madam Justice Claire L'Heureux-Dubé of the Supreme Court of Canada" (2000) 25 Queen's L.J. 417 at 431–32.
10 E.g., Claire L'Heureux-Dubé, "A Response to Remarks by Dr. Judith Wallerstein on the Long-Term Impact of Divorce on Children" (1998) 36(3) Family and Conciliation Courts Rev. 384 at 384.
11 *Ibid.* at 387.
12 *Ibid.*

13 *Ibid.* Here she quoted from her own judgment in *Young v. Young*, [1993] 4 S.C.R. 3 at 99.
14 See, e.g., Susan B. Boyd, *Child Custody, Law, and Women's Work* (Toronto: Oxford University Press, 2003).
15 Claire L'Heureux-Dubé, "Family Law in Transition: An Overview," in Rosalie S. Abella and Claire L'Heureux-Dubé, eds., *Family Law: Dimensions of Justice* (Toronto: Butterworths, 1983) 301 at 307.
16 For a review of these trends, see Boyd, *Child Custody, Law, and Women's Work*, *supra* note 14.
17 [1973] 3 O.R. 921, 38 D.L.R. (3d) 641 (C.A.).
18 L'Heureux-Dubé, "Family Law in Transition," *supra* note 15 at 307. Here she referred to the influential book by Joseph Goldstein, Anna Freud, and Albert J. Solnit, *Beyond the Best Interests of the Child* (New York: The Free Press, 1973, 1979). It is interesting to note how quickly this emphasis on the relationship between child and custodial parent went out of vogue.
19 L'Heureux-Dubé, "Making Equality Work in Family Law," *supra* note 1 at 106.
20 *Ibid.* at 113, 120.
21 *Ibid.* at 114.
22 The length of Justice L'Heureux-Dubé's decisions has been much criticized, perhaps especially by those who are critical of her approach to custody and access, e.g., Glen W. How, "Custody and Access: The Supreme Court Compounds Confusion" (1994) 11 Can. Fam. L.Q. 109 at 114.
23 L'Heureux-Dubé, "Making Equality Work in Family Law," *supra* note 1 at 120.
24 See Martha A. Fineman, "Dominant Discourse, Professional Language, and Legal Change in Child Custody Decisionmaking" (1988) 101 Harv. L. Rev. 727.
25 For example, one of the intervenors in the *Gordon v. Goertz* case, [1996] 2 S.C.R. 27, stated in its factum: "It is now widely assumed to be self-evident that it is in the child's best interests to ensure the access parent's involvement in the life of the child": Children's Lawyer of Ontario, Factum, unpublished, at paras. 21–22.
26 L'Heureux-Dubé, "A Response," *supra* note 10 at 389.
27 *Ibid.* at 388.
28 *Supra* note 13.
29 [1993] 4 S.C.R. 141.
30 L'Heureux-Dubé, "Making Equality Work in Family Law," *supra* note 1 at 124.
31 *Supra* note 25.
32 L'Heureux-Dubé, "Making Equality Work in Family Law," *supra* note 1 at 125–26.
33 Carol Smart and Bren Neale, *Family Fragments* (Cambridge, U.K.: Polity Press, 1999).

34 For a deeper analysis, see Boyd, *Child Custody, Law, and Women's Work*, *supra* note 14, esp. ch. 6.
35 *Divorce Act*, R.S.C. 1985, c. 3 (2d Supp.), s. 16(10).
36 *P. (D.) v. S. (C.)*, *supra* note 29 at 178.
37 *Young*, *supra* note 13 at 98, 106.
38 *Ibid.* at 106.
39 *Ibid.* at 60.
40 *Ibid.* at 58.
41 *Ibid.* at 67.
42 *Ibid.* at 82.
43 *Ibid.* at 99.
44 *Ibid.* at 49.
45 *Ibid.* at 44.
46 *Ibid.* at 51.
47 *Ibid.*
48 *Ibid.* at 50.
49 *Ibid.* at 52.
50 *Supra* note 25.
51 For further analysis, see ch. 6 of Boyd, *Child Custody, Law, and Women's Work*, *supra* note 14.
52 *Gordon v. Goertz*, *supra* note 25 at paras. 108–10.
53 *Ibid.* at para.121.
54 *W. (V.) v. S. (D.)*, [1996] 2 S.C.R. 108; *Thompson v. Thompson*, [1994] 3 S.C.R. 551.
55 *Young*, *supra* note 13 at 42.
56 *Ibid.* at 52.
57 Rollie Thompson, "Relocation and Re-Litigation: After *Gordon v. Goertz*" (1999) 16 Can. Fam. L.Q. 461 at 472–73; Martha Bailey, "The Right of a Non-Custodial Parent to an Order for Return of a Child Under the *Hague Convention*" (1996) 13 Can. J. Fam. L. 287. But see Smart and Neale, *Family Fragments*, *supra* note 33.
58 Indeed, Justice L'Heureux-Dubé herself used this language. See also Shauna Van Praagh's discussion in "Religion, Custody, and a Child's Identities" (1997) 35 Osgoode Hall L.J. 320 at 326–28, 335.
59 See John Dewar and Stephen Parker, "The Impact of the new Part VII *Family Law Act* 1975" (1999) 13 Austl.J.Fam.L. 96; Helen Rhoades, "The Rise and Rise of Shared Parenting Laws: A Critical Reflection" (2002) 19(1) Can. J. Fam. L. 75. The Government of Canada introduced Bill C-22, *An Act to amend the Divorce Act, the Family Orders and Agreements Enforcement Assistance Act, the*

*Garnishment, Attachment and Pension Diversion Act and the Judges Act and to amend other Acts in consequence,* in December 2002, but it died on the order paper when Parliament was prorogued.

60 See analysis of Justice Rosalie Abella in *McGyver v. Richards* (1995), 11 R.F.L. (4th) 432 at 445 (Ont. C.A.).

61 *Tropea v. Tropea; Kenward v. Brown* (1996), 87 N.Y. (2d) 727, Titone J. at 740 (N.Y.C.A.).

62 L'Heureux-Dubé, "Making Equality Work in Family Law," *supra* note 1 at 125. Although she was the minority opinion in *Gordon v. Goertz* on relocation of custodial parents, her approach held the day in the unanimous decision in the *Hague Convention* case released on the same day. In *W. (V.) v. S. (D.), supra* note 54, Justice L'Heureux-Dubé held for the Court that the mandatory return mechanism provided by the Convention and the relevant Quebec legislation was aimed at the enforcement of custody, not access. Thus, the mechanism did not apply when a custodial parent proposed to relocate with a child, even if the access rights of the other parent were thereby infringed. However, six justices concurred with Justice L'Heureux-Dubé, subject only to a reservation as to her views on the rights and obligations of custodial parents, thus leaving some uncertainty as to the authority of the judgment: Martha Bailey, "The Right of a Non-Custodial Parent to an Order for Return of a Child Under the *Hague Convention*," *supra* note 57 at 314.

63 L'Heureux-Dubé, "Making Equality Work in Family Law," *supra* note 1 at 125.

64 *Young, supra* note 13 at 99–100.

65 Mimi Liu does not even mention a child custody decision in her review of Justice L'Heureux-Dubé's jurisprudence in the family law field. "A 'Prophet With Honour'," *supra* note 9 at 457–62.

66 [1992] 3 S.C.R. 813.

67 See Boyd, *Child Custody, Law, and Women's Work, supra* note 14, ch. 8.

68 Rhoades, "The Rise and Rise of Shared Parenting Laws," *supra* note 59.

69 L'Heureux-Dubé, "Making Equality Work in Family Law," *supra* note 1 at 111 (emphasis added).

70 See Brenda Cossman, "Developments in Family Law: The 1998–99 Term" (2000) 11 Sup.Ct.L.Rev. 433; Brenda Cossman, "Family Feuds: Neo-Liberal and Neo-Conservative Visions of the Reprivatization Project," in Brenda Cossman and Judy Fudge, eds., *Privatization, Law, and the Challenge to Feminism* (Toronto: University of Toronto Press, 2002) 169.

71 Boyd, *Child Custody, Law, and Women's Work, supra* note 14, ch. 9.

72 Bill C-22, *supra* note 59.

73 Rhoades, "The Rise and Rise of Shared Parenting Laws," *supra* note 59.

74 The phrase, the "post-divorce family unit," first appeared in Canadian jurisprudence at the Supreme Court of Canada level of *Thibaudeau v. Canada (M.N.R.)*, [1995] 2 S.C.R. 627. Cory and Iacobucci JJ. used the term to describe the restructured nuclear family unit of access parent, custodial parent, and children, and decided that the inclusion/deduction regime of the *Income Tax Act* in fact conferred a benefit to the "unit" as a whole and was therefore not discriminatory. L'Heureux-Dubé and McLachlin JJ. dissented in this case. Dawn M. Bourque has examined the ways in which new trends in custody and access law similarly "reconstruct" the nuclear family after it has split up: "'Reconstructing' the Patriarchal Nuclear Family: Recent Developments in Child Custody and Access in Canada" (1995) 10 C.J.L.S. 1.
75 Bailey, "The Right of a Non-Custodial Parent," *supra* note 57 at 314.
76 Thompson, "Relocation and Re-Litgation," *supra* note 57 at 473.
77 There has been an interesting shift since the late 1980s and early 1990s, when she was criticized for not being interventionist (see Cano, "Claire L'Heureux-Dubé," *supra* note 2.)
78 How, "Custody and Access," *supra* note 22 at 121.
79 Janice Tibbetts, "Fathers' group to file complaint against high court; All nine justices: Challenge targets 'feminist' slant of Supreme Court" *National Post*, (13 March 1999) A6. The group in question was the National Shared Parenting Association.
80 Anne-France Goldwater, "'Long Distance' Custody Cases: Are the Child's Best Interests Kept at a Distance?" (1998) 16 Can.Fam.L.Q. 145 at 186.
81 Cano, "Claire L'Heureux-Dubé," *supra* note 2.
82 L'Heureux-Dubé, "Making Equality Work in Family Law," *supra* note 1 at 107.

Eleven

*Baker* revisité : Le contrôle judiciaire de décisions humanitaires où l'intérêt de l'enfant est en cause

YVES LE BOUTHILLIER*

Introduction

Madame la juge Claire L'Heureux-Dubé a su rallier à son point de vue cinq des sept juges de la Cour suprême du Canada[1] entendant l'affaire *Baker*[2], et créer un précédent qui a eu des répercussions importantes et durables sur le droit de l'immigration, le droit administratif en général, le rôle du droit international en droit canadien et la protection des droits et des intérêt des enfants. Ce chapitre examine le dernier aspect de cette décision. Deux développements récents, l'un jurisprudentiel et l'autre législatif, justifient notre propos.

1) D'une part, dans l'affaire *Suresh*[3], la Cour suprême du Canada a réexaminé sa décision dans l'affaire *Baker* dans le but de restreindre l'étendue du contrôle judiciaire qu'elle semblait préconiser dans cette affaire. La Cour d'appel fédérale, dans deux décisions ultérieures, les arrêts *Legault*[4] et *Hawthorne*[5], tente de préciser à son tour, à la lumière des deux arrêts de la Cour suprême, les contours du contrôle judiciaire en matière d'immigration quand l'intérêt d'un enfant est en jeu. Depuis l'arrêt *Baker*, la question de l'intérêt de l'enfant a fait l'objet d'un grand nombre de décisions rendues par la Cour fédérale de première instance. Pour les fins de ce chapitre, notre étude de la jurisprudence se limitera à un examen des enseignements qu'on peut tirer des quatre affaires précitées.

2) D'autre part, la nouvelle *Loi sur l'immigration et la protection des réfugiés*[6] intègre un élément clé de l'affaire *Baker*, en incluant pour la première fois dans une loi canadienne de l'immigration des dispositions reconnaissant expressément « l'intérêt supérieur de l'enfant » comme un facteur à prendre en ligne de compte dans la prise de décisions de nature humanitaire. Il semble donc opportun de s'interroger, en conclusion, sur les effets possibles de cette nouvelle loi sur l'intérêt de l'enfant.

### I. La pondération comme élément du contrôle judiciaire dans l'affaire *Baker* (Cour suprême du Canada)

Dans l'affaire *Baker*, la Cour suprême devait réviser le refus d'un agent d'immigration d'exempter madame Baker, pour des raisons humanitaires, de l'obligation prévue par la loi de se trouver à l'extérieur du Canada au moment de présenter sa demande de résidence permanente[7]. Comme le note madame la juge L'Heureux-Dubé, de telles décisions ont généralement «des conséquences capitales sur l'avenir des personnes visées»[8], car le fait d'accorder ou ne pas accorder cette dispense «détermine si une personne qui est au Canada, mais qui n'a pas de statut, peut y demeurer ou sera tenue de quitter l'endroit où elle s'est établie»[9]. La Cour a retenu la «raisonnabilité *simpliciter*» comme norme de contrôle judiciaire appropriée pour des décisions de cette nature[10]. La Cour peut donc faire preuve de moins de retenue dans son examen d'une décision que si la norme avait été «la décision manifestement déraisonnable». Alors que cette dernière règle n'entraîne l'annulation d'une décision que si la décision a été «prise arbitrairement ou de mauvaise foi», «n'est pas étayée par la preuve» ou si «le ministre a omis de tenir compte des facteurs pertinents»[11], la norme de la «décision raisonnable» permet d'annuler une décision «qui, dans l'ensemble, n'est étayée par aucun motif capable de résister à un examen assez poussé»[12]. Comme nous le verrons ci-dessous, une lecture des motifs rédigés par madame la juge L'Heureux-Dubé suggère que l'examen du caractère raisonnable d'une décision de nature humanitaire ne se limite pas à vérifier si l'agent a tenu compte de tous les facteurs pertinents. Encore faut-il également que la décision de l'agent soit fondée sur une pondération raisonnable de certains facteurs clés.

Avant de prendre sa décision, l'agent doit considérer toute une série de facteurs. Les facteurs de nature humanitaire font référence principalement

aux effets de la décision pour la personne qui présente la demande. Par exemple, dans l'affaire *Baker*, madame la juge L'Heureux-Dubé statue que les facteurs suivants sont pertinents pour décider si madame Baker peut ou non faire sa demande de résidence permanente au Canada ou si elle doit être déportée en Jamaïque : le fait qu'elle soit malade, les incertitudes quant à sa possibilité de recevoir les soins dont elle a besoin en Jamaïque, son séjour de longue durée au Canada et la séparation de certains de ses enfants au moins qui résulterait de sa déportation[13]. L'agent tient aussi compte d'autres considérations reliées à l'intérêt public. Ainsi, dans l'affaire *Baker*, l'agent a pris note, entre autres, du fait que madame Baker était demeurée illégalement au Canada pendant une longue période de temps[14]. D'autres facteurs, enfin, ont trait aux conséquences de la décision pour d'autres personnes que celle qui fait la demande[15], par exemple l'effet d'une déportation sur la santé physique ou mentale d'un conjoint, d'une conjointe ou des enfants.

Après avoir identifié les facteurs pertinents dans le dossier devant lui, l'agent doit déterminer le poids à accorder à chacun de ces facteurs. L'importance d'un facteur précis étant généralement déterminée par rapport à l'ensemble des facteurs considérés, en tenant compte du contexte particulier de chaque affaire, l'agent d'immigration jouit normalement d'une marge de manœuvre considérable dans la pondération des facteurs pertinents. Un facteur peut avoir une grande importance dans une situation donnée, mais très peu dans une autre. La latitude énorme dont dispose habituellement le décideur dans la pondération de facteurs de décision pertinents a été reconnue en droit administratif dans d'autres domaines que celui de l'immigration. Dans l'affaire *Southam*, par exemple, la Cour suprême du Canada a refusé de considérer comme déraisonnable la décision du Tribunal de la concurrence, au motif que ce dernier n'avait pas accordé suffisamment de poids à un facteur précis. La Cour déclare que :

> [...] l'appréciation des divers éléments d'un critère de pondération doit, *dans une large mesure*, être laissée au pouvoir discrétionnaire du décideur. L'objet même d'un critère comportant de multiples facteurs, tel celui qu'a utilisé le Tribunal pour déterminer les dimensions du marché pertinent pour ce qui est du produit, est de permettre au juge des faits de rendre justice dans des situations de fait particulières.

> *En règle générale*, dans des affaires comme celle qui nous occupe, il est possible que le fait d'accorder une importance primordiale ou prépondérante à un facteur donné ne favorise pas la réalisation des buts et des objectifs de la loi. Il est impossible d'affirmer, en droit, que la preuve de l'interchangeabilité fonctionnelle devrait avoir plus de poids que d'autres types de preuve. La question est donc de savoir si l'attention accordée par le Tribunal à l'interchangeabilité fonctionnelle était raisonnable compte tenu des faits de l'espèce [nos italiques][16].

Dans cette affaire, la Cour a conclu que le facteur en question n'avait en droit ni un caractère décisif, ni plus de poids que d'autres facteurs. La Cour, toutefois, n'exclut pas expressément la possibilité que dans certains types de décisions, on puisse accorder à certains facteurs, étant donné leur nature, un poids plus important qu'à un ou plusieurs autres facteurs lors de la pondération de l'ensemble des facteurs. À la lecture de l'affaire *Baker*, il ressort que c'est précisément un cas où la Cour a placé un facteur, celui de l'intérêt supérieur de l'enfant, dans une catégorie particulière, en déclarant sans équivoque que ce facteur joue toujours un rôle important dans les décisions de nature humanitaire. S'appuyant sur les objectifs de la loi, sur les instruments internationaux dont le Canada est signataire et sur les lignes directrices adoptées par le ministre, madame la juge L'Heureux-Dubé conclut :

> [...] [P]our que l'exercice du pouvoir discrétionnaire respecte la norme du caractère raisonnable, le décideur devrait considérer l'intérêt supérieur des enfants comme un facteur important, *lui accorder un poids considérable*, et être réceptif, attentif et sensible à cet intérêt [nos italiques][17].

En l'espèce, il est indiqué dans les notes de l'agent, que la Cour considère comme les motifs de la décision, que «les enfants souffriraient si elle était renvoyée»[18]. L'agent ajoute un peu plus loin : «Il n'existe pas d'autres facteurs d'ordre humanitaire que ses QUATRE ENFANTS NÉS AU CANADA.»[19] Contrairement à la juge de première instance, qui avait «conclu que la preuve démontrait que les enfants constituaient un facteur important dans le processus décisionnel»[20], madame la juge L'Heureux-Dubé semble d'avis que non

seulement «l'agent n'a prêté aucune attention à l'intérêt des enfants de Mme Baker»[21], mais il a refusé la demande en partie à cause du nombre élevé de ses enfants nés au Canada[22]. Autrement dit, si un poids a été accordé aux enfants, ce n'est pas pour veiller à leurs intérêts, mais plutôt pour justifier le renvoi de la mère! Toutefois, en fin de jugement, elle semble indiquer que l'erreur de l'agent n'a pas été d'ignorer totalement l'intérêt de l'enfant, mais plutôt d'en avoir «minimisé» l'importance[23].

En supposant, pour les fins de l'analyse, que madame la juge L'Heureux-Dubé soit d'avis que l'agent n'a pas considéré l'intérêt des enfants dans l'affaire *Baker*, elle ne suggère aucunement dans ses motifs qu'elle aurait jugé la décision de l'agent raisonnable s'il avait pris en compte l'intérêt des enfants au même titre que d'autres facteurs. La citation précitée, reprise ailleurs dans le jugement, révèle clairement que non seulement il faut considérer l'intérêt des enfants (car c'est un facteur important), mais qu'en plus l'agent doit accorder une importance considérable à ce facteur dans sa prise de décision[24]. Notons que c'est d'ailleurs l'interprétation qu'a retenue la Cour d'appel fédérale dans l'affaire *Suresh*. Monsieur le juge Robertson écrit, au nom de la Cour :

> Ce qui est important en ce qui concerne l'arrêt *Baker*, précité, c'est que la Cour suprême n'a pas conclu que la décision du ministre devait être annulée parce qu'elle ne tenait pas compte d'un facteur pertinent, soit l'intérêt des enfants de Mme Baker qui étaient nés au Canada. Ce qu'établit l'arrêt *Baker*, précité, c'est que la décision doit être infirmée si un poids «insuffisant» a été attribué à un facteur pertinent. Comme l'intérêt des enfants avait été «minimisé», l'exercice du ministre de son pouvoir discrétionnaire a été jugé «déraisonnable».[25]

Toutefois, et ce point est fondamental dans la décision *Baker*, le «poids considérable» de l'intérêt de l'enfant ne signifie pas, selon madame la juge l'Heureux-Dubé, que cet intérêt «l'emportera toujours sur d'autres considérations, ni qu'il n'y aura pas d'autres raisons de rejeter une demande d'ordre humanitaire même en tenant compte de l'intérêt des enfants»[26]. En d'autres mots, il ne s'agit pas dans chaque cas de déclarer la «primauté» de ce facteur sur tous les autres, ni d'exclure des scénarios où d'autres facteurs l'emporteront sur l'intérêt de l'enfant. Comme le souligne la Cour suprême du

Canada dans l'affaire *Southam*, où elle renverse la décision de la Cour d'appel fédérale rendue par monsieur le juge Robertson, une telle approche rendrait futile l'exercice de la pondération :

> Il serait extrêmement dangereux d'accorder à certains types de preuve un poids décisif, par exemple en disant que la preuve de l'existence de la concurrence interindustrielle est toujours suffisante pour établir que deux sociétés exercent leurs activités sur le même marché. Un critère serait artificiel et impossible à appliquer s'il prétendait accorder un poids fixe à certains facteurs, par exemple si, suivant ce critère, la preuve de la concurrence interindustrielle avait 10 fois plus de poids dans les délibérations du Tribunal que la preuve de ressemblances physiques entre les produits en cause. Les choses de ce genre ne sont pas facilement quantifiables [...][27]

Soulignons aussi que la décision n'exclut pas la possibilité de conclure, dans certains cas, probablement assez rares, que le meilleur intérêt de l'enfant serait mieux servi si l'un ou les deux parents étaient déportés.

En définitive, le jugement *Baker* ne donne pas carte blanche au tribunal pour réévaluer la décision de l'agent. Elle permet toutefois au tribunal d'examiner la pondération des facteurs afin de déterminer si, au moment de sa décision, l'agent a soupesé l'intérêt de l'enfant et a accordé à ce facteur tout le poids qu'il mérite. En pratique, selon le précédent établi dans l'arrêt *Baker*, cela signifie qu'une décision sera considérée déraisonnable si le décideur

1) ne tient aucunement compte de l'intérêt des enfants;
2) tient compte de l'intérêt des enfants, mais accorde peu d'importance à ce facteur;
3) prétend accorder une importance considérable à l'intérêt de l'enfant, mais omet d'étayer cette prétention dans la décision;
4) prétend accorder une importance considérable à l'intérêt de l'enfant, mais considère ce facteur moins importants que d'autres dans les circonstances, sans pour autant donner d'explications raisonnables pour justifier ce point de vue.

La nature du contrôle judiciaire en matière des décisions humanitaires où l'intérêt d'un enfant est en jeu suggéré dans l'arrêt *Baker* semble des plus

raisonnables lorsqu'on considère l'effet potentiel de ces décisions sur un tiers. Après tout, l'enfant d'un parent susceptible d'être déporté est très souvent aussi touché par le renvoi de son parent que le parent même. En effet, cet enfant n'a guère d'autres choix que de suivre le parent dans un pays étranger, qu'il n'a peut-être jamais visité auparavant, dont il ignore peut-être la langue et où les systèmes d'éducation, les services de santé et les services sociaux sont peut-être moins développés qu'au Canada. Dans l'alternative où l'enfant ne suit pas le parent, la séparation du parent risque de causer à l'enfant un préjudice émotionnel. Dans ces circonstances, étant donné surtout que l'enfant n'est aucunement responsable de la situation, il est normal que les tribunaux s'assurent que le décideur accorde une grande importance à son intérêt.

## II. La pondération éliminée du contrôle judiciaire dans l'affaire *Suresh* (Cour suprême du Canada)

La Cour suprême du Canada, dans l'affaire *Suresh*, commente sur l'étendue du contrôle judiciaire. Ce n'est pas tellement pour les fins de sa décision, mais parce que la Cour juge important d'aborder cette question «afin d'aider les tribunaux qui seront appelés ultérieurement à contrôler une décision ministérielle»[28].

La Cour déclare expressément qu'il n'appartient pas aux tribunaux de remettre en question la pondération du décideur :

> La première question consiste à déterminer quelle norme de contrôle doit être appliquée à la décision ministérielle portant qu'un réfugié constitue un danger pour la sécurité du Canada. Nous souscrivons à l'opinion du juge Robertson selon laquelle le tribunal de révision doit faire preuve de retenue à cet égard et annuler la décision discrétionnaire seulement si elle est manifestement déraisonnable parce qu'elle aurait été prise arbitrairement ou de mauvaise foi, qu'elle n'est pas étayée par la preuve ou que la ministre a omis de tenir compte des facteurs pertinents. *Le tribunal de révision ne doit ni soupeser à nouveau les différents facteurs ni intervenir uniquement parce qu'il serait arrivé à une autre conclusion [...] Il s'ensuit que la pondération des facteurs pertinents ne ressortit pas au tribunal appelé à contrôler l'exercice du pouvoir discrétionnaire ministériel* (voir, par exemple, *Pezim c. Colombie-Britannique (Superintendent of*

> Brokers), [1994] 2 R.C.S. 557 à la p. 607, où le juge Iacobucci a expliqué que le tribunal de révision doit s'abstenir de modifier une décision rendue dans l'exercice d'un «vaste pouvoir discrétionnaire», sauf si l'auteur de cette décision «a commis une erreur de principe dans l'exercice de son pouvoir discrétionnaire ou [s'il] l'a exercé d'une façon arbitraire ou vexatoire» [nos italiques][29].

Si la Cour en était restée là, il aurait été tout à fait raisonnable de déduire que les limites posées par la Cour au contrôle judiciaire ne s'appliquent qu'à la norme de contrôle appliquée dans l'affaire *Suresh*, soit la norme du «manifestement déraisonnable». Une grande retenue étant de rigueur en vertu de cette norme, la Cour vérifie simplement si les facteurs pertinents ont été pris en considération. Cependant, la Cour ajoute trois paragraphes sur l'affaire *Baker*, répondant ainsi à l'invitation de monsieur le juge Robertson de la Cour d'appel fédérale dans l'affaire *Suresh* de clarifier la portée de *Baker*. Le juge Robertson s'était alors exprimé comme suit :

> [...] la plupart des tribunaux ont tenu pour acquis qu'ils n'ont pas compétence pour annuler une décision exécutive simplement parce qu'ils auraient pondéré les intérêts en cause ou apprécié la preuve différemment. Il se pourrait bien que le droit ait subi une réforme radicale avec le prononcé de l'arrêt *Baker*, précité. Mais je ne suis pas convaincu que c'est le cas. Si la Cour suprême s'engage dans un changement fondamental des règles de droit, elle le précise habituellement en écartant expressément ses décisions antérieures. Quoi qu'il en soit, on ne peut ignorer l'arrêt *Baker*, même si l'un de ses éléments cruciaux constitue une remarque incidente.[30]

Les extraits les plus pertinents de la décision de la Cour suprême dans *Suresh* sur l'affaire *Baker* sont les suivants :

> Dans le récent arrêt *Baker*, précité, notre Cour n'a pas dérogé à cette opinion [...] Dans cette affaire, notre Cour a également indiqué que son analyse «ne devrait pas être considérée comme une diminution du niveau de retenue accordé aux décisions de

nature hautement discrétionnaire» (par. 56) et, qui plus est, que l'obligation du ministre de tenir compte de certains facteurs «ne donne au demandeur aucun droit à un résultat précis ou à l'application d'un critère juridique particulier» (par. 74). Dans la mesure où notre Cour a contrôlé l'exercice du pouvoir discrétionnaire du ministre dans cette affaire, sa décision se fondait sur l'omission du délégataire du ministre de se conformer à des lignes directrices établies par le ministère lui-même, telles qu'elles se dégageaient des objectifs de la Loi ainsi que des obligations découlant de conventions internationales et, surtout, des directives destinées aux agents d'immigration.

C'est dans ce contexte qu'il faut interpréter les passages de *Baker* où il est question de l'« importance accordée » à certains facteurs (par. 68 et 73–75). Il n'incombait à personne d'autre qu'au ministre d'accorder l'importance voulue aux facteurs pertinents. Cet arrêt n'a pas pour effet d'autoriser les tribunaux siégeant en révision de décisions de nature discrétionnaire à utiliser un nouveau processus d'évaluation, mais il repose plutôt sur une jurisprudence établie concernant l'omission d'un délégataire du ministre de prendre en considération et d'évaluer des restrictions tacites ou des facteurs manifestement pertinents [...][31]

La Cour semble suggérer, dans cet extrait, que sa décision dans l'affaire *Baker* se résume à un constat que la décision de l'agent est «déraisonnable» parce qu'il a omis de suivre les lignes directrices du ministre. Elle confirme la grande discrétion du ministre, à qui seul incombe la responsabilité «d'accorder l'importance voulue aux facteurs pertinents». Pourtant il est clairement précisé dans l'arrêt *Baker* qu'il «faut que le pouvoir discrétionnaire soit exercé conformément aux [...] valeurs fondamentales de la société canadienne»[32], que «les droits des enfants, et la considération de leurs intérêts, sont des valeurs d'ordre humanitaire centrales dans la société canadienne»[33] et que cette considération importante n'est pas reflétée uniquement dans les lignes directrices du ministre, mais aussi dans les objectifs de la loi et dans les instruments internationaux pertinents[34]. En somme, madame la juge L'Heureux-Dubé n'a pas limité son analyse à vérifier si les lignes directrices ont été suivies, loin de là.

Malheureusement des pans importants de son analyse sont oubliés, notamment, ses remarques qu'il faut accorder à l'intérêt de l'enfant «un poids considérable» et que c'est «un facteur décisionnel important». De plus, la Cour semble relire l'arrêt *Baker* comme si elle appliquait la même norme que celle établie dans l'affaire *Suresh*, c'est-à-dire la norme «manifestement déraisonnable», en déclarant que la décision dans *Baker* «repose plutôt sur une jurisprudence établie concernant l'omission d'un délégataire du ministre de prendre en considération et d'évaluer des restrictions tacites ou des facteurs manifestement pertinents»[35]. En somme, on banalise ou on ignore plusieurs aspects de cette décision importante.

Il est navrant que la Cour n'ait pas résisté à la tentation de clarifier certains éléments de l'affaire *Baker* dans le contexte de l'affaire *Suresh*, étant donné la nature très différente de ces dossiers. L'enjeu dans l'affaire *Suresh* n'est rien d'autre que la sécurité de l'État et le refoulement d'une personne risquant la torture, une décision à caractère polycentrique. L'affaire *Baker* a trait plutôt à la prise d'une décision discrétionnaire pour des motifs humanitaires qui peut influer sur l'intérêt des enfants qui se trouvent, malgré eux, souvent directement et gravement touchés par une telle décision. Dans le premier cas, on peut penser que le ministre ou du moins ses conseillers les plus proches joueront un rôle actif dans la prise de décision, alors que dans l'autre cas, en pratique, la décision sera le fait de fonctionnaires à l'échelon intermédiaire, en vertu des pouvoirs qui leur sont délégués. Tel que mentionné précédemment, la norme de contrôle applicable dans ces deux genres de décisions n'est pas la même. De toute évidence, dans l'affaire *Suresh*, la Cour a prêté attention, comme il se doit, aux questions fondamentales directement soulevées dans l'affaire devant elle. La Cour, comme elle le dit dans les passages introductifs de sa décision, devait considérer le difficile équilibre entre les libertés fondamentales et la lutte au terrorisme. Cet arrêt a été rendu peu de temps après les événements marquants du 11 septembre 2001, dans un climat où la population avaient les yeux tournés vers la Cour, en espérant que celle-ci pourrait aider l'État en lui suggérant une orientation utile pour relever les nouveaux défis auxquels il était confronté. Devant l'énormité de cette tâche, il semble que son examen de l'affaire *Baker* soit passé au second plan. À la lecture de l'arrêt rendu par la Cour dans *Suresh*, il appert regrettable que la Cour n'ait pas choisi un contexte plus semblable à celui de l'affaire *Baker* pour préciser la règle énoncée par madame la juge L'Heureux-Dubé.

### III. Les précisions des éléments du contrôle judiciaire dans les affaires *Legault* et *Hawthorne* (Cour d'appel fédérale)

Les affaires *Legault* et *Hawthorne* concernent toutes deux une demande de dispense de l'obligation de présenter une demande de résidence permanente à l'extérieur du Canada pour des motifs humanitaires. Dans la première, M. Legault invoque, notamment, les conséquences de son retour aux États-Unis pour ses sept enfants, dont six sont nés au Canada. Les autorités américaines avaient demandé son extradition, mais sans succès. Si une ordonnance de déportation est rendue à son égard, le demandeur craint que les États-Unis ne l'accusent de fraude et ne l'incarcèrent[36]. En conséquence, le demandeur allègue qu'il pourrait être séparé de ses enfants pendant un long moment et que ses enfants pourraient se trouver dans une situation financière difficile. Le juge Nadon de première instance était peu convaincu que la situation de M. Legault méritait une dispense de la loi, mais il a accepté la demande de contrôle judiciaire uniquement parce qu'il estimait que l'affaire *Baker* ne lui laissait guère le choix de décider autrement.

> [...] je suis d'avis que l'arrêt rendu par la Cour suprême du Canada dans l'affaire *Baker* appelle un certain résultat, et ce résultat est que, sauf les cas exceptionnels, l'intérêt supérieur des enfants doit prévaloir [...] Comme je l'ai indiqué clairement, je ne partage pas l'avis exprimé par la Cour suprême dans l'arrêt *Baker*. Toutefois, je suis lié par cet arrêt et, par conséquent, je suis arrivé à la conclusion que la décision rendue par l'agente Nappi le 16 septembre 1999 doit être annulée. Vu cet arrêt *Baker* de la Cour suprême, force m'est de conclure que la décision de l'agente Nappi est déraisonnable. Elle a pris en compte l'intérêt supérieur des enfants pour arriver à une décision, mais l'on ne peut dire qu'elle a accordé à cet intérêt le «poids considérable» commandé par l'arrêt *Baker*[37].

La Cour d'appel fédérale a rejeté cette analyse, avec raison, indiquant que l'affaire *Baker* «ne dit nulle part, de manière expresse, que la décision de l'agent d'immigration doit être dictée par les enfants»[38]. Elle aurait pu souligner aussi, comme nous l'indiquons plus haut, que madame la juge L'Heureux-Dubé dit clairement l'inverse, à savoir que cet intérêt ne l'emporte

pas toujours. Toutefois, la Cour préfère prendre ses distances de l'affaire *Baker*, indiquant que si le sens retenu par le juge de première instance et par d'autres juges dans des affaires similaires peut paraître «excessif», il s'explique dans une certaine mesure par «certains propos» de madame la juge L'Heureux-Dubé, laquelle laisse planer une «ambiguïté» sur le sens véritable de *Baker*[39]. La Cour d'appel n'indique pas, toutefois, à quels propos de la juge elle fait référence. La Cour rappelle aussi que dès la publication de l'arrêt *Baker*, elle-même avait «exprimé quelques inquiétudes quant à sa portée», citant à cet égard le juge Robertson dans l'affaire *Suresh* :

> On peut se demander comment un tribunal ou un agent administratif obéit à une directive d'attribuer plus de poids à un facteur. Comment une personne peut-elle déterminer si un poids suffisant a été attribué à un facteur sans préjuger ni dicter l'issue d'une décision[40]?

Or, comme nous l'avons expliqué précédemment, madame la juge L'Heureux-Dubé ne s'immisce pas dans la discrétion du décideur en lui imposant un résultat précis chaque fois qu'une décision met en cause l'intérêt d'un enfant. Son approche ne trouve toutefois pas preneur dans l'affaire *Legault*. S'appuyant sur la décision de la Cour suprême du Canada dans *Suresh*, la Cour conclut que les tribunaux saisis d'une demande de révision judiciaire n'ont pas à se mêler aux exercices de pondération :

> La Cour suprême, dans *Suresh*, nous indique donc clairement que *Baker* n'a pas dérogé à la tradition qui veut que la pondération des facteurs pertinents demeure l'apanage du ministre ou de son délégué. Il est certain, avec *Baker*, que l'intérêt des enfants est un facteur que l'agent d'immigration doit examiner avec beaucoup d'attention. Il est tout aussi certain, avec *Suresh*, qu'il appartient à cet agent d'attribuer à ce facteur le poids approprié dans les circonstances de l'espèce. Ce n'est pas le rôle des tribunaux de procéder à un nouvel examen du poids accordé aux différents facteurs par les agents. Bref, l'agent d'immigration doit se montrer «réceptif, attentif et sensible à cet intérêt» (*Baker*, para. 75), mais une fois qu'il l'a bien identifié et défini, il lui

appartient de lui accorder le poids qu'à son avis il mérite dans les circonstances de l'espèce [...] L'arrêt *Baker* n'entraîne pas une présomption *prima facie* selon laquelle l'intérêt supérieur des enfants devrait prévaloir, sous réserve seulement des raisons contraires les plus graves[41].

Dans l'exercice du contrôle judiciaire, l'intérêt de l'enfant se distinguerait des autres facteurs pertinents simplement parce que c'est un facteur dont il faut toujours tenir compte. Or, la Cour d'appel a peut-être voulu lui conférer un statut particulier additionnel en précisant que «[l]a simple mention des enfants ne suffit pas. L'intérêt des enfants est un facteur qui doit être examiné avec soin et soupesé avec d'autres facteurs. Mentionner n'est pas examiner et soupeser»[42]. Par conséquent, si le tribunal n'a pas à remettre en question la pondération de l'agent, il doit tout de même s'assurer que l'agent a été «réceptif, attentif et sensible» à l'intérêt de l'enfant. Pour ce faire, le tribunal examinera si l'agent a :

a) «bien identifié et défini»[43] l'intérêt de l'enfant,
b) prêté «beaucoup d'attention» à cet intérêt[44],
c) soupesé cet intérêt avec les autres facteurs[45].

En espèce, l'agente a soupesé l'intérêt de l'enfant avec le fait que M. Legault devait répondre à un acte d'accusation pour de graves infractions dans un pays étranger, une considération pertinente aux yeux de la Cour[46]. Écrivant au nom de la Cour, monsieur le juge Décary est «[...] d'avis que l'agente d'immigration a examiné avec beaucoup d'attention l'intérêt des enfants, qu'elle a soupesé ce facteur et les autres facteurs reliés, y compris la conduite passée de monsieur Legault, et qu'elle est arrivée à une décision qui me paraît raisonnable dans les circonstances»[47].

Bien que cet arrêt apporte certaines précisions quant au contenu du contrôle judiciaire lorsque l'intérêt d'un enfant est en jeu, il aurait été utile que la Cour dise expressément ce qu'elle considère comme étant dans «l'intérêt des enfants» dans les circonstances et comment elle est arrivée au constat que l'agente avait accordé suffisamment d'attention à cet intérêt. Plus surprenant encore, en concluant que l'agente «en est arrivée à une décision *qui me paraît raisonnable dans les circonstances*» [nos italiques], monsieur le juge Décary semble ouvrir la porte à une remise en question de la pondération exercée par

l'agente, malgré toutes ses exhortations à ne pas s'engager dans cette voie!

Dans l'affaire *Hawthorne*, la Cour d'appel fédérale suggère que la question du contrôle judiciaire des décisions d'immigration où des enfants sont en jeu reste à clarifier à bien des égards, à approfondir au-delà des principes élaborés dans l'affaire *Legault*. La Cour n'a pas pu s'entendre dans *Hawthorne* sur la démarche que doit suivre l'agent pour «identifier et définir» l'intérêt de l'enfant. De l'avis de messieurs les juges Décary et Rothstein, ce qu'il faut déterminer c'est le degré de difficulté auquel sera confronté un enfant si un parent est déporté; il faut ensuite soupeser ce facteur avec les autres facteurs pertinents[48]. Le fait d'englober ainsi l'intérêt de l'enfant dans l'appréciation des difficultés que risque d'entraîner le renvoi d'un parent semble toutefois dangereux aux yeux du juge Evans. Selon lui, cela peut distraire l'attention du scénario le plus favorable au bien-être de l'enfant et, par voie de conséquence, diminuer l'importance de ce facteur en comparaison avec les autres facteurs pertinents. Il illustre son propos en se référant aux faits particuliers devant lui. Le juge Evans souligne que l'agente a conclu que la fille de la demanderesse ne serait pas exposée à des difficultés particulières en suivant sa mère en Jamaïque, puisque c'est le pays où elle avait résidé toute sa vie jusqu'à son arrivée au Canada il y a un an. Le juge Evans explique les failles de cette analyse comme suit :

> Toutefois, si l'agente avait commencé par déterminer que l'intérêt supérieur de Suzette, aujourd'hui résidente permanente, consistait en la possibilité pour elle de continuer à demeurer au Canada, le renvoi de Mme Hawthorne ne pourrait qu'être raisonnablement considéré comme étant hautement préjudiciable à l'intérêt supérieur de Suzette si, de ce fait, celle-ci avait effectivement été obligée de retourner en Jamaïque avec sa mère. Dans le cadre de l'analyse de l'intérêt supérieur, le point de comparaison pertinent est la vie que Suzette mène actuellement au Canada, et non sa résidence antérieure en Jamaïque.[49]

Par ailleurs, la question de la pondération est mentionnée brièvement, mais suffisamment pour suggérer que les tribunaux n'ont peut-être pas encore complètement vidé le contrôle judiciaire de cet élément. L'avocate d'une intervenante, la *Canadian Foundation for Children, Youth and the Law*, formule l'argument suivant sur cette question :

> [...] la Cour doit se demander si, en rejetant la demande de considérations humanitaires, l'agente a réalisé un équilibre déraisonnable entre, d'une part, l'intérêt de l'enfant et, d'autre part, l'intérêt public qui consiste en l'application régulière de la loi. [...] Le pouvoir discrétionnaire est exercé de manière déraisonnable ou arbitraire lorsque le préjudice causé aux intérêts individuels importants est disproportionné au bénéfice découlant de la décision[50].

Alors que le juge Décary rejette d'emblée cet argument[51], le juge Evans préfère laisser à un autre jour la question de savoir si «l'arrêt *Suresh* exclut entièrement cet examen du caractère déraisonnable, quant au fond, de l'exercice du pouvoir discrétionnaire»[52], puisqu'en l'espèce il n'est pas nécessaire d'examiner cet argument car «l'erreur relevée dans la décision de l'agente est survenue avant qu'elle ne soupèse les facteurs»[53]. Cette question et d'autres encore pourront dorénavant être examinées à la lumière de la nouvelle loi sur l'immigration.

### Conclusion : La réapparition de la pondération avec la nouvelle *Loi sur l'immigration et la protection des réfugiés*?

Dans l'affaire *Legault*, la Cour d'appel fait une observation qui semble aujourd'hui avoir une certaine connotation prophétique. La Cour écrit :

> Dans sa question, le juge Nadon a référé à l'«intérêt supérieur des enfants». Cette expression se rencontre à quelques reprises dans Baker, mais dans la mesure où elle laisse entendre que l'intérêt des enfants est supérieur à d'autres intérêts, elle peut mener le décideur à croire que ce facteur est au départ plus important qu'un autre, ce qui, à la lumière de *Suresh, et en l'absence de prescriptions législatives ou réglementaires*, ne doit pas être. Il est plus sage de se contenter de l'expression «intérêt des enfants» [nos italiques][54].

La nouvelle *Loi sur l'immigration et la protection des réfugiés*, sanctionnée le 1er novembre 2001 et entrée en vigueur le 28 juin 2002, contient pré-

cisément plusieurs références expresses à «l'intérêt supérieur de l'enfant»[55]. Le nouvel article 25 prévoit expressément «l'intérêt supérieur de l'enfant» comme motif humanitaire :

> Article 25 : Le ministre doit, sur demande d'un étranger interdit de territoire ou qui ne se conforme pas à la présente loi, et peut, de sa propre initiative, étudier le cas de cet étranger et peut lui octroyer le statut de résident permanent ou lever tout ou partie des critères et obligations applicables, s'il estime que des circonstances d'ordre humanitaire relatives à l'étranger – *compte tenu de l'intérêt supérieur de l'enfant directement touché* – ou l'intérêt public le justifient [nos italiques].

Dans quelle mesure ce nouvel article permet-il d'espérer que la Cour suprême et d'autres tribunaux verront là une invitation du législateur à s'assurer que l'agent d'immigration accorde un véritable poids à l'intérêt de l'enfant lors de sa prise de décision? À notre avis, ce n'est pas tellement l'emploi du qualificatif «supérieur» qui incitera un tribunal à tirer une telle conclusion, mais davantage le fait que le législateur ait identifié expressément, parmi tous les facteurs qui peuvent être pertinents pour les fins de la prise de décision, celui de l'intérêt de l'enfant. Dans ses nouvelles directives adoptées concernant la mise en œuvre de la nouvelle loi, le ministère propose l'interprétation suivante de l'article 25 :

> Cela précise à la Loi la pratique du ministère d'éliminer tout doute sur la prise en compte de l'intérêt supérieur de l'enfant. L'agent doit toujours être conscient de l'intérêt de l'enfant lors de l'examen des demandes au titre du L25(1). Toutefois, l'intégration du concept de *l'intérêt supérieur de l'enfant* dans la Loi *ne signifie* pas que l'intérêt de l'enfant contrebalance tous les autres facteurs de la demande. L'intérêt supérieur de l'enfant est l'un des nombreux facteurs importants dont l'agent doit tenir compte lorsqu'il prend une décision sur des motifs humanitaires ou de politique publique [nos italiques][56].

«Les directives sont une indication utile de ce qui constitue une interprétation raisonnable»[57], mais les tribunaux ne sont pas liés par celles-ci. Leur

tâche consiste avant tout à rechercher l'intention du législateur, lequel est présumé légiférer en pleine connaissance de cause des développements jurisprudentiels récents. Le législateur est donc censé savoir que «l'intérêt de l'enfant» est déjà reconnu comme un facteur pertinent et important dans l'interprétation de l'ancienne loi[58]. Par conséquent, il est tout à fait raisonnable de déduire qu'en incorporant ce facteur, et uniquement ce facteur, à l'article 25, le législateur a voulu s'assurer, d'une part, que l'agent accorde à ce facteur un poids, qui sans être toujours décisif, sera néanmoins très considérable et, d'autre part, que les tribunaux veillent à ce que cette intention soit pleinement respectée. La mise en œuvre de cette disposition pourrait bien redonner à l'intérêt de l'enfant toute l'importance que la Cour suprême du Canada, sous la plume de madame la juge L'Heureux-Dubé, avait voulu lui conférer dans l'affaire *Baker*.

### Endnotes

\* L'auteur remercie son collègue Denis Boivin pour ses commentaires et Hélène Laporte pour la révision du texte.

1 La juge L'Heureux-Dubé a signé un jugement auquel ont souscrit les juges Gonthier, McLachlin, Bastarache, et Binnie. Le juge Iacobucci a écrit un jugement concurrent auquel a souscrit le juge Cory.

2 *Baker c. Canada (M.C.I.)*, [1999] 2 R.C.S. 817.

3 *Suresh c. Canada (M.I.C.)*, [2002] 1 C.S.C. 1.

4 *Canada (M.C.I.) c. Legault*, [2002] 4 C.F. 358 (Appel).

5 *Canada (M.C.I.) c. Hawthorne*, [2003] 2 C.F. 555 (Appel).

6 L.C. 2001, c. 27.

7 Le paragraphe 9(1) de la *Loi sur l'immigration* alors en vigueur, L.R.C. 1985, c. I-2, prévoyait que, sauf pour les exceptions prévues par règlement, toute demande de visa de résident permanent devait être faite avant l'entrée. Cependant, le paragraphe 114(2) de la loi permettait au gouverneur en conseil d'autoriser, par règlement, le ministre à accorder «pour des raisons d'ordre humanitaire» une dispense de cette exigence. Le paragraphe 2(1) du règlement autorisait le ministre à exercer cette discrétion. Comme l'observe madame la juge Claire L'Heureux-Dubé dans son jugement, en pratique de telles décisions sont prises par des agents d'immigration au nom du ministre. *Supra* note 2 à la p. 834.

8 *Ibid.*

9 *Ibid.*

10 *Ibid.* à la p. 858.

11 *Supra* note 3 à la p. 23.

12 *Canada (Directeur des enquêtes et recherches) c. Southam Inc.*, [1997] 1 R.C.S. 748 à la p. 776.
13 *Supra* note 2 à la p. 863.
14 *Ibid.* à la p. 827.
15 *Ibid.* à la p. 834.
16 *Supra* note 12 à la p. 781.
17 *Supra* note 1 à la p. 864.
18 *Ibid.* à la p. 827.
19 *Ibid.* L'agent avait utilisé à deux reprises des lettres majuscules dans ses notes pour insister sur le nombre d'enfants de madame Baker.
20 *Ibid.* à la p. 831.
21 *Ibid.* aux pp. 858 et 859.
22 *Ibid.* à la p. 851, où elle souligne que «L'utilisation de majuscules par l'agent pour souligner le nombre des enfants de madame Baker peut également indiquer au lecteur que c'était là une raison de lui refuser sa demande».
23 *Ibid.* à la p. 864.
24 Voir aussi les extraits suivants de la décision «[…] j'estime que le défaut d'accorder de l'importance [en anglais «serious weight»] et de la considération à l'intérêt de l'enfant» (*ibid.* à la p.859); «L'objectif à l'al. 3 c) énonce l'obligation d'accorder une grande importance [«take seriously and place important weight» en anglais] au maintien des enfants en contact avec leurs deux parents, si cela est possible […]» (p. 860); «La Convention sur les droits de l'enfant et d'autres instruments internationaux …aident à démontrer les valeurs qui sont essentielles [«central» en anglais] pour déterminer si la décision en l'espèce constitue un exercice raisonnable du pouvoir en matière humanitaire» (p. 862); «[…] étant donné que les motifs de la décision n'indiquent pas qu'elle a été rendue d'une manière réceptive, attentive ou sensible à l'intérêt des enfants de Mme Baker, *ni que leur intérêt ait été considéré comme un facteur décisionnel important*, elle constituait un exercice déraisonnable du pouvoir conféré par la loi […]» [nos italiques] (p.863).
25 *Suresh c. Canada*, [2000] 2 F.C. 592 aux pp. 676 et 677.
26 *Supra* note 2 à la p. 864.
27 *Supra* note 12 à la p. 770.
28 *Supra* note 3 à la p. 23.
29 *Ibid.* aux pp. 23–24 et 26.
30 *Supra* note 25 à la p. 23.
31 *Supra* note 3 aux pp. 26 et 27.
32 *Supra* note 2 à la p. 855.
33 *Ibid.* à la p. 860.

34 *Ibid.*
35 *Supra* note 3 à la p. 27.
36 Bien que la requête en extradition contre M. Legault ait été rejetée en 1983 par la Cour supérieure du Quebec étant donné l'insuffisance de la preuve présentée par les autorités américaines, en 1986 un grand jury fédéral a déclaré fondées les accusations de fraude et autres crimes dont il a fait l'objet et un mandat a été délivré par une cour de district américaine pour son arrestation.
37 *Legault c. Canada (M.C.I.)*, [2001] 3 C.F. 277 à la p. 306.
38 *Supra* note 4 à la p. 369 : «La présence d'enfants, contrairement à ce qu'a conclu le juge Nadon, n'appelle pas un certain résultat. Ce n'est pas parce que l'intérêt des enfants voudra qu'un parent qui se trouve illégalement au Canada puisse demeurer au Canada (ce qui, comme le constate à juste titre le juge Nadon, sera généralement le cas), que le ministre devra exercer sa discrétion en faveur de ce parent. Le Parlement n'a pas voulu, à ce jour, que la présence d'enfants au Canada constitue en elle-même un empêchement à toute mesure de refoulement d'un parent se trouvant illégalement au pays […]».
39 *Ibid.* à la p. 366.
40 *Ibid.*
41 *Supra* note 3 aux p. 368 et 369.
42 *Ibid.* à la p. 369. On peut penser toutefois que la même attention devrait alors être accordée à tout facteur pertinent. Du moment qu'un facteur peut jouer un rôle dans une prise de décision, le décideur devrait l'examiner avec soin, quel que soit le poids de ce facteur.
43 *Ibid.*
44 *Ibid.* à la p. 368.
45 *Ibid.* à la p. 369.
46 À cet égard, la Cour écrit : «[…] il est loisible au ministre de prendre en considération le fait que les raisons d'ordre humanitaire dont une personne se réclame soient le fruit de ses propres agissements […] ministre peut tenir compte des agissements passés et actuels de la personne qui demande la dispense». *Ibid.* aux pp. 371 et 375.
47 *Ibid.* à la p. 375.
48 *Supra* note 5 à la p. 563.
49 *Ibid.* à la p. 577.
50 *Ibid.* aux pp. 574 et 575.
51 *Ibid.* à la p. 563.
52 *Ibid.* à la p. 575.
53 *Ibid.* à la p. 580.
54 *Supra* note 4 aux pp. 369 et 370.

55 *Supra* note 6, art. 25, 28, 60, 67, 68 et 69.
56 Voir le *Guide sur le traitement de demandes au Canada* – (IP5) sur le site Web du ministère de l'Immigration et de la Citoyenneté (www.cic.gc.ca/manuals-guides/francais/ip/ip05f.pdf) à la p. 11 du *Guide*.
57 *Supra* note 1 à la p. 862.
58 R. Sullivan, *Driedger on the Construction of Statutes*, 3e éd., Toronto, Butterworths, 1994 aux pp. 156 et 157.

Twelve

# The Social Phenomenon of Handicapping

ENA CHADHA*

## Introduction

In the legacy of important equality rights jurisprudence authored by Justice L'Heureux-Dubé, the *Mercier*[1] decision will stand as a significant milestone in the advancement of the rights of persons with disabilities. At first blush, the key legal question raised in *Mercier*, specifically what constitutes a "handicap," appeared simple and straightforward compared to weighty and controversial disability judgments previously rendered by the Supreme Court of Canada. By the year 2000, the Court had already tackled such contentious disability issues as forced sterilization, the right to die, and segregated versus integrated education.[2] In fact, one wondered what aspect of this seemingly ordinary disability employment discrimination case the Supreme Court considered to be of such paramount national interest to warrant granting leave to appeal.

The importance of the *Mercier* decision is found in Justice L'Heureux-Dubé's lucid and thoughtful understanding of the multi-dimensional nature of disability and her progressive approach towards eliminating disability discrimination and inequality. In *Mercier*, Justice L'Heureux-Dubé did with ease and eloquence what she is so good at doing—identifying and naming prejudice, barriers, myths, and stereotyping. Justice L'Heureux-Dubé introduced Canadian jurists to the "social phenomenon of handicapping."[3] In *Mercier*, she recognized that disability is a complex phenomenon that manifests not

only as a physical condition, but also as a social and cultural state of being.[4]

Writing on behalf of a unanimous Supreme Court, Justice L'Heureux-Dubé boldly interpreted the term "handicap" to include a form of disadvantage that arises out of society's prejudice and paternalistic stereotyping of disability. By conceiving disability as having both objective and subjective dimensions and as being contextual in experience, the *Mercier* decision emerges at the forefront of disability jurisprudence with its developing awareness of the "universality" of disability. Universalism, as a theory of disablement, is grounded in the notion that disability is not a fixed and special condition of a homogenous group, but rather is fluid and affects all members of humankind.[5]

### Facts of the Case

In *Mercier*, the claimants were persons with disabilities who were refused employment or fired because of their health conditions, notwithstanding the fact that their conditions did not produce functional impairments. Réjeanne Mercier applied to the City of Montreal for a job as a gardener-horticulturalist. Her pre-employment medical examination revealed an anomaly in her spinal column. While the medical evidence established that there was no specific limitation arising out of Mercier's condition, the City of Montreal was concerned that Mercier could develop lower back pain. The second complainant, Palmerino Troilo, a newly hired police officer with the City of Boisbriand, was diagnosed with Crohn's disease and underwent surgery during his probation. Although Troilo was medically cleared to return to work, the City of Boisbriand terminated his employment on the basis that he presented a risk of absenteeism. A third individual, Jean-Marc Hamon, was refused employment as a police officer by the Communauté urbaine de Montréal when he was diagnosed with anomalies in his spinal column, although it was determined that the condition was asymptomatic. In all three situations, the medical evidence indicated that the claimants could perform the regular duties of the job.

In seeking to enforce their right to be free of disability discrimination, each claimant filed human rights complaints with the Quebec Commission des droits de la personne et des droits de la jeunesse. With respect to the claims of Mercier and Troilo, the Human Rights Tribunal held that the claimants had

no remedy under section 10 of the *Quebec Charter of Human Rights and Freedoms* because their conditions did not result in functional limitations and therefore did not meet the definition of handicap.[6] The Human Rights Tribunal rejected the notion that an individual's "state of health" came within the definition of handicap and further stated that such an interpretation would trivialize human rights protection accorded to persons with disabilities.

Surprisingly, the Hamon claim, which almost mirrored the Mercier situation, was decided in the opposite manner. In the Hamon case, a different Human Rights Tribunal noted that while Hamon was in excellent health, the respondent employer had erroneously projected onto him the attributions of an impairment, which thwarted Hamon's exercise of his right to be free of discrimination in employment. The Human Rights Tribunal concluded that the term "handicap" must be given a broad and liberal interpretation consistent with the objectives of human rights legislation, and as such, a purely subjective perception of a handicap could give rise to discrimination.

At the Quebec Court of Appeal, the respondent employers posited that since the physical conditions did not affect the claimants' abilities to do their jobs, the claimants did not have a handicap and therefore could not seek protection under human rights legislation. The Quebec Court of Appeal rejected this argument and concluded that the claimants had been victims of discrimination. Justice L'Heureux-Dubé, for the Supreme Court, affirmed the Court of Appeal's decision and upheld the finding that there was discrimination on the basis of handicap.

### Definition of Disability

Although fifteen years had passed since the inclusion of mental and physical disability in section 15 of the *Canadian Charter of Rights and Freedoms*,[7] and despite having rendered a significant disability decision that informed substantive equality rights analysis,[8] the Supreme Court had never directly confronted the meaning of the words "disability" or "handicap" prior to *Mercier*. In *Mercier*, Justice L'Heureux-Dubé took on this important challenge by identifying the complicated and multifaceted nature of disability, delineating the concepts of "handicap," "impairment," and "functional limitation" and explaining how these terms converge into the social and environmental processes of disability discrimination.

Justice L'Heureux-Dubé approached the legal analysis of the meaning of "handicap" as a simple statutory interpretation problem.[9] She began by pointing out that the Quebec human rights legislation does not define the term "handicap" and that even the "ordinary meaning" rule of statutory interpretation[10] was of little assistance in view of the myriad uses for the words disability and handicap.[11] She noted that a variety of definitions of "disability" and "handicap" are used in human rights legislation across the country.[12] After reiterating the broad and liberal principles of interpretation that apply to quasi-constitutional enactments such as human rights statutes,[13] Justice L'Heureux-Dubé concluded that a purposive reading of "handicap" necessitated the inclusion of subjective considerations. Consequently, she found that the term "handicap" included past and present conditions, as well as non-evident[14] or perceived ones:

> It would be strange indeed if the legislature had intended to enable persons with handicaps that result in functional limitation to integrate into the job market, while excluding persons whose handicaps do not lead to functional limitations. Such an approach appears to undermine the very essence of discrimination. I am, therefore, of the view that the *Charter's* objective of prohibiting discrimination requires that "handicap" be interpreted so as to recognize its subjective component. A "handicap," therefore, includes ailments which do not in fact give rise to any limitation or functional disability.[15]

Interestingly, in addition to finding that the concept of "handicap" must be expansive enough to include a respondent's subjective or perceived views of the claimant's abilities, Justice L'Heureux-Dubé further noted that a respondent's preconceived notions had to be balanced against the duty of accommodation:

> The purpose of Canadian human rights legislation is to protect against discrimination and to guarantee rights and freedoms. With respect to employment, its more specific objective is to eliminate exclusion that is arbitrary and based on preconceived ideas concerning personal characteristics, which when the duty

to accommodate is taken into account, do not affect a person's ability to do a job.[16]

This *obiter* statement has great significance. In this simple, unadorned passage, Justice L'Heureux-Dubé emphasized that the right to accommodation is a critical component of the right to be free of discrimination because of disability. Regardless of whether a disability is real or perceived in the mind of the respondent, there remains the consideration of whether the respondent could have accommodated the claimant's needs. Borrowing the words of Justice Sopinka in *Eaton v. Brant County Board of Education*, it is important to recall that the duty to accommodate, and the corresponding principle of inclusiveness, is the "essence of true equality."[17] While in earlier disability decisions such as *Eaton* and *Eldridge v. British Columbia (Attorney General)*, the Supreme Court had articulated the point that "discrimination can accrue from a failure to take positive steps,"[18] the Court had never previously assigned the duty to accommodate to a perceived disability.

In *Mercier*, Justice L'Heureux-Dubé expressly queried whether it is possible, or even useful, to arrive at a more precise definition of "handicap." Rejecting a narrow and inflexible definition of "handicap," she proposed a contextual and purposive framework to facilitate the legal interpretation and development of the notion of disability. First, she expressly rejected the respondents' assertion that in order to constitute a "handicap," the claimants had to suffer from functional limitations that were caused by a physical anomaly. Second, she held that there was a clear connection between the words "health" and "handicap," and therefore human rights protection from discrimination because of "handicap" necessarily included "ailments related to health."[19]

By recognizing that disability is a mutable identity dependent on "biomedical, social and technological factors,"[20] Justice L'Heureux-Dubé's non-exhaustive definition captures the multifaceted nature of disability in its ever-evolving and diverse forms. She suggests that emphasis be placed on human dignity, respect, and the right to equality rather than a simple biomedical condition. Justice L'Heureux-Dubé noted that this approach "recognizes that the attitudes of society and its members often contribute to the idea or perception of a 'handicap.' In fact, a person may have no limitations in everyday activities other than those created by prejudice and stereotypes."[21] Based on

this framework, she held that the word "disability" is broad enough to include a physical or mental limitation, an ailment, a social construct, a perceived limitation, or a combination of all of these factors.

### Contrasting Theories of Disability

In *Mercier*, Justice L'Heureux-Dubé articulated a social context theory of disability. The social context theory of disability is often more easily understood in contrast to the biomedical theory of disability, which conceptualizes "disability" as a problem in human anatomy and physiology.[22] The medical model of disablement situates the problem firmly in the disabled person who is seen as defective, different, and incapable, in relation to medically defined norms upon which the medical model of disablement is built.[23] Jerome Bickenbach, a noted Canadian scholar in disability analysis, observes that the "most commonly held belief about disablement is that it involves a defect, deficiency, dysfunction, abnormality, failing or medical problem that is located in an individual."[24] Bickenbach argues that the medical model leads to a predisposition to seek solutions in medical treatment, rather than changing the social environment, and "tends to suggest a charity or needs-based normative basis for disablement theory. As a result, societal, and especially medical, attention is directed at fixing or curing the individual and not the systemic barriers posed by society."[25]

Moving beyond this biomedical model of disability, Justice L'Heureux-Dubé described the "social phenomenon of handicapping" as being the process of disadvantagement experienced by persons with disabilities when society views such individuals as abnormal or defective, and/or fails to accommodate their needs. Citing the work of Professor Bickenbach, Justice L'Heureux-Dubé advanced a theory of disability that situates disability not in the claimant's pathology but in the handicapping and pejorative attitudes of society. This social context approach recognizes that disability is a multidimensional concept produced not only by physical ailments, but also and more often from socially constructed barriers and societal responses to difference and perceived limitations:

> Thus, a "handicap" may be the result of a physical limitation, an ailment, a social construct, a perceived limitation or a combina-

tion of all of these factors. Indeed, it is the combined effect of all these circumstances that determines whether the individual has a "handicap"... Courts will, therefore, have to consider not only an individual's biomedical condition, but also the circumstances in which a distinction is made. In examining the context in which the impugned act occurred, courts must determine, *inter alia*, whether an actual or perceived ailment causes the individual to experience the loss or limitation of opportunities to take part in the life of the community on an equal level with others.[26]

Justice L'Heureux-Dubé discerned that disability is often generated and perpetuated by socially erected hurdles, such as pre-existing attitudes, physical environments, and policies and practices. By finding that a disability may be a result of a physical limitation, an ailment, a social construct, a perceived limitation, or a combination of these factors, Justice L'Heureux-Dubé recognized that a disability does not always entail or cause functional limitations, but in fact is often the manifested outcome of societal barriers and entrenched patterns of discrimination and prejudice. Thus, the most important determination to be made in assessing a disability discrimination claim, as expressed in *Mercier*, is whether, because of an actual or perceived disability, the claimant lost an opportunity or had an opportunity limited, to participate in community life with others. The thrust of this critical inquiry is to call attention to the "social phenomenon of handicapping," that is, to put an end to the disadvantages experienced by people with functional limitations or perceived to be "handicapped because of barriers, prejudice, stereotyping, social attitudes and fears."[27]

A few months after *Mercier*, the Supreme Court elaborated on the multidimensional approach to disability advocated by Justice L'Heureux-Dubé in a *Charter* challenge to the federal disability pension plan in *Granovsky*.[28] Following Justice L'Heureux-Dubé's approach of distinguishing the various facets of disability, the *Granovsky* decision demarcates three separate aspects of disability: physical or mental impairments (first aspect) that may or may not give rise to functional limitations (second aspect) and the socially constructed handicap (third aspect).[29] For example, in a situation where a person is blind, the blindness would be the physical impairment, while lack of vision or sight would be the functional limitation. The socially constructed handi-

cap would be the state's restriction of licences to drive to those who can pass a vision test appropriate to the function of driving.[30]

The *Granovsky* decision suggests that in a disability discrimination claim, the Court should concentrate on this third aspect, the socially constructed handicap, to assess society's response to the disability, and look to see whether the respondent has paid too much or too little attention to functional limitations.[31] Again echoing Justice L'Heureux-Dubé in *Mercier*, the Court noted in *Granovsky* that

> A proper analysis necessitates unbundling impairment from the reaction of society to the impairment, and a recognition that much discrimination is socially constructed ... Exclusion and marginalization are generally not created by the individual with disabilities but are created by the economic and social environment and unfortunately, by the state itself.[32]

Recognizing disability as a social construct is the foundation of much critical disability theory.[33] In a recent article about the relevance of legal theory in contemporary society, Professor Richard Devlin commended critical disability theory to the National Judicial Institute as a necessary addition to education programs on social context issues provided to judges.[34] For equality analysis to be meaningful to persons with disabilities, it must be underscored with an understanding that the problem is not the person with the disability, or even the purported health impairment. The problem lies in the "pervasive impact of ableist assumptions, institutions and structures that disadvantage persons with disabilities."[35]

A second positive feature of the *Mercier* decision is the practical implications it presents for litigation of disability rights cases.[36] Justice L'Heureux-Dubé stressed that in the human rights context, a claimant does not bear the onus to prove that her disability poses no limitations. Rather, the onus rests on the respondent to demonstrate that there are real limitations and not just perceived impairments that justify the respondent's discriminatory conduct:

> The objectives of the *Charter*, namely the right to equality and protection against discrimination, cannot be achieved unless we recognize that discriminatory acts may be based as much on perception and myths and stereotypes as on the existence of actual

functional limitations. *Since the very nature of discrimination is often subjective, assigning the burden of proving the objective existence of functional limitations to a victim of discrimination would be to give that person a virtually impossible task. Functional limitations often exist only in the mind of other people, in this case that of the employer [emphasis added].*[37]

Adopting the reasons of the Quebec Court of Appeal, Justice L'Heureux-Dubé affirmed that the proper analysis of a disability discrimination claim is a two-stage process.[38] First, the court looks to see if the claimant has established a *prima facie* case of discrimination. The claimant must establish, on a balance of probabilities, a connection between the impugned conduct and the protected ground, namely disability.[39] At this juncture, there is no evidentiary burden on the claimant to show her abilities or capacities are limited by a disability in order to discharge her obligation to make out a *prima facie* case of discrimination.[40] The onus then shifts to the respondent to rebut, if possible, the *prima facie* case by providing an explanation of the challenged behaviour. It is at this second stage, when the respondent puts in a defence, that the respondent should demonstrate that the alleged discriminatory conduct was in fact based on valid aptitudes, skills, or qualifications. It is important to note that evidence of an actual limitation becomes relevant only at this second stage in the adjudication of a disability claim. The *Mercier* decision signals to respondents across the country that a human rights claimant need only persuade the decision-maker of the existence of a link between the harm complained of and the prohibited ground of disability in order to require the respondent to justify its conduct. There is no onus on the claimant to prove the degree of disability; rather, the emphasis is on the respondent to demonstrate that that claimant's actual limitations or capacities justified the respondent's actions. The emphasis is clearly on the respondent's impugned actions and the effects of those actions, and not on the nature of the claimant's disability.

### An Economic Theory of Disability

The *Mercier* decision stands in stark contrast to a recent trend exhibited by the (U.S.) Supreme Court in defining "disability" under the *Americans with Disabilities Act (A.D.A.)*.[41] In 1990, the enactment of the *A.D.A.* was heralded

as a momentous step towards protecting the equality rights of persons with disabilities.[42] But in January 2002, the (U.S.) Supreme Court issued the latest in a series of judgments adopting a narrow definition of disability,[43] which one writer has described as "gutting" the *A.D.A.* of any effective protection.[44] In that U.S. case, styled *Toyota v. Williams*,[45] the claimant was diagnosed with carpal tunnel syndrome. She sought accommodation from her employer as her assembly line job involved repetitive hand motions. The U.S. Supreme Court held that even though the claimant's condition prevented her from doing part of her job, since she could do other manual tasks such as household chores, the claimant was not disabled and therefore was not entitled to accommodation in the workplace.

In *Toyota v. Williams*, the U.S. Supreme Court held that the evidence must establish that the disability was "considerable" or of a "large degree" and that the disability affected important life activities. Clearly, this position stands in direct contradiction with the *ratio* in *Mercier*. The U.S. Supreme Court further decided that in order to come within the purview of *A.D.A.* protection, the disabling impairment must be so substantial as to reach beyond a task in the workplace or other tasks significant to the claimant to "activities that are of central importance to daily life."[46] The U.S. Supreme Court rejected the decision of the Court of Appeals for the Sixth Circuit that "inability to perform manual tasks associated only with her job" was sufficient to qualify the claimant as "disabled" under the *A.D.A.* The U.S. Supreme Court preferred instead to restrict the scope of activities to "tasks of central importance to people's daily lives," such as bathing or brushing teeth. Justice O'Connor, writing for the majority, stated that the terms within the definition of "disability" had to be strictly interpreted "to create a demanding standard for qualifying as disabled." In her opinion, the U.S. Congress did not intend to protect every person with a disease or impairment under the *A.D.A.*[47]

Unfortunately, *Toyota v. Williams* is not an aberration in legal reasoning from the U.S. Supreme Court. Starting in 1999, the U.S. Supreme Court embarked upon a path of narrowing the "disability" definition of the *A.D.A.*, beginning with decisions in *Sutton v. United Airlines Inc., Murphy v. United Parcel Service, Inc.,* and *PGA Tour, Inc. v. Martin.*[48] The trend emerging from these cases, and culminating in the *Toyota v. Williams* decision, involves a judicial inquiry into the severity of the plaintiff's disability, rather than into the defendant's discriminatory actions. Commenting on the sad irony borne

from this line of reasoning, one disability rights advocate has written that the narrow interpretation of "disability" in the *A.D.A.* means that

> persons who had spent their entire lives attempting to overcome or manage with the effects of their disabilities were subjected to the demeaning process of "proving" how disabled they were in order to establish that their disability was severe enough to warrant being protected against discrimination.[49]

We should all be disturbed by the recent disability rulings from the U.S. Supreme Court. What is most objectionable about this judicial trend is the impoverished interpretation of the *A.D.A.* What some in North America hailed as a beacon of disability rights protection has now become the tool for wilful disregard of the importance of financial integrity, work, and income security for persons with disabilities. This line of American cases contradicts the ideal of "economic self-sufficiency" that is declared in the opening section of the *A.D.A.* as a goal for persons with disabilities.[50] The U.S. Supreme Court apparently failed to recall this objective given that the grave consequence of Williams' disability was that she was no longer able to work. A definition of disability that minimizes the importance of occupational-related activities to daily life ignores the reality of employment in contemporary Western society. It would have been preferable, and more consistent with the *A.D.A.*'s legislative commitment to economic self-sufficiency, if the U.S. Supreme Court had interpreted the definition of disability by identifying the economic forces underlying the concept of disablement, particularly in the context of the value of gainful employment to society.

Stereotypical and paternalistic ideas about the quality of lives of persons with disabilities and their ability to contribute economically remain deeply rooted in society's consciousness. Underpinning these stereotypes is the historical perception that persons with disabilities are helpless, dependent, and to be pitied. In addition to the biomedical model of disability, the persistence of these stereotypes can be attributed to the powerful legacy of the "economic model of disablement," which views disability through the lens of labour and capital.[51] Under this model, a disability "is a social cost caused both by the extra resources that people with disabilities require and by their limited productivity at work, relative to people without disabilities."[52] The economic the-

ory of disablement has been explored most extensively in the academic work of Michael Oliver, a prominent disability scholar from Britain.[53] Oliver holds that the oppression experienced by persons with disabilities is rooted in the economic and social structures of capitalism. The focus for this model is on the individual's repertoire of productive skills and capacities.[54] Oliver argues that the systemic exclusion of persons with disabilities from the mainstream world of work is caused by their categorization as "non-productive" members, an underclass of society that is marginalized, isolated, and devalued as a liability on the state and taxpayers.

The economic model concentrates on the role of individuals in the labour market and the ordering of relationships based on economic value. The economic perspective of disability is premised on the concept that an individual's social worth is measured in relation to his or her attachment to the labour force.[55] This perspective renders persons with disabilities as second class citizens, because they have no value in terms of economic efficiency. The combination of the biomedical and economic models of disability makes the need for a cure and charity as central to disability identity.

In Canada, our goal should be to better understand the economic consequences of disability. We know in broad terms that disability is closely linked with negative economic factors.[56] The Supreme Court of Canada has recognized, and statistics confirm, that persons with disabilities are among the most disadvantaged groups in Canada. They face higher levels of unemployment and underemployment, have lower incomes, and achieve lower levels of educational attainment than the non-disabled population.[57] Notwithstanding provincial and federal prohibitions against discrimination, disability continues to be one of the leading grounds of discrimination in human rights complaints filed with both the provincial and federal human rights agencies.[58]

### Conclusion

Professor Richard Devlin has written that law and disability theory is still in its infancy in Canada and that critical disability theory may be one of the greatest challenges for social context education.[59] Critical disability theory emphasizes the "inevitability of difference"[60] and fundamentally problematizes the assumptions of normalcy. I agree that we are still in the preliminary

stages of understanding the dynamics and diversity of disability. As legal practitioners, scholars, and jurists, we must develop new theories to understand disability as a social, political, cultural, and, often the most ignored sphere, as an economic phenomenon. I submit that our most important theorizing will be around comprehending disability as an outcome of economic discrimination. As evidenced by the shift in American jurisprudence, society, regrettably, does not view the financial integrity of persons with disabilities as worthy of protection because poverty, dependency, and charity are normative under the current paradigm of disability.

In order to ensure substantive equality for persons with disabilities, courts must recognize that the human dignity of persons with disabilities is integrally and historically linked to economic well-being. Fortunately, in Canada we have Justice L'Heureux-Dubé's decision in *Mercier*, which offers an intelligent and principled basis for a progressive definition of disability that emphasizes human dignity, respect, and a right to equality. One disability rights activist, in writing about the *Mercier* decision, has said that "by reducing the onus on complainants with disabilities, Canada's highest court has made the human rights process more accessible and humane."[61] Thank you, Justice L'Heureux-Dubé, for being the source of this humanity.

### Endnotes

* This case commentary is a revised version of an address presented at the "Adding Feminism to Law: The Contributions of Madam Justice L'Heureux-Dubé" conference, sponsored by the University of Ottawa on 27 September 2002. I wish to express my sincerest gratitude to Courtney Harris and Christian Lyons, students-at-law, for their legal research and assistance.

1 Quebec *(Commission des droits de la personne et des droits de la jeunesse) v. Montréal (City)*, [2000] 1 S.C.R. 665 [*Mercier*]. This case concerned the appeals of three human rights complainants (Réjeanne Mercier, Palmerino Troilo, and Jean-Marc Hamon) involving the interpretation of "handicap" in Quebec human rights legislation.

2 *Re Eve*, [1986] 2 S.C.R. 388; *Rodriguez v. British Columbia (Attorney General)*, [1993] 3 S.C.R. 519; *Eaton v. Brant County Board of Education*, [1997] 1 S.C.R. 241.

3 Justice L'Heureux-Dubé adopted this phrase from the work of prominent disability scholar Jerome Bickenbach, *Physical Disability and Social Policy* (Toronto: University of Toronto, 1993).

4 The issue of mental health is never expressly dealt with in *Mercier* and this omission is a recurrent issue in disability discourse. Regrettably, this case commentary perpetuates this situation. For a critical analysis of this shortcoming in human rights jurisprudence, see Judith Mossop, "Is the Human Rights Paradigm 'Able' to Include Disability: Who's In? Who Wins? What? Why?" (2000) 26 Queen's L.J. 225.

5 As explained in a recently published text by the World Health Organization, the theory of "universalism" is based on the principle that disability is a universal trait of all human beings and not a unique identifier of a social group: "The principle of universalism entails that all human beings have, either in fact or potentially, some limitation in functionality at the body, person, or social level associated with a health condition. Disability is not, in short, a defining feature of a minority of people; it is a universal human trait." See T.B. Üstün, Somnath Chatterji, Jerome E. Bickenbach, Robert T. Trotter II, Robin Room, Jurgen Rehm, and Shekhar Saxena, eds., *Disability and Culture: Universalism and Diversity* (Cambridge, Mass.: Hogrefe & Huber Publishers, 2001) at 9.

6 *Quebec Charter of Human Rights and Freedoms*, R.S.Q., c. C-12, s.10 states: "Every person has a right to full and equal recognition and exercise of his human rights and freedoms without distinction, exclusion or preference based on race, colour, sex, pregnancy, sexual orientation, civil status, age, except as provided by law, religion, political convictions, language, ethnic or national origin, social condition, a handicap or the use of any means to palliate a handicap."

7 *Canadian Charter of Rights and Freedoms*, Part I of the *Constitution Act, 1982*, being Schedule B of the *Canada Act 1982* (U.K.), 1982, c. 11. Section 15(1) of the *Charter* provides as follows: "Every individual is equal before and under the law and has the right to the equal protection and equal benefit of the law without discrimination and, in particular, without discrimination based on … mental or physical disability."

8 *Eldridge v. British Columbia (Attorney General)*, [1997] 3 S.C.R. 624. In considering whether the enumerated ground of physical disability captured the claimants' condition, Justice La Forest simply indicated that "As deaf persons, the appellants belong to an enumerated group under s. 15(1)—the physically disabled."

9 *Mercier, supra* note 1 at 682, paras. 25 and 26.

10 *Dreidger on the Construction of Statutes* states that the ordinary meaning rule, as applied by modern courts, consists of the following propositions: "(1) It is assumed that the ordinary meaning is the most appropriate meaning; (2) Even where the ordinary meaning of a legislative text appears to be clear, the courts

must consider the purpose and scheme of the legislation, and the consequences of adopting this meaning; (3) The court may adopt an interpretation in which the ordinary meaning is modified or rejected providing that the interpretation is plausible and that the words are reasonably capable of bearing that meaning." Ruth Sullivan, *Dreidger on the Construction of Statutes,* 3d ed. (Toronto: Butterworths, 1994) at 7.

11 In *Mercier,* Justice L'Heureux-Dubé states that "handicap can have a vague or very broad meaning," *supra* note 1 at para. 26. This observation is also reported by the editors of *Disability and Culture, supra* note 5, who state that "(a)lthough 'disability' is a universally used term in both everyday language and the professional and scientific literature, it is ambiguous."

12 All fourteen provincial, federal, and territorial jurisdictions in Canada prohibit discrimination on the ground of handicap and/or disability in their respective human rights legislation. Several different approaches are used to explain the concepts of handicap and disability. While there is no specific definition of disability or handicap in the Quebec, British Columbia, Yukon, Northwest Territories, and Nunavut legislation, there are detailed lists of examples of disabilities in the human rights statutes of Alberta, Ontario, Saskatchewan, Manitoba, New Brunswick, Nova Scotia, and Newfoundland. These can be compared to the brevity seen in the *Canadian Human Rights Act,* which defines "disability" as "any previous or existing mental or physical disability and includes disfigurement and previous or existing dependence on alcohol or a drug." R.S.C. 1985, c. H–6, s. 25.

13 The Supreme Court of Canada has repeatedly pronounced upon the importance of interpreting human rights legislation liberally and purposively. The Court has said: "Legislation of this type is of a special nature, not quite constitutional but certainly more than ordinary—and it is for the courts to seek out its purpose and give it effect." See *O'Malley v. Simpson-Sears Ltd.,* [1985] 2 S.C.R. 536 at 547.

14 The *Policy and Guidelines on Disability and the Duty to Accommodate* of the Ontario Human Rights Commission uses "non-evident" to describe to disabilities that are not "seen," for example, mental illness, learning disabilities, developmental disabilities, chronic pain conditions, and/or episodic disabilities, such as epilepsy. Ontario Human Rights Commission, *Policy and Guidelines on Disability and the Duty to Accommodate* (23 November 2000).

15 *Mercier, supra* note 1 at para. 40.

16 *Ibid.* at para. 36.

17 *Eaton, supra* note 2 at para. 66. Sopinka J. noted that "[t]he principal object of certain of the prohibited grounds is the elimination of discrimination by the

attribution of untrue characteristics based on stereotypical attitudes relating to immutable characteristics such as race or sex. In the case of disability, this is one of the objectives. *The other equally important objective takes into account the true characteristics of this group which act as headwinds to the enjoyment of society's benefits and to accommodate them"* [emphasis added] at para. 67.

18 *Eldridge, supra* note 8 at para. 78.
19 *Mercier, supra* note 1 at para. 69.
20 *Ibid.* at para. 76.
21 *Ibid.* at para. 77.
22 The biomedical model of disability, which has been explained most cogently by Jerome Bickenbach in ch. 3 of *Physical Disability and Social Policy, supra* note 3, "embodies an evaluative ranking" where persons with disabilities are "subnormal and biologically inferior."
23 Ian B. McKenna, "Legal Rights for Persons with Disabilities in Canada: Can the Impasse be Resolved?" (1997–98) 29 Ottawa L. Rev. 153 at 163.
24 Bickenbach, *Physical Disability and Social Policy, supra* note 3 at 61.
25 *Ibid.*
26 *Mercier, supra* note 1 at paras. 79–80.
27 The fear of the unknown is an important theme in disability discourse; discrimination is often perpetuated by non-disabled because they fear difference. C.H.R.R., Human Rights Digest (2000) Vol. 1 No. 4 at 2.
28 *Granovsky v. Canada (Minister of Employment and Immigration)*, [2000] 1 S.C.R. 703.
29 The Court's analysis refers to the manner of differentiating among the different aspects of disabilities found in the World Health Organization, *International Classification of Impairments, Disabilities, and Handicaps: Manual of Classification Relating to the Consequence of Disease* (1980); restated in United Nations Decade of Disabled Persons, 1983–1992, *World Programme of Action Concerning Disabled Persons* (1983) at 2–3. The International Classification distinguishes between "impairment" as an abnormality of physiological structure or functioning, "disability" as a limitation to activity considered normal that results from impairment, and "handicap," the negative social consequences that result. There is also a 1997 classification scheme that refers to impairments, activity limitations, and participation restrictions to convey the same ideas. See World Health Organization, *International Classification of Impairments, Disabilities, and Handicaps* (1997). These categories are revisited in *Disability and Culture, supra* note 5.
30 The facts of an earlier human rights case considered by the Supreme Court demonstrate the three aspects in operation. In *British Columbia*

*(Superintendent of Motor Vehicles) v. British Columbia (Council of Human Rights)*, [1999] 3 S.C.R. 868 (referred to as "*Grismer Estate*"), the appellant, whose peripheral vision had been severely impaired by a stroke, was assumed by the Superintendent of Motor Vehicles, without testing, to have a sufficient level of functional limitation to disqualify him from holding a driver's licence. The Superintendent of Motor Vehicles based its decision on the medical condition without administering individual tests to determine whether the attributed limitation did in fact exist. The Supreme Court ordered that such individualized testing be administered.

31 Since *Granovsky* was a *Charter* challenge, the Court spoke in terms of scrutinizing the actions of state authorities.

32 *Granovsky, supra* note 28 at para. 30.

33 Richard F. Devlin, "Jurisprudence for Judges: Why Legal Theory Matters for Social Context Education" (2001) 27 Queen's L.J. 161.

34 *Ibid.* Devlin states: "Perhaps the most important theoretical insight on disability is that it is a social construct" at para. 92.

35 *Ibid.* at para. 92.

36 One favourable outcome of *Mercier* anticipated by an experienced disability advocate is that the litigation process will be shortened. See David Baker, "The Supreme Court of Canada Comes to the Rescue: *Mercier* Changes the Law" (July 2000) Shell Jacobs Newsletter 2:1.

37 *Mercier, supra* note 1 at para. 39.

38 *Ibid.* at para. 66.

39 Béatrice Vizkelety, *Proving Discrimination in Canada* (Toronto: Carswell, 1987) at 127.

40 *Mercier, supra* note 1 at para. 65.

41 42 U.S.C. § 12101 (1990).

42 The *A.D.A.* seeks to end discrimination against individuals with disabilities by imposing mandatory barrier removal duties on both the public and private sector. It specifically prohibits discrimination against a "qualified person with a disability" with respect to employment and creates accessibility requirements for services, such as transportation systems, hotels, restaurants, stores, and telecommunications.

43 The definition of "disability" found at s. 12102(2) of the *A.D.A.* reads: "A 'disability' is: (a) a physical or mental impairment that substantially limits one or more of the major life activities of such individual; (b) a record of such an impairment; or (c) being regarded as having such an impairment."

44 Richard Elliot, "U.S. Supreme Court Adopts Narrow Definition of Disability" (March 2002) 6(3) Canadian HIV/AIDS Policy and Review. See also Lisa

Sciallo, "The *A.D.A.*: Through the Looking Glass" (Winter 2002) Brook. L. Rev.; Katherine Annas, "*Toyota Manufacturing, Kentucky, Inc. v. Williams*: Part of an Emerging Trend of Supreme Court Cases Narrowing the Scope of the *A.D.A.*" (January 2003) N.C.L. Rev.
45 *Toyota Motor Mfg., Ky., Inc. v. Williams*, 534 U.S. 184, 184 (2002).
46 *Ibid* at 197.
47 *Ibid*.
48 *Sutton v. United Airlines, Inc.*, 527 U.S. 471 (1999); *Murphy v. United Parcel Service, Inc.*, 527 U.S. 516 (1999); *PGA Tour, Inc. v. Martin*, 532 U.S. 661 (2001).
49 Baker, "The Supreme Court of Canada Comes to the Rescue," *supra* note 36.
50 Section 2(8) of the *A.D.A.* states that "the Nation's proper goals regarding individuals with disabilities are to assure equality of opportunity, full participation, independent living, and economic self-sufficiency."
51 The "economic" theoretical paradigm of disablement has been written about by Michael Oliver, who explains that "[t]he economy, through both the operation of the labour market and the social organisation of work, plays a key role in producing the category of disability and in determining societal responses to disabled people." *The Politics of Disablement* (London: Macmillan, 1990).
52 M.A. McColl and J.E. Bickenbach, eds., *Introduction to Disability* (London: WB Saunders Company Ltd., 1998).
53 *Ibid*.
54 Bickenbach, *Physical Disability and Social Policy, supra* note 3 at 101.
55 Oliver, *The Politics of Disablement, supra* note 51.
56 The poverty rate for women and men aged fifteen and older with disabilities was 21.9 per cent compared to the poverty rate of 12.6 per cent for the same age group without disabilities. Adults with severe disabilities had an even higher poverty rate of 30.3 per cent—nearly one-third. Gail Fawcett, *Living with Disability in Canada: An Economic Portrait* (Ottawa: Human Resources Development Canada, 1996) at 129–30.
57 *Eldridge, supra* note 8.
58 In 2002 complaints grounded on disability constituted 49 per cent of all complaints filed at the Ontario Human Rights Commission. Ontario Human Rights Commission, *Annual Report 2001–2002* (Toronto, 2002) at 45. At the Canadian Human Rights Commission 37 per cent of all claims filed were filed on grounds of disability. Canadian Human Rights Commission, *Annual Report 2001* (Ottawa: Minister of Public Works and Government Services, 2002) at 38.
59 Devlin, "Jurisprudence for Judges," *supra* note 33 at para. 90.
60 *Ibid*. Devlin, in turn, relies on the work of Martha Minow. Minow raises the "dilemma of difference": "When does treating people differently emphasize

their difference and stigmatize or hinder them on that basis? And when does treating people the same become insensitive to their difference and likely to stigmatize or hinder them on that basis? Martha Minow, *Making All the Difference* (Ithaca: Cornell University Press, 1990) at 20.
61 Baker, "The Supreme Court of Canada Comes to the Rescue," *supra* note 36.

Thirteen

## Taxing Times at the Supreme Court of Canada: The Contributions of Justice L'Heureux-Dubé to a Better Understanding of the Application of the *Charter* to the Income Tax System

CLAIRE F.L. YOUNG

Introduction

My purpose in this article is to discuss the extremely important contribution that L'Heureux-Dubé J. has made to our understanding of the function and purpose of our tax system. In brief, I shall demonstrate that she recognizes that the income tax system is much more than a mere revenue-raising instrument. Her analysis is that the tax system is also an important social and economic tool. Using this position as her starting point, she is then able to situate the tax system in its social context when determining the application of its provisions. Such an approach leads to a fairer and more accurate interpretation of a highly complex piece of legislation.

I also argue that her analysis of the application of section 15(1) of the *Charter of Rights and Freedoms*[1] to our income tax system has laid the groundwork for future successful challenges to discriminatory provisions of the *Income Tax Act*[2] by members of historically disadvantaged groups. I contend that, drawing on her analysis, judges considering the application of section 15(1) of the *Charter* to tax legislation will be less deferential in their approach to the Act. They will also, by drawing on her contextual approach, be better situated to understand the complex ways in which the Act discriminates in contravention of the *Charter*. I conclude by hypothesizing about how her analysis could be used to challenge the discriminatory application of the

spousal support tax rules to separated or divorced women. I focus in this article on two of her tax decisions, namely, *Symes v. Canada*[3] and *Thibaudeau v. Canada*.[4] In both those cases the Supreme Court of Canada split along gender lines, with the majority of the Court consisting of all the male judges while the two women on the Court were in dissent.

### Symes v. Canada

*Symes*[5] was the first case heard by the Supreme Court of Canada in which a taxpayer argued that a provision of the Act discriminated in contravention of section 15(1) of the *Charter*. Section 63 of the Act provides that certain childcare expenses are deductible in the computation of income under the Act. Currently the amount of the deduction is up to $7,000 for childcare expenses in respect of a child under seven and up to $4,000 in respect of a child aged seven to fifteen.[6] In *Symes*, the taxpayer was a lawyer who claimed that her childcare expenses should be deductible as a business expense under sections 9 and 18(1)(a) of the Act. If the expense was held to be a business expense, in contrast to the deduction under section 63, there would be no limitation on the amount that could be deducted. Section 18(1)(a) of the Act provides that no expense is deductible "except to the extent that it was made or incurred by the taxpayer for the purpose of gaining or producing income from the business." Symes made a two-part argument. She contended, first, that the salary paid to the nanny who cared for her children was a business expense incurred to gain or produce income. Had she not had childcare help, she would not have been able to practise law, and consequently, would have earned no income from her business. Second, she argued that to disallow her the deduction was to deny her equal benefit of the law on the basis of her sex. This disallowance was in contravention of section 15(1) of the *Charter* because it has a disproportionate impact on women who are primarily responsible for childcare.

At the Federal Court (Trial Division),[7] Cullen J. held that Ms. Symes's expenses should be deductible for two reasons. He found, first, that the issue had to be interpreted in light of the "social and economic realities of the times."[8] He held that Symes had "exercised good business and commercial judgment in deciding to dedicate part of her resources from the law practice to the provision of child care"[9] and that, consequently, the childcare expens-

es were deductible as a business expense. Even though he found for Ms. Symes on his interpretation of the Act, Cullen J. went further and held that Revenue Canada's denial of the deduction was discrimination against Ms. Symes on the basis of her sex in contravention of section 15(1) of the *Charter*, noting that as a result she was "not treated like a serious business person with a serious expense incurred for a legitimate purpose."[10]

That decision was overturned by the Federal Court of Appeal. Décary J.A., writing for the court, held that childcare expenses were not a business expense under section 18(1)(a) because they were a "parental" expense under section 63 and were only deductible in accordance with that section.[11] He also rejected Ms. Symes's *Charter* argument because, unlike Cullen J., who viewed Ms. Symes as a businesswoman standing next to a businessman, Décary J.A. chose to compare Ms. Symes to other women who did not earn business income. He pointed out that Ms. Symes was not arguing that, if she were successful, the Act would then discriminate against women employees in favour of self-employed women. He stated, "I am not prepared to concede that professional women make up a disadvantaged group against whom a form of discrimination recognized by section 15 has been perpetrated."[12]

The Supreme Court of Canada upheld the decision of the Federal Court of Appeal and, as mentioned, in so doing split along gender lines with the majority of the Court consisting of all the male judges, while the only two women on the Court, L'Heureux-Dubé and McLachlin JJ., were in dissent. The majority held that the expenses were not deductible under sections 9 and 18(1)(a) of the Act because, as Iacobucci J. wrote, "the *Income Tax Act* intends to address child care expenses, and does so in fact, entirely within s. 63."[13] He endorsed Décary J.A.'s description of section 63 as a self-contained and complete code for the deduction of childcare expenses, which precludes any further deduction for these expenses. He also characterized the *Charter* issue in terms of whether section 63 of the Act disproportionately limited the deduction with respect to childcare expenses incurred by women. He reached the decision that it did not. Iacobucci J. said, "[T]he appellant taxpayer has failed to demonstrate an adverse effect created or contributed to by s. 63, although she has overwhelmingly demonstrated how the issue of child care negatively affects women in employment terms. Unfortunately, proof that women pay the social costs is not sufficient proof that women pay child care expenses."[14]

### Thibaudeau v. Canada

In *Thibaudeau*[15] the issue was whether the requirement that Suzanne Thibaudeau include child support payments received from her ex-spouse in income discriminated against her in contravention of section 15(1) of the *Charter* on the basis of her family status as a divorced custodial parent. Sections 60(b) and (c) of the Act provided a tax deduction to the payor of child support and sections 56(1)(b) and (c) required that if the payor was entitled to a tax deduction, the recipient of the child support payment must include it in income. This system is known as the inclusion/deduction system. The gender dimensions of these rules are straightforward: 98 per cent of those paying child support, and thereby entitled to the deduction, are men, and 98 per cent of those receiving child support payments, which they must include in their income, are women.[16] The primary justification for these rules put forward by the Department of Finance was that the inclusion/deduction system provided a subsidy that resulted in higher support payments, thereby benefiting children whose parents have separated or divorced.[17] The subsidy arises where the payor is in a higher tax bracket than the recipient because the monetary value of the deduction to the payor exceeds the amount of the tax payable by the recipient. In theory, this overall tax saving permits higher support awards.

In May 1995 the Federal Court of Appeal upheld Thibaudeau's argument and held that the requirement to include child support payments in income discriminated against separated custodial parents because neither separated non-custodial parents nor separated custodial non-parents are required to include in income any amounts that they receive for the support of children. This decision was heralded by many women's groups as a victory for women who receive child support from their ex-spouses.[18] The decision was, however, overturned on appeal by the Supreme Court of Canada. By a majority of 5:2, the Court held that the requirement to include child support payments in income did not contravene the *Charter*.[19] As in *Symes*, the Court split on gender lines, with all the men sitting on the case finding that there was no discrimination and the two women on the Court in dissent.

The decision of the majority in *Thibaudeau* was based on two points. First, the judges held that the relevant group for the purposes of their *Charter* analysis was separated or divorced couples or, as Cory and Iacobucci JJ. put it, the "post-divorce 'family unit.'"[20] With this "unit" as the starting point for the

section 15 analysis, it was easy for the majority to conclude that there was no discrimination because the inclusion/deduction system benefited the group of separated or divorced parents by generating "substantial savings."[21] Overall, the tax burden of the *couple* was reduced and this in turn increased the resources available for the benefit of the children. The second point made by the majority was that if there was a problem with this distribution of resources, it was a problem generated by the family law system, not the tax system.

### The Dissents of L'Heureux-Dubé J.

I now turn to the dissenting judgments of L'Heureux-Dubé J. in both these cases. In *Symes*, L'Heureux-Dubé J. began by considering whether childcare expenses were deductible as a business expense under sections 9 and 18(1)(a) of the Act and, as did the majority, she saw this question as being one of statutory interpretation. But, where she differed from the majority and took the analysis a step forward was her emphasis that statutory interpretation is a broad-based exercise that must take issues of equality into account. Statutory interpretation does not occur in a vacuum and her analysis of the Act recognized this reality. As she said of the issue at hand, "[t]he answer, with regard to statutory interpretation of the Act, requires that the Court consider the reality of the relationship of both women and men to child care and to work, as well as the impact of the concepts of equality on the interpretation of legislation."[22]

L'Heureux-Dubé J.'s approach to the interpretation of the Act was drawn in part from her understanding of the role of the income tax system. As she correctly acknowledged, revenue raising is only one function of the tax system. The income tax system is, as she said, a "powerful tool" that is used to direct social and economic activity in Canada. I suggest that while she did not use the term "tax expenditure analysis" to describe her approach to the analysis of the issue, she certainly understood the childcare expense deduction and the deductibility of business expenses as tax subsidies. She thereby implicitly adopted an approach that draws on tax expenditure analysis as its theoretical underpinning.[23]

Tax expenditure analysis recognizes that any departure from a normative tax system (a system that consists only of the basic elements to raise revenue) by way of measures such as income exclusions, deductions, credits, or tax deferral is a tax expenditure. That is, rather than delivering a direct sub-

sidy for a particular activity or endeavour by way of, for example, a direct grant, the government delivers the subsidy through the tax system.[24] In Canada, the importance of tax expenditure analysis in tax policy-making is illustrated by the fact that the government currently publishes annual accounts detailing the cost of all tax expenditures.[25] What are the benefits of tax expenditure analysis? Put simply, by drawing on the concept that many tax measures are spending measures the debate becomes one that focuses on spending and not taxing. When the focus is spending, the evaluative criteria that we apply are very different from those applied when we view the tax system as only being about revenue raising and the redistribution of income. In particular, this approach allows us to consider whether funds allocated through the tax system are allocated in a fair manner. Who benefits from these expenditures, and, perhaps most importantly, who does not benefit? Given that the tax system is replete with tax expenditures, this insight is critical. I suggest that any future analysis of the income tax system from an equality perspective must draw on tax expenditure analysis and the decision of L'Heureux-Dubé J. in *Symes* lays the groundwork for such an analysis. I discuss this issue in more detail below.

In *Symes*, L'Heureux-Dubé J. agreed with the analysis of Iacobucci J. (speaking for the majority) with respect to the approach to be taken in determining what is a business expense under sections 9 and 18(1)(a) and (h). But in adopting that approach, she took a more contextual approach than the majority. The question both she and Iacobucci J. addressed was whether Symes incurred childcare expenses for the purpose of gaining or producing income from business.[26] In answering that question, however, only L'Heureux-Dubé J., looked at the reality of who bears the cost of childcare. As she said, "the reality is that it is primarily women who incur the cost, both social and financial, for child care and this decision cannot, as such, ignore the contextual truth when examining whether child care may be considered a business expense."[27]

In reaching her conclusion, L'Heureux-Dubé J. relied heavily on expert social science evidence about the increased participation in the paid labour force by women with young children. Referring to the evidence, she determined that while men might see childcare as being within the personal realm, this was because "for most men, the responsibility of children does not impact on the number of hours they work, nor does it affect their ability to

work."²⁸ She referred to several reports, including the CBA *Touchstones for Change* Report, which found that women lawyers were more likely to rely on paid childcare givers than male lawyers by a ratio of three to one. Use of this socio-economic material was central to her decision and, I submit, absolutely essential to any future analysis of whether an expense is of a personal or business nature. Given the role of our income tax system as a social and economic tool, one cannot interpret it without taking socio-economic factors such as these into account.²⁹

L'Heureux-Dubé J. also found that the existence of the childcare expenses deduction did not affect Symes's ability to claim a business deduction for her childcare expenses. Again, L'Heureux-Dubé J. took a contextual approach to this issue, one that acknowledged that the tax system had been interpreted from a male perspective in the past. As she commented, "[t]he definition of a business expense under the Act has evolved in a manner that has failed to recognize the reality of business women. It is thus imperative to recognize that any interpretation of s. 63 which prevents the deduction of child care as a business expense may, in fact, be informed by this partisan perspective."³⁰

The majority of the Court also held that section 63 of the Act did not discriminate on the basis of sex in contravention of section 15(1) of the *Charter*. Even though L'Heureux-Dubé J. did not need to consider the section 15(1) *Charter* argument made by Symes because she found that childcare expenses were deductible under sections 9 and 18(1)(a) of the Act, she chose to discuss the impact of the *Charter* in response to the majority's *Charter* analysis as espoused by Iacobucci J. She disagreed that the focus should be the application of the *Charter* to the section 63 childcare expense deduction. For L'Heureux-Dubé J., the issue of deductibility of childcare expenses as a business expense was the real issue and that is where the equality analysis should be applied. In applying the *Charter* to the issue of whether childcare expenses are deductible business expenses she said, "s. 15 of the *Charter* demands that the experience of both women and men shape the definition of business expense."³¹

L'Heureux-Dubé J. elaborated on her analysis of the application of the *Charter* to tax legislation in *Thibaudeau*. She opened her decision by stating that the Act is subject to section 15 *Charter* scrutiny in the same way as any other federal legislation. She also emphasized that a deferential approach is

not part of any section 15(1) analysis. She continued, "inequality is inequality and discrimination is discrimination, whatever the legislative source. To water down one's analysis of a legislative distinction or burden merely because it arises in a statute which makes many other distinctions is antithetical to the broad and purposive approach to s. 15 of the *Charter* which this court has repeatedly endorsed."[32] This statement was in direct response to the approach taken by Gonthier J. for the majority, who had commented on the "special nature" of the Act and thus taken a somewhat deferential approach in finding that there was no discrimination in contravention of section 15(1) of the *Charter*. L'Heureux-Dubé J.'s statement is key in ensuring that deference as a concept of *Charter* interpretation does not creep into the section 15(1) analysis, but rather remains confined to any subsequent section 1 analysis.

In their dissents in *Thibaudeau*, McLachlin and L'Heureux-Dubé JJ. also debunked the notion of the "post-divorce family unit," which was so central to the finding of the majority who held that the inclusion/deduction system did not discriminate against single custodial parents because overall there was a tax saving for the couple after divorce. L'Heureux-Dubé J., in particular, made the point that the unit of taxation in Canada is the individual, that we do not have joint filing for spouses, and to consider a divorced couple as one for tax purposes, as the majority did, is just plain wrong. This understanding of tax law is key to moving away from the dangerous concept of the "post-divorce family unit." The majority's view that the divorced or separated couple should be viewed as a single unit is problematic for several reasons. First, it is at odds with one of the objectives of family law, which is to promote a "clean break" or self-sufficiency of spouses after separation or divorce. While the *Moge* v. *Moge*[33] decision of the Supreme Court of Canada clarified that this objective was only one among others, including compensation for the economic consequence of family breakdown, the promotion of self-sufficiency remains a key component of support law. Treating the divorced couple as a single unit flies in the face of this development. Second, if one takes the view of the majority to its logical conclusion, it appears that once a couple has a child, it remains a couple forever. Neither separation, divorce, or even remarriage by one or both of the parties, can dissolve the "family," at least insofar as the inclusion/deduction rules apply to them.

Another important aspect of L'Heureux-Dubé J.'s judgment is her critique of the "gross-up" system. Any argument that the inclusion/deduction

system does not discriminate against the recipient of child support depends on demonstrating that the amount received is increased to ensure that the amount required for child support is not diminished by taxation. For example, if a court determines that $10,000 a year is the appropriate amount for child support for a taxpayer who pays tax at an average rate of 20 per cent, then she must be compensated for the tax payable on that amount ($2,000) in order to ensure that the actual amount of child support is not eroded below the set figure. There are many problems associated with the gross-up that preclude the amount awarded being truly reflective of the tax liability. For example, the amount must be grossed up many times to ensure that the tax on the gross-up is also taken into account. Furthermore, the child support award may result in a reduction of the taxpayer's entitlement to other tax subsidies such the Canada Child Tax Credit, the amount of which diminishes as income increases. As L'Heureux-Dubé J. states, "it is, therefore, virtually undeniable that the family law system is, as a practical matter, incapable of addressing to any meaningful extent the inequalities flowing from the burden imposed upon custodial spouses of an imperfect gross up."[34]

### The Significance of the Dissents

What is the significance of L'Heureux-Dubé J.'s dissents in *Symes* and *Thibaudeau*? Historically, tax law has always been interpreted in a manner that assumes that one should take a technical approach to a complex legislative measure. Further, tax legislation is viewed in a narrow manner, that is, as a revenue-raising instrument that imposes a burden on the taxpayer. This approach has had several consequences. First, drawing on concerns about the burdensome aspects of our tax system, judges have taken as their starting point the position that any ambiguity in the application of a tax provision should be resolved in favour of the taxpayer.[35] As an aside I would note, however, that in *Symes* it was only L'Heureux-Dubé J. who took heed of this rule.[36] The second consequence is that to date judges have been so preoccupied with the perceived technical nature of the Act that their interpretative approach is decontextualized and tends to view the tax system as one that operates in isolation from the realities of society today.

I believe two very important and interconnected streams of analysis, which have the potential to transform our approach to the interpretation of

tax legislation, are embedded in L'Heureux-Dubé J.'s dissents in *Symes* and *Thibaudeau*. The first is the importance of taking context and socio-economic factors into account. As she demonstrates, our tax system is a powerful tool, one that operates in complex ways to affect and influence our social and economic behaviour. Ignoring this fact and taking an interpretive approach that isolates a legislative provision from its context can only result in an artificial result that bears no relation to the realities of how the provision operates. The second analytic point is L'Heureux-Dubé J.'s understanding that a major function of the tax system is to subsidize certain activities and endeavours—the tax expenditure side of the system. Given the increasing use by governments of tax expenditures, it is key that any future interpretation of the Act recognize this function. When we treat departures from the normative tax bases as tax expenditures, we think about different issues as we interpret them. The fairness of a provision is measured by answering questions such as who benefits from the expenditure and who does not. Answers to these and related questions about allocation of the subsidy allow for a more reflective interpretation of the application of the provision.

I now turn to the most important contribution that I believe L'Heureux-Dubé J. has made in the tax arena: her analysis of the application of the *Charter* to tax law. As mentioned above, her position is that the Act is subject to the *Charter* in the same manner as any other legislation. She emphasizes that deference to the legislature is not part of a section 15(1) analysis, an important point given the perception by some judges that there is something special about tax law that might require some deference.[37] Drawing on her analysis in *Egan v. Nesbitt*, she takes a contextual approach to the *Charter* analysis, understanding the system to be a powerful social and economic tool. To illustrate the importance of this contribution I shall now hypothesize about how her work might be used in the future to bring a successful *Charter* challenge on the basis of sex discrimination to another provision of the Act. My case study is the inclusion/deduction system for spousal support.[38]

### Applying L'Heureux-Dubé J.'s Analysis to a Case Study

The inclusion/deduction system for spousal support is very similar in its operation to the recently repealed inclusion/deduction system for child sup-

port. The payor of spousal support may take a deduction in the computation of income, while the recipient must include any amount in income that is deductible by the payor. There is a gendered impact to these rules, with significantly more women receiving spousal support than men, and thus more women bearing the tax burden that arises from the requirement to include spousal support payments in income. As with child support payments, one policy underlying these rules is that they create a tax subsidy by reason of the payor having a higher effective tax rate than the recipient. While the intention is that greater financial resources are available to the couple, as John Durnford and Stephen Toope point out in their excellent article on spousal support, "if any tax subsidy exists, the principal beneficiary is the paying spouse, and not the recipient."[39] They also note that the inclusion/deduction rules have "not been successful in ameliorating the distinct economic disadvantages experienced by women after divorce."[40]

How does the analysis of L'Heureux-Dubé J. in *Symes* and *Thibaudeau* support the arguments that the inclusion/deduction rules in respect of spousal support contravene section 15(1) of the *Charter* by discriminating on the basis of sex and that they cannot be saved by section 1? There are four key points to be made. First, L'Heureux-Dubé J. has made it clear that the Act is subject to the *Charter* in the same manner as any other legislation. While that conclusion might seem obvious, her intervention in this regard has been important given Gonthier J.'s musings in *Thibaudeau* about the "special nature" of the Act. Deference to the legislature is not, according to L'Heureux-Dubé J., part of the section 15 analysis. Second, the contextual approach taken by L'Heureux-Dubé J. in both cases is key to making a successful argument on this issue. That context includes the fact that women experience a decline in their economic well-being after divorce or separation while men's economic well-being improves. Evidence of this economic reality would establish unequal treatment. Third, understanding that the inclusion/deduction rules are intended to provide a subsidy to reduce the payor's cost of spousal support is critical to the analysis. As one author has noted, the purpose of the rules is also to allow "the spouses greater financial resources than when living together, compensating in part for the lost economies of maintaining a single household."[41] The importance of considering these rules a tax expenditure together with an understanding of the flaws in the gross-up as demonstrated by L'Heureux-Dubé J. is that one can then demonstrate that equal benefit of

the law is not enjoyed by the recipient of spousal support. Not only does she receive none of the subsidy, but she is penalized by being required to pay tax on her spousal support, which reduces the amount that she receives. In contrast, had she received money from a relative or friend to support herself post-divorce or separation, she would not pay tax on that amount. Fourth, L'Heureux-Dubé J. applied the section 15(1) analysis to the application of the Act to Suzanne Thibaudeau, not to her and her ex-spouse. Thus one can argue that any challenge to the requirement to include spousal support in income should focus on the impact on the individual recipient and not on the "post-divorce spousal unit." Indeed, in this case it would be even more ridiculous than it was in *Thibaudeau* to treat the divorced or separated couple as one unit because, without children, they have absolutely no remaining ties.

With respect to section 1 of the *Charter*, L'Heureux-Dubé J. took the position in *Symes* that in determining the legislative objectives for the purposes of the *Oakes*[42] test, not only was it important to consider the operation of the Act as a whole, but one must also take into account "the operation of other government systems relating to child care."[43] I suggest that when considering the spousal support tax subsidy, it should be viewed in the larger context of the failure of both the tax rules and family law to ensure that women receive the full amount of spousal support that they should. Furthermore, in *Thibaudeau* L'Heureux-Dubé J. found that the purpose of the inclusion/deduction scheme for child support was to place more money in the hands of the separated couple. But her conclusion was that the government had not demonstrated that the benefit that might accrue to the couple was "fairly and equitably shared between the two individuals."[44] She also stated that even though the inclusion/deduction system might be effective in some instances, it was not effective in a significant number of cases, thereby leading to an unequal distribution of the benefit. She referred to the work of Durnford and Toope in discussing how the system might be improved so that the inequities were redressed and concluded that "the inequality is too evident, and the range of more palatable alternatives is too readily available."[45] She thus concluded that the discrimination could not be saved by section 1. One can see a parallel argument with respect to the inclusion/deduction system for spousal support. The current rules are not effective in ensuring that the subsidy or benefit is shared between spouses and, as with the child support inclusion/deduction system, other means of accomplishing the objective of putting more money in the hands of the separated couple are available.

## Conclusion

L'Heureux-Dubé J.'s contribution to our understanding of the function and purpose of our income tax system is significant for several reasons. First, by situating the Act in the socio-economic context in which it operates when considering the application of its provisions, she has made a quantum leap in our approach to tax jurisprudence. That leap, which recognizes the multiple and complex roles that our tax system plays in society today, is well overdue. Second, she has provided the foundation on which future *Charter* challenges to discriminatory provisions of the income tax system can be constructed by articulating an approach that does not treat the tax system as merely a technical, complicated legislative measure that should be viewed in a narrow manner because of its complexity. Taking a narrow view of the role and impact of the tax system leads all too easily to a deferential approach, one that L'Heureux-Dubé J. has made clear is not appropriate simply because the impugned legislation is a tax measure.

Given the increasing use of the tax system to deliver subsidies for social programs, it is clear that there will be future *Charter* challenges to tax rules that allocate those subsidies in an inequitable manner. The success or failure of those challenges will depend, in part, on the extent to which the Supreme Court of Canada is prepared to recognize and adopt the important insights about tax law that have been provided by L'Heureux-Dubé J. She has provided the analytical framework for the Court and now it is up to it to use it to good effect. Such a course of action would become another part of the outstanding legacy that she leaves behind on her retirement.

## Endnotes

1 *Canadian Charter of Rights and Freedoms*, Part 1 of the *Constitution Act*, 1982, being Schedule B to the *Canada Act* 1982 (U.K.) 1982, c.11.
2 R.S.C. 1985, (5th Supp.) c. I-5, as amended. To date, there has never been a successful s. 15(1) *Charter* challenge on the basis of sex discrimination to the Act.
3 [1993] 4 S.C.R. 695.
4 [1995] 2 S.C.R. 627.
5 Much has been written on this case. See, e.g., Donna Eansor and Christopher Wydrzynski, "Troubled Waters: Deductibility of Business Expenses under the *Income Tax Act*, Child Care Expenses and *Symes*" (1993) 11 Can. J. Fam. L. 247; Audrey Macklin, "*Symes v. M.N.R.*: Where Sex Meets Class" (1992) 5 C.J.W.L.

498; Gabrielle St. Hilaire, "Fange législative: La deduction des frais de garde d'enfants à l'article 63 de la Loi de l'impôt sur le revenu" (1998) 10 C.J.W.L. 17; Claire F.L. Young, "Child Care and the *Charter:* Privileging the Privileged" (1994) 2 Rev. Const. Stud. 20; Claire F.L. Young, "(I)nvisible Inequalities: Women, Tax and Poverty" (1995) 27 Ottawa L. Rev. 99; Claire F.L. Young, "Child Care: A Taxing Issue?" (1994) 39 McGill L.J. 539; Rebecca Johnson, *Taxing Choices: The Intersection of Class, Gender, Parenthood, and the Law* (Vancouver: U.B.C. Press, 2002); Vern Krishna, "Does the Supreme Court Expand Deductibility of Business Expenses in *Symes*?" (1994) 4 Can. Curr. Tax J35; D.M. McAllister, "The Supreme Court in *Symes*: Two Solitudes" (1994) 4 N.J.C.L. 248; M. Buckley, "*Symes v. The Queen*" (1993) 2(4) National 37; David A. Steele, "The Deductibility of Childcare Expenses Re-examined" (1991) 7 Can. Fam. L.Q. 315; R.B. Thomas, "No to Nanny Expense Deduction" (1991) 39 Can. Tax J. 950; Claire F.L. Young, "*Symes v. The Queen*" (1991) 1991 Br. Tax Rev. 105; F. Woodman, "A Child Care Expenses Deduction, Tax Reform and the Charter: Some Modest Proposals" (1990) 8 Can. J. Fam. L. 384; F. Woodman, "The *Charter* and the Taxation of Women" (1990) 22 Ottawa L. Rev. 625; G. Corn, "Childcare Expenses: Deductibility as Business Expenses or Personal Living Expenses" (1989) 2 Can. Curr. Tax 145; and K.S.M. Hanly, "A Break for Working Women?" (1989) 37 Can. Tax J. 733.

6 Section 63 contains several limitations, including the requirement that in two-parent families the deduction must be claimed by the person earning the lower income.

7 *Symes v. Canada*, [1989] 3 F.C. 59 (T.D.).

8 *Ibid.* at 73.

9 *Ibid.* at 71.

10 *Ibid.* at 81.

11 *M.N.R. v. Symes*, [1991] 3 F.C. 507 at 525 (F.C.A.).

12 *Ibid.* at 531.

13 *Symes, supra* note 3 at 750.

14 *Ibid.* at 765. On this issue it is important to note that in her dissent L'Heureux-Dubé J. strongly disagreed with Iacobucci J., saying that Symes "has proven that she has incurred an actual and calculable price for child care and that this cost is disproportionately incurred by women." *Ibid.* at 821.

15 Suzanne Thibaudeau argued that it was discriminatory on the basis of family status to require her to include child support payments in her income. The intervenors, SCOPE (Support and Custody Orders for Priority Enforcement) and the Coalition of Intervenors (consisting of the Charter Committee on Poverty Issues, the Federated Anti-Poverty Groups of British Columbia, the National

Action Committee on the Status of Women, and the Women's Legal Education and Action Fund) argued that it was also discriminatory on the basis of sex because the requirement had an adverse impact on women, compared to men.

16 See the evidence of Nathalie Martel, a federal government economist, on cross-examination in *Thibaudeau* (F.C.A.) Supplementary Case on Appeal, Vol. 2 at 185.

17 See Ellen Zweibel and Richard Shillington, *Child Support Policy: Income Tax Treatment and Child Support Guidelines* (Toronto: Policy Research Centre on Children, Youth and Families, 1993) at 8.

18 See, e.g., "Mothers Stand to Gain Through Tax Ruling" [Toronto] *Globe and Mail*, (4 May 1995) A2, where Ardyth Cooper, of the Canadian Advisory Council on the Status of Women said that "[i]t sends out a clear message that the rights of these parents—most of them women and many of them among Canada's poorest—cannot be trampled by outdated tax law."

19 The majority consisted of Justices La Forest, Sopinka, Gonthier, Cory, and Iacobucci, with L'Heureux-Dubé and McLachlin JJ. dissenting.

20 *Thibaudeau, supra* note 4 at 702. This characterization of separated or divorced parents can be contrasted to that of McLachlin J. who describes them as "the fractured family" at 710.

21 *Ibid.* at 691.

22 *Symes, supra* note 3 at 786.

23 For example, she raises the issue of whether "child care should not even be subsidized through the tax system but, rather, provided for in another manner," and she also refers generally to tax deductions as subsidies. *Ibid.* at 823.

24 Tax expenditure analysis was first introduced as a concept by Stanley Surrey in *Pathways to Tax Reform* (Cambridge, Mass.: Harvard University Press, 1973). Since that time much has been written on the issue. One excellent Canadian collection of articles is edited by Neil Bruce, *Tax Expenditures and Government Policy* (Kingston, Ont.: John Deutsch Institute for the Study of Economic Policy, Queen's University, 1988).

25 The latest tax expenditure account is Government of Canada, *Tax Expenditures and Evaluations 2001* (Ottawa: Department of Finance, 2001).

26 Section 18(1)(a) of the Act prohibits the deduction of an expense "except to the extent that it was made or incurred by the taxpayer for the purpose of gaining or producing income from the business" and s. 18(1)(h) prohibits the deduction of personal expenses.

27 *Supra* note 3 at 791.

28 *Ibid.* at 800.

29 It should be noted that the legislators have always left the issue of determining whether an expense is a deductible business expense or a non-deductible per-

sonal expense to the courts. There is no statutory definition of a business expense.

30 *Supra* note 3 at 819. It is also important to note that by finding that childcare expenses were deductible business expenses, she answered the question posed to the court, a question that the majority declined to answer. This is a key issue because by finding that s. 63 was a complete code with respect to the deduction of childcare expenses, the majority never reached a conclusion about whether childcare expenses were deductible business expenses under s. 9 and s. 18(1)(a) of the Act. That issue remains unresolved.

31 *Ibid.* at 827–28.

32 *Supra* note 4 at 642.

33 (1992), 43 R.F.L. (3d) 345 (S.C.C.).

34 *Ibid.* at 652. It is important to note that event though the majority of the Court found that there was no discrimination in *Thibaudeau*, the federal government repealed the inclusion/deduction system with respect to child support orders made or varied on or after 1 May 1997. At the same time the government introduced the Child Support Guidelines, which establish a set of uniform rules to be applied when determining the amount of child support payments. I suggest that, in addition to the public outcry at the decision, the strong dissents of McLachlin and L'Heureux-Dubé JJ. persuaded the policy makers that there was something inherently unfair about the inclusion/deduction system.

35 See, e.g., *Johns-Manville Canada Inc. v. The Queen*, [1985] 2 C.T.C. 111 (S.C.C.), where the court said, "where the taxing statute is not explicit, reasonable uncertainty or factual ambiguity resulting from lack of explicitness in the statute should be resolved in favour of the taxpayer."

36 On this point, see Johnson, *supra* note 5 at 100.

37 In *Rosenberg v. Canada (Attorney-General)* (1998), 98 D.T.C. 6286 (Ont.C.A.), two lesbian employees of CUPE argued that the definition of spouse in the Act as it applied to the registration of pension plans discriminated against them on the basis of sexual orientation because it did not include same-sex couples. They were successful at the Ontario Court of Appeal. In that case, the federal government conceded that the definition of spouse discriminated against lesbians and gay men in contravention of s. 15(1) of the *Charter* and the case turned on the application of s. 1 of the *Charter*. I speculate that the strong stance taken by L'Heureux-Dubé J. that deference is not part of a s. 15(1) analysis may have had something to do with that concession.

38 Sections 56(1)(b), 56.1, and 60(b) of the Act provide for the deduction of spousal support payments in the computation of the payor's income and the inclusion in the recipient's income of any amount deductible to the payor.

39 John Durnford and Stephen Toope, "Spousal Support in Family Law and Alimony Law in Taxation" (1994) 42 Can. Tax J. 1 at 27.
40 *Ibid.* at 28.
41 Carolyn Dawe, "Section 60(b) of the *Income Tax Act:* An Analysis and Some Proposals for Reform" (1980) 5 Queen's L.J. 153 at 153.
42 *R. v. Oakes*, [1986] 1 S.C.R. 103.
43 *Supra* note 3 at 773.
44 *Supra* note 4 at 662.
45 *Ibid.*

Fourteen

## Justice L'Heureux-Dubé and Canadian Sexual Assault Law: Resisting the Privatization of Rape

ELIZABETH SHEEHY AND CHRISTINE BOYLE*

Introduction

Justice Claire L'Heureux-Dubé's sexual assault judgments make a remarkable contribution to the reform of Canadian rape law. Her analyses, even when written in dissent, have ultimately reshaped the common law and instigated new legislation. L'Heureux-Dubé J.'s judgments sustain the feminist project of realizing women's equality by resisting the privatization of sexual assault through her linguistic choices, legal methodology, fact determinations, and doctrinal shifts.

Sexual assault is privatized when it is governed by legal doctrines that decriminalize predatory and injurious male sexual behaviour,[1] treat the crime as an individual and gender-neutral deviation that carries no social consequences for the structuring of our society, and impose unconscionable burdens upon women who report male sexual violence to the criminal justice system. In contrast, Justice L'Heureux-Dubé's judgments recognize that, while sexual assault is perpetrated by individual men, it is carried out by men as a group, against women as a group, with our permission as a society, signalled in part through legal rules that define the range of behaviours labelled as criminal. Her decisions frame women who report rape as citizens assuming a grave and onerous public responsibility as witnesses to violent crime, and not as vindictive females with an axe to grind. Her opinions recognize the gross under-report-

ing of rape and its implications for the full public participation of women.

The legal regime proposed through L'Heureux-Dubé J.'s judgments treats women who report sexual assault as members of society whose health, well-being, and survival have been compromised by a brutalizing experience. She endorses legal definitions and rules of culpability for sexual assault that do not force women to abandon the public sphere or active social and sexual lives and to assume responsibility for their own safety as against predatory men. Furthermore, Justice L'Heureux-Dubé's legal understanding of sexual assault would not leave individual women to bear alone the social and economic costs of their rapes,[2] unassisted even by the knowledge that the crime against them was condemned.

L'Heureux-Dubé J.'s dissent in *R. v. Seaboyer*[3] perhaps best illustrates how her decisions provide a blueprint for resisting the privatization of sexual assault. The scope of the mistake of fact defence was at issue in that case, and in particular, the use of a woman's sexual history to give an "air of reality" to an accused's alleged mistaken belief in consent. The defence challenged the *Criminal Code*'s strict rules around the use of women's past sexual history as evidence on the basis of s. 7 of the *Charter*. First, L'Heureux-Dubé J.'s judgment recognized that language matters. She thus began by defining her linguistic terrain in a manner respectful of women and attentive to the public nature of the wrong committed. Her dissent eschewed the use of the term "prosecutrix" because sexual assault is no longer a private matter but is rather a crime against the public order that is prosecuted by the Crown. L'Heureux-Dubé J. also rejected the term "alleged victim" because it is over-inclusive and presumes that the woman has nothing to complain of. She settled for the term "complainant" because it was the least infirm term available, but acknowledged that it is also a harsh term.

Justice L'Heureux-Dubé recognized that a woman who has been sexually assaulted but whose assailant has been acquitted by virtue of the honest mistake defence nonetheless has been injured. She refused to adopt the phrase "rape shield law," a short form often used to describe legislation that limits the cross-examination of women as to their sexual histories, on the basis that the term "rape shield" suggests that the sole or primary purpose of such legislation is to protect women from the rigours of cross-examination. Instead, she argued, several equally significant societal interests are served by the exclusion of such evidence, including truth-seeking and public confidence in the criminal justice system.

Second, L'Heureux-Dubé J.'s methodology in her *Seaboyer* dissent is characterized by attention to the rights of the collectivity, including the rights of women, children, the broader society, and of men accused of the crime.[4] She consistently relied upon equality rights as an implicit if not explicit interpretive framework informing the law of sexual assault. Her approach was definitively contextual: her analysis of the constitutional challenge was grounded in the legal history of the provision in question, the social science evidence situating sexual assault as a gendered crime that is rarely reported and whose legal treatment has been rife with discriminatory practices and doctrines, and the distorting effects that sexual history evidence has upon the trial process and a principled search for truth. This judgment thus reflects a move away from reliance upon abstract doctrine, unstated and untested assumptions and beliefs, and "common sense" reasoning in support of the *status quo;* it towards a broader public law approach that situates law's response to sexual assault as significant for women's status in society and holds law accountable for its impact upon the social practice of rape.

We do not argue that all of L'Heureux-Dubé J.'s sexual assault judgments can be forced into a public law, equality-enhancing paradigm;[5] instead, we examine those opinions that contribute significantly to resisting the privatization of sexual assault. Such resistance depends on egalitarian fact-finding—the determination and application of the relevant facts[6]—and legal doctrine, both informed by substantive equality. In the first part of this chapter, we examine Justice L'Heureux-Dubé's influence on the elements of the crime, focusing on the concepts of *mens rea* and non-consent in the *actus reus*. In the second part, we examine how her judgments rise to the challenges posed by the constitutional requirement that sexual assault trials be conducted in a fair and egalitarian manner.

### Defining Sexual Assault

Justice Claire L'Heureux-Dubé was appointed to the Supreme Court in 1987, and although her first very visible sexual assault judgment was her dissenting opinion in *R. v. Seaboyer* in 1991, the dissent that she joined in *R. v. Kirkness*,[7] written by Justice Wilson in 1990, and her own dissent in *R. v. Martineau*[8] that same year, clearly show the origins of her use of equality as an interpretive principle shaping the substantive elements of sexual assault and the mistake of fact defence.

### Mens Rea *and Moral Innocence*

The dissents in both *Kirkness* and *Martineau* provide the basic conceptual principles that have subsequently informed the law of *mens rea* for sexual assault. In *Kirkness* the dissent delineated the basis of party liability for rape and homicide committed in the course of rape; in *Martineau*, the dissent defended the constitutionality of objective standards of fault for constructive murder. These conceptual principles are most clearly and finely developed in the jurisprudence that has come to define the parameters of the mistake of fact defence.

*Kirkness* was a prosecution for homicide of an accomplice who aided the principal in breaking and entering the home of an eighty-three-year-old woman. While the principal raped and then choked and suffocated the woman, Kirkness blocked the outside door of the house with a chair and carried out the robbery of the woman's home, yet claimed to have verbally protested his accomplice's final acts of suffocation. Kirkness was acquitted when the trial judge instructed the jury that they could either find both accused guilty of murder or the included offence of manslaughter, or they could find only the principal guilty of murder. The Crown appealed on the basis that the judge had inadequately instructed the jury on the possibility of party liability for manslaughter when the principal is convicted of murder.

The majority of the Court upheld the acquittal of Kirkness, holding that he could only have been convicted as a party to murder or manslaughter if he was a party to both the rape and the homicide committed by the principal. The majority held that the Crown had failed to prove that Kirkness had the requisite intent to be a party to either murder or manslaughter, since he claimed not to have known that his accomplice would rape the occupant and rape was not an act that he knew was likely to cause some harm short of death. Further, they held that since in fact the woman did not die as a result of the rape but rather from distinct acts of violence to which Kirkness had objected, he was not a party to the homicide.

At this time there were only two women on the Court, and thus *Kirkness* is an interesting early case where a gendered division in a sexual assault case appeared. The women, Justice Bertha Wilson with Justice Claire L'Heureux-Dubé concurring, proceeded from the same legal principles used by the majority but applied them to the facts quite differently. They reviewed the law of party liability in the case of gang rape, noting that the critical distinction

between innocence and guilt relies upon "mere acquiescence" as opposed to "encouragement," particularly where the accused is present but not actively involved in the actual attack. They concluded that the jury should have been instructed to consider whether Kirkness became a party to rape by acting as a look-out and effectively blocking the means of escape or rescue. In addition, if he was a party to rape, then the jury should have been asked whether he was also a party to manslaughter on the basis that the crime of sexual assault, conceptualized as a crime of violence, is a crime of the same type as suffocation and certainly can cause bodily harm short of death:

> [I]t may be somewhat artificial to draw a sharp line between the act of sexual assault and the act of suffocation in a case such as this where the violence inherent in the sexual assault escalated in a maniacal way to the violence accompanying the suffocation. The sexual assault and the suffocation could be viewed as offences of the same type in the sense that together they combine to form the offences proscribed by either s. 246.2 or s. 246.3 of the *Code*.[9]

Further, Wilson and L'Heureux-Dubé JJ. would have held that since violence is implicit in the very nature of sexual assault, bodily harm is a probable consequence. Where the woman attacked is also old and frail, the question of whether the accused was a party to a crime that he knew would probably cause at least bodily harm short of death to the victim should be left for the jury to determine. In light of the fact that Kirkness stayed in the house during the attacks upon the woman, did not remove the chair from the door, and persisted in the plan to carry out the robbery, the dissenters would have directed a new trial for the jury to consider whether Kirkness in fact encouraged the rape and whether his protest against the killing of the woman amounted to abandonment of the joint endeavour.

In *Martineau*, L'Heureux-Dubé J. authored her first dissent, declaring constitutional the use of objective standards to undergird criminal responsibility for murder. In this decision she set a pattern in her approach to culpability that she enlarged upon in her later sexual assault judgments. She identified collective interests as critical to the *Charter*'s section 7 guarantee of principles of fundamental justice and used statistics regarding homicides in

the context of crimes like robbery and sexual assault to support her deference to Parliament's decision to punish, using objective standards, the deliberate use of violence to achieve criminal ends. Justice L'Heureux-Dubé pointed out the moral poverty of the constitutional standard for criminal fault where its assessment is exclusively based upon what the accused subjectively and consciously intended. She identified a broader basis for responsiblity: "flagrant, callous, ruthless, or selfish acts causing death, perpetrated by one whose purpose is already criminal, [should] be treated more harshly than a mere accidental killing."[10] Her judgment eschewed abstract propositions in favour of the facts in the case, which here included murders committed by Martineau's co-accused in the course of an armed break and enter, and Martineau's words (or thoughts) and actions—"Lady say your prayers"[11]—that suggest he possessed a culpable state of mind.[12]

### Mistaken Belief in Consent

The claim to moral innocence in the context of sexual assault often takes the form of the defence of mistake of fact, or mistaken belief in consent. When this defence is used to raise a doubt about an accused's *mens rea*, L'Heureux-Dubé J.'s contextual and equality-driven analysis of the concept of moral innocence is critical to resisting the privatization of the crime of sexual assault. The implications of a contextual approach for developing a conceptual framework for *mens rea* for sexual assault include attention to external evidence when assessing the accused's culpability, as opposed to reliance upon his subjective interpretation, and attention to the broader data regarding women's experience of sexual assault.

Justice L'Heureux-Dubé has repeatedly urged the Court to move from a purely subjective test for mistaken belief in consent towards a more nuanced test that includes objective assessment of that claimed belief. The subjective approach was adopted seven years before her appointment, when, in 1980, the Supreme Court determined in *R. v. Pappajohn*[13] that the defence of mistake of fact must be tested on a subjective basis such that a man is not guilty of rape if he honestly but unreasonably believed that the woman consented. Although the Court backed away from the full implications of the subjectivist logic in *R. v. Sansregret*[14] five years later, it was not until *Seaboyer* in 1991 that L'Heureux-Dubé J. was presented with an opportunity to respond to the ways

in which mistake of fact is argued in practice. That case involved an argument that a woman's sexual history should be available to support an accused's defence of mistake regarding consent. Substantively, L'Heureux-Dubé J.'s dissent would have shifted the defence so as to include an equality-based objective component: she essentially claimed that it is neither reasonable nor morally innocent to rely on a woman's sexual history as indicative of consent over and above her response to the individual accused man. This dissent foreshadowed L'Heureux-Dubé J.'s later ruling in *R. v. Park*,[15] which held that in order to exculpate, mistakes must be mistakes of fact as opposed to law, and must therefore be grounded in mis-communication, not individually- or collectively-held erroneous beliefs or assumptions about what a man can get away with or presume regarding sexual access to a woman.

Whereas *Seaboyer* was a constitutional challenge decided in a factual void, the abundance of "facts" in *R. v. Osolin*[16] demonstrates the critical role played by egalitarian factual analysis in determining whether there is an "air of reality" to the defence such that it can be put before the jury. Osolin admitted at trial to having pulled a seventeen-year-old woman from a bed that she was sharing with another man, torn off her underwear and forced her into a car, while she was naked, and contrary to her objections. Osolin's friend drove them forty kilometres away to a cabin where Osolin acknowledged that he tied her up spread-eagled on a bed, shaved her pubic hair, and had intercourse with her. At trial Osolin argued consent to defeat both a kidnapping and a sexual assault charge, but was precluded by the trial judge from advancing the defence of honest mistake regarding consent on the basis of the facts supporting a kidnapping conviction. He was convicted of both offences in spite of the fact that he testified that the woman had, to his knowledge, engaged in consensual sexual intercourse with two other men that same day. On appeal, counsel for Osolin requested a new trial to permit him to cross-examine the woman on her medical records in order to argue mistaken belief in consent based on her statements to a therapist that perhaps her rape was her own fault.

Writing for the majority, Cory J. held that while an accused must do more to raise mistake than simply assert his mistaken belief in consent, the proposed cross-examination of the young woman regarding her feeling of responsibility for the offence might provide the requisite air of reality to that defence. Justice Cory stated that no air of reality would be generated if this statement had its source in the "feelings of guilt, shame and lowered self-

esteem [that] are often the result of the trauma of a sexual assault," but said that "in the absence of cross-examination it is impossible to know what the result might have been."[17] He went on to hold that while mistake could not be advanced if Osolin had been convicted of kidnapping in relation to his conduct that night, here both crimes were tried together and the Crown had to prove beyond a reasonable doubt a separate *mens rea* for the crime of kidnapping before it could be said that mistake was thereby precluded as a defence to the sexual assault. Since the trial judge had relied on kidnapping to bar the mistake defence for the sexual assault, an error in law had occurred, warranting a new trial to enable Osolin to pursue the proposed cross-examination and, if it generated an air of reality, to advance a mistake defence.

Justice L'Heureux-Dubé read the same factual record as did the majority, yet found mistake to be impossible. She based her conclusion on Osolin's admissions (that he "overrode" her objections to being thrown in the car) and other evidence (her torn underwear was found outside the trailer; she was found naked and hysterical on the highway; she had bruises consistent with having been hit over the head, injuries to her wrists, and injuries to her pubic area consistent with rape) that supported the young woman's account of the attack: "[A]ny mistake of perception or interpretation that might have existed was a matter located solely in the mind of the appellant; nothing in the subsequent comments of the complainant could add to, detract from, or have any relevance to the presence or absence of that belief at the time."[18]

L'Heureux-Dubé J.'s analysis of the air of reality test for determining whether to leave a mistake defence with the jury accorded with Cory J.'s test: mistake arises as a possible theory where the accused and the woman give essentially the same account but differ in their interpretations of whether her acts or words amounted to consent. In her view, there was no accordance between the two accounts such that mistake would be a viable third explanation and the objective evidence contra-indicated "mistake." She insisted that a mistaken belief in consent cannot be supported by the woman's thoughts recounted to a counsellor after the assault:

> The complainant's reflections on how the situation might have been avoided, even assuming they are correct, can have no probative value as to whether or not there was consent to the assault or mistaken belief in consent on the part of the appellant. In any event, it is hardly surprising that such statements are to

be found in her medical records; in this, as in other traumatic situations such as the death of a loved one, especially by suicide, it is not uncommon for people to blame themselves for the event.[19]

Justice L'Heureux-Dubé's application of the mistake doctrine demands that the larger context inform the "air of reality" test, taking account of objectively implausible but socially dangerous beliefs and the effects on women of permitting their post-trauma grief and self-doubt to be publicly aired to support an accused's defence of mistake. In doing so, she shifts the defence so that it assesses Osolin's moral innocence, as opposed to his subjectively held beliefs about the meaning of women's behaviour, thereby rendering vulnerable to criminal sanction his undeniably highly coercive behaviour.[20]

The majority decision potentially renders a large group of women—those who blame themselves in counselling for their own rapes—beyond the protection of the criminal law, leaving them to private justice, whatever that may be. It also covertly reinforces the myth that the promiscuous cannot be raped: it seems hard to believe that the evidence that on the same day the woman had enjoyed consensual sexual contact with two other men did not influence the judicial assessment that her self-blame was potentially "relevant" to a mistake defence. Finally, Cory J.'s resolution of the air of reality test permits the judge to put the defence of mistake to the jury even in circumstances where it can only exonerate the accused if discriminatory reasoning or stereotypes are employed by the jury.

Two years later, in 1995, Justice L'Heureux-Dubé advanced the law of *mens rea* and mistake in *Park*, wherein she emphasized that the *mens rea* inquiry with respect to the man's culpability must be focused on the woman's actual communicative behaviour and the totality of evidence that explains how the accused understood the words or behaviour to communicate consent. She also managed in *Park* to consolidate a majority opinion that reversed a decision by Justice McClung of the Alberta Court of Appeal on the availability of the mistake defence on the facts and at the same time articulated a legal test that should, in the future, prevent the evidence reaching the jury in cases like *Osolin*.

The traditional position is that the *mens rea* for sexual assault is made out when the accused is aware of, reckless as to, or wilfully ignorant of the woman's non-consent. L'Heureux-Dubé J.'s interpretation of *mens rea* in *Park* stated that the accused should be found guilty if he knew, was reckless, or wil-

fully blind to "an absence of communicated consent."[21] She grounded this shift in the legal understanding of *mens rea* in the changing interests and rights protected by the crime of sexual assault. Moving from the history of rape law, whereby men's property interests in their daughters and wives shaped the contours and procedural rules by which rape was regulated, to the present day, she argued that the law of sexual assault currently protects not only women's physical security but also their personal and sexual integrity:

> As long as the effect of our approach to the *mens rea* of sexual assault reinforces the view that sexual activity is consensual in the absence of communicated non-consent, the damaging communication gap between the sexes, and the terrible costs that flow from it, will continue unacknowledged and will be perpetuated rather than narrowed. In order to give full and meaningful effect to women's right to control their own bodies, we must recognize that awareness of, or wilful blindness to, an absence of communicated consent is sufficient to found the *mens rea* of the offence of sexual assault.[22]

Thus *mens rea* is not assessed internally and privately, exclusively from the point of view of the accused, but rather must be grounded in the external and public world in a manner that respects the rights and interests of both women and men. Justice L'Heureux-Dubé attempted to allocate to both sexes the burden of the criminal law:

> Women, as a practical matter, still run the risk of being sexually assaulted unless they communicate non-consent in a manner that is sufficiently clear for others to understand. Men, by contrast, must assume the responsibility for that part of the communication gap that is driven by androcentric myths and stereotypes, rather than by genuine misunderstanding due to gender-based miscommunication.[23]

Her decision enlarged mistake to the benefit of the accused in several respects: he need not specifically testify as to mistake in order for this defence to be a live issue, and he can raise this defence even if his version of the event is diametrically opposed to hers as long as it is possible to "splice some of each

person's evidence ... and settle upon a reasonably coherent set of facts, supported by the evidence ... ."[24]

Justice L'Heureux-Dubé went on to argue that to pursue the *mens rea* inquiry we must break down "that formless and undigested mass of evidence" called "mistaken belief," distill it, and analyze it in order to separate out genuine errors of communication from sex-discriminatory beliefs. She ruled that an accused cannot advance a mistake defence where it is based upon the accused's bare assertion without more, where it is inconsistent with other evidence that is not materially in dispute, or where the totality of the evidence cannot support the defence. The defence is therefore unavailable where the accused's testimony or physical evidence whose significance is disputed is logically inconsistent with testimonial evidence that is not in dispute (for example, in *Osolin*, the fact that he had dragged the woman from the bed of another man, naked, into a car, over her protests) or physical evidence whose significance is not in dispute (the retrieval of the young woman's torn underwear outside the trailer, when Osolin had denied having ripped off her underwear). Justice L'Heureux-Dubé noted that by focusing on real and testimonial evidence that is not in dispute, her approach relieves the trial judge of the responsibility of evaluating the accused's claim against evidence that is materially in dispute and thus avoids assessments of credibility that are properly the domain of the jury.

On the facts in *Park*, L'Heureux-Dubé J.'s approach meant that there was no air of reality to the accused's claimed mistake, since the accounts provided by the accused and the complainant were totally at odds with each other and the totality of the evidence provided no support for the accused's claim, leaving the jury with the choice of consent or non-consent as the only possible interpretations of the evidence. The woman had met the accused two weeks before in a parking lot and they had spent one date together thirteen days before the assault. He claimed that during that date they engaged in sexual contact and discussed her religious beliefs and birth control. She acknowledged the discussion, but testified that no sexual contact had occurred because of her religious position on pre-marital sex. As L'Heureux-Dubé J. analyzed the facts:

> The factors listed by McClung, J.A. [in the court below] as lending an air of reality to that defence—the complainant's telephone overture to the respondent, the discussions of her use of birth

control, the sexual activity engaged in thirteen days earlier, and the fact that she met him with a kiss at 6:10 a.m. on November 25 wearing her bathrobe—are all only capable, if anything, of supporting a belief ... that the complainant *would* consent, not a belief that she actually did *in fact* consent. None of these factors address or relate in any realistic way to the events that actually took place at the time of the alleged sexual assault.[25]

Justice L'Heureux-Dubé insisted on a critical look at the facts urged in support of mistake—a public airing of the specifics that are usually only alluded to in judicial decisions on sexual assault prosecutions. She ruled that none of the above facts themselves speak to a belief regarding actual consent to sexual contact. She noted that Park's account of the events was "sketchy," generally portraying the woman as a "willing participant" except with respect to unprotected intercourse, and describing the encounter as "hot."

The majority judgment agreed with her analysis with the explicity exception of the "mistake of fact and consent" section. Sopinka J. thought it undesirable to exhaustively define the offence and would have found that since the accused had testified that no intercourse actually occurred, it would be logically inconsistent to permit him to advance an alternative of mistake regarding consent to intercourse. Iacobucci, Cory, and Major JJ. agreed with the latter point and also pointed out that the physical evidence supported the woman's assertion that intercourse had in fact occurred.

The different factual resolution of the two judgments has implications for the privatization of sexual assault. Justice Sopinka's is a narrower judgment, dependent on a logical inconsistency in the accused's own defences. On this view, the significance of this case is reduced to one of poor defence choices or dishonest clients, far away from the public realm of defining the parameters of predatory sexual behaviour or moral innocence. In contrast, L'Heureux-Dubé J. states a broader proposition. She insists that for sexual contact to remain non-criminal, men must rely upon women's actual words and acts communicating consent as opposed to past interactions or interpretations of the meaning signalled by a woman's clothing.

Although Justice L'Heureux-Dubé's analysis of *mens rea* and its relation to the mistake defence was not endorsed by the other justices in *Park*, in *R. v. Livermore*,[26] McLachlin J., writing for the majority, adopted a key aspect of

L'Heureux-Dubé J.'s analysis. Affirming the Ontario Court of Appeal's conclusion that mistake should not have been left to the jury, McLachlin J. noted that "There was evidence that Valerie had said no; there was no evidence that she had said yes."[27] She went on to hold that the facts relied on for an air of reality in support of mistake—the teenage girl had voluntarily entered the accused's car after midnight, changed seats with another girl in the car, failed to scream out the open windows for help, and hugged the accused when parting instead of fleeing—could in no way support an honest belief in actual consent.

McLachlin J. more clearly adopted Justice L'Heureux-Dubé's *mens rea* analysis from *Park* in *R. v. Esau*,[28] a decision in which they both dissented. In *Esau*, after a night of heavy drinking, the woman woke up and discovered that someone had had sexual intercourse with her. Her cousin Esau was identified as the perpetrator through DNA testing. At trial he argued that she was not too drunk to know what she was doing and that she had consented. She, having no memory of the events, testified that she would not have consented to sexual contact with her cousin. Counsel for the defence disavowed a mistake defence expressly, and thus the Crown did not interrogate the reasonable steps requirement that had been adopted in the 1992 rape law reforms.

On appeal, the majority held that the trial judge should have put mistake to the jury, finding an air of reality to the accused's narrative. They held that his was not a bare assertion but rather an account, and relied for the air of reality upon the fact that the woman had no memory of the events and there was no evidence of force or violence.[29] The majority refused to assess the mistake defence against the reasonable steps requirement because it was not raised at trial or on appeal.

*Esau* is important in the trajectory of L'Heureux-Dubé J.'s mistake analysis for several reasons. First, in a separate concurring dissent, McLachlin J. expressly adopted the analysis of the *mens rea* requirement and the mistake defence from Justice L'Heureux-Dubé's decision in *Park*. Second, in contrast to the majority's finding of an air of reality to mistake based on the woman's lack of memory, her inability to posit an affirmative account of what happened, and the absence of evidence of force or violence, L'Heureux-Dubé J. wrote that the question is not whether or how the woman communicated refusal, but whether and how she communicated consent to the activity in question. She made clear that the *mens rea* analysis must focus on an objec-

tive examination of the verbal and behavioural indicators of the woman's subjective state as identified by the accused, as well as his subjective perception of that state. The lack of evidence of force or violence is legally irrelevant to the question of mistake: Esau's culpability turned on his intent, recklessness, or wilful ignorance regarding his cousin's consent, not on her resistance. Justice McLachlin explained this point in her separate dissent as follows: "If the respondent wrongly inferred clear capacity and an active communication of consent from lack of struggle or passivity, it is hard to avoid the conclusion that he must have been either wilfully blind or dishonest."[30]

Third, since Esau testified at trial as to unambiguous consent, L'Heureux-Dubé J. found no evidence supporting a third alternative of mistake. She would have ruled that this support cannot come solely from the fact that the woman was so intoxicated that she could not recall what happened: "To put this defence to the jury would require assumptions about the behaviour of intoxicated women which have no demonstrated basis in reality and could potentially be seen as biased or stereotypical."[31]

The majority decision in *Esau* furthers the relegation of sexual assault to the private sphere. Its reasoning provides practical and legal immunity through the mistake defence for men who use drugs or alcohol to subdue women or who opportunistically assault women who are unconscious for whatever reason. It also effectively privatizes the public law of the *Criminal Code*, specifically section 273.2 (b), by holding that the legislative limit on the mistake defence—the "reasonable steps" requirement—only applies if it is argued by the Crown at trial. As McLachlin J. stated in her dissent: "Parliament has spoken. It has set out minimum conditions for the defence of mistaken belief in consent. If those conditions are not met, the defence does not lie. This Court cannot resurrect the defence on the ground that the parties failed to allude to the governing provisions."[32]

One year later, in a terse decision dismissing an appeal from the Quebec Court of Appeal, Justice L'Heureux-Dubé repositioned the reasonable steps requirement in the public domain. This case involved two young men who administered PCP to an unsuspecting woman, and then raped her. This was one of the extremely rare cases where administration of a date rape drug was admitted by the men,[33] and yet the trial judge acquitted them, holding that the young woman had "consented"![34] A unanimous Court of Appeal overturned the acquittal and entered a conviction because the stupefying effects

of PCP negate true consent. In affirming the conviction, and in spite of the lack of discussion of section 273.2, L'Heureux-Dubé J. stated: "We would simply add that the appellant could not rely on the defence of honest but mistaken belief since he had not taken reasonable steps to ascertain that the victim was consenting."[35]

The significance of Justice L'Heureux-Dubé's reframing of the mistake defence for resisting privatizating interpretations of it and for promoting women's equal status is perhaps most vividly illustrated by her own words in *Esau*:

> Evaluating consent and mistaken belief in consent in terms of the complainant's communication is essential if we are to bridge the damaging communication gap between men and women, to encourage men to ascertain whether their sexual partners are consenting, and, most importantly, to prevent sexual behaviour on the part of men which is driven by the biased views and stereotypes that women are consenting when passive or incapable of communicating and do not have a full right of control over what is done to and with their bodies.[36]

Justice L'Heureux-Dubé's recasting of *mens rea* was ultimately adopted by a majority of the Supreme Court of Canada in *R. v. Ewanchuk*[37] in 1999. The accused must identify how the complainant communicated consent by her words or behaviour: "A belief by the accused that the complainant, in her own mind wanted him to touch her but did not express that desire, is not a defence. The accused's speculation as to what was going on in the complainant's mind provides no defence."[38] The majority also accepted a proposition that Justice L'Heureux-Dubé put forward in 1995 in *Park*, that a man's claim that he thought a woman's silence, passivity, or ambiguous conduct constituted consent is a mistake of law that provides no defence.[39]

In spite of these equality-promoting advances, the majority in *Ewanchuk* furthered the privatization trend evident in many of the Court's sexual assault judgments. It continued to refer to the mistake defence as evaluated solely on a subjective basis and stated that the reasonable steps requirement in section 273.2 need only be considered by the trier of fact once the judge has determined that there is an air of reality to the accused's claim of honest mistake.

In contrast, L'Heureux-Dubé J.'s concurring judgment, joined by Gonthier J., posited sexual assault as a human rights issue. She explicitly framed the issues within an equality analysis of sexual assault, referring to public and international commitments entered into by the federal government. She reminded the majority that the impact of the reasonable steps law reform is that men who fail to make an effort to ascertain consent or who are careless as to consent are at risk of conviction. Justice L'Heureux-Dubé argued that if the mistake defence now has a reasonable steps component, then the evidentiary burden must be adjusted accordingly. There must be an air of reality to a man's claim that he took reasonable steps to ascertain consent before the defence can go to the jury. Finally, L'Heureux-Dubé J. itemized and rejected the rape mythology that informed the trial judge's analysis of the facts and law and more blatantly, those rape myths and prohibited inferences repeatedly invoked by McClung J. of the Alberta Court of Appeal. For this effort to resist publicly what the other members of the Court implicitly rejected, Justice L'Heureux-Dubé was vilified in the media.[40]

### Non-Consent and Consent

The reconceptualizion of the *mens rea* for sexual assault through L'Heureux-Dubé J.'s analysis of mistaken belief in consent has had a corresponding impact on the *actus reus* of non-consent, particularly in light of the 1992 reforms that defined consent for the first time as the "voluntary agreement … to engage in the sexual activity in question." The idea that the accused must show how the woman communicated her agreement in order for him to claim moral innocence has implications for Crown proof of "non-consent" and its mirror image, the defence of consent. Global notions of consent to assault, including the doctrine of implied consent, are obvious candidates for re-visioning consistent with the shift to protect women's automony interests.

For example, in *Ewanchuk*, the Court was called upon to determine whether a woman impliedly consented to a sexual assault. Acceptance of implied consent meant that the judges below could find that the complainant "consented" because of her dress and her manner, even while accepting that she had not, in fact, agreed to the sexual contact. This doctrine has been invoked in sports contests and in fist fights to immunize from criminal law those assaults where the victim's behaviour suggests acceptance of the inevitability of physical contact and its attendant risks.[41]

All of the justices in *Ewanchuk* repudiated implied consent as inconsistent with the protection of the physical and psychological integrity of women against sexual assault. To prove the *actus reus*, the Crown need only prove that the woman did not voluntarily agree to the contact in her own mind. However, Major J.'s decision stated that any ambiguous conduct by the woman may be used to test her credibility and to support the accused's mistake defence.[42]

Justice L'Heureux-Dubé's judgment goes further by providing the tools with which to challenge these other uses of women's "ambiguous conduct." Her judgment insists that consent must be to sexual activity as opposed to other social or physical contact, such as agreeing to go to someone's apartment or accepting a massage. L'Heureux-Dubé J. unpacked the content of "implied consent" in this context, revealing judicial reliance upon prohibited sex discriminatory myths and stereotypes. To transform the requirement that the Crown prove non-consent into implied consent would suggest that "women are 'walking around this country in a state of constant consent to sexual activity.'"[43] Myths and stereotypes such as this must, she argued, be repudiated in all of their doctrinal incarnations.[44]

The reconfiguration of "consent" has done much to bring the harms of sexual assault into the public realm. Another aspect of that shift can be seen in the debate over the meaning of "fraud." Fraudulent sexual assault is a crime, but Parliament has left the courts to address what fraud means in this context. Historically, and as reflected in the now-repealed definition of rape in the *Criminal Code*, the behaviour caught by the concept was very narrow, relating only to fraud as to the nature and quality of the act. For instance, in the indecent assault case of *Bolduc v. R.*,[45] the Supreme Court of Canada quashed the conviction of a doctor who misrepresented a friend to be a doctor so that he could be present at a vaginal examination. The group of women and girls offered the protection of such a law was very small indeed, for instance, those young women who were completely ignorant of sex and so could be deceived by doctors or singing teachers into thinking that sexual intercourse was a form of treatment or voice training.[46] The current definition of assault, including sexual assault, simply states that "no consent is obtained where the complainant submits or does not resist by reason of … (c) fraud"[47]

The issue of the breadth of the new definition came before the Supreme Court of Canada during L'Heureux-Dubé J.'s tenure in *R. v. Cuerrier*,[48] in which the Court split three ways. Here Justice L'Heureux-Dubé explicitly

grounded her concurring judgment in the rejection of privacy as the dominant concern. She concluded:

> [I]t is not for this Court to narrow this protection [of autonomy and physical integrity granted by Parliament through the assault provisions] because it is afraid that it may reach too far into the private lives of individuals. One of those private lives presumably belongs to the complainant, whose feeling of having been physically violated, and fraudulently deprived of the right to withhold consent, warrants the protection and condemnation provided by the *Criminal Code*.[49]

L'Heureux-Dubé J. therefore adopted a broader test for fraud than those adopted by the other members of the Court. In her view, "fraud is simply about whether the dishonest act in question induced another to consent to the ensuing physical act, whether or not that act was particularly risky or dangerous."[50] Cory J., speaking for the four-member majority, held that in addition to the traditional form of fraud, dishonestly exposing a person to a significant risk of serious bodily harm (here the risk of contracting AIDS) would constitute fraud. In his view, adopting Justice L'Heureux-Dubé's approach would "trivialize" the criminal process. McLachlin and Gonthier JJ., also concurring, took the narrowest approach, holding that deception as to the presence of a sexually transmitted disease giving rise to a serious risk or probability of infecting the complainant is included in fraud. In their view, L'Heureux-Dubé J.'s approach would vastly extend the offence of assault, in a way that would pose difficulties with respect to the commonplace small deceits of sexual interaction, such as lies about one's age or marital status.

It is tempting to make fun of concerns of the "what about the 'false moustache'" variety.[51] However, McLachlin J. did engage L'Heureux-Dubé J. on a level that requires critical reflection on the broad sweep of criminalization of fraudulent sexual assault supported by Justice L'Heureux-Dubé. Since *Cuerrier* involved non-disclosure of HIV-positive status, the issue of when to use criminal sanctions as compared to other methods of social control was a central feature of the case, attracting intervenors such as the Canadian Aids Society. Justice L'Heureux-Dubé did not address the concern raised by

McLachlin J. about the negative impact of the use of criminal sanctions on public health efforts to encourage infected people to come forward for testing and treatment. While the private sphere is a place where power can be abused with impunity, it is also a place where non-coercive methods may be used to minimize the risk of certain harmful behaviours.

Nevertheless, there are stronger arguments in support of L'Heureux-Dubé J.'s position than her lone judgment suggests. These include consistency, principle, and concern about avoiding the message that privacy interests are more important than sexual integrity. This broad re-conceptualization of the notion of legal consent contrasts positively with the majority tinkering with specialized rules for sexual assault. Further, her judgment would have avoided the troubling issue before the Supreme Court of Canada in *R. v. Williams*.[52] Williams continued to have unprotected sexual intercourse with the complainant without telling her that he had tested HIV-positive and was charged with aggravated assault. The court held that it could not be proven that her life was endangered, since she may already have been infected before he knew of his status.

The *Cuerrier* test requires the courts to grapple with complex assessments of risk, with the attendant possibility that HIV-positive women might somehow be entitled to less information from prospective sexual partners than other women. It shifts the focus away from the accused's risk-taking and publicly dangerous behaviour to the complainant's private health status in determining the criminality of his conduct. It also authorizes and requires exposure of her prior and subsequent sexual history, the health status of her partners, and inspection of medical and other records, privatization issues that will be more fully interrogated below.

More fundamentally, however, *Cuerrier* gives courts the power to assess the risk, rather than the responsibility of finding, as a matter of fact, what the complainant's assessment of the risk would have been, an inquiry more consistent with sexual autonomy and the Court's understanding of consent as a subjective issue in *Ewanchuk*. This seems similar to telling a person who has been subjected to a non-consensual surgical procedure that even though she would not have consented to it, the procedure did not do her any harm. The real harm to autonomy and the risks to health that are not visible through the *Cuerrier* filter are thus left to the private realm.

### The Trial Process

Justice L'Heureux-Dubé's attention to the intersection of equality and sexual assault law is particularly evident in her judgments relating to procedure and evidence, which govern the determination of whether sexual assault was committed. The process of making such determinations must be both fair and egalitarian. Unfair and/or inegalitarian procedural and evidentiary rules could functionally leave women outside the criminal law system to fend for themselves. Concern about such a privatization effect may be seen as underlying the evolving law relating to sexual history, private records, and methods for taking the evidence of children.

With respect to the first two, the use of the criminal law is a two-edged sword, as women may pay a price for publicization in loss of privacy themselves. Efforts to treat sexual assault as a public wrong while preserving an appropriate level of privacy for women require a fine line-drawing exercise. Similarly, with the evidence of children, attention to the public wrong of sexual assault must reflect attention to the costs to children of our public trial process.

*Sexual History*

We touched above on the linkage between the use of sexual history evidence and the defence of mistaken belief in consent. However, the law relating to the use of such evidence in sexual assault trials has broader significance, providing a rich source of insight into the social and legal status of women, the common sense grounding of determinations of relevance and prejudice, and the importance of men's sexual access to women in both the public world of strangers and the private one of intimate relationships.

The striking evolution of the law in this area can be briefly summarized. In *Seaboyer*, section 276 of the *Criminal Code* (which sets non-discretionary limits on the admissibility of sexual history evidence) was struck down as inconsistent with accused persons' right to a fair trial, leaving complainants to rely on judicial perspectives on relevance and prejudice.[53] *Seaboyer* provided the political impetus for Bill C-49,[54] which established new legislative controls on the exercise of judicial discretion. These new controls survived constitutional challenge in *R. v. Darrach*.[55] The Supreme Court, including L'Heureux-Dubé J., took the view that the provisions were essentially a codification of the common law as stated in *Seaboyer*.

Justice L'Heureux-Dubé's dissent in *Seaboyer* may thus be her least successful (though perhaps her most famous) contribution to this area of law. She was unsuccessful in persuading the majority of the Court to her view of the (ir)relevance of sexual history evidence, and Parliament did not challenge the majority view, although the accompanying reform of the substantive law of sexual assault did go some way towards limiting the impact of *Seaboyer* in its common law and codified forms.

In her dissent, joined by Gonthier J., L'Heureux-Dubé J. laid bare the assumption underlying the use of sexual history evidence. The primary focus of her extensive analysis was relevance.[56] It must be assumed that a woman's past sexual conduct says something meaningful about her propensity to consent or her credibility if her past sexual history is to have any relevance. The dissent depicted such an assumption as largely based on discriminatory myths:

> Any connection between the evidence sought to be adduced and the fact or matter of which it was supposedly probative must be bridged by stereotype (that "unchaste" women lie and "unchaste" women consent indiscriminately), otherwise the proposition makes no sense.[57]

Her relevance analysis is significant for a number of reasons. First, the dissent is still a classic source of information about the social reality of sexual assault and its treatment in the criminal justice system as a whole. Second, it is also striking for its listing of myths and stereotypes, such as "Woman as Fickle and Full of Spite" and "The Female Under Surveillance: Is the Victim Trying to Escape Punishment?"[58] Third, L'Heureux-Dubé J. identified the problem in transplanting similar fact evidence reasoning to this context. A significant argument that the (then) limits on sexual history evidence were unconstitutional was that they excluded pattern evidence, that is, of sexual disposition. The conception of women's autonomy reflected in the dissent underscores consent as going to a person and not a circumstance, such that in her view a woman's past relationships have no bearing on whether she is likely to consent in any other encounter. Her analysis is premised on women's capacity to discriminate and women's exercise of choice of their sexual partners. She rejects the caricature of capricious and superficial women who pursue sexual relationships based upon "such extraneous considerations as the

location of the act, the race, age or profession of the alleged assaulter and/or considerations of the nature of the sexual act engaged in."[59]

While this could be stated another way, that a woman's sexual history tells us nothing about the likelihood of her having been raped on a particular occasion, nevertheless, the reflection of respect for women's autonomy in the dissent is a striking reminder not to treat women as bundles of mindless disposition. Although *Darrach* sees the later legislative controls on sexual history evidence as a codification of *Seaboyer*, there is still room for L'Heureux-Dubé J.'s relevance analysis to be influential. Debate continues over the meaning of section 276(1) of the *Criminal Code*, which bars inferences that by reason of the complainant's sexual history, she is more likely to have consented or is less worthy of belief.[60] Depending on the direction of that debate and its influence on the judiciary, it may be that Bill C-49 will be seen as reflecting elements of both the majority and dissent in *Seaboyer*.

We hope that the dissent in *Seaboyer* will strengthen judicial determination to exclude irrelevant sexual history evidence while respecting the fair trial rights of accused persons. Justice L'Heureux-Dubé's approach is consistent with both, as is illustrated by her majority judgment in *R. v. Crosby*.[61] In this case the police had intermingled questions about the reported assault with questions about previous sexual contact between the complainant and one of the accused. This meant that proper cross-examination about a material inconsistency could not be carried out without improper reference to this sexual contact. L'Heureux-Dubé J. stated that "it would be unfair for an accused person to be denied access to evidence which is otherwise admissible and relevant to his defence if the prejudice related to admitting that evidence is uniquely attributable to the authorities' conduct."[62] Thus the police, the prosecution, and women have to live with the consequences of investigatory mistakes (or stereotypes) in the interest of fairness to the accused.

The importance of getting the balance right can be understood through the privatization theme of this chapter. The focus on discriminatory relevance reasoning brings to the forefront the role of the "private" common sense of the judge. Thus, according to the dissent in *Seaboyer*, the decision about relevance is "particularly vulnerable to the application of private belief … the content of any relevancy decision will be filled by the particular judge's experience, common sense and/or logic."[63] The question of who is given the protection of the law of sexual assault can be determined by private assump-

tions about human behaviour rather than public values. In the words of Justice L'Heureux-Dubé herself, "[t]he guilt or innocence determination is transformed into an assessment of whether or not the complainant should be protected by the law of sexual assault."[64]

*Records*

Justice L'Heureux-Dubé's dissent in *Seaboyer* clearly made the linkage between promoting a fair trial and respecting the equality rights of witnesses. However, the majority view can be said to be consistent with her dissent in that discriminatory stereotypes were rejected in order to achieve a fair trial. The evolution of an express majority commitment to the linkage can be traced through the case law on the related issue of defence access to the private records (such as rape crisis centre or medical records) of complainants.[65]

The dominant issues with respect to records were whether, and under what circumstances, the defence could get pre-trial production of such records. A related issue, foreshadowed in *Osolin*, discussed above, had to do with the extent to which such records could be used at trial, for instance in cross-examination.

L'Heureux-Dubé J.'s dissent (with La Forest, McLachlin, and Gonthier JJ. concurring) in the leading case of *R. v. O'Connor*,[66] continued the focus on equality. In this case a judge had ordered extensive pre-trial disclosure of the complainants' therapy, medical, school, and employment records.[67] The issue of whether such an order was proper was not directly before the Supreme Court of Canada, since the order had been obeyed, albeit with delays, just before the trial.[68] Nevertheless, the case was seen as raising, *inter alia*, the question of "whether and under what circumstances an accused is entitled to obtain production of sexual assault counselling records in the possession of third parties."[69] On that issue the Court was in agreement that there is some right to production of such records.[70]

The 5:4 split in the Court over the production issue occurred with respect to the relative ease, or circumstances of, production. For example, the process adopted by the Lamer C.J.C. majority would have made it relatively easy for the defence to pass the "low" threshold of "likely relevance" for production to the court for examination. The minority view in the L'Heureux-Dubé J. decision would have treated the threshold as a significant one, not met

by bare assertions, and sensitive to the fact that the focus of therapy is very different from truth-seeking in a trial. Further, before looking at the records, given that even an order for production to the court is an invasion of privacy, her judgment would have required the court to balance the salutary and deleterious effects of production.

More fundamentally, the split in the Court can be seen as grounded in the (in)attention to equality for complainants. There is a striking contrast in the description of the rights at stake. Thus the majority said, "we are concerned with the competing claims of a constitutional right to privacy in the information on the one hand, and the right to full answer and defence on the other."[71] The dissent said that "it is important to appreciate fully the nature of the various interests at issue ...: (1) the right to full answer and defence; (2) the right to privacy; and (3) the right to equality without discrimination."[72]

What followed *O'Connor* was significant in two ways. First, L'Heureux-Dubé J.'s dissent influenced subsequent amendments to the *Criminal Code*, which reflected both aspects of the dissent mentioned above. Second, subsequent case law reflected acceptance by the whole Court of the relevance of an equality analysis to the process of trying sexual assault offences.

Parliament responded to the *O'Connor* decision by introducing a production application process that incorporates a more challenging threshold for production to a judge than that required by the majority, which is grounded in constitutional values including equality. Thus the Preamble states:

> Whereas the Parliament of Canada continues to be gravely concerned about the incidence of sexual violence and abuse in Canadian society and, in particular, the prevalence of sexual violence against women and children;
>
> Whereas the Parliament of Canada recognizes that violence has a particularly disadvantageous impact on the equal participation of women and children in society and on the rights of women and children to security of the person, privacy and equal benefit of the law as guaranteed by sections 7, 8, 15 and 28 of the *Canadian Charter of Rights and Freedoms*.[73]

Further, section 278.3(4) of the *Criminal Code* lists assertions that are not sufficient on their own to meet the test of likely relevance, for example,

that the record may disclose a prior inconsistent statement of the complainant. In deciding whether to examine the records the judge, following section 278.4(2), "shall consider the salutary and deleterious effects of the determination on the accused's right to make a full answer and defence and on the right to privacy and equality of the complainant or witness." These points illustrate the influence of Justice L'Heureux-Dubé's dissent on the parliamentary view of how the criminal law should reflect the constitutional rights of accused persons and women and children, the primary targets of sexual assault. That influence reflects the ideal that when women and children appear publicly in court as witnesses to their own sexual violation, they appear as constitutional rights holders, and must not be re-violated by assumptions of inferior status emanating from the private realm.

The constitutional challenge to this legislation in *R. v. Mills*[74] provided an opportunity for the full Court to include equality as a relevant constitutional right. Lamer C.J.C., dissenting in part with respect to records in the hands of the Crown, stated the issue in the case as being whether the new provisions struck "the appropriate constitutional balance between protecting the accused's right to a fair trial and the privacy and equality rights of complainants and witnesses when an accused seeks access to their confidential records in sexual assault proceedings."[75] This statement was consistent with the relevant rights as described by the full Court, which was unanimous with respect to upholding the remainder of the provisions, stating:

> Equality concerns must also inform the contextual circumstances in which the rights of full answer and defence and privacy will come into play ... . the right to make full answer and defence does not include the right to information that would only distort the truth-seeking goal of the trial process ... . The accused is not entitled to "whack the complainant" through the use of stereotypes regarding victims of sexual assault.[76]

It is important to avoid painting too rosy a picture here. It is true that Parliament adopted L'Heureux-Dubé J.'s approach to the production of records and that the Supreme Court of Canada has included equality in its analysis of the law in this area, but the bottom line is still that persons accused of sexual assault can seek access to private records.[77] The law does not provide that women who have been raped can seek medical help, talk to other women

(including rape crises workers), and write in their diaries, confident that whatever soul-searching they do or comfort they seek is safe from the eyes of their assaulters.[78] Further, the commitment to an equality analysis might not be robust, given that the Court attempted to minimize C-46's departures from the majority's *O'Connor* rules.[79]

Indeed, in *R. v. Shearing*,[80] the Court, over the dissent of L'Heureux-Dubé and Gonthier JJ., found that accused persons could use a complainant's diary at a trial even though it had come into defence hands by a route other than the legislated production application. Justice L'Heureux-Dubé was of the view that the diary should have been returned to its rightful owner and production sought through the statutory channels. In effect, *Shearing* allowed the private circumvention of the public process of determining whether production was appropriate. The case also raises another issue. Once records, or in this case a diary, are in the hands of the accused, the issue becomes whether they may be used at trial.

Here the accused wished to cross-examine the complainant about the absence of reference to the alleged sexual assaults in her diary. The test was not in issue: would cross-examination create prejudice that would substantially outweigh its probative value? Probative value depended on the significance of an omission. Could any inference be drawn about silence in this context? The Binnie J. majority conclusion was that cross-examination should have been allowed. This conclusion depended on a rather fine distinction:

> [T]he probative value to the defence depended on establishing that if the sexual and physical abuse occurred, it would have been recorded. The defence was rightly precluded from *assuming* the truth of that premise, but it did not follow that the defence should also be precluded from attempting to *demonstrate* it with this particular diary on the particular facts of a case.[81]

Thus the defence cannot reason in general along the lines that "people who have really been sexually assaulted would have written it down in their diaries" as a reincarnation of the recent complaint rule.[82] However, the defence can question a complainant to see if it can find a particularized version of this general reasoning: if this particular woman had really been assaulted, would she have written it down in her diary? What could a legitimate, particularized

version of illegitimate, generalized reasoning be? How could the defence place the complainant in a sub-group of women who would have documented sexual assault in their diaries? At best, it seems possible to argue that where a complainant wrote one account of rape in her diary, some proper inference can be drawn from a lack of record of other allegations, but this is not a case of a proper inference being drawn from silence on the facts of a particular case. If particular chains of inference are hypothesized but not identified, then it is impossible to subject them to an equality analysis.

Justice L'Heureux-Dubé would not have permitted cross-examination on the facts of this case. Using the same weighing process as the majority but with explicit attention to privacy and equality, L'Heureux-Dubé J., Gonthier J. concurring, would have found the prejudice to both to substantially outweigh the minimal probative value of the evidence. The only object of the questioning was to show fabrication, relying on the discriminatory beliefs underlying the recent complaint rule. The assumption that "silence speaks volumes" is unfounded. No other, legitimate, purpose was placed before the trier of fact.[83] Justice L'Heureux-Dubé did not reject the idea that silence may sometimes mean something, but she at least required some articulation of the purpose of the cross-examination.

*Shearing* echoes the structure of earlier cases. L'Heureux-Dubé J. was explicitly attentive to equality analysis in her dissent. At best, equality values were implicit in the majority ruling. Binnie J. stated:

> [T]he result of allowing the cross-examination to proceed as proposed by the defence ... would be to allow the defence to go to the jury at the end of the trial and to point to the absence of entries in an effort to suggest—nod nod wink wink—that women and children who are ... abused do not suffer in silence, but must and do confide their inner hurt even if only to their private diaries.
>
> ... sexual assault cases pose particular dangers. *Seaboyer, Osolin,* and *Mills* all make the point that these cases should be decided without resort to folk tales about how abuse victims are expected by people who have never suffered abuse to react to the trauma.[84]

The essence of Justice L'Heureux-Dubé's dissent is that where the complainant has legitimate privacy concerns, the defence should at least be able to articulate a non-discriminatory purpose for invading her privacy. L'Heureux-Dubé J.'s inability to take a majority with her on this point suggests that the *Mills* analysis is fragile. It also justifies continued concern that the price of public denunciation of sexual assault is an unnecessary invasion of women's privacy.

*Children*

A particular challenge for the law of sexual assault is the development of a trial process that allows evidence to be properly tested and yet avoids both rendering the evidence of certain groups of people, such as children, especially vulnerable to disbelief and creating barriers that preclude their testimony altogether. Parliament has addressed this challenge by introducing a number of aids to vulnerable witnesses, such as those permitting child witnesses in abuse cases to testify outside the courtroom or behind a screen.[85]

Such provisions have been subject to constitutional challenge, providing the Supreme Court with an opportunity to articulate its view of the fundamental purpose of the trial as a truth-seeking process. The issue in *R. v. D.O.L.*[86] was the constitutionality of the use of a videotape of the statement of a child or young person. In *R. v. Levogiannis*[87] it was the constitutionality of the use of a screen. In essence both cases found the aids in question constitutional as assisting "in the preservation of the evidence and the discovery of truth."[88]

Why were Justice L'Heureux-Dubé's views stated in a concurring minority in *D.O.L.*, while she was able to write the unanimous decision in *Levogiannis*? The difference appears to lie in her attention to the gendered nature of sexual abuse in *D.O.L.* Thus the majority in *D.O.L.* stated that "s. 715.1 is designed to accommodate the needs and to safeguard the interests of young victims of various forms of sexual abuse, irrespective of their sex."[89]

Of course this is true, but neglect of the gendered nature of the social phenomenon of sexual assault facilitates a non-critical stance towards the law in relation to it, and presents a barrier to an equality analysis. L'Heureux-Dubé J. is resolute in her willingness to speak out about the gendered power imbalance and its implications for the criminal process:

> The innate power imbalance between the numerous young women and girls who are victims of sexual abuse at the hands of

almost exclusively male perpetrators cannot be underestimated when "truth" is being sought before a male-defined criminal justice system .... We cannot disregard the propensity of victims of sexual abuse to fail to report the abuse in order to conceal their plight from institutions within the criminal justice system which hold stereotypical and biased views about the victimization of women.[90]

Her goals are very clear here: to protect (and promote) a public system that is open to all because it generates faith that it is committed to truth-seeking even where the persons before it accused of crimes are drawn from relatively privileged sections of the community. A commitment to equality is fundamental to the legitimacy and truth-seeking function of the trial.

### Conclusion

The discussion above argues that Justice L'Heureux-Dubé has maintained a commitment both to egalitarian fact-finding and to the development of sexual assault doctrine based on women's equality rights. Both are crucial to the rejection of sexual violence as an accepted fact of life in the private realm and to the full acceptance of women in the public realm. Yet, without sustained pressure, the law governing sexual assault is likely to revert to recycling centuries-old myths and stereotypes, albeit in new doctrinal dress.

Also critical to resisting the privatization of sexual assault, therefore, is the participation of women as finders of law and of fact in criminal trials, both as judges and as jurors. Here too L'Heureux-Dubé J.'s decisions have, perhaps less directly, contributed to reforming rape law. For example, decisions issued by Justice Helper of the Manitoba Court of Appeal,[91] Justice Abella of the Ontario Court of Appeal,[92] and Chief Justice Fraser of the Alberta Court of Appeal[93] bear the hallmarks of attention to context and to women's equality as interpretive values informing the law of sexual assault. Justice L'Heureux-Dubé's decision co-authored with McLachlin J. in *R. v. R.D.S.*[94] defends and valorizes egalitarian fact-finding by judges, and L'Heureux-Dubé J. has also acted as a role model for other women judges in the country who have taken courage from her willingness to examine and reshape doctrine and practice that conflicts with equality values.[95]

Finally, and perhaps most significantly for Canadian women, she has

resisted defence efforts to limit women's role as jurors in sexual assault prosecutions. Such defence efforts have taken the form of argument that an exclusively female jury would raise a reasonable apprehension of bias or, less directly, that there may be people, particularly women and feminists, who feel so strongly about sexual assault that they should not be permitted to sit as jurors in such cases. In Justice L'Heureux-Dubé's view, women's public role includes respected and impartial participation in the fact-finding process. Thus in *R. v. Biddle*,[96] in which the majority did not address the ground of appeal based on the Crown's use of its peremptory challenges to produce an all-female jury, L'Heureux-Dubé J. agreed with Doherty J.A. in the court below: it "is dangerous and contrary to our concepts of equality and individuality to make findings of partiality on the basis of assumed stereotypical reactions based on gender."[97]

In *R. v. Find*,[98] Moldaver J.A., in dissent in the court below, had found that for some "feminists," "commitment gives way to zealotry and dogma."[99] Justice L'Heureux-Dubé joined with a unanimous Court in rejecting (as unsupported and not self-evident) a proposition that jurors with strong views are more willing to cross the line from opinion to prejudice in relation to sexual assault than for any other serious crime: "General disagreement or criticism of the relevant law ... does not mean a prospective juror is inclined to take the law into his or her own hands at the expense of an individual accused."[100]

Justice L'Heureux-Dubé leaves the Supreme Court of Canada having reformed the law of sexual assault through her judgments as well as having created "space," both legally and metaphorically, for women in the adjudication of the facts and law of rape. The public recognition of women as equal and significant members in Canadian society requires law that recognizes the full gendered harm of sexual assault, rejects discriminatory reasoning, and claims a system of justice in which women play a respected role. L'Heureux-Dubé J. has contributed on all three fronts, providing Canadian women with an unprecedented opportunity to realize three decades' worth of grassroots knowledge and feminist research, activism, and advocacy around the law of rape.

### Endnotes

\* Elizabeth would like to thank Susan Chapman for her contributions to this paper and Sanda Rodgers for editorial assistance.

1 Sexual assault is treated as a public issue when that behaviour is appropriately criminalized rather than left to be dealt with through self-help. Rape that is unrecognized or denied is harmful to the well-being of women and conducive of public disorder.

2 While recognizing that other public regimes such as our public health care system and criminal injuries compensation schemes may alleviate some of the economic and health costs of rape to women, the narrower the scope of effectively criminalized sexual assault, the more women may have to depend on political strategies such as educational health campaigns and funding for rape crisis centres to ensure the adequacy of such regimes. Remedies in private law may meet some economic and social needs for denunciation, but again the legal definitions in crime and tort for sexual assault are largely similar, with no particular procedural advantages attached to the civil process. Civil suits may be costly in emotional terms to women since there is negligible protection against disclosure of private counselling records and women must paint themselves as "damaged" for the purposes of assessment of compensation, although some women report significant therapeutic benefits from the civil process: Bruce Feldthusen, Olena Hankivsky, and Lorraine Greaves, "Therapeutic Consequences of Civil Actions for Damages and Compensation Claims by Victims of Sexual Abuse" (2000) 12 C.J.W.L. 66. Most importantly, for the argument pursued in this paper, is the fact that private law is just that—an individual and private legal response that cannot effectively challenge the systemic inequalities and the structure of the law that together facilitate rape: Elizabeth Sheehy, "Compensation for Women Who Have Been Raped," in Julian Roberts and Renate Mohr, eds., *Confronting Sexual Assault: A Decade of Legal and Social Change* (Toronto: University of Toronto Press, 1994) 205.

3 [1991] 2 S.C.R. 577 [*Seaboyer*].

4 This attention to the rights of the collectivity is also brought to bear on the role and responsibility of the Crown prosecutor by L'Heureux-Dubé J. in cases like *R. v. O'Connor*, [1995] 4 S.C.R. 411 [*O'Connor*], where the majority decision condemned unequivocally the actions of a Crown who had attempted to resist a sweeping disclosure order against the complainants. L'Heureux-Dubé J.'s view of the prosecutor as protector of the public interest and equality rights led her to be much more circumspect in her criticism, noting that in fact the Crown was resisting an order that was wrong in law and that she was defending broader social interests.

5 Justice L'Heureux-Dubé's attempt to bring the law of sexual assault under the scrutiny of equality analysis is incomplete, in our view, for her failure to con-

sider the equality interests of accused themselves and indeed prisoners. For example, in *R. v. Sauvé*, [2002] S.C.C. 68, she joined the dissent authored by Gonthier J. in which he found that prisoners are not entitled to the protection of s. 15 of the *Charter*. Nor can Justice L'Heureux-Dubé's sentencing decisions be neatly categorized in terms of our privatization thesis: while emphasizing the high incidence of sexual assault and denouncing judicial reliance on sex discriminatory biases in sentencing in cases like *R. v. W. (G.)*, [1999] 3 S.C.R. 597, her judgments also seem to support the law and order call for more and longer jail sentences. For example, in *R. v. R.A.R.*, [2000] 1 S.C.R. 163 and *R. v. L.F.W.*, [2000] 1 S.C.R. 132, L'Heureux-Dubé J. rejected the use of conditional sentences, which may include house arrest and supervision by family members, for sexually predatory men. Although her stance might be cast as resisting privatization, it is complicated by the fact that she invoked general deterrence and not women's equality rights, in support of her position in these cases.

6   The question of how to approach fact-finding arises in many doctrinal contexts, not all of which are explored in this paper. One striking example has arisen in the form of the question of when a court of appeal can overturn a guilty verdict as unreasonable. This issue does not exclusively arise with respect to verdicts in sexual assault trials. However, it is in that context that the role of the "lurking doubt" has come to a head. See the "historical" sexual assault case of *R. v. A.G.*, [2000] 1 S.C.R. 439. In the Ontario Court of Appeal, Finlayson J., in dissent, expressed concern about conviction on the basis of ambiguous (since the accused's acts could have been horseplay) and unsupported allegations. He felt that Parliament and the judiciary have radically eroded the traditional protections for accused persons. The Supreme Court of Canada unanimously rejected the lurking doubt standard as a proper basis for interfering with a verdict. Justice L'Heureux-Dubé, in her concurring judgment, said at paras. 2 and 4 that the "Court has repeatedly held that myths and stereotypes have no place in a rational and just system of law." Further, it was not the case that "violations of sexual integrity of the type at issue in this case may be properly characterized as 'horseplay.'"

7   [1990] 3 S.C.R. 74 [*Kirkness*].
8   [1990] 2 S.C.R. 633 [*Martineau*].
9   *Kirkness*, supra note 7 at para. 65.
10  *Martineau*, supra note 8 at para. 37.
11  *Ibid.* at para. 24.
12  The long-term influence of this dissent can be seen in the *Creighton* decision (for her emphasis on consequences as part of the constitutional basis for a murder conviction and its accompanying stigma, not exclusively *mens rea*) and later

in *R. v. Morissey*, [2000] 2 S.C.R. 90 (for her point that the constitutional requirements of s. 7 are satisfied if the stigma and punishment correspond to "the combination of the physical and mental elements that collectively define a [crime]" at 163). For sophisticated and detailed analyses of the implications of Justice L'Heureux-Dubé's dissent in *Martineau* see Rosemary Cairns Way, "Constitutionalizing Subjectivism: Another View" (1990), 79 C.R. (3d) 260 and "Culpability and the Equality Value: The Legacy of the *Martineau* Dissent" (2003) 15 C.J.W.L. 53.

13 [1980] 2 S.C.R. 120.
14 [1985] 1 S.C.R. 570 [*Sansregret*]. The frightening consequences of a purely subjective approach to the mistake doctrine were most compellingly revealed in *Sansregret*. The accused successfully claimed innocence at trial because his former partner had feigned agreement and she so testified. The Court overturned the acquittal, finding that Sansregret had, on a prior occasion, broken into her home, threatened her, and had intercourse with her and then had received notice that she considered it rape when she reported the crime to police. In committing the same acts a second time, Sansregret was said to have been wilfully blind to her non-consent. The Court clearly stated that in the absence of evidence regarding the first rape, it would have been "difficult indeed" to find sufficient moral culpability to convict Sansregret for this attack, even though he had broken into her home, cut the telephone line, struck and threatened her with a weapon, stripped her, and tied her up.
15 [1995] 2 S.C.R. 836 [*Park*].
16 [1993] 4 S.C.R. 595 [*Osolin*].
17 *Ibid.* at para. 179.
18 *Ibid.* at para. 81.
19 *Ibid.* at para. 78.
20 For an excellent analysis of moral innocence in this context see Annalise Acorn, *The Defence of Mistake of Fact and the Proposed Recodification of the General Part of the* Criminal Code: *A Feminist Critique and Proposals for Reform* (Edmonton: Alberta Women's and Senior's Secretariat, 1994).
21 *Park, supra* note 15 at para. 47.
22 *Ibid.* at para. 43.
23 *Ibid.* at para. 46.
24 *Ibid.* at para. 25.
25 *Ibid.* at para. 52.
26 [1995] 4 S.C.R. 123.
27 *Ibid.* at para. 13.
28 [1997] 2 S.C.R. 777 [*Esau*].

29 *Ibid.* at para. 19.
30 *Ibid.* at para. 96.
31 *Ibid.* at para. 40.
32 *Ibid.* at para. 50.
33 The men actually told the fifteen-year-old woman that they had drugged her: *R. c. Daigle*, [1997] A.Q. No. 2668 (C.A.) [*Daigle*] at para. 9. Sexual assault committed by means of "date rape" drugs can almost never be prosecuted because either the women never know that they were drugged or if they do know, it cannot be proven since the drug has long passed through the body by the time women recover from its effects and get to a hospital: Tamara Gorin, "Rohypnol—How the Hype Tricks Women. A Rape Crisis View" (2000) 20 Canadian Woman Studies 92 at 92, 93.
34 "[C]'est clair qu'elle en a pris de l'alcool. C'est clair qu'elle est allée à l'appartement, c'est clair qu'a un moment donné, comme on le dit souvent, chaque personne est responsable de ses actes ... ." *Daigle, ibid.* at para. 13.
35 *R. v. Daigle*, [1998] 1 S.C.R. 1220 at para. 3.
36 *Esau, supra* note 28 at para. 39.
37 [1999] 1 S.C.R. 330 [*Ewanchuk*].
38 *Ibid.* at para. 46.
39 *Ibid.* at para. 51.
40 See the chapters by Hester Lessard and Sheila McIntyre in this volume, as well as Constance Backhouse, "The Chilly Climate for Women Judges" (2003) 14 C.J.W.L., forthcoming.
41 See, e.g., *R. v. Jobidon*, [1991] 2 S.C.R. 714 and *R. v. Leclerc* (1991), 4 O.R. (3d) 788 (C.A.).
42 *Ewanchuk, supra* note 7 at para. 30.
43 *Ibid.* at para. 87, quoting Justice Fraser C.J. of the court below.
44 *Ibid.* at para. 95.
45 [1967] S.C.R. 677.
46 See Christine Boyle, "The Judicial Construction of Sexual Assault Offences," in Roberts and Mohr, eds., *Confronting Sexual Assault, supra* note 2 at 143–46.
47 *Criminal Code*, s. 265(3).
48 [1998] 2 S.C.R. 371 [*Cuerrier*].
49 *Ibid.* at para. 22.
50 *Ibid.* at para. 16.
51 *Ibid.* at para. 32.
52 [2003] 2 S.C.R. 134.
53 For reaction at the time, see Christine Boyle and Marilyn MacCrimmon, "*R. v. Seaboyer*: A Lost Cause?" (1991), 7 C.R. (4th) 225.

54 *An Act to Amend the Criminal Code (sexual assault)*, S.C. 1992, c-38. See now sections 276–76.5 of the *Criminal Code*.
55 [2000] 2 S.C.R. 443 [*Darrach*].
56 However, she did go on to say that if she were wrong that no relevant evidence was excluded by the contested provision, then its exclusion was proper because of its extremely prejudicial effect: *Seaboyer, supra* note 3 at para. 224.
57 *Ibid.* at para. 195.
58 *Ibid.* at para. 142.
59 *Ibid.* at para. 209.
60 See Christine Boyle and Marilyn MacCrimmon, "The Constitutionality of Bill C-49: Analysing Sexual Assault as if Equality Really Mattered" (1998) 41 Crim. L. Q. 198 and in particular the discussion of similar fact evidence at 229–30.
61 [1995] 2 S.C.R. 912.
62 *Ibid.* at para. 10.
63 *Seaboyer, supra* note 3 at para. 197.
64 *Ibid.* at para. 231.
65 See generally, Marilyn T. MacCrimmon and Christine Boyle, "Equality, Fairness and Relevance: Disclosure of Therapists' Records in Sexual Assault Trials," in Marilyn T. MacCrimmon and Monique Ouellette, eds., *Filtering and Analysing Evidence in an Age of Diversity* (Montreal: Canadian Institute for the Administration of Justice, Les Éditions Thémis, 1993) 81.
66 *O'Connor, supra* note 4.
67 For the order, see *ibid.* at para. 39.
68 *Ibid.* at para. 221.
69 *Ibid.* at para. 1.
70 L'Heureux-Dubé J. did not accept the argument for the intervenor coalition, the Aboriginal Women's Council, the DisAbled Women's Network of Canada, the Canadian Association of Sexual Assault Centres, and the Women's Legal Education and Action Fund. This coalition argued against any right to production of records: "The Coalition submits, therefore, that until the devaluation of women and children, their word, and their integrity are addressed instead of reinforced by law, this Court should hold that disclosure of complainants' personal records is so likely to reinstate sexism in the administration of criminal law, to deter reporting, to distort the fact finding process and to violate victims' integrity that affirmation of complainants' constitutional rights, no less than of the integrity of the justice system, requires that no personal records be disclosed in any sexual offence proceeding." See Women's Legal Education and Action Fund, *Equality and the* Charter: *Ten Years of Feminist Advocacy Before the Supreme Court of Canada* (Toronto: Emond Montgomery Publications Ltd., 1996) at 443.

71 *O'Connor*, supra note 4 at para. 17.
72 *Ibid.* at para. 106.
73 *Criminal Code*, R.S.C. 1985, c. C-46, as am. by S.C. 1997, c. 30.
74 [1999] 3 S.C.R. 668.
75 *Ibid.* at para. 1.
76 *Ibid.* at para. 90.
77 Indeed, L'Heureux-Dubé J. herself rejected a class privilege for such records in the companion case to *O'Connor, L.L.A. v. A.B.*, [1995] 4 S.C.R. 536, in a way consistent with her commitment to truth-seeking as fundamental to the trial process.
78 This places record-keepers in some difficulty. See, e.g., *R. v. Carosella*, [1995] 1 S.C.R. 80 and Christine Boyle, "The Case of the Missing Records: *R. v. Carosella*" (1997) 8(3) Constitutional Forum 59.
79 Steve Coughlan, "Complainants' Records After *Mills:* Same As It Ever Was" (2000), 33 C.R. (5th) 300.
80 2002 SCC 58 [*Shearing*].
81 *Ibid.* at para. 146.
82 For discussion of this rule see Christine Boyle, Marilyn MacCrimmon, and Dianne Martin, *The Law of Evidence: Fact-Finding, Fairness, and Advocacy* (Toronto: Emond Montgomery, 1999) at 522–35.
83 *Ibid.* at para. 176.
84 *Ibid.* at paras. 120, 121.
85 See *Criminal Code*, ss. 486(1.2), 486(2.1), 486(2.3), and 715.1.
86 [1993] 4 S.C.R. 419 [*D.O.L.*].
87 [1993] 4 S.C.R. 475 [*Levogiannis*].
88 *D.O.L.*, supra note 86 at para. 1, Lamer C.J. for the majority. See also *Levogiannis, ibid.* at para. 32, L'Heureux-Dubé J. for the Court.
89 *D.O.L., ibid.* at para. 1.
90 *Ibid.* at para. 30.
91 *R. v. Malcolm*, [2000] 8 W.W.R. 438 (Man. C.A.).
92 *R. v. Osvath*, [1996] O.J. No. 193 (C.A.), dissenting.
93 *R. v. Ewanchuk* (1998), 212 A.R. 81 (C.A.), dissenting.
94 [1997] 3 S.C.R. 484.
95 See Justice Corrine Sparks, "Justice L'Heureux-Dubé: Dimensions of a Quintessential Judicial Leader," in this volume, infra ch. 20; Justice Donna Hackett, "Finding and Following 'The Road Less Travelled': Judicial Neutralilty and the Protection and Enforcement of Equality Rights in Criminal Trial Courts" (1998) 10 C.J.W.L. 129.
96 [1995] 1 S.C.R. 761.

97 *Ibid.* at para. 39.
98 [2001] 1 S.C.R. 863.
99 *Ibid.* at para. 62.
100 *Ibid.* at para. 64.

Committing to Equality

Fifteen

## Travels With Justice L'Heureux-Dubé: Equality Law Abroad

MARGOT YOUNG

Courts face a challenging conceptual task in interpreting and applying constitutional guarantees of equality. This challenge has been clearly recognized by the judges of the Canadian Supreme Court. For instance, in a recently published paper, Chief Justice Beverley McLachlin wrote that "of all the rights, [the equality guarantee] is the most difficult."[1] And in *Law v. Canada (Minister of Employment and Immigration)*,[2] a benchmark equality case in Canadian Supreme Court jurisprudence, Iacobucci J. introduced section 15, the equality provision of the *Canadian Charter of Rights and Freedoms*,[3] as "perhaps the *Charter*'s most conceptually difficult provision."[4]

Not all courts faced with a constitutional equality provision have done justice to equality aspirations. Indeed, some national courts have failed to rise to the task: a notable example is, perhaps, the American judiciary's treatment of its constitution's equal protection amendment.[5] However, both South African and Canadian courts have tackled their respective equality guarantees in interesting and, arguably, ambitious ways—and some of the credit for this occurrence in both of these jurisdictions goes to Justice L'Heureux-Dubé.

This chapter tells this tale of bi-continental influence. The chapter begins with a whirlwind tour of Canada's equality jurisprudence, with only a few pit stops to capture the flavour of Canadian equality law, and then moves to the geography of South African equality jurisprudence. It ends by recounting

some of the South African commentary on its Constitutional Court's adoption of aspects of L'Heureux-Dubé J.'s formulation of Canadian equality rights, and it looks forward to a time when these critical South African perspectives on the features of equality doctrine that we share are, in turn, brought to bear on Canadian equality jurisprudence. There is a certain irony to the story: the doctrinal elements of the ambitious equality perspective urged by L'Heureux-Dubé J., now in the hands of the current Supreme Court of Canada, threaten to restrict significantly, at least in the Canadian context, the reach of constitutional equality rights. We would do well in this situation to be as open to South African perspectives as South African jurists have been to Canadian equality discourse.

### Canadian Equality Jurisprudence

A trip through Canadian constitutional equality law embarks, of course, from the Supreme Court of Canada's first section 15 case, *Andrews v. Law Society of British Columbia*.[6] In this case, McIntyre J., writing for the Court with respect to the interpretation of section 15(1), clearly rejected a formal equality route. Justice Wilson, in her concurring judgment, was more explicit about identifying a substantive analysis as the approach to be followed: "this is a determination which is not to be made only in the context of the law which is subject to challenge but rather in the context of the place of the group in the entire social, political and legal fabric of our society."[7] In *R. v. Turpin*,[8] a case that followed on the heels of the *Andrews* decision, Wilson J., writing for a unanimous Court, is clear that exacerbation of previous disadvantage is the key to a finding of discrimination under the *Charter*:

> A finding that there is discrimination will, I think, in most but perhaps not all cases, necessarily entail a search for disadvantage that exists apart from and independent of the particular legal distinction being challenged.[9]

She continued, stating that the purpose of section 15 was to fix or prevent "discrimination against groups suffering social, political, and legal disadvantage in our society."[10]

Our story now fast-forwards to the 1995 equality trilogy released by the Supreme Court of Canada: *Miron v. Trudel*,[11] *Egan v. Canada*,[12] and *Thibaudeau v. Canada*.[13] The cases we skip over are not insignificant: on their own they signal an increasing and troubling inability of the Court to develop a coherent and reliable substantive approach to equality law.[14] However, it is in the trilogy cases that the pattern McIntyre J., and then Wilson J., attempted to set in place most starkly unravels. And, importantly for us, it is in the trilogy cases that L'Heureux-Dubé J.'s influential analysis emerges.

These cases—the bane of students of equality law everywhere—resulted in the Court breaking into three conflicting understandings of section 15(1). Each of the three approaches adamantly claimed the ancestry of the *Andrews* analysis, but L'Heureux-Dubé J. alone was successful in formulating an equality analysis that projected a substantive vision of equality. L'Heureux-Dubé J.'s analysis centred on discriminatory impact as determined by the nature of the group and the importance of the interest adversely affected, rather than framing the analysis in terms of the ground of discrimination involved. In her own words, the approach she set out in these cases focused "directly on the contextual factors involved."[15] The more vulnerable the group, the more likely the harm; the more fundamental the interest affected, the more significant the difference in treatment. These two factors must be assessed from the perspective of a reasonable person in the same circumstances as those of the individual claiming discrimination. This standpoint has become known as a subjective/objective perspective. The purpose underpinning such an equality analysis should be respect for fundamental human dignity.[16]

After the trilogy cases, the Court struggled to generate a unified equality analysis. Although the Court was often able to agree on result, the doctrinal path to that result either offered patently false reassurance of analytic agreement or simply bypassed the trilogy logjam. And although L'Heureux-Dubé J. signed on to these judgments, it seemed in many as if her analysis had disappeared entirely from the mix.[17]

It was not until the 1999 case of *Law v. Canada*[18] that the curial effort for doctrinal agreement was rewarded. In this case, a unified approach emerged. More importantly for our purposes, aspects of L'Heureux-Dubé J.'s trilogy analysis re-emerged as central to the new line. The Court accepted her formulation of a subjective/objective approach to assessing the contextual

factors relevant to the determination of the question of discrimination.[19] Consideration of the nature of the group and of the nature of the interest affected—central elements of L'Heureux-Dubé J.'s trilogy analysis—became factors relevant to a finding that burdensome differential treatment is discriminatory. And the purpose of section 15 was declared to be the prevention of the violation of essential human dignity, clearly an adoption of the central purposive element of L'Heureux-Dubé J.'s equality analysis:

> It may be said that the purpose of s. 15(1) is to prevent the violation of essential human dignity and freedom through the imposition of disadvantage, stereotyping, or political or social prejudice, and to promote a society in which all persons enjoy equal recognition at law as human beings or as members of Canadian society, equally capable and equally deserving of concern, respect and consideration.[20]

Dignity thus assumes a central place in any section 15 analysis, largely replacing Wilson J.'s earlier postulation of prevention of exacerbation of pre-existing disadvantage as the central purpose of section 15. As Justice L'Heureux-Dubé has recently written:

> It is now fair to say that the Court has adopted the view I advanced in *Egan v. Canada*[21] that "at the heart of section 15 is the promotion of a society in which all are secure in the knowledge that they are recognized at law as equal human beings, equally capable, and equally deserving."[22]

*Law* has replaced *Andrews* as the benchmark case for equality analysis under section 15(1). However, as commentators increasingly note,[23] the consequence of incorporating L'Heureux-Dubé J.'s postulation of violated human dignity as the central preoccupation of the equality analysis has rendered section 15 claims more burdensome for their claimants. Whereas previously a section 15 claim was satisfied if negative different treatment along an enumerated or analogous ground was established, *Law* now adds the additional requirement that such treatment must also be an affront to the claimant's dignity. This added element has, in a number of recent cases, resulted in the dismissal of the equality claim. Indeed, the Supreme Court's latest case, *Gosselin*

*v. Quebec (Attorney General),*²⁴ clearly illustrates this phenomenon.

### Equality in the South African Constitution

The next stop in this tour is South Africa. South Africa's history is a long tale of "institutionalized discrimination, oppression and subjugation of certain groups in society—first in the form of missionary and capitalist colonialism, and later through the ideology of Afrikaner Nationalism and apartheid"²⁵. It is against this background that the South African Constitution²⁶ was adopted. The South African Constitution has been described by that country's academic commentators as taking up the "cudgels of transformation."²⁷

As with the Canadian *Charter*—but to an even greater degree—the inclusion of equality protections in the South African Constitution involved tremendous political thought and effort. The result is a Constitution that is bold and explicit in its foregrounding of the value of equality. The 1996 Constitution, South Africa's final constitution, reflects this history in its advocacy of equality as a core value in the newly-democratic South African society. As one South African scholar writes: "South Africa's 1996 Constitution is steeped in the language of equality."²⁸ Justice Kriegler of the Constitutional Court, in *Hugo v. President of the Republic of South Africa and Another*,²⁹ describes the South African Constitution as follows:

> The South African Constitution is primarily and emphatically an egalitarian Constitution. The supreme laws of comparable constitutional states may underscore other principles and rights. But in the light of our own particular history, and our vision for the future, a Constitution was written with equality at its centre. Equality is our Constitution's focus and its organising principle.³⁰

So, for instance, the preamble to the 1996 Constitution states that the Constitution is adopted as the supreme law in order to "[l]ay the foundations for a democratic and open society in which government is based on the will of the people and every citizen is equally protected by the law."³¹ Section 1 of the final Constitution states that the Republic of South Africa is a "sovereign democratic state founded [on] ... the achievement of equality."³² Section 7(1) states that the Bill of Rights "enshrines the rights of all people in our country and affirms the democratic values of human dignity, equality and freedom."³³

The limitation clause of the final Constitution provides that any limitation must be justifiable in a society based on "human dignity, equality and freedom."[34] Elsewhere in the Bill of Rights, courts and other tribunals are urged to "promote the values that underlie an open and democratic society based on human dignity, freedom and equality."[35] And finally, the Bill of Rights contains what one commentator has called "an elaborate equality clause."[36]

It is easy to see, then, why South African commentators have written that equality appears as both a value and a right in their Constitution:

> As a value, equality gives substance to the vision of the Constitution. As a right, it provides the mechanism for achieving substantive equality, legally entitling groups and persons to claim the promise of the fundamental value and providing the means to achieve this.[37]

The constitutional equality provision itself is complex and contains a number of clauses.[38] The first two clauses set out a right to equality before the law and to equal protection and benefit of the law, as well as recognition that positive measures taken to protect or advance discriminated-against groups or individuals are consistent with equality protections. The third clause sets out an open-ended list of grounds on which unfair discrimination by the state is prohibited, while the fourth clause extends such prohibition to persons and obligates the government to enact national legislation to prevent or prohibit unfair discrimination. The fifth and final clause states that discrimination on one of the enumerated grounds is unfair unless otherwise established to be fair.

The trajectory of the Constitutional Court's interpretation of these provisions is remarkably similar to the Canadian Supreme Court's course in relation section 15 of the Canadian *Charter*. Similar doctrinal shifts, albeit in a more condensed timeframe, mark its evolution. Thus, early equality cases under the South African Interim Constitution contained, at least in some judgments, reference to the concepts of systemic discrimination and group-based disadvantage as central to the equality right:

> ... in the recognition that discrimination against people who are members of disfavoured groups can lead to patterns of group

disadvantage and harm. Such discrimination is unfair: it builds and entrenches inequality amongst different groups in our society ... . The need to prohibit such patterns of discrimination and remedy their results are the primary purposes of s. 8.[39]

The prevention of systemic and historic group-disadvantage was thus early on in the jurisprudence identified as the purpose of the Bill of Rights equality provision. This perspective is, of course, reminiscent of Wilson J.'s judgment in *R. v. Turpin*,[40] cited earlier in this chapter.

Moreover, it has been clear that, from the beginning of its interpretive tasks, the South African Constitutional Court has looked with great interest to Canadian equality case law. Justice Albie Sachs of the South African Constitutional Court has written of the "illumination" he received from the Canadian *Andrews* decision. Of this decision, he wrote:

> As I understood it, the decision centred equality law on the need to overcome discrimination against groups historically subject to disadvantage. I thought, "Hooray, the Canadians have found the magic bullet that cures all equality-related infirmity."[41]

The case *President of Republic of South Africa v. Hugo*[42] marks the South African Constitutional Court's convergence with the *Egan* judgment of L'Heureux-Dubé J. Here, members of the Court first articulated a number of key elements of current South African equality jurisprudence, elements that have moved that Court away from its earlier focus on previous disadvantage. It is this stage of the Court's equality analysis that has been influenced strongly and directly by L'Heureux-Dubé J.'s judgment in the trilogy case of *Egan*.

To begin with, *Hugo* imports into South African equality jurisprudence a central preoccupation with human dignity. Initial reference to this was made by Goldstone J.'s judgment in *Hugo*:

> At the heart of the prohibition of unfair discrimination lies a recognition that the purpose of our new constitutional and democratic order is the establishment of a society in which all human beings will be accorded equal dignity and respect regardless of their membership of particular groups.[43]

Thus, the key concept of unfair discrimination is assigned the purpose of protecting the dignity of all individuals, and L'Heureux-Dubé J.'s statement from her minority judgment in *Egan* about human dignity and equality is quoted in support of this assignation.[44] In a separate judgment in the *Hugo* case, Krieger J. also refers to Justice L'Heureux-Dubé, describing her discussion of dignity in *Egan* as a "telling passage."[45]

The South African Court goes on to provide a broad and expansive definition of human dignity, stating that human dignity is impinged upon whenever a legally relevant differentiation treats individuals as "second-class citizens" or "demeans them" or "treats them as less capable for no good reason," or in some other way infringes "fundamental human dignity" or violates an individual's self esteem and personal integrity.[46] Evidence of such an unfair impact is garnered from examination of the group who has been disadvantaged, the nature of the power that effected the discrimination, and the nature of the interests affected by the discrimination.[47] That this formulation is so very similar to the one mapped out by L'Heureux-Dubé J. in *Egan* is, of course, no coincidence. Indeed, L'Heureux-Dubé J. herself has claimed originating authorship of this element of South African jurisprudence, stating that its origin lies in her *Egan* test.[48]

Subsequent equality decisions of the Constitutional Court have confirmed the view of equality as inextricably tied to the concept of dignity.[49] More specifically, this approach was solidified in *Harksen v. Lane NO & Others*.[50] *Harksen* clarifies the nature of the inquiry at each of the equality provision stages[51] and sets out more clearly the Court's understanding of the principles that underlie the right. And in this case, L'Heureux-Dubé J.'s influence becomes even more obvious. The South African Constitutional Court again relies upon her judgment in *Egan* to support its alignment of anti-discrimination with protection of individual dignity. Additionally, the elements of the test for unfair discrimination resemble those articulated by the Canadian Supreme Court, again, in part, as originally formulated in L'Heureux-Dubé J.'s analysis in *Egan*.

L'Heureux-Dubé J.'s judgment in *Egan* is obviously and clearly central to how the South African Constitutional Court has come to understand the parsing of its own constitutional prohibition against unfair discrimination. And, although the text of the South African Court looks to a finding of "unfair discrimination" and the Canadian *Charter* to "discrimination" alone,

what each document has come to mean through these phrases appears, at least in abstract formulation, to be very similar.

The recognition of impairment of fundamental dignity as the benchmark of unfair discrimination has met with a mixed reception. There is debate within the South African legal community over this understanding of equality. At the heart of the debate is concern about the ability of the Court to help achieve the constitutionally-desired transformation of South African society while operating with this understanding of equality. This concern marks a possible point of divergence between South African and Canadian equality jurisprudence.

Discussion of the South African Constitution emphasizes the Constitution's intentional transformative character—even its, in the words of an American commentator, post-liberal character. The historical consciousness of the Constitution as an instrument committed to social reconstruction, and the substantive equality vision that is part of reconstruction, are essential elements in this project of social transformation. The challenge of such transformation lies in the eradication of systemic forms of domination and material disadvantage. Equality, as both a value and a right in the Constitution, is central to the project of transformation and social reconstruction. This understanding of the role of the Constitution points to an equality jurisprudence that requires sensitivity to social context, to the "intricate and compounding nature of disadvantage."[52]

South African commentators have expressed concern about conflating equality with dignity, with shifting the focus away from group-based disadvantage. In both South African and Canadian equality analysis historical disadvantage has been relegated to one criterion among many that guide a court's assessment of impact. South African commentators argue that the replacement of disadvantage by dignity is a return to liberal and individualized conceptions of the equality right—conceptions that emphasize individual self-esteem and personal integrity, not material disadvantage. The focus becomes concern with individual personality issues rather than with an appreciation of more material systemic issues and relationships. Simply put, the danger is that a focus on dignity will distract from attention to substantive considerations of disadvantage.

Liberal legalism has been critiqued for its abstract individualism, for its focus on "rights-bearing human beings devoid of social relationships and

outside of contextual reality."[53] Instead, it is argued, law should "recognize the unequal life chances occasioned by race, gender, socio-economic status and a host of other factors, which affect a person's ability to compete on an equal footing."[54] Eradication of these unequal life chances and conditions requires legal sensitivity to the individual in the context of her group, social, and economic circumstances.[55] This sensitivity necessitates an equality analysis that focuses on "difference and disadvantage,"[56] that is based on a contextual analysis of the situation.

Within the South African debate, the answer to this concern has been to point to a concept of dignity that focuses on collective concerns. The idea of *ubuntu*—a concept that recognizes human worth and dignity and that is indigenous to South African culture—is used to bridge individual and collective concerns, to link human worth and material position.

Canadian commentators have been considerably less concerned with the centrality of dignity in equality doctrine—although there is growing criticism of it.[57] This may have to do with the more constrained starting expectations mainstream Canadian legal and political actors had for our *Charter* or the lack of consensus about the degree to which our equality rights should bear a purposive role in bridging the transformation of Canadian society. Indeed, current section 15 litigation over social and economic inequality[58] can perhaps be understood as a highly contested engagement over the transformative potential of section 15.

The liveliness and breadth of the debate in South African jurisprudence is a valuable souvenir of our travels with Justice L'Heureux-Dubé. Indeed, a debate over how dignity is used to ground equality doctrine may be of more value to us than, ultimately, it will be to South African equality rights claimants. In the South African constitutional context, alloyed as it is by other explicit substantive, material, and transformative aspects (such as the presence of socio-economic rights, horizontal application, positive obligations, and multicultural rights), the risk of individualization or formalization of equality rights seems slighter. Our *Charter*, which is more firmly entrenched within a liberal model of rights, needs greater judicial self-consciousness about forging more transformative constitutional provisions.

Justice L'Heureux-Dubé's legacy in the area of equality law is a reminder of important contextual factors of group history, social position, and the character of the interest affected, as well as the challenge of thinking of human dig-

nity in a way that does not reduce a more complex, substantive analysis to an inquiry into issues of individual self-esteem and personality. It is here, in relation to this last challenge, that South African jurisprudence—both its case law and academic commentary—may help point the way to a vision of human dignity that promotes, rather than impedes, transformative re-structuring of social, political, and economic relations. This would be an outcome that is, in the end, closer to Justice L'Heureux-Dubé's substantive vision of equality—closer, ironically, than much of current Canadian equality jurisprudence already explicitly deploying the concepts she introduced into Canadian equality law.

Endnotes

1 The Right Honourable Beverley McLachlin, P.C., "Equality: The Most Difficult Right" (2001) 14 Sup. Ct. L. Rev. 17 at 17.
2 [1999] 1 S.C.R. 497 [*Law*].
3 The Canadian constitutional equality provisions are contained in s. 15 of the *Charter*:
Equality before and under law and equal protection and benefit of law:
(1) Every individual is equal before and under the law and has the right to equal protection and equal benefit of the law without discrimination and, in particular, without discrimination based on race, national or ethnic origin, colour, religion, sex, age or mental or physical disability.
Affirmative action programs:
(2) Subsection (1) does not preclude any law, program or activity that has as its object the amelioration of conditions of disadvantaged individuals or groups including those that are disadvantaged because of race, national or ethnic origin, colour, religion, sex, age or mental or physical disability.
4 *Law, supra* note 2 at para. 507.
5 U.S. Const. amend. XIV. In the 1973 U.S. Supreme Court case *San Antonio v. Rodriguez*, 411 U.S. 1 (1973) at 98, American Justice Thurgood Marshall criticized, in dissent, the American Court's "rigidified approach to equal protection analysis."
6 [1989] 1 S.C.R. 143 [*Andrews*].
7 *Ibid.* at para. 5, Wilson J.
8 [1989] 1 S.C.R. 1296 [*Turpin*].
9 *Ibid.* at para. 45, Wilson J.
10 *Ibid.* at para. 47, Wilson J.
11 [1995] 2 S.C.R. 418.

12 [1995] 2 S.C.R. 513 [*Egan*].
13 *Ibid.* at 627.
14 For example, in *Weatherall v. Canada (Attorney-General)*, [1993] 2 S.C.R. 872, the Court, although arriving at what I would consider the "right" answer, does so by route of a particularly formalistic understanding of differences between male and female prisoners. Not only did it conflate biological, historical, and sociological differences, it failed to situate the claimant sufficiently such that both his sex and his status as prisoner were adequately considered. In *Symes v. Canada*, [1993] 4 S.C.R. 695, another intervening case, the Court failed to connect social and actual gender ordering. For an insightful discussion of this case, see Audrey Macklin, "*Symes v. M.N.R.*: Where Sex Meets Class" (1992) 5 C.J.W.L. 498.
15 Claire L'Heureux-Dubé, "Making a Difference: The Pursuit of Equality and a Compassionate Justice" (1997) 13 S.A.J.H.R. 335 [L'Heureux-Dubé] at 340.
16 The other judgments focused on either stereotype or relevancy as the key to identifying discrimination.
17 See *Eaton v. Brant County Board of Education*, [1997] 1 S.C.R. 241 [*Eaton*]; *Benner v. Canada (Secretary of State)*, [1997] 1 S.C.R. 358; *Eldridge v. British Columbia (Attorney General)*, [1997] 3 S.C.R. 624; and *Vriend v. Alberta*, [1998] 1 S.C.R. 493. Indeed, in many of these cases, take the *Eaton* decision for example, L'Heureux-Dubé J. appears to have signed on to the judgment despite failing to convince the Court to include any of her analysis in the decision.
18 *Law, supra* note 2.
19 "… subjective in so far as the right to equal treatment is an individual right, asserted by a specific claimant with particular traits and circumstances; and objective in so far as it is possible to determine whether the individual claimant's equality rights have been infringed only by considering the larger context of the legislation in question, and society's past and present treatment of the claimant and of other persons or groups with similar characteristics or circumstances. The objective component means that it is not sufficient, in order to ground a s. 15(1) claim, for a claimant simply to assert, without more, that his or her dignity has been adversely affected by a law." (*Law, ibid.* at para. 59.)
20 *Law, supra* note 2 at para. 51. For a collection of opinions on dignity, see R. Dillon, ed., *Dignity, Character and Self-Respect* (New York: Routledge, 1995).
21 *Egan, supra* note 12.
22 *Law, supra* note 2 at paras. 49 and 88.
23 The Constitutional Law Group, *Canadian Constitutional Law, 3d ed.* (Toronto: Emond Montgomery Ltd., 2003) at 1180; Sheilah Martin, "Balancing Individual Rights to Equality and Social Goals" (2002) 80 Can. Bar Rev. 299;

and Peter W. Hogg, *Constitutional Law of Canada*, loose-leaf (Toronto: Carswell, 2003) at 52–56.
24 [2002] 4 S.C.R. 429 [*Gosselin*].
25 Pierre de Vos, "Equality For All? A Critical Analysis of the Equality Jurisprudence of the Constitutional Court" 2000 (63) T.H.R.H.R. 62 [de Vos] at 62.
26 *Constitution of the Republic of South Africa*, Act 200 of 1993. This was an interim constitution. *Constitution of the Republic of South Africa*, Act 108 of 1996 [*1996 Constitution*]. This is South Africa's final constitution.
27 Cathi Albertyn and Beth Goldblatt, "Facing the Challenge of Transformation: Difficulties in the Development of an Indigenous Jurisprudence of Equality" (1998) 14 S.A.J.H.R. 248 [Albertyn and Goldblatt] at 248.
28 de Vos, *supra* note 25 at 63.
29 1996 (4) S.A. 1012 (D.).
30 *Ibid.* at para. 74, Kriegler J.
31 *1996 Constitution*, *supra* note 26, Preamble.
32 *Ibid.*, s. 1 (a).
33 *Ibid.*, s. 7(1).
34 *Ibid.*, s. 36.
35 *Ibid.*, ss. 36(1) and 39(1)(a).
36 de Vos, *supra* note 25 at 63.
37 Albertyn and Goldblatt, *supra* note 27 at 249.
38 In full, the text of s. 9 of the Constitution of South Africa, 1996 is as follows:
9. (1) Everyone is equal before the law and has the right to equal protection and benefit of the law.
(2) Equality includes the full and equal enjoyment of all rights and freedoms. To promote the achievement of equality, legislative and other measures designed to protect or advance persons, or categories of persons, disadvantaged by unfair discrimination may be taken.
(3) The state may not unfairly discriminate directly or indirectly against anyone on one or more grounds, including race, gender, sex, pregnancy, marital status, ethnic or social origin, colour, sexual orientation, age, disability, religion, conscience, belief, culture, language and birth.
(4) No person may unfairly discriminate directly or indirectly against anyone on one or more grounds in terms of subsection (3). National legislation must be enacted to prevent or prohibit unfair discrimination.
(5) Discrimination on one or more of the grounds listed in subsection (3) is unfair unless it is established that the discrimination is fair.
39 *Brink v. Kitshoff*, 1996 (6) B.C.L.R. 752 (C.C.), O'Regan J.
40 *Turpin*, *supra* note 8.

41 Justice Albie Sachs, "Equality Jurisprudence: The Origin of Doctrine in the South African Constitutional Court" (1999) 5 Rev. Const. Stud. 76 at 80.
42 (1997) C.C.T. 11/96, [1997] S.A.J. No. 4 (S.A.C.C.) (QL) [*Hugo*]. This case involves a challenge to a special remission of criminal sentence for mothers with young children.
43 *Ibid.* at para. 41.
44 *Ibid.*, Goldstone J.
45 *Ibid.* at footnote 10, Krieger J.
46 Albertyn and Goldblatt, *supra* note 27 at 260.
47 *Hugo*, *supra* note 42 at para. 40.
48 L'Heureux-Dubé, *supra* note 15 at 340.
49 *Prinsloo v. Van der Linde and Another*, 1997 (6) B.C.L.R. 759 (C.C.) [*Prinsloo v. Van der Linde*] at paras. 31–33.
50 1998 (1) S.A. 300 (C.C.), 1997 (11) B.C.L.R. 1489 (C.C.) [*Harksen*]. The case involved the claim that the effect of sequestration provisions in the *Insolvency Act* 24 of 1936 was unequal treatment of and discrimination against the solvent spouses of insolvent individuals compared to the burdens imposed on other persons with whom an insolvent spouse had close commercial dealings.
51 The equality inquiry is divided into a s. 8(1) analysis and a s. 8(2) analysis. The first stage, the s. 8(1) inquiry, involves determining whether the law or conduct under scrutiny *differentiates* between individuals or groups. If the law or conduct does discriminate, then, in order not to infringe s. 8(1), "there must be a rational connection between the differentiation in question and the legitimate governmental purpose it is designed to further or achieve" (*Harksen, ibid.* at para. 43). For this last inquiry, the Court considers (i) the purpose of the law or conduct, (ii) whether the purpose is a legitimate one, and if so, (iii) whether the differentiation in question has a rational connection to that purpose. The applicant bears the onus at this stage. If s. 8(1) has not been violated, the inquiry then turns to s. 8(2), which requires that, even if the state has acted in a rational manner, such action not amount to unfair discrimination. Thus rational action by the state can still amount to unfair discrimination. This analysis has itself two stages. The court must establish, first, whether there has been discrimination and, second, whether such discrimination, if found, has been unfair. The constitutional provisions set out fourteen grounds of discrimination, in which a presumption of unfairness operates. Also recognized is the possibility of analogous or unspecified grounds which, like the enumerated grounds, are deemed to have the potential to "impair the fundamental dignity of persons as human beings, or to affect them adversely in a comparably serious manner" (*Harksen, ibid.* at para. 47, Goldstone J.). To determine whether

discrimination is unfair, the Court stated that it will look to the position of the individual in society and any history of disadvantage, the extent to which the discrimination has affected the rights or interests of the complainants, the purpose of the provision, and the question of whether the discrimination has impaired fundamental human dignity (*Harksen, ibid.* at para. 50). In *Prinsloo v. Van der Linde* (*supra* note 49), the Court gave an expanded interpretation of discriminatory treatment "by adding that not only an infringement of human dignity, but also 'other forms of differentiation, which in some other way affect persons adversely in a comparably serious manner' could constitute a harm prohibited by the non-discrimination provisions of the Constitution" (de Vos, *supra* note 25 at 66, quoting *Prinsloo v. Van der Linde, supra* note 49, 773E, 774B).

52  Albertyn and Goldblatt, *supra* note 27 at 253.
53  *Ibid.* at 251.
54  *Ibid.*
55  *Ibid.* at 252.
56  *Ibid.* at 253.
57  See, e.g., Sheilah Martin, "Balancing Individual Rights to Equality and Social Goals" (2001) 80 Can. Bar Rev. 299. For a thoughtful discussion of the full potential of this notion of human dignity and of the challenge of giving the concept some meaningful content, see Denise Réaume, "Discrimination and Dignity" (2003) 63 La. L. Rev. 645.
58  For example, *Gosselin, supra* note 24; *Masse v. Ontario* (1996), 134 D.L.R. (4th) 20 (Ont. Div. Ct.), leave to appeal to C.A. refused, [1996] O.J. No. 1526 (C.A.) (QL), leave to appeal to S.C.C. refused, [1996] S.C.C.A. No. 373 (QL); *Falkiner v. Ontario* (2002), 59 O.R. (3d) 481 (C.A.), leave to appeal to S.C.C. granted, [2003] S.C.C.A. No. 297 (QL); and *Auton v. British Columbia* (2002), 6 B.C.L.R. (4th) 201 (C.A.), leave to appeal to S.C.C. granted, [2002] S.C.C.A. No. 510 (QL).

Sixteen

# Inequalities and the Social Context

MARY JANE MOSSMAN

Dans ses décisions, L'Heureux-Dubé s'est montrée *sensibilisée et sensible* au contexte social dans lequel se trouvent bien ancrées les inégalités ...[1]

In thinking about my comments for this workshop, I was reminded of this assessment of Justice L'Heureux-Dubé, written by our late colleague Professor Marlène Cano in 1991. Marlène's assessment appeared only a few years after Justice L'Heureux-Dubé was appointed to the Supreme Court of Canada, and just a few years before Marlène's untimely death. It focused on the contributions of Justice L'Heureux-Dubé to family law jurisprudence in Quebec, when Justice L'Heureux-Dubé was a member of the Quebec Court of Appeal and at a time when courts in Quebec were engaged in interpreting revisions to the *Civil Code*. In this context, Marlène identified Justice L'Heureux-Dubé's abiding concern for equality and the need to understand legal principles in a social context, goals to which Marlène was similarly committed as a legal scholar and law teacher.[2]

Thus, in reflecting on Justice L'Heureux-Dubé's contributions to equality in relation to legal aid and family law, I want first to examine how her legal approach was "anchored in a social context of inequality" in the Supreme Court of Canada's decision in *New Brunswick v. G.(J.)*[3] In this case, the Court decided that state-funded counsel was required when an indigent mother faced the possibility that her children would be apprehended by the state. In addition to examining the reasoning in *G.*, my comments sketch some of the current issues in Canada concerning unrepresented litigants, particularly in family law

matters, and the need for policy responses to these issues to be similarly "anchored in a social context" and informed by goals of substantive equality.

### New Brunswick v. G.

In *G.*, Justice L'Heureux-Dubé's concurring decision[4] focused on three *Charter* arguments: "security of the person" in section 7; "liberty" in section 7; and "equality" in section 15. In my view, her reasoning confirms Marlène Cano's view that Justice L'Heureux-Dubé was committed to taking into account the social context in which legal facts are defined, and to achieving substantive equality in family law cases.

#### "Security of the Person"

The Supreme Court of Canada unanimously concluded that the trial judge in this case should have appointed state-funded legal counsel for an indigent mother in a child protection hearing, even though the New Brunswick legal aid program did not provide services for such proceedings. In doing so, the Court applied a test that included three elements: the seriousness of the interests at stake; the complexity of the proceedings; and the capacities of the appellant.[5] Interpreting "security of the person" in section 7 as extending beyond the criminal law context, the Court held that it included interference with the psychological integrity of a parent resulting from potential removal of her children by the state. The Court agreed *unanimously* on this test to determine whether state-funded counsel is necessary to ensure a fair trial in child protection proceedings. Indeed, as I have argued elsewhere, the decision in *G.* defined a *constitutional obligation* for the judiciary to ensure a fair trial in civil, as well as criminal, cases.[6]

However, the majority in *G.* concluded that such situations would not be frequent. By contrast, Justice L'Heureux-Dubé's concurring reasons suggested that a trial judge should not apply the Court's test on the assumption that such orders would be necessary *only rarely*. Like many legal practitioners who are regularly involved in child protection proceedings, Justice L'Heureux-Dubé understood that parents in such proceedings are often indigent or unacquainted with court processes, and sometimes disadvantaged by language, ethnicity, or illness; and *they are often mothers*.[7] In acknowledging the reality of this context, Justice L'Heureux-Dubé's conclusion that trial

judges need to take account of the important value of "meaningful participation" is particularly significant.[8] For her, the idea of meaningful participation is recognition of a substantive right not to be excluded from participating in significant decisions affecting one's life. As Jennifer Nedelsky has also argued, it is important for litigants to have

> an opportunity to be heard by those deciding one's fate, to participate in the decision at least to the point of telling one's side of the story ... [in a] hearing [that is part of a] process of collective decision-making, rather than as passive, external objects of judgment. Inclusion in the process offers ... a sense of dignity, competence and power.[9]

### "Liberty"

The majority decision did not address the section 7 "liberty" interest. However, the concurring reasons of Justice L'Heureux-Dubé confirmed the continuing vitality of an expanded view of the "liberty" interest, a view also adopted in the dissenting judgment of the New Brunswick Court of Appeal.[10] Such an expanded version of "liberty" arguably permits the reasoning in *G.* to be extended to family law cases beyond child protection proceedings. As David Dyzenhaus argued in his work for the *Ontario Legal Aid Review* in 1997,[11] the unequal power relations between the state and a criminal accused, often used to justify priority for legal aid funding in criminal law matters, also provide a philosophical basis for extending a requirement for state-funded counsel to civil matters. The key factor is the existence of disparate power among litigants, not the *source* of the power differential: as Dyzenhaus argued, "What should matter is not the source of the power which worsens one's situation of inequality before the law, but the fact that the situation has worsened."[12] Justice L'Heureux-Dubé's reasons suggest that recognition of the real context of differential power relationships in court proceedings creates *substantive rights* in relation to an indigent litigant's *access* to legal processes.

### "Equality"

The majority judgment also did not address section 15. However, the concurring reasons of Justice L'Heureux-Dubé connected the section 7 rights of

"security of the person" and "liberty" to the equality guarantee of section 15 of the *Charter*. For Justice L'Heureux-Dubé, section 7 rights must be "interpreted through the lens of sections 15 and 18."[13] Stressing the relevance of equality guarantees in the *G.* case, Justice L'Heureux-Dubé pointed out that child protection proceedings disproportionately affect single mothers, and that issues of fairness in child protection hearings are thus particularly important to "women and men who are members of other disadvantaged and vulnerable groups, particularly visible minorities, Aboriginal people, and the disabled."[14] Such arguments may also extend to other kinds of family law proceedings, particularly where there is an imbalance of power and resources among litigants, and to other civil proceedings where the failure to provide state-funded legal counsel to indigent persons may similarly serve to *reinforce* inequality before the law. In such situations, as Dyzenhaus argued, "the legal system is fostering (rather than constraining) the abuse of power and resources by the other party."[15]

Thus, as Patricia Hughes has suggested, access to the legal system may need to be understood as a systemic issue, one that fundamentally affects our existence as participating citizens of a democracy.[16] In this context, for both advocates and policy makers, the *G.* decision creates an opportunity for re-envisioning the content and form of legal aid services in ways that ensure that the Canadian legal system fundamentally reflects the goals of the *Charter*. Although all members of the Court accepted a need for *fairness* in proceedings, and recognized that this goal could require state-funded counsel for indigent litigants in some cases, Justice L'Heureux-Dubé's concurring reasons expressly acknowledged the social context in family law matters, especially for women, and the need to envision both "liberty" and "equality" so as to recognize *substantive* rights to representation in pursuit of access to justice.

### Unrepresented Litigants: Equality and the Social Context

Thus, the Court's decision in *G.*, and especially the reasoning in Justice L'Heureux-Dubé's concurring reasons, have provided significant encouragement to advocates involved in access to justice issues, particularly in the context of challenges to legal aid cutbacks.[17] Yet, potential use of *G.* as a legal precedent in future challenges needs to be "anchored in the social context of inequality" in relation to issues of legal representation in Canadian courts.

Certainly, there have been widespread reports in the press about the dire situation of unrepresented litigants in criminal and family courts and in refugee determination hearings.[18] Statistics about family law cases in Ontario have revealed a significant increase in unrepresented litigants in both the Unified Family Court and in the Family Division.[19] Thus, as one judge commented in August 2002, the task for judges all too often seems to involve "bailing the Titanic with a teacup."[20] Increasingly, the unrepresented litigant has been identified as the source of new problems for jurisprudence and legal precedents, as well as for lawyers when the other party is not represented and for litigants who do not understand the court system or legal procedures. In this context, one response has been the creation of judicial protocols for dealing with unrepresented litigants and guides for lawyers who must engage in negotiation with an unrepresented litigant on the other side of a case.[21]

Yet, while these problems are certainly all too real in practice, it may be important to examine the phenomenon of unrepresented litigants more closely, particularly in the family law context, and to assess the Court's decision in *G.* "anchored in the social context of inequalities." In an overview of unrepresented litigants in Nova Scotia, for example, Rollie Thompson identified three main categories: the "self-represented," the "unrepresented," and the "invisible."[22] According to Thompson, "self-represented" litigants include a large number of litigants who are "do-it-yourself'ers" or "recreational litigants." In addition, a smaller proportion of "self-represented" litigants are rather disaffected and vexatious, but not really dangerous, while a small minority are both dangerous and borderline in their capacity to deal with legal issues in a reasonable way.[23] By contrast with the "self-represented" group, however, there are those who are "unrepresented" not as a result of choice, but rather because their eligibility has been eliminated by legal aid cutbacks; Thompson referred to these litigants as "LULAs" because they are litigants who are Left Unrepresented by Legal Aid.[24]

Significantly, Thompson's research suggested that the majority of "self-represented" litigants were men, while the majority of "unrepresented" litigants were women. Moreover, since about 70 per cent of family law legal aid clients in Nova Scotia were women, cuts to civil legal aid fell disproportionately on women. Indeed, as Thompson pointed out, it is likely that some women simply abandoned their claims in the face of legal aid cutbacks, becoming part of the category of "invisible" litigants, those for whom a lack of access to repre-

sentation resulted in a lack of substantive legal rights.[25] Thus, the use of legal principles concerning state-funded representation in family law matters pursuant to the decision in G. clearly requires careful attention to the social context of inequality among different categories of "unrepresented" litigants.

In such a context, future applications of the test adopted unanimously by the Supreme Court of Canada in G. need to take account of these issues. While "the seriousness of the interests at stake" and "the complexity of the proceedings" may well extend to family law matters beyond child protection, the application of the test of "capacity of the appellant" requires careful analysis. In the first place, it seems to require the applicant to demonstrate incapacity, another context in which legal strategies may require rather demeaning assertions about the powerlessness and victimization of women.[26] More significantly, in the context of gendered power relations within the family, the application of this branch of the test should not be based on assumptions that women and men stand in positions of equality in their need for representation. At the same time, there are undoubtedly some cases where men, as well as women, can demonstrate a need for state-funded legal representation in family law matters: the problem is to define an approach that takes into account the social context of *substantive*, not just formal, equality.

One possible approach was identified by Diana Majury in her analysis of the doctrine of unconscionability in relation to domestic contracts.[27] As she suggested, courts could better take account of inherent gender inequality in the family bargaining context by presuming that such bargains are unequal, thus shifting the onus of demonstrating that an individual contract was in fact fair to the party asserting it (usually the male partner). Such an approach assumes a social context of inequality, but preserves the possibility of demonstrating equality in particular circumstances, while ensuring that the party who wants to assert that the bargain was equal has legal responsibility for proving the claim.[28] In the context of access to state-funded representation in family law matters, the social context of inequality may similarly require a presumption that an indigent woman does not have sufficient capacity to represent herself effectively, with the onus on the state to demonstrate the contrary; by contrast, no such presumption would need to apply to indigent men, although they would be entitled to prove their incapacity in the particular circumstances of individual cases.

As is evident, however, a legal presumption of women's incapacity to provide their own representation *both* reflects the social context of gendered inequality *and also* tends to reinforce it.[29] Such a dilemma frequently results from efforts to promote substantive, rather than formal, equality goals: principles that attempt to take account of circumstances of substantive gendered inequality frequently result in the appearance of formal inequality, at the same time that they also reinforce the inequalities that we wish to overcome. This problem is both the promise and the problem of taking account of the social context of inequality. In such a context, we must exercise great care in constructing legal challenges after *G.* to further goals of access to justice in family law. In anchoring our legal principles in the social context of equality, the fundamental goal must be justice for all individuals in family relationships.[30]

### Endnotes

1 Marlène Cano, "Claire L'Heureux-Dubé et le droit de la famille: Juge innovateur? ... Innovatrice" (1991) 98 Queen's Q. 131 at 155 (emphasis added). As Cano explained, "L'Heureux-Dubé a comme objectif l'efficacité du système dans son ensemble, sans pour autant négliger le grand besoin d'humaniser l'appareil judiciaire. Compte tenu de la nature et de la teneur des conflits familiaux, la justice repose sur cette base, surtout lorsque des enfants sont en cause."

2 See Mary Jane Mossman, "Feminism and the Law: Challenges and Choices" (1997) 10:(1) C.J.W.L. 1 at 14–16.

3 [1999] 3 S.C.R. 46; (1997), 145 D.L.R. (4th) 349 (N.B.C.A.); (1995), 131 D.L.R. (4th) 273 (N.B. Q.B.). See also Rollie Thompson, "Annotation" (1999) 50 R.F.L. (4th) 74; Nicholas Bala, "The *Charter of Rights* and Family Law in Canada: A New Era" (2000) 18 Can. Fam. L.Q. 373; and Mary Jane Mossman, "*New Brunswick v. G. (J.)*: Constitutional Requirements for Legal Representation in Child Protection Matters" (2000) 12 C.J.W.L. 490.

4 In the Supreme Court of Canada, *supra* note 3, the majority judgment was written by Chief Justice Lamer (with Justices Gonthier, Cory, McLachlin, Major, and Binnie concurring). Both Justices Gonthier and McLachlin joined in Justice L'Heureux-Dubé's concurring judgment.

5 S.C.C. decision, *supra* note 3 at para. 75.

6 Mary Jane Mossman, "A Constitutional Right to Civil Legal Aid in Canada," in Canadian Bar Association, *Making the Case: The Right to Publicly-Funded Legal Representation in Canada* (Ottawa: CBA, 2002), with Cindy L. Baldassi.

7 S.C.C. decision, *supra* note 3 at paras. 112–25.
8 *Ibid.*, at para. 125.
9 Jennifer Nedelsky, "Reconceiving Autonomy: Sources, Thoughts and Possibilities" (1989) 1 Yale J.L. Feminism 7 at 27. See also Jennifer Nedelsky "Reconceiving Rights as Relationship" (1993) 1:(1) Rev. Const. Stud. 1.
10 N.B.C.A. decision, *supra* note 3, Bastarache and Ryan JJ.A.
11 David Dyzenhaus, "Normative Justifications for the Provision of Legal Aid," in Ontario Legal Aid Review, *Report of the Ontario Legal Aid Review: A Blueprint for Publicly Funded Legal Services*, vol. 2 (Toronto: Ontario Legal Aid Review, 1997) at 475.
12 *Ibid.* at 479. See also Nathalie DesRosiers, "The Legal and Constitutional Requirements for Legal Aid," in Ontario Legal Review, *Report*, *supra* note 11 at 503; Brenda Cossman and Carol Rogerson, "Case Study on the Provision of Legal Aid: Family Law," in *ibid.* at 773; and Martha Jackman, "From National Standards to Justiciable Rights: Enforcing International Social and Economic Guarantees Through *Charter of Rights* Review" (1999) 14 J.L. & Soc. Pol'y 69.
13 S.C.C decision, *supra* note 3 at para. 115.
14 *Ibid.* at para. 114.
15 Dyzenhaus, "Normative Justifications," *supra* note 11 at 487. See also Patricia Hughes, "Domestic Legal Aid: A Claim to Equality" (1995) 2 Rev. Const. Stud. 203; Patricia Hughes, "The Gendered Nature of Legal Aid," in F.H. Zemans, P.J. Monahan, and A. Thomas, eds., *A New Legal Aid Plan for Ontario: Background Papers* (Toronto: York University Centre for Public Law and Public Policy, 1997); and Mary Jane Mossman, "Gender Equality, Family Law and Access to Justice" (1994) 8 Int. J. Fam. L. 357.
16 Patricia Hughes, "*New Brunswick (Minister of Health and Community Services) v. G. (J.)*: En Route to More Equitable Access to the Legal System" (2000) 15 J.L. & Soc. Pol'y 93.
17 See the papers collected in *Making the Case*, *supra* note 6.
18 For example, see Lynne Cohen, "Unrepresentative Justice" (2001) 25:(8) *Canadian Lawyer* 40; David Gambrill, "The Floodgates Open: 10 Successful Fisher Applications" (2002) 13:(32) *Law Times* 1; and Advocates' Society, "Report on Self-Represented Litigants" (1999), online: www.advsoc.on.ca/publications/pdf/1999.pdf.
19 See Jim Middlemiss, "Who Needs a Lawyer? The Self-Represented Litigant Crisis" (1999) 8:(6) *National* 13 at 15; and Vicki Trerise, *Where the Axe Falls: The Real Cost of Government Cutbacks to Legal Aid* (Vancouver: Law Society of British Columbia, 2000).

20 David Gambrill, "LAO Sends in Staff Lawyers to Cover Cases" (2002) 13:30 *Law Times* 1 at 5; the quotation was attributed to Superior Court Justice Paul Cosgrove in relation to courts in Brockville, Perth, and Cornwall.
21 David Gambrill, "Talking With Unrepresented Litigants Key" (2002) 13:(8) Law Times 1; Marguerite Trussler, "A Judicial View on Self-Represented Litigants" (2002) 19 Can. Fam. L.Q. 547; and D.A. Rollie Thompson, "No Lawyer: Institutional Coping with the Self-Represented" (2002) 19 Can. Fam. L.Q. 455.
22 D.A. Rollie Thompson, "A Practising Lawyer's Field Guide to the Self-Represented" (2002) 19 Can. Fam. L.Q. 529. These comments were also informed by field research undertaken by Cindy L. Baldassi and Jessica Ginsburg in Family Court proceedings in Barrie in July 2002.
23 Thompson, "Practising Lawyer's Field Guide," *supra* note 22 at 532–33. According to Thompson, these are "lawyer wannabes," those who want to act as their own lawyers.
24 *Ibid.* at 531–32.
25 *Ibid.* at 531. As Thompson noted, some of these clients may have legal representation at the outset, but lose counsel at some point for financial reasons.
26 For example, see Anne Bottomley and Joanne Conaghan, eds., *Feminist Theory and Legal Strategy* (Oxford and Cambridge: Basil and Blackwell Ltd., 1993).
27 Diana Majury, "Unconscionability in an Equality Context" (1991) 7 Can. Fam. L.Q. 123.
28 Majury, *supra* note 27, also explored the often difficult role for lawyers in providing independent legal representation in the context of unequal bargaining relations in family law. See also Robert Mnooken, "Divorce Bargaining: The Limits of Private Ordering," in J. Eekelaar and S. Katz, eds., *The Resolution of Family Conflict* (Toronto: Butterworths, 1984).
29 See Carol Smart, *Feminism and the Power of Law* (London: Routledge, 1989); and Mary Jane Mossman, "Feminism and Legal Method: The Difference it Makes" (1986) 3 Austl. J.L. & Soc.'y 30.
30 See Claire L'Heureux-Dubé, "Making Equality Work in Family Law" (1997) 14 Canadian Journal of Family Law 103; L'Heureux-Dubé, "Conversations on Equality" (1999) 26:(2) Man. L.J. 273; and L'Heureux-Dubé "Making a Difference: The Pursuit of a Compassionate Justice" (1997) 31 U.B.C. L. Rev. 1.

## Seventeen

# Personalizing the Political and Politicizing the Personal: Understanding Justice McClung and his Defenders

SHEILA MCINTYRE

Introduction

We are all students of this language called equality.[1]

My preferred focus is thus not on the difference that women and other previously excluded groups will make in judging, but on how we can enable all judges, indeed all individuals in positions of authority and power, to make a difference, and to ensure that the law responds not only to the needs of those whose interests it has traditionally served, but to those of all members of society.[2]

When I first thought about what I would most want to celebrate of Justice Claire L'Heureux-Dubé's immense contribution to Canadian and international law, I immediately thought of her dissenting opinion in *R. v. Seaboyer*.[3] Openly reliant on feminist legal and social science scholarship as authorities to document "the prevalence and impact of discriminatory beliefs" on the substance, enforcement, and interpretation of sexual offence laws,[4] and relentlessly fact-driven and concrete, her 1991 dissent is memorable on three counts. It is an explicitly feminist analysis by a Supreme Court of Canada judge. It illustrates the method and the virtues of a substantive approach to constitutional rights. It is unflinching in its deconstruction and repudiation

of the everything-is-okay, air-brushed, purportedly neutral, liberal abstraction of the seven-judge majority opinion.[5] The power of the dissent derives as much from its contrast with the majority's style of legal reasoning as from its unprecedented feminist content.[6]

In its grappling with realities of inequality all-too-often abstracted from "law,"[7] the *Seaboyer* dissent remains for me the single most memorable judgment in Justice L'Heureux-Dubé's remarkable *oeuvre*. Her adherence to substantive analysis can be found in other inequality-sensitive and equality-driven judgments: *McKinney*,[8] *Norberg*,[9] *Dickason*,[10] *Moge*,[11] *Mossop*,[12] *Osolin*,[13] *Symes*,[14] *Egan*,[15] *Thibaudeau*,[16] *O'Connor*,[17] *Park*,[18] *Gould*,[19] *Cooper*,[20] *R.D.S.*,[21] *Ewanchuk*,[22] and *Mercier et al.*[23] to name a few. All of these judgments illustrate Justice L'Heureux-Dubé's commitment to speak and teach the language of substantive equality.[24] All reflect her efforts "to make a difference, and to ensure that the law responds not only to the needs of those whose interests it has traditionally served, but to those of all members of society."[25]

These judgments also model and vindicate her conviction that judges should be "voracious readers not only of law, but of developments in all fields,"[26] and her belief that judging is and should be "an intellectual challenge" and "a constant learning process."[27] I want to underline the scholarly dimension of Justice L'Heureux-Dubé's equality jurisprudence for two reasons. First, many of her judgments, particularly the dissents, draw heavily on contemporary critical legal theories that challenge and/or refute the unsubstantiated assertions or unquestioned dominant assumptions animating the reasons of the courts below and/or of fellow Supreme Court justices. For lawyers and judges and social conservatives who disdain new developments in legal theory and Canadian jurisprudence (and the women and minority men who produce it), this commitment to expanding and updating her jurisprudential resources reduces to ideological bias.[28] Second, the content, context, and sources of the attacks directed at her, particularly for her equality thinking, are very similar to the attacks directed at the feminist, critical race, and lesbian scholars upon whose works she so often draws. They are also similar to the attacks on students, staff, and faculty who have named sexism, heterosexism, racism, eurocentrism, classism, and ablism within the academy.

By drawing attention to the similarities between attacks on Justice L'Heureux-Dubé[29] and on equality activists in the academy, I do not wish to diminish the violence of the personal attacks levelled against her, particular-

ly in the wake of her *Ewanchuk* judgment.³⁰ By any measure, Justice McClung's notorious outburst on being criticized for the sexism of his reasons in *Ewanchuk* was as shocking as it was indefensible.³¹ The unbridled hostility and virulent counterattacks directed against her by those who rushed to Justice McClung's defence were equally ugly. What I wish to underline, however, is that this was a proxy fight.

Predictably, the personal and professional aspersions against Justice L'Heureux-Dubé for naming and criticizing the sexism of a senior male judge were laced with the familiar tropes of anti-feminism. However, the sniping against her served as mere preface for an indictment of feminists and feminism in law generally, and of those judges and legal institutions said to be in the thrall of or cowed by feminists and feminists' allies—notably, gay and lesbian rights activists. In the popular press and in later academic discussion of the *Ewanchuk* controversy, the salvos regularly culminated in a wholesale denunciation of the *Charter of Rights*³² and the purportedly anti-democratic judicial activism and illiberal legal order that the *Charter* "revolution"³³ has spawned. Justice L'Heureux-Dubé became the personification of a constitutional jurisprudence utterly opposed by the social, political, and legal conservatives who loathe feminism and the social and legal changes they believe feminism has wrought. No less importantly, the discreditation of the *Charter* and *Charter* jurisprudence turned on guilt by association achieved by use of discrediting stereotypes about the equality-seeking groups—particularly feminists and lesbians and gay men—who have advocated and benefitted (in differing degrees) from substantive equality jurisprudence. The response to the *Ewanchuk* decision offers a paradigm of this two-way demonizing of substantive equality and its advocates.

### The *Ewanchuk* Case

The *Ewanchuk* story began with the acquittal of a forty-four-year-old man charged with sexually assaulting a seventeen-year-old woman at a job interview.³⁴ The trial judge found the complainant credible in her testimony that she had not consented to any sexual activity with the accused and had told him to stop each time he made unsolicited, and increasingly invasive and intimate, sexual contact with her. He also accepted her testimony that she had believed herself locked inside his trailer during the sexual assaults and had

been extremely frightened throughout her confinement but had attempted to mask her fear in the belief that if she displayed her fear, Ewanchuk would become violent. Notwithstanding these findings of fact, the trial judge acquitted the accused on the basis of what he termed "the doctrine of implied consent." In his view, the complainant had not clearly communicated to Ewanchuk that she was so frozen by fear she was unable to leave the trailer.[35]

Justice McClung accepted the trial judge's findings of fact and his (flawed) conclusion in law[36] that the complainant's conduct amounted to "implied" consent. Expanding on this conclusion, he commented on the complainant's attire ("she did not present herself to Ewanchuk or enter his trailer in a bonnet and crinoline"),[37] and her sexual maturity (noting she had a child and co-habited with her boyfriend),[38] and took potshots at feminist "sloganeering" such as "No means No!" "Zero Tolerance!" and "Take Back the Night!" en route.[39] He also sneered at the complainant for reporting the sexual assaults at all ("in a less litigious age, going too far in the boyfriend's car was better dealt with on site—a well-chosen expletive, a slap in the face, or, if necessary, a well-directed knee"[40]), doubtless because he minimized Ewanchuk's molestations as mere "clumsy passes" in aid of "romantic intentions" that were "more hormonal than criminal."[41] Chief Justice Fraser's detailed dissent amply exposed both the errors of law and the role of rape myths and sexist stereotypes in the trial judge's reasons—reasons that she asserted reflected "an approach to consent and to women that Parliament has now made three legislative attempts to overcome."[42] Justice McClung dismissed her lengthy reasons in a scant four paragraphs.[43] He offered no comment on her analysis of how rape myths and stereotypes underpinned the numerous errors of law in the trial judgment (and, by implication, in his own analysis).

The Supreme Court of Canada unanimously reversed the acquittal and substituted a conviction on the basis that the facts clearly established the *actus reus* and the *mens rea* of sexual assault and that the acquittal was grounded in an error of law about the legal meaning of consent. The six-judge majority opinion authored by Justice Major focused strictly on legal doctrine and the errors of law punctuating the trial and Court of Appeal decisions, holding, *inter alia*, that there is no doctrine of implied consent in Canadian law. In separate concurring reasons, Justice L'Heureux-Dubé, joined by Justice Gonthier, opted to "add some comments and discuss some of the reasoning" of the trial judge and the Court of Appeal majority. She observed: "This case is not about consent, since none was given. It is about myths and stereotypes, which have

been identified by many authors ...."⁴⁴ The remainder of the opinion analyzed the reasoning in the courts below as instances of classic rape myths and stereotypes. It unpacked the "inappropriateness" of each of the rape myths, the denigrating comments about the complainant, and the trivializations of the accused's conduct that punctuated Justice McClung's reasons. Finally, it endorsed Chief Justice Fraser's and rejected Justice Major's analysis of the relevance of the mistake of fact provisions in section 273(2) of the *Criminal Code*.⁴⁵ Justice McLachlin added her own brief, separate concurring judgment, agreeing with Justice Major on the merits and with Justice L'Heureux-Dubé that "stereotypical assumptions lie at the heart of what went wrong in this case." She continued:

> The specious defence of implied consent ... rests on the assumption that unless a woman protests or resists, she should be "deemed" to consent (See L'Heureux-Dubé J.). On appeal, the idea also surfaced that if a woman is not modestly dressed, she is deemed to consent. Such stereotypical assumptions ... no longer find a place in Canadian law.⁴⁶

The day after the Supreme Court's decision was released, Justice McClung took the unprecedented step of retaliating against Justice L'Heureux-Dubé in a letter to the *National Post*.⁴⁷ He decried her "graceless slide into *personal* invective" and remarked:

> Whether the *Ewanchuk* case will promote the fundamental right of every accused person to a fair trial will have to be left to the academics. Yet there may be one immediate benefit. The *personal* convictions of the judge, delivered again from her chair, could provide a plausible explanation for the disparate (and growing) number of male suicides being reported in the province of Quebec.⁴⁸

Initially, Justice McClung's letter was met with shock. The suicide remark seemed either unfathomable or deeply cruel, and in either case, to use the Canadian Judicial Council's later assessment of his conduct, "simply unacceptable ... for a judge."⁴⁹ Lawyers, judges, and legal academics contacted for their views on his outburst forcefully condemned the conduct even as

they found his response unaccountable.⁵⁰ Several complaints about his letter and about the sexism of the views expressed in his *Ewanchuk* judgment were filed with the Judicial Council. Within a few days, numerous commentators rallied to Justice McClung's defence. For them, the villain in the piece became Justice L'Heureux-Dubé; the real victim became Justice McClung.⁵¹ In due course, the socially conservative group, REAL Women, filed a complaint about the feminism of Justice L'Heureux-Dubé's *Ewanchuk* opinion with the Judicial Council.

### The post-*Ewanchuk* Controversy

In the first two weeks after release of the decision, the *National Post* and the *Globe and Mail* each devoted twenty articles to the *Ewanchuk* judgment and its fallout.⁵² Prominent members of the criminal defence bar, social conservatives from REAL Women and the Reform Party, fathers' rights groups, the neo-conservative press, and conservative academics all weighed in, using denunciations of Justice L'Heureux-Dubé's *Ewanchuk* reasons—often distorted beyond recognition—as a springboard for their broader attack on feminists and on "judicial activism." Criminal defence lawyers who seek to expand accuseds' rights and social and political conservatives who push the law-and-order "victims' rights" agenda normally have little in common. In this political moment, however, they united in their invocation of a particular discourse, the 1990s discourse sounding shrill alarms against the so-called tyranny of the forces of "political correctness" to assail a feminist judge and the substantive jurisprudence with which feminists and other equality-seeking groups are associated.⁵³ In the counter-offensive launched in defence of Justice McClung and against Justice L'Heureux-Dubé, the familiar narrative and tropes of the anti-PC campaign originally mounted against egalitarian change within universities was directed against a leading feminist jurist and the jurisprudence a Supreme Court majority has developed and embraced—albeit inconsistently—for a full decade.

### Anti-PC Discourse⁵⁴

Beginning in the late 1980s, and prolific by 1990 and 1991, a well-orchestrated, Right-wing campaign against "political correctness" decried the

"takeover" of American and Canadian universities by a movement of radical leftists, feminists, anti-racist and queer activists, and postmodern theorists. The claim was that these distinct scholarly communities in alliance were undermining the deserved pre-eminence of Western liberal educational and democratic traditions, substituting second-class works by second-rate artists and scholars for the time-honoured great works of the Western canon, and disseminating faddish and incomprehensible theoretical nonsense or political dogma in lieu of disinterested scholarship and teaching. This hostile takeover of prestigious campuses throughout Canada and the United States was said to have been achieved through the intimidation and silencing of anyone who opposed the PC radicals' ideological agenda by labelling them sexists, racists, or homophobes.

The alarmist group portrait of a subversive "movement" said to have hijacked liberal educational institutions by fraud and intimidation relied in large measure on stereotypes and rhetoric designed to discredit each distinct community through guilt by association. Three distinctive scholarly communities were conflated such that the negative cultural stereotypes that devalued the worth or personhood of members of one allegedly PC faction became the patchwork deviancy and subversiveness of all.

The first of the three primary PC constituencies assailed in anti-PC narratives was "Marxists" or "Leftists," often described as "former sixties radicals," whose politics, by definition, aimed to subvert Western liberal values and institutions.[55] Given the failure of Communism and the collapse of the Soviet Union in the late 1980s, the "Left" mostly attracted derision in anti-PC literature. Inclusion of the Left in the PC camp provided two clusters of metaphors to discredit the entire PC "movement": red-baiting metaphors such as "thought control," "totalitarianism," and "re-education camps" that equate the PC camp with dogma, brainwashing, and intolerance of dissent; and metaphors such as "witch hunts" and "persecution" meant to evoke the discredited tactics of the McCarthy hearings. In one of the distortions of history characteristic of anti-PC diatribes, PCness was labelled "The New McCarthyism" in many anti-PC texts.[56]

"Deconstructionists" or "postmodernists" composed the second group. Their insistence on the social construction, contingency, and partiality of universal (i.e., dominant) truths and norms, and their unmasking as ideological all claims of objectivity were understood in anti-PC texts to be subversive

not only of the pre-eminence of liberal academic and political traditions, but of the recognition of values as such. Anti-PC writing lampooned abstruse or sensational snippets of post-modern scholarship as faddish nonsense illustrative of the threat to "time-tested" academic norms posed by this branch of the PC camp. But it also sounded serious alarms against the "nihilism" and "cultural relativism" it ascribed to critiques of academic objectivity and of the Western canon.[57]

The third group was a trio of historic outsiders to the academy who were politically conscious of the social, political, and institutional foundations of their outsider status and committed to changing them. In my view, these equality activists always were and still are the real target of the anti-PC campaign, the core menace to the academic and political traditions said to be besieged in anti-PC diatribes. Typically, they were explicitly or implicitly portrayed as underqualified beneficiaries of affirmative action agitating for changes to the traditional curriculum and to hiring, tenure, and promotion policies that were portrayed as erosive of academic excellence and merit. To underline their sub-standardness and subversiveness, anti-PC literature offered up as flagbearers for the PC movement a tiny handful of feminist and/or racialized and/or queer scholars,[58] always described (sometimes fairly) as "radicals" or "extremists," their work usually distorted and caricatured beyond recognition. Anyone familiar with the scholars and the works caricatured must conclude that the anti-PC campaign, apart from being deeply anti-feminist, racist, and homophobic, was deeply anti-intellectual[59] and pandered to anti-intellectualism.[60]

The overt charge against PCers was their disregard for and critiques of "time-honoured" traditions of disinterested scholarship, academic excellence, and academic freedom and their counter-hegemonic critiques of "Western" liberal traditions including the rule of law and democratic process. They were said to produce propaganda or faddish "gibberish," not scholarship; they sought to indoctrinate, not educate, their students and to demand that their opponents be subjected to "re-education" programming; they secured tenure and positions of power by fraud (bogus claims of discrimination), or by intimidation ("denouncing" as sexists, racists, and homophobes those who dare to oppose their ideological agenda or defend traditional academic norms). They eschewed due process in favour of "Star Chamber" tactics.

Nowhere in anti-PC literature can one find reference to twenty years of studies documenting the under-representation of women of all races and sex-

ualities and of racialized and gay men on campus. Nowhere is there any reference in anti-PC works to chilly climate literature and documented incidents or written forms of sexism, misogyny, racism, anti-semitism, homophobia, ableism, or xenophobia on American and Canadian campuses.[61] Complaints made by women and minority men about the sexism, racism, or homophobia of colleagues or teachers were sneeringly dismissed and disparaged; the only acknowledged "victims" in anti-PC texts were "eminent," "accomplished," "renowned" scholars, usually white men, "persecuted" and "pilloried" for what anti-PC writing invariably described as unfounded or trivial incidents of discriminatory conduct. Often these dismissive or trivializing renderings falsified what actually transpired.[62]

Empirical reality to the contrary, anti-PC narratives asserted that feminists, racialized minority women and men, and queer scholars had achieved a "takeover" of universities throughout Canada and the United States.[63] In anti-PC discourse, this surprising coup was secured by stealth (radicals did not show their true colours until tenured), by opportunism (attacks on the objectivity of merit criteria white women and racialized minorities could not meet), by corrupt means (cynical deployment of false allegations of sexism and racism to mute their opponents), or by outright coercion (the threat of such reputation-destroying allegations and the threat of discrimination suits).

I have argued elsewhere[64] that the attack on "political correctness" did not originate with liberals concerned about what they viewed as a chilling of intellectual diversity and freedom of inquiry and expression on North American campuses, and it was not, in fact, a defence of academic freedom or of academic standards. It was a manufactured crisis launched by proponents (and, it should be noted, the chief beneficiaries) of formal equality against substantive egalitarian change both in academic institutions and in law. It sought to discredit substantive equality principles by denigrating those who advocated and modelled them. Such denigration relied on pre-existing stereotypes of women, feminists, racialized minorities, Leftists, and "homosexuals." I want to argue here that the demonization of Justice L'Heureux-Dubé post-*Ewanchuk* relied on the anti-PC metaphors and distortions that devalue historically subordinated groups in order to discredit established Canadian constitutional law norms, particularly a purposive and contextual approach to constitutional interpretation, and a substantive approach to equality guarantees and remedies.

### Justice McClung and his Defenders, Justice L'Heureux-Dubé and her Detractors

Consistent with the tactics refined in anti-PC narratives, Justice McClung's supporters displayed scant interest in facts in defending his *Ewanchuk dicta* and his extraordinary response to the Supreme Court's *Ewanchuk* decision. They glossed over or airbrushed his actual comments about the complainant in his judgment and in his comments to the press, and they ignored his gratuitous sneers at the feminist anti-violence movement. They misrepresented the complainant's explicit and repeated "no's" to Ewanchuk's sexual aggressions as a case of "yes means no," and from this falsification of facts, defended Justice McClung's extraction of "implied consent" from the complainant's attire and sexual experience. Their misrepresentations also facilitated a frontal attack on Justice L'Heureux-Dubé, the feminist movement, and the political and legal institutions that feminists were said to have indoctrinated into adopting anti-male law reforms.[65] Ewanchuk's multiple prior rape convictions were almost completely ignored. McClung defenders also distorted Justice L'Heureux-Dubé's criticisms of his *Ewanchuk dicta*, but in the opposite direction. What she actually said about what he actually said is not reproduced. Instead, one can find only nightmarish caricatures of her conduct that are concordant with Justice McClung's description of her critical analysis as "personal invective." As in anti-PC literature, these distortions of fact convert the sexist into the paradigm of injured innocent, present the act of naming sexism as the real violence in the story, and communicate that being called a sexist from the bench is a far worse injury than being a rape victim demeaned, discredited, and denied justice because of sexism from the bench.

Shannon Sampert's analysis of the media coverage of the *Ewanchuk* story[66] revealed that the press devoted considerable attention to L'Heureux-Dubé's personal life—her marital status, her maternity, the suicide of her husband, the mental illness and death of her son —and relatively little to her legal career.[67] The reverse was true of Justice McClung. Strikingly, the fact that Justice McClung's father had killed himself was rarely mentioned. This double standard on privacy strikes me as remarkable precisely because his suicide remark is so unaccountable.[68] Sampert argues that by focusing on the personal tragedies in Justice L'Heureux-Dubé's personal life, the media not only deprofessionalized her but depicted her as a bad wife and mother.[69] Commenters who jumped to Justice McClung's defence also stripped her of

the stereotypical womanly virtues, and characterized her as a "bully," "cruel," "mean-spirited," "vicious," even sadistic.[70] In Mr. Greenspan's rendering, for instance, Justice L'Heureux-Dubé said "vicious," "mean, gratuitous, and terrible things" about Justice McClung designed "to publicly humiliate, heap scorn ... [and] cause enormous pain" to a lower court judge. Judges, he railed, are not "given the right to pull a lower court judge's pants down in public and paddle him."

While media portraits tended to deprofessionalize Justice L'Heureux-Dubé, those quoted who were critical of her censure of sexism from the bench tended to assail her professionalism in two ways familiar in anti-PC writing. First, she was portrayed as a beneficiary of affirmative action, unqualified for appointment to the Supreme Court.[71] Second, she was portrayed as deficient in judicial impartiality and disrespectful of the principle of judicial independence. Justice McClung launched the first salvo against her professionalism. In response to the uproar caused by his letter, he explained that his suicide jibe had been meant as a "facetious chide" to give "my friend Claire a prod because of her consistent anti-male response on these matters."[72] Other McClung defenders quickly joined in, adopting many of the discrediting tropes of the anti-PC campaign. Justice L'Heureux-Dubé was not just a "feminist" but a "radical" feminist and, of course, a man-hater. She was a "zealot," and an "ideologically driven" "activist" who had been "relentless since 1973 in manifesting her biases in her professional life."[73] Her *Ewanchuk* judgment "reads less like a Supreme Court judgment on a specific case than a manifesto on feminist legal theory," and "showed how far her desire to entrench extreme feminist ideology in law now guides her reasoning."[74]

Like the academic activists condemned in anti-PC literature for departing from principles of disinterested scholarship and academic objectivity, Justice L'Heureux-Dubé's detractors alleged that she had persistently disregarded principles of judicial impartiality to advance her radical feminist agenda[75] and was prepared to imperil judicial independence by using her high office to "intimidate" lower court judges who do not share her ideology.[76] Her allegiance was to politics, not law, and not just any politics—better dead than red politics. Mr. Greenspan insisted that she was "hell-bent on re-educating Judge McClung, bullying and coercing him into looking at everything from her point of view." Barbara Amiel's take on the controversy, entitled, "Feminists, fascists, and other radicals,"[77] asserted that "[t]he authorities and

quotes L'Heureux-Dubé chooses to illustrate her judgments and speeches are relentlessly anti-male, illiberal, and anti-equality," and that her feminist values were as distanced from liberal assumptions and traditions "as those of communists or fascists."[78] Defence lawyer Alan Gold was reported to have labelled L'Heureux-Dubé's judgment "totalitarian."[79] Eddie Greenspan referred to "the feminists and their fellow travellers."[80] George Jonas used Justice L'Heureux-Dubé's *Ewanchuk* comment that "it is part of the role of the court to denounce" language like that of Justice McClung, and her statement that the *Criminal Code* was amended in 1992 to "eradicate" reliance on rape myths and stereotypes, to indulge in red-baiting:

> Denounce? Eradicate? Language like this has rarely been seen since *Pravda* stopped publishing minutes of the Politburo. It's hardly the language Canadian judges have customarily used in relation to each other's reasons. No wonder that after Ms. Amiel read Justice L'Heureux-Dubé's judgment she made a connection in her essay between the matriarchy and the communist party.[81]

For the social Right, Justice L'Heureux-Dubé was guilty for her association, not with Communists, but with "homosexuals." Her political agenda was not simply anti-male but anti-family and pro-lesbian and gay rights. In an editorial entitled "Homosexual Strategy: Intimidation," REAL Women's March 1999 Newsletter claimed that over the years, "activists within the homosexual community have driven their campaign by the wielding of a major tool—intimidation," and that they did so again after REAL Women filed a complaint against Justice L'Heureux-Dubé with the Judicial Council post-*Ewanchuk*. "We are not surprised," they wrote,

> that homosexuals are obviously annoyed that we raised a complaint with the CJC against Mme. Claire L'Heureux Dube. She, of course, has been unfailing in her judgments in favour of homosexual rights and righteous in her indignation against Mr. Justice John McClung of the Alberta Court of Appeal who had, incidentally, not supported the homosexual arguments in the Alberta homosexual *Vriend* case.

Justice McClung's defenders did not stop with personal attacks on Justice L'Heureux-Dubé as a woman or with attacks on her professionalism. They attacked feminist "ideology" generally in classic anti-PC terms. In the post-*Ewanchuk* press, Gwen Landolt, President of REAL Women, attacked retired Justice Bertha Wilson along with Justice L'Heureux-Dubé: both, she claimed, abused their positions on the Supreme Court "to impose these [feminist] views on the rest of us" and "to push the *Charter* to radical extremes."[82] Mr. Greenspan insisted that the legal community's "lining up" on Justice L'Heureux-Dubé's side showed that it was "clear that the feminist influence has amounted to intimidation, posing a potential danger to the independence of the judiciary." Feminists, he maintained, were attempting to use the Judicial Council "as an agent of the women's movement ... against judges whose remarks do not accord with the feminist world view." Feminists "have entrenched their ideology in the Supreme Court of Canada and put all contrary views beyond the pale." "The feminist perspective," he declaimed, "has hijacked" the Court.[83] Likewise, arch-conservative Claire Hoy reduced the *Ewanchuk* affair to "A feminist hijacking of justice."[84] Senator Ann Cools remarked of the complaint proceedings against Judge McClung, "I would be concerned if he is submitted to any mean-spirited witch hunt."[85] A group of lawyers sought intervenor standing at the Judicial Council inquiry into the complaints against Justice McClung for fear he would not get a fair hearing because of the involvement of "special interest groups." "We're interested in ensuring that all the evidence comes out—not just sociology gibble," they claimed.[86] Columnist George Jonas used his comment on the *Ewanchuk* controversy to assail "radical" feminists' success in persuading "Canada" to substitute "a liberal principle, namely equality, with an illiberal principle, to wit, inequality" by the rhetorical trick of sticking the adjective "formal" in front of "equality" and the adjective "substantive" in front of "inequality."[87] Referring to the substantive model of equality variously as "the feminist party line," "justice in high heels," and "the matriarchy's reign of terror," Jonas insisted that feminists

> not only regard their ideas as universal truth, but call on the authorities for the removal of anyone who disagrees with them. They usually demand human rights commissions or judicial

councils censure their opponents or fire them from their jobs. It's one of several reasons why some people, myself included, have tended to confuse the matriarchy—if "confuse" is the word—with fascists and communists.[88]

From their attack on feminism, McClung defenders proceeded to assail the Supreme Court as a whole. The *National Post* described the *Ewanchuk* decision as "a classic example of 'ideologically twisted logic'": "while supplanting the criminal law's historic insistence on individual responsibility with a feminist indictment of an entire sex, the Court refused to admit that it was departing in any way from established legal principles."[89] Defence lawyer Alan Gold labelled the unanimous *Ewanchuk* decision "a radical feminist judgement."[90] A *Calgary Herald* editorial strongly criticized the Supreme Court for ordering the conviction rather than a retrial of Mr. Ewanchuk. The editorial concluded, "We hope that political correctness did not trump a man's right to a fair trial, but in this age of judicial activism, we are almost afraid to ask."[91] Two weeks into the controversy, a fathers' rights group announced its intention to file a complaint with the Judicial Council against all nine Supreme Court judges for their "feminist" slant in decisions denying men access to children after divorce, and for their "judicial activism."[92] When the Judicial Council dismissed REAL Women's complaint against Justice L'Heureux-Dubé but reprimanded Judge McClung,[93] Professor Ted Morton deplored the latter decision. In his view, the Judicial Council was "trying to enforce a code of political correctness on conservative judges while allowing judges like Justice L'Heureux-Dubé and others to quote whatever they like from radical feminists."[94] The Judicial Council was "trying to censor a judge whose views don't fit with the prevailing pro-gay, pro-feminist, politically correct philosophy."[95] Professor Morton added that criticisms of Justice McClung and the Judicial Council complaints against him amounted to "an attempt to stigmatize and intimidate all critics of *Charter* activism and feminist influence in the courts."

In their book-length critique of what they see as the judicialization of Canadian politics, Professor Morton and co-author Rainer Knopff deplore what they describe as a "*Charter* Revolution" spearheaded by what they call "the Court Party." They discuss the *Ewanchuk* affair in a chapter titled "Jurocracy."[96] There they draw links (treated as suspicious) among those said

to constitute the Court Party: "activist" scholars in law schools, Supreme Court clerks, human rights commission staff, NDP-appointed Crown counsel, lawyers and bureaucrats in the Justice Department, and *Charter* litigators. One of the "least visible but most influential institutional nodes" in the Court Party network, they claim, are judicial education programs, which have become "indoctrination centres for Court Party orthodoxy."[97] Although some judges have protested judicial sensitivity training as a threat to judicial independence, the seminars, according to Morton and Knopff, "send a subtle but powerful message to new and younger judges: if you aspire to further judicial appointments, then get on side—the Court Party side."[98] The reprimand issued by the Judicial Council to Judge McClung is offered to illustrate the claim.

What is this Court Party orthodoxy with which they associate Justice L'Heureux-Dubé? According to Professors Morton and Knopff, orthodoxy means aggressive advocacy of a "revolutionary" understanding of the *Charter*'s equality provisions that they attribute to "radical feminists." This "feminist version of section 15" has also been promoted by other equality-seeking groups such as visible and religious minorities, the mentally and physically disabled, the elderly, homosexuals [sic], non-citizens, linguistic minorities, multicultural communities, and Aboriginals.[99] This model of equality rejects formal equality principles and "a policy of non-discrimination" as inadequate, and adopts "sophisticated jurisprudential theories of disparate impact and systemic discrimination that invite judicial revision of legislative decision-making" and endorses "judicially ordered positive remedies" to achieve equality of results. Morton and Knopff bemoan the fact that the Supreme Court of Canada has embraced much of this "revolutionary" equality theory in *Andrews v. Law Society of B.C.* and subsequent cases.[100] In their view, since minorities and equality advocates cannot achieve their "radical" political agendas through regular democratic means, they have a vested interest in expanded access to courts, expanded rules of standing, expansive interpretations of *Charter* guarantees and remedies, and an expansive approach to judicial review. To their regret, judges have welcomed this expansion of their powers. It is such anti-democratic means by Court Party members and the impact of the "judicial activism" it encourages and feeds that attract the designation, "*Charter* Revolution."

REAL Women's Newsletter sounds the same takeover (and guilt by association) themes. Unnoticed and through intimidation, feminists "estab-

lished the radical feminist/homosexual-owned and operated Court Challenges Program," which funds LEAF and "homosexual" legal challenges before the courts.[101] Feminists have gained control of most Canadian law schools and their reference materials to inject feminist theory into the curriculum and ensure a "steady stream of feminist indoctrinated students."[102] To complete their "takeover," they "clandestinely" gained control of gender sensitivity training of judges, "more accurately described as indoctrination."[103] The definition of equality in these judicial education programs, they argue, was written by "lesbian partners" Shelagh Day and Gwen Brodsky.[104] REAL Women, too, traces what it perceives as feminist control of Canadian legal institutions to their success in entrenching a feminist version of equality into section 15 of the *Charter*.

On the retirement of Justice L'Heureux-Dubé, inveterate anti-feminist, Professor Robert Martin, declaimed that she had viewed the law as her "personal possession" and had "politicized the law more than any other Canadian judge."[105] Seven years earlier, Martin and co-author Robert Hawkins had likewise condemned Justice Bertha Wilson, the first woman to sit on the Supreme Court of Canada. Justice Wilson, they asserted, "used judicial review as a vehicle for promoting her personal ideological agenda" and became "the most political Supreme Court Judge in Canadian history."[106] Their critique focused on the rejection by both feminist judges[107] of abstract formalism in favour of a contextual, rather than textual, approach to *Charter* rights, and a substantive, rather than formal, approach to equality. Contextualism, in the view of Martin and Hawkins, allowed Justice Wilson to ignore legislative intent as reflected in statutory language, the "plain meaning" of words and the traditional canons of interpretation, and to give the text of legislation, including the Charter, whatever meaning was required to promote her personal political agenda.[108] In particular, it allowed her to "strip" the word "equality" of its "usual," "generally understood," meaning as formal equality before and under the law, and to depart from "any objective reading" of section 15 in order to advance the interests of those "who, in her view, [sic] had suffered historical, social or political disadvantage" and who are "most likely to be ignored when laws are made."[109] Instead of upholding the rule of law and elaborating principles of universal application originating in external sources like the common law, statutes, and the constitution, the contextual, effects-sensitive approach, they concluded, has led to unprincipled subjectivism and usurpation of the legislative function in the interest of judicial social engineering.[110]

### Making Connections

In my view, Justice L'Heureux-Dubé's *Seaboyer* dissent of 1991[111] was far more groundbreaking in its feminism than the *Ewanchuk* decision, not least because of its analysis and indictment of sexism at every stage of the legal processing of sexual assault complaints[112] and in common law and statutory law.[113] Justice L'Heureux-Dubé detailed the long history of judicial bias in assessing the credibility of complainants in order to justify legislated curbs on the admissibility of sexual history evidence, and to repudiate the majority's benign assumption that, in the absence of such curbs, judges and juries of the 1990s could be trusted to abjure rape myths and stereotypes.[114] The *Seaboyer* dissent attracted far less negative press than the majority opinion.[115] Eight years later, remarks entirely consistent with her *Seaboyer* decision set off a tantrum from Justice McClung and a fierce counter-attack from the social and legal Right. What is to be made of the post-*Ewanchuk* firestorm?

Right-wing opposition to the *Charter* and *Charter* jurisprudence has escalated considerably since the *Seaboyer* decision was released.[116] Likewise, anti-feminism has proliferated in the wake of successful feminist lobbying for equality-driven criminal law reforms, including in the wake of *Seaboyer*.[117] Anti-PC discourse has provided a wildly successful rhetorical strategy for discrediting egalitarian change in law and society.

Anti-PC diatribes sought to defend the norms and normalization of the dominant order by invoking "time-honoured" tradition, "universal" or "objective" principle, and old-fashioned "common sense" against challenges by equality-seeking groups who exposed the oppressive dynamics and the partiality of, and the specific interests served by, purportedly neutral, transcendent traditions. In anti-PC writing such challenges are answered indirectly, by misrepresenting the substance of the challengers' critique of hegemonic norms and inviting dismissal of the critique by reference to the stereotypes of inferiority, deviance, and irrationality by which the dominant have always justified the subordination of those they oppress. In a legal context, timeless tradition is equated with formal equality norms dating back to Aristotle, and the idealization of blind justice. The upstart challenger is substantive equality. In anti-PC logic, proof of the illiberalism and injustice of the latter lies in the fact that law's historic outsiders—women of all races and sexualities and racialized and sexualized minority men—advocate it.

Justice McClung should not be dismissed simply as an old-fashioned and unrepentant sexist given to gratuitous anti-feminist utterances from the

bench. Many of his supporters on the Right and in the criminal defence bar endorsed the sexism and rape myths that punctuated his *Ewanchuk* opinion as "common sense" and engaged in sweeping feminist bashing of anyone who reasons differently.[118] As his *Alberta v. Vriend* judgment reveals, Justice McClung is a social conservative versed in the rhetoric and logic of the anti-PC world-view. In addition to being anti-feminist, *Vriend* revealed him to be an overt homophobe,[119] derisive of the "rights-euphoric, cost-scoffing left,"[120] and hostile towards equality-seeking minorities[121] and "the creeping barrage of special-interest constituencies that now seem to have conscripted the *Charter*"[122] and who expect majority rights and interests to "curtsy, endlessly, to minority rites [*sic*]."[123]

Justice McClung's *Vriend* judgment is extraordinarily intemperate in its antipathy to judges who accept the *Charter* as a break with the tradition of parliamentary supremacy.[124] There, Justice McClung rails against "constitutionally-hyperactive," "legisceptical," "rights-restive," "ideologically determined" judges who "pitchfork their courts into the uncertain waters of political debate" and engage in "judicial carpentry" and "judicial midwifery" by "pummelling" "small old words" beyond recognition to engage in "undisguised social engineering" on behalf of minorities.[125] In response to those who argue that judges' new law-making functions were "politically thrust upon an unwilling judiciary by the imperatives of the *Charter*," Justice McClung retorts, "This is no doubt so, but, disquietingly, more and more judges are lying back and enjoying."[126] The *Vriend* decision devotes twelve florid pages to a denunciation of the remedy of reading in as an "extravagant" and "undesirable arrogation of legislative power."[127]

Not surprisingly, the *Vriend* decision reveals Justice McClung to be an adherent of formal equality and a shrill critic of substantive equality. In his analysis, the deliberate, repeated refusal by the Alberta legislature to codify sexual orientation as a prohibited ground of discrimination in the province's human rights statute was a "neutral" silence, an "even-handed" omission that "neither subjugates nor promotes" homosexuals.[128] The statute extended to heterosexuals and homosexuals, alike and equally, protection on all statutorily codified grounds; it denied to both protection from discrimination based on their respective sexual orientations.[129] Formalists like Justice McClung and his defenders refuse to credit the existence of systemic discrimination and its socializing effects on us all in part because they refuse to respect the scholars,

the equality thinkers, and the lawyers and the judges, particularly the feminists, who have documented and explicated the dynamics of systemic discrimination. They prefer to attribute Canadian courts' development and adoption of substantive equality analysis to a takeover by illicit means of the entire Canadian legal system than to educate themselves in the empirical, sociological, and theoretical underpinnings of contemporary Canadian jurisprudence, to say nothing of the case law itself. Dismissal of the realities of systemic discrimination is, of course, self-serving. Exercise of this "right not to know"[130] allows the dominant to dissociate from their/our own implication in sustaining and benefiting from the systems of domination responsible for the forced dispossession of historically subordinated groups while enjoying the inflated self-regard systemically entrenched privilege provides.

Adherents of formalism, instead, prefer a 1950s view of discrimination as the practice of isolated bigots, not as a routine manifestation of immersion in systemically unequal institutions. For formalists, discrimination is something done by ignorant bigots from remote places, not by ordinary people, far less by highly educated, liberal-minded professionals like themselves and their peers. To Mr. Greenspan, for instance, Justice L'Heureux-Dubé's comments on Justice McClung's reasoning amounted to labelling McClung "in effect, the male chauvinist pig of the century, the chief yahoo from Alberta, the stupid, ignorant, ultimate sexist male jerk."[131] From the same formalist world-view, Justice L'Heureux-Dubé's criticism of the operation of rape myths and stereotypes in his *Ewanchuk* judgment struck Justice McClung as *personal* attack—a "graceless slide into *personal* invective" —not a legal analysis of flawed legal reasoning. Both Justice McClung and his defenders viewed being called sexist a humiliating and serious reputational harm because they self-servingly and ignorantly refuse to upgrade their intellectual tools and legal knowledge.

As Martin and Hawkins affirm, the formal equality approach relies on abstraction. It idealizes blind justice, not contextual, fact-driven analysis. By contrast, the work of Justice L'Heureux-Dubé locates language, law, and inequality in the world and tests entrenched social and legal assumptions against the insights of new scholars and jurists.[132] In one of the many tributes paid to Justice L'Heureux-Dubé on her retirement, the current Chief Justice credited Justice L'Heureux-Dubé with "teaching us that we cannot decide issues in the abstract, but rather in the full context of how they impact on

peoples' lives. Context is pivotal to her methodology."[133] Combining compassion for others and attention to context, Chief Justice McLachlin underlined, "allows us to cut through the stereotypes to see the truth."[134] The contextual, substantive reasoning that distinguishes Justice L'Heureux-Dubé's jurisprudence speaks of her serious commitment to learn the language of equality and of her recognition that she has much to learn. It betrays no interest in exercising the right to know by hiding behind "tradition" or abstraction.

Justice L'Heureux-Dubé has been the most consistent and articulate proponent of substantive equality jurisprudence to sit on the Supreme Court of Canada. We should be worried that she was singled out and demonized as a "radical feminist" although her reasons were signed by Justice Gonthier[135] and echoed in a separate concurrence by Chief Justice McLachlin, as part of a unanimous nine-person judgment authored by Justice Major reversing the trial judge and the Court of Appeal for errors of law.[136] And we should be worried that when Justice L'Heureux-Dubé practises the substantivism that the Court preaches she is subjected to complaints for alleged bias and denigrated as an "ideologue" who makes up the law as she goes. I do think the Court's grasp of substantive equality is shaky and at risk of floating off into liberal abstraction of little use to equality-seeking groups.[137] Justice L'Heureux-Dubé's retirement represents a genuine loss for the eradication of systemic inequality in law and society. The loss will be the more devastating if her fidelity to substantive equality principles is repackaged by social, political, and legal conservatives as feminist extremism that does not belong on the bench.

### Endnotes

1 Claire L'Heureux-Dubé, "Conversations on Equality" (1999) 26 Man. L.J. 273, QL version at para. 26. She elaborated: "I think it is helpful to regard equality as a language like every other: with rules of grammar and syntax, nuances, exceptions, and dialects. More importantly, language is more than a form of communication. It is an embodiment of the norms, attitudes, and cultures that are expressed through that language. Learning a language and learning a culture go hand in hand ... [e]quality analysis does not easily fit into traditional legal discourses and concepts" (at para. 23).

2 *Ibid.* at para. 33.

3 *R. v. Seaboyer; R. v. Gayme*, [1991] 2 S.C.R. 577. I am not alone in singling out the *Seaboyer* opinion. Cristin Schmitz lists *Seaboyer* among the top ten of

Justice L'Heureux-Dubé's 252 judgments between 1987 and 2002: see "A Supreme Court judge for all seasons" *Lawyers Weekly* (20 May 2002) 11. See also Janice Tibbett, "The Supreme Court's great dissenter" *National Post* (27 February 1999) A3 (describing the *Seaboyer* dissent as "one of her best known commentaries [*sic*]").

4 The first sentence of the section entitled "Analysis" reads: "Of tantamount importance in answering the constitutional questions in this case is a consideration of the prevalence and impact of discriminatory beliefs on trials of sexual offences. These beliefs affect the processing of complaints, the law applied when and if the case proceeds to trial, the trial itself and the ultimate verdict. It is my view that the constitutional questions must be examined in their broader political, social and historical context in order to attempt any kind of meaningful analysis" (*ibid.* at 647).

5 In my view, Chief Justice McLachlin has largely abandoned the abstraction that marked her *Seaboyer* opinion and her most civil libertarian judgments, such as *R. v. Keegstra*, [1990] 3 S.C.R. 697. In any event, she credits Justice L'Heureux-Dubé with teaching "us that we cannot decide issues in the abstract, but rather in the full context of how they impact on peoples' lives. Context is pivotal to her methodology." Combining compassion for others and attention to context, the Chief Justice underlined, "allows us to cut through the stereotypes to see the truth." See John Jaffey, "High praise at symposium honouring retiring jurist" *Lawyers Weekly* (17 May 2002) 2.

6 See, on this point, Diana Majury, "*Seaboyer* and *Gayme*: A Study in Equality," in Julian Roberts and Renate Mohr, eds., *Confronting Sexual Assault: A Decade of Legal and Social Change* (Toronto: University of Toronto Press, 1994) 268.

7 Here, I mean "law" in the broadest sense, including the norms defining and confining legal education and professional development, legal reasoning and discourse, legal practice, the legislative process and its outcomes, statutory drafting, legal advocacy, and legal interpretation and adjudication, as well as which expertise and what experts and written authorities are accredited, what facts are officially and unofficially noticed, the rules of standing, and so on.

8 *McKinney v. University of Guelph*, [1990] 3 S.C.R. 229 (separate judgment concurring in Justice Wilson's dissent setting out an expansive test for application of *Charter* and dissenting against majority ruling that mandatory retirement in universities is justified).

9 *Norberg v. Wynrib*, [1992] 2 S.C.R. 226 (joined separate concurring judgment by McLachlin J. analyzing sexual exploitation of drug-addicted patient as a breach of fiduciary duty, rather than as a tort or a breach of contract, and rejecting sexist reasoning in trial judgment).

10 *Dickason v. University of Alberta*, [1992] 2 S.C.R. 1103 (dissent urging deferential review of social fact-finding by human rights tribunals, and upholding tribunal's rejection of mandatory retirement as a *bona fide* occupational requirement).

11 *Moge v. Moge*, [1992] 3 S.C.R. 813 (majority judgment denying reduction in former wife's spousal support, taking judicial notice of adverse effects of divorce on women and modifying formal egalitarian approach to spousal support. McLachlin J. wrote separate concurring judgment).

12 *Mossop v. Canada*, [1993] 1 S.C.R. 554 (dissent urging deferential review of human rights tribunal's statutory interpretation and upholding tribunal's finding of discrimination against gay complainant based on his family status).

13 *R. v. Osolin*, [1993] 4 S.C.R. 595 (dissent joined by La Forest J. holding medical records of sexual assault complainant not admissible to issue of consent and holding mistake of fact defence should not have been put to jury. Separate concurring dissent by McLachlin J. joined by La Forest as well as Gonthier JJ.).

14 *Symes v. Canada*, [1993] 4 S.C.R. 695 (dissent finding non-deductibility of full childcare costs as business expense for self-employed women violates s. 15 of *Charter*. Separate dissent by McLachlin J.).

15 *Egan v. Canada*, [1995] 2 S.C.R. 513 (separate concurrence advancing new approach to s. 15 joining majority finding that denial of spousal allowance to same-sex couples is unconstitutionally discriminatory).

16 *Thibaudeau v. Canada*, [1995] 2 S.C.R. 627 (dissent holding that taxation of child support paid to custodial parent and deductibility of payments by non-custodial parent unconstitutionally discriminates against women. McLachlin J. wrote separate dissent to same effect).

17 *R. v. O'Connor*, [1995] 4 S.C.R. 411 (dissent joined by McLachlin, La Forest, and Gonthier JJ. rejecting expansive pre-trial disclosure to defence of third-party personal records of sexual assault complainants).

18 *R. v. Park*, [1995] 2 S.C.R. 836 (for unanimous majority restoring sexual assault conviction and dismissing appeal against trial judge's refusal to put mistake of fact defence to jury. Lamer C.J. joined by La Forest, Gonthier, Cory, and McLachlin JJ. dissociating from L'Heureux-Dubé J.'s analysis of the relation between statutory definition of consent and mistake of fact defence).

19 *Gould v. Yukon Order of Pioneers*, [1996] 1 S.C.R. 571 (dissent urging deferential standard of review of human rights tribunal and upholding tribunal's finding of sex discrimination. Separate dissent to same effect by McLachlin J.).

20 *Cooper v. Canada*, [1996] 3 S.C.R. 854 (joined separate concurrence by McLachlin J. on merits rejecting formalism of majority's approach and urging expanded and substantive approach to jurisdiction of administrative tribunals to determine the constitutionality of provisions of its enabling statute).

21 *R. v. S. (R.D.)*, [1997] 3 S.C.R. 484 (separate concurrence on merits co-authored with McLachlin J. (and separately concurred with by Gonthier and La Forest JJ.) holding black trial judge's advertence to systemic racism does not come close (as asserted by Cory and Iacobucci JJ.) to giving rise to reasonable apprehension of bias).

22 *R. v. Ewanchuk*, [1999] 1 S.C.R. 330 (separate concurrence joined by Gonthier J. on merits but emphasizing role of sexist myths and stereotypes in trial and appellate decisions. McLachlin J. wrote a six-line concurrence also observing rape myths and stereotypes influenced judgments below).

23 *Quebec (Commission des droits de la personne et des droits de la jeunesse v. Montréal (City); and Quebec v. Boisbriand (City)*, [2000] 1 S.C.R. 665 (for unanimous majority holding that discrimination based on perceived disability constitutes disability discrimination).

24 L'Heureux-Dubé, "Conversations on Equality," *supra* note 1.

25 See quotation at note 2, *supra*.

26 Kirk Makin, "Gatecrashing the old boys' club" *Globe and Mail* (2 May 2002) A8.

27 Schmitz, "A Supreme Court judge for all seasons,"*supra* note 3.

28 See, e.g., Editorial, "Judging the judges" *Ottawa Citizen* (3 March 1999) A13 and F.L. Morton and Rainer Knopff, *The Charter Revolution & the Court Party* (Peterborough: Broadview Press, 2000) at ch. 6: "Power Knowledge: The Supreme Court as the Vanguard of the Intelligentsia," esp. at 130. Interestingly, in his letter of self-explanation/justification submitted to the Canadian Judicial Council (the "Judicial Council"), Justice McClung complained that much of Justice L'Heureux-Dubé's criticism of his *Ewanchuk* reasons "emerged from feminist writing cited by intervening parties at the Supreme Court of Canada level," which had not been before the Court of Appeal. The Judicial Council had little time for this excuse and observed that the attempt to dispel rape myths and stereotypes has been the aim of "numerous legislative reforms in recent years" and the subject of Supreme Court of Canada commentary since *Seaboyer*. As well, Chief Justice Fraser of the Alberta Court of Appeal had referred to *Seaboyer* and scholarship on rape mythology in her *Ewanchuk* dissent, a dissent that Justice McClung's judgment stated he had read. See Canadian Judicial Council, "Panel expresses strong disapproval of McClung conduct," News release and reasons in relation to complaints against Justice McClung (21 May 1999) online: www. cjc-ccm.gc.ca/english/news_releases/ 1999_05_21.htm.

29 Other judges who are or who are deemed by the Right to be feminist have also been singled out for attack, e.g., Ontario Superior Court judge Lynn Ratushny, Court of Quebec judge Juanita Westmoreland-Traoré, Ontario Court of Appeal judge Rosalie Abella, and all women judges ever appointed to the Supreme Court of Canada. See, e.g., Ian Hunter, "How refreshing if justice were served"

*National Post* (26 April 2000) online: www.nationalpost.com/commentary.asp?
f=00426/270896 (assailing Justice Abella's far left-wing [*sic*] judicial activism);
Rob Martin, "The Bertha Wilson Award: The envelope please" *Lawyers Weekly*
(8 September 1995) (nominating Justice Abella for the Wilson award for subjective, ideologically driven judging); Editorial, "Vacancy Arising on Supreme
Court of Canada" *REALity* (Jan.–Feb. 1999) [newsletter of REAL Women of
Canada] (critical of the "aggressive feminism" of Justice Louise Arbour and of
the "pure feminist ideology" and the "strident feminist, politically correct opinions" of Justice Abella); Editorial, "The Feminist Canaries are Singing Again"
*REALity* (May–June 2000) (critical of Justices Wilson, Abella, and L'Heureux-Dubé); Editorial, "Feminists Stand on Guard to Protect Gender Program for
Judges" *REALity* (July–August 2000) (including Judge Westmoreland-Traoré
among the "feminist sentries" ensuring the "feminist purity" of the National
Judicial Institute's gender sensitivity training). REAL Women, a social conservative organization, has filed complaints with the Judicial Council against each
of Justice Wilson (1990), Justice McLachlin (1991), and Justice L'Heureux-Dubé (1998) for alleged gender bias. All references to *REALity* come from the
REAL Women website at www.realwomenca.com/newsletters.
30 A summary of the *Ewanchuk* affair can be found below.
31 Two days after writing his letter to the *National Post* attacking Justice
L'Heureux-Dubé, Justice McClung issued an apology admitting he had made
"an overwhelming error" with "no justification": see *Toronto Star* (2 March
1999) A7. Nonetheless, he did seek to make excuses in the media and when
responding to the Judicial Council complaint. He rationalized the suicide
remark as a "facetious chide" offered tongue-in-cheek to give Justice
L'Heureux-Dubé "a prod because of her consistent anti-male responses on
these matters." He added to his derogatory remarks about the complainant and
argued their legitimacy as observations about her "sexual maturity": see Shawn
Ohler, "Judge reiterates belief that teen wasn't assaulted" *National Post*
(27 February 1999) A8; and Janice Tibbetts, "Judge gets into deeper hot water:
McClung attacks victim in interview" *Calgary Herald* (28 February 1999) A3.
He complained he had made a mistake in thinking he was talking off the record
when he made demeaning comments about the complainant in the Ohler
interview, but advanced no apology for the demeaning comments themselves.
He complained that Justice L'Heureux-Dubé's criticism of the rape myths and
stereotypes underpinning his *dicta* in *Ewanchuk* was based on feminist literature amounting to new evidence not before his court.
32 Part I of the *Constitution Act, 1982*, being Schedule B to the *Canada Act 1982*
(U.K.), 1982, c. 11.

33 See Morton and Knopff, *The Charter Revolution, supra* note 28. The arguments flagged by the title of their book first appeared a decade ago. See, e.g., F.L. Morton and Rainer Knopff, "The Supreme Court as the Vanguard of the Intelligentsia: The *Charter* Movement as Post Materialist Politics," in Janet Ajzenstat, ed., *Canadian Constitutionalism: 1791–1991* (Ottawa: Canadian Study of Parliament Group, 1992), and F.L. Morton, "The *Charter* Revolution and the Court Party" (1992) 30 Osgoode Hall L.J. 627.

34 The age of the accused is not reported in the trial decision. It was reported in the media. See Tonda MacCharles, "Judge 'sorry' for outburst" *Toronto Star* (2 March 1999) A1 at A7.

35 It is difficult to reconcile this legal conclusion with the finding that the complainant had repeatedly asked the accused to stop his sexual contact. As Chief Justice Fraser put it: "The trial judge began his analysis with a misunderstanding of the legal test for valid 'consent'." He then proceeded, wrongly, to equate submission out of fear, where that fear has not been communicated to an accused, with the complainant's implied consent. Not only is this, by itself, an error in law, but the trial judge then compounded these errors by imposing a strictly objective test on the assessment of the fear sustained by the complainant. And then, he went even further by ignoring, as part of the totality of the events . . . the legal effect of the 'No's' which, according to his own fact findings, the complainant uttered." See *R. v. Ewanchuk*, [1998] A.J. No. 152 (Alta.C.A.) (QL) at para. 50.

36 Justice McClung's analysis is confused and inconsistent on the distinction between error of fact and of law, notwithstanding Chief Justice Fraser's clear and correct analysis and application of the distinction in her dissenting reasons.

37 *Ewanchuk, supra* note 35 at para. 4.

38 *Ibid.*

39 *Ibid.* at para. 12.

40 *Ibid.* at para. 21.

41 *Ibid.* at paras. 5, 8, and 21.

42 *Ibid.* at para. 45. Her ninety-three-paragraph opinion is nearly four and a half times the length of Justice McClung's (twenty-two paragraphs). He cited seven criminal cases in support of his analysis. She cited twenty-four cases, three textbooks, and fifteen scholarly authorities in an elegant analysis of the legislative history underlying the codification of a definition of sexual consent in the *Criminal Code*'s sexual assault provisions in 1992, of myths and stereotypes that the 1992 package of *Code* reforms was intended to minimize, and of case law on the mistake of fact defence. She also offered a crystal clear analysis of the

mistakes of law as well as the prejudicial myths and stereotypes underpinning the reasoning of the trial judge and, by implication, Justice McClung.

43 See paras. 1 and 8–10.

44 *Ewanchuk, supra* note 22 at para. 82. She then quoted David Archard's enumeration of classic rape myths, most of which appeared in Justice McClung's reasons: "Myths of rape include the view that women fantasise about being rape victims; that women mean 'yes' even when they say 'no'; that any woman could successfully resist a rapist if she really wished to; that women who are sexually experienced do not suffer harms when raped (or at least suffer lesser harms than the sexually 'innocent'); that women often deserve to be raped on account of their conduct, dress, and demeanour; that rape by a stranger is worse than rape by an acquaintance. Stereotypes of sexuality include the view of women as passive, disposed submissively to surrender to the sexual advances of active men, ...." See David Archard, *Sexual Consent* (Boulder, Co.: Westview Press, 1998). The Archard quotation was then followed by references to Justice L'Heureux-Dubé's *Seaboyer* dissent, as well as six other articles describing common rape myths and stereotypes.

45 *Ibid.* at paras. 97–101.

46 *Ibid.* at para. 103.

47 His letter does not acknowledge that Justice Gonthier signed on to Justice L'Heureux-Dubé's opinion, or that Justice McLachlin also explicitly criticized his reasoning, or that the Supreme Court unanimously reversed the trial and Court of Appeal judgments for multiple errors of law.

48 "Right of Reply" *National Post* (26 February 1999) A19 (emphasis added).

49 See *supra* note 28.

50 The most sympathetic early response I could find was from long-time friend Justice William Girgulis, who confessed himself "at a loss to explain" Justice McClung's "extraordinarily unusual actions." See Cristin Schmitz, "Critics call for judge's ouster" *Lawyers Weekly* (12 March 1999) 10.

51 Mr. Ewanchuk, who had three rape convictions in the 1970s and a conviction for sexual assault in 1989, painted himself as a victim of women's groups and judicial activism: see Joanne Wright, "Consent and Sexual Violence in Canadian Public Discourse: Reflections on *Ewanchuk*" (2001) 16 Can. J. Law & Soc. 173 at 193.

52 See Shannon Sampert, "Bitch on the Bench: Canada's National Newspapers and Feminist Ideology in the No-Means-No Case," M.A. thesis, Communications Faculty, University of Calgary, 2000.

53 The so-called political correctness movement was a manufactured menace that rationalized opposition by social and political conservatives to anti-sexism,

anti-racism, and anti-homophobic initiatives in North American universities, and to the non-white, non-male, non-heterosexual outsiders who pressed for such initiatives in the late 1970s and early 1980s. I have adopted the shorthand "PC" and "anti-PC" to convey the symbolic aspect of this political discourse and to reduce the alleged menace to size.

54 For sources of the assertions in this section, see Sheila McIntyre, "Backlash Against Equality: The 'Tyranny' of the 'Politically Correct'" (1993) 38 McGill L.J. 1, esp. at 14–15, 23–25, and 35–37.

55 Canadian anti-PC writing distinguished between the economic Left, which has long been deeply sceptical about or hostile to constitutional rights activism, and the social Left composed of equality-seeking groups pursuing equality of results and "materialists" or "post-materialists." The latter camp is described as a small intelligentsia that backs new social movements such as environmentalism, peace activism, criminal law reform, and equality activism and that wields power at elite levels such as courts and state bureaucracies because it lacks the support of popular majorities. See, e.g. Morton and Knopff, *The Charter Revolution, supra* note 28 at 66–73 and 78–84; and Anthony Peacock, *Rethinking the Constitution: Perspectives on Canadian Constitutional Reform, Interpretation and Theory* (Toronto: Oxford University Press, 1996) at ix–x.

56 See McIntyre, "Backlash Against Equality," *supra* note 54 at 54–55.

57 See, e.g., Anthony Peacock, "Strange Brew: Toqueville, Rights, and the Technology of Equality," in Peacock, ed., *Rethinking the Constitution, supra* note 55, 122 at 136, and Robert Martin, "Reconstituting Democracy: Orthodoxy and Research in Law and Social Science" in *ibid.* 249 at 250–53.

58 It is difficult to find language to convey the intersections among these three groups. Not all women are white or heterosexual. Not all non-heterosexuals are white.

59 Although anti-PC writing criticizes the work of PC academics as dogma or nonsense rather than scholarship, and describes the scholars who produce it in terms of their political affiliations rather than their professional credentials, or simply as unqualified beneficiaries of affirmative action, its reductive, sensationalized, and hostile distortions of complex and diverse scholarly fields display deep suspicion, even contempt, of theory and of what Morton and Knopff and Rob Martin disparage as an "intelligentsia." See Morton and Knopff, *The Charter Revolution, supra* note 28 ch. 6: "The Supreme Court as Vanguard of the Intelligentsia"; and Martin, "Reconstituting Democracy," *supra* note 57 at 253.

60 This tendency is most marked in anti-PC treatment of postmodern writing. See McIntyre, "Backlash Against Equality," *supra* note 54 at 14–15.

61 For a list of Canadian accounts of systemically discriminatory, hence, chilly,

academic working environments, see Sheila McIntyre, "Studied Ignorance and Privileged Innocence: Keeping Equity Academic" (2000) 12 C.J.W.L. 147 esp. notes 37 and 41.

62 See McIntyre, "Backlash Against Equality," *supra* note 54 at 47–51 for examples.

63 See Peacock, *Rethinking the Constitution, supra* note 55 at x, and Morton and Knopff, *The Charter Revolution, supra* note 28, ch. 6.

64 See McIntyre, "Backlash Against Equality," *supra* note 54, esp. at 14–18 and 26–34.

65 See Wright, "Consent and Sexual Violence," *supra* note 51 at 186–87 for an analysis of the conversion of a clear "no means no" case into a mythic "yes means no" case.

66 *Supra* note 52.

67 Sampert contrasts companion stories in the *National Post* on 27 February 1999. The article on L'Heureux-Dubé J. leads with a description of her as a woman who has "suffered enduring grief." Its next five paragraphs mention her husband's suicide, her son's depression and death (two years after threatening her with a gun during a paranoid episode), and a friend's observation that she had faced many personal trials. The portrait of Justice McClung leads with his judicial career and seniority and then discusses his controversial judgments and views on gay and lesbian rights and women's proper roles. It says nothing about his father's suicide (*ibid.* at 93–94).

68 Sampert notes that the suicide of L'Heureux-Dubé's husband was mentioned in eight of the fifteen *National Post* news stories and seven of the fourteen *Globe* stories that followed Justice McClung's letter to the editor. Only two stories in total mentioned the suicide of McClung's father. That Mr. McClung Sr. killed himself does not illuminate Justice McClung's strange logic (*ibid.* at 93–95 and 106).

69 *Ibid.* at 95. Gendered descriptors also appear in one of the few articles to mention that Justice McLachlin also criticized the sexism of Justice McClung's reasons: she was described as "scolding" Justice McClung. See Janice Tibbetts, "Women justices rebuke male judge in sex-assault case" *National Post* (26 February 1999) A1.

70 Eddie Greenspan, "Judges have no right to be bullies" *National Post* (2 March 1999) A18. See also *Ottawa Citizen* editorial, "Judging the Judges" (3 March 1999) A13; Shawn Ohler, "Women's group turns tables on L'Heureux-Dubé" *National Post* (4 March 1999) A5; and Valerie Lawton, "Women's group says wrong judge under fire" *Toronto Star* (5 March 1999) A8.

71 See Barbara Amiel, "Feminists, fascists, and other radicals" *National Post* (6 March 1999) B7: "she is living beyond her intellectual means. She doesn't real-

ly understand what she is saying, or its consequences. ... she is an example of the singular kindness Canada shows in giving lesser minds a role in society." See also the unnamed Quebec "court analyst" quoted by Janice Tibbetts in "Farewell Claire" *Canadian Lawyer* (September 2002) 38 at 41, who sneered, "Claire got to the Supreme Court because of her personality, her charm, her generosity. She managed to climb well beyond where she should have landed."

72 Ohler, "Judge reiterates belief that teen wasn't assaulted," *supra* note 31.
73 See, e.g., defence lawyer Alan Gold, quoted in Tonda MacCharles, "Judge's sex case ruling 'delights' women" *Toronto Star* (26 February 1999) A7 at A8 under the sub-heading "Defence lawyer criticizes 'radical feminist' ruling"; Editorial, "Assaulting the law" *National Post* (1 March 1999) A19; Geoffrey Scotton, "Lawyers seek standing at McClung hearing" *Lawyers Weekly* (2 April 1999) 1 at 3; REAL Women quoted in Ohler, "Women's group turns tables," *supra* note 70 at A5; and Amiel, "Feminists, fascists, and other radicals," *supra* note 71.
74 Editorial, *Ottawa Citizen*, *supra* note 70.
75 REAL Women quoted in Ohler, "Women's group turns tables," *supra* note 70; Calgary chapter of the National Council of Women quoted in Scotton, "Lawyers seek standing," *supra* note 73; Rob Martin quoted in Tibbetts, "Farewell Claire," *supra* note 71 at 41.
76 See, e.g. Greenspan, "Judges have no right to be bullies," *supra* note 70; *National Post* Editorial, *supra* note 73; and Gwen Landolt, "Letter for REAL Women" *Lawyers Weekly* (19 July 2002) 5.
77 *Supra* note 71.
78 By "anti-equality," Ms. Amiel means inconsistent with formal equality.
79 Nahlah Ayed, "L'Heureux-Dubé attacked as support for McClung builds" *Calgary Herald* (4 March 1999) A12.
80 See Greenspan, "Judges have no right to be bullies," *supra* note 70.
81 "Canada has snatched the blindfold from the Goddess of Justice" *National Post* (20 March 1999).
82 Letter to the editor, *Lawyers Weekly* (19 July 2002) 5. REAL Women subsequently filed a complaint with the Judicial Council against Justice L'Heureux-Dubé for demonstrating "bias" not only in her *Ewanchuk* reasons but more generally, by identifying "solely with the legal perspective of feminists." The complaint was dismissed: Nahlah Ayed, "Judge's sex-case remarks 'robust' but not biased, watchdog rules" *Toronto Star* (2 April 1999) A3.
83 Greenspan, "Judges have no right to be bullies," *supra* note 70.
84 *Toronto Star* (3 March 1999) A19.
85 Shawn Ohler, "Groundswell of support rises for embattled McClung" *National Post* (3 March 1999) A6.

86 Scotton, "Lawyers seek standing," *supra* note 73.
87 See Jonas, "Canada has snatched the blindfold," *supra* note 81 responding to Kathleen Mahoney, "Feminists, Equality, and the Law" *National Post* (15 March 1999) A18, who was responding to Barbara Amiel's comment on the *Ewanchuk* affair, *supra* note 71.
88 *Ibid.* See also Jonas, "The Canadian Matriarchy's reign of terror" *Toronto Sun* (4 March 1999) 1. The "matriarchy" trope is a variant on the "takeover" metaphor.
89 Editorial, "Assaulting the Law," *supra* note 73.
90 MacCharles, "Judge's sex case ruling," *supra* note 73 at A7.
91 Editorial, "Unappealing decision" *Calgary Herald* (26 February 26 1999) A18. The prior paragraph states, "We can only speculate on whether the political nature of the *Ewanchuk* case, made worse by Appeal Court Justice John McClung's clearly inappropriate comments about the victim not presenting herself in 'bonnet and crinolines,' was a factor in the court's decision."
92 Janice Tibbetts, "Fathers' group to file complaint against high court" *National Post* (13 March 1999) A6. The column is accompanied by a photo of Justice L'Heureux-Dubé. Half of the column's content focuses on the *Ewanchuk* controversy.
93 The Judicial Council rebuked Justice McClung on five counts. His disparaging comments about the complainant within his *Ewanchuk* judgment [see text *supra* at notes 37 and 38] were described as "simply unacceptable for a judge." His letter to the *National Post* attacking Justice L'Heureux-Dubé was labelled "inappropriate," "impetuous," "a significant indiscretion," and "unfortunate" in the pain it caused her. The Council flatly rejected characterization of Justice L'Heureux-Dubé's reasons for judgment as a personal attack on Justice McClung, expressed concern about the several excuses Justice McClung offered for his injudiciousness, and found some of the rationales offered for the letter "not credible." The Council also rejected Justice McClung's rationales for giving a media interview to the *National Post* after his letter to the editor attracted widespread criticism, and asserted that his reiterations of negative comments about the complainant in that media interview were "entirely inappropriate." Finally, the Council revisited comments made by Justice McClung in his opinion in *Vriend v. Alberta* (1996), 132 D.L.R. (4th) 595 (C.A.), and found "they cross the boundary of even the wide latitude given to judges" and "constitute inappropriate conduct for a judge." As a whole, the Council considered Justice McClung's conduct "to reflect negatively on the judiciary." See News release by the Judicial Council, 21 May 1999, available at www.cjc-ccm.gc.ca/english/news_releases/1999.
94 Robert Fife, "McClung reprimanded for critical remarks made at L'Heureux-Dubé" *National Post* (22 May 1999) A4.

95 Mark Bourrie, "McClung survives judicial council probe" *Law Times* (31 May–6 June 1999) 1 at 4.
96 Morton and Knopff identify five sometimes overlapping, sometimes conflicting constituencies within the Court Party: proponents of national unity, civil libertarians, equality seekers, social engineers, and post materialists. Each constituency, they argue, shares a belief in using "systematic litigation," rather than conventional electoral politics, to achieve political ends they would not otherwise achieve through the electoral process. Each supports expansive rules of standing, expansive use of appellate intervention, expansive interpretation of *Charter* guarantees, and the expansion of judicial power. *The Charter Revolution, supra* note 28, ch. 3, "The Court Party."
97 *Ibid.* at 125.
98 *Ibid.* at 127.
99 *Ibid.* at 68.
100 *Andrews v. Law Society of B.C.*, [1989] 1 S.C.R. 143.
101 "The Feminist Canaries are Singing Again," *supra* note 29. See also "Court Challenges Program," *REALity*, September–October, 2000: "It is not surprising that homosexual legal challenges are being so generously funded by the Program, since homosexual/lesbian activists are closely involved with the administration of the Program." The column goes on to assert that four of twelve organizations represented on the Court Challenges Program Advisory Committee are "actively involved in promoting homosexual/lesbian rights"; two of seven members of the Equality Panel are lesbian/homosexual, and feminist organizations were among the equality-seeking groups that attended the CCP's Annual Meeting in 1998.
102 *Ibid.*
103 Neil Seeman, "Who runs Canada?" *National Post* (24 July 1999) nationalpost.com/news.asp?s2=national&s3=news&f=990724/36762, quoting Gwen Landolt, former President of REAL Women. See also "The Feminist Canaries are Singing Again" and "Feminists Stand on Guard to protect Gender Program for Judges," both *supra* note 29.
104 "Feminists Stand on Guard to protect Gender Program for Judges," *supra* note 29. This column as well as a later column ("The Human Rights Crazies Just Get Crazier," *REALity*, July–August 2000), asserts that while serving as Director of the Equality Panel of the Court Challenges Fund, Ms. Day personally approved funding to Ms. Brodsky for research and for litigation.
105 Tibbetts, "Farewell Claire," *supra* note 71 at 41.
106 "Democracy, Judging and Bertha Wilson" (1995) 41 McGill L.J. 1 at 13.
107 Martin also attacked Justice Rosalie Abella for the same flaws. See "The Bertha Wilson Award," *supra* note 29.

108 *Ibid.* at 36–38.
109 *Ibid.* at 26, 37, 45, and 50.
110 *Ibid.* at 10–11 and 41–42.
111 *Supra* note 3.
112 *Ibid.* at 647–65.
113 *Ibid.* at 666–94.
114 *Ibid.* at 660 and 707–9. In her *Ewanchuk* opinion, Justice L'Heureux-Dubé quotes this section of her *Seaboyer* opinion and notes that the *Ewanchuk* record "has not dispelled any of the fears I expressed in *Seaboyer* about the use of myths and stereotypes in dealing with sexual assault complaints," *supra* note 22 at paras. 94–95.
115 See Sheila McIntyre, "Redefining Reformism: The Consultations that Shaped Bill C-49," in Roberts and Mohr, eds., *Confronting Sexual Assault, supra* note 6 at 293.
116 For a summary of the anti-*Charter* writing from the Right, see Sheila McIntyre, "Feminist Movement in Law: Beyond Privileged and Privileging Theory," in Radha Jhappan, ed., *Women's Legal Strategies in Canada* (Toronto: University of Toronto Press, 2002) 42 at 49–50 and 53–54, and Kent Roach, *The Supreme Court on Trial: Judicial Activism or Democratic Dialogue* (Toronto: Irwin Law, 2001) at 74–80.
117 See, e.g., Rob Martin, "Proposed sex assault Bill an expression of feminist hatred" *Lawyers Weekly* (31 January 1992); Alan Gold, "The Sexual Assault Amendments: Flawed, Fallacious But Feminist; When One Out of Three is Enough" (1993) 42 U.N.B.L.J. 381; Don Stuart, "Mills: Dialogue with Parliament and Equality by Assertion at What Cost?" (2000) 28 C.R. (5th) 275.
118 See Joanne Wright's interesting analysis of this running theme in the post-*Ewanchuk* controversy: "Consent and Sexual Violence," *supra* note 51 at 183–86.
119 See *Alberta v. Vriend* (1996), 132 D.L.R. (4th) 575 (C.A.) esp. at 609 and 611. The Judicial Council observed that these passages, which bear "no logical connection to the issues in the case," "could be seen as categorizing gays and lesbians as sexual deviants who prey on children" and "could perpetuate the stereotype which has led to violence in the gay community": See Judicial Council News release, *supra* note 28 at 6. Professor F.C. Decoste has labelled Justice McClung's *Vriend* reasoning "politically and morally repugnant," his attitude throughout the judgment as "homophobic," and his disposition of the appeal contingent on the reduction of gay and lesbian people to a "homosexual Other" defined by immoral and/or sexually predatory practices and corruptive ambitions. See "Case Comment: *Vriend v. Alberta*, Sexual Orientation and

Liberal Polity" (1996) 34 Alta. L. Rev. 950 at 954 and 978–79.
120 *Alberta v. Vriend, supra* note 119 at 606–7.
121 *Ibid.*, esp. at 606–7 and 613–14. The Judicial Council, *supra* note 28 concluded that such remarks "detract from respect for equality rights." Professor Sheilah Martin has described Justice McClung's decision as "remarkable for its disrespectful tone and extravagant rhetoric," its ridicule of human rights advocates, and its "homophobic overtones"; see "*Vriend v. Alberta*: A Victory for Discrimination" (1996) 4 Cdn. Lab. & Emp. L. J. 389.
122 *Alberta v. Vriend, supra* note 119 at 613.
123 *Ibid.* at 621.
124 See note 119 *supra* for DeCoste's compelling critique of Justice McClung's stated views on the proper division of powers between legislatures and courts.
125 *Alberta v. Vriend, supra* note 119 at 613–19.
126 *Ibid.* at 617–18. The rhetoric, it should be noted, derives from an old rape "joke."
127 *Ibid.* at 611–12. The quoted phrase is at 611.
128 *Ibid.* at 602–9.
129 *Ibid.* at 606, 613, 614, and 616.
130 See Bruce Feldthusen, "The Gender Wars: 'Where the Boys Are'" (1990) 4 C.J.W.L. 66.
131 "Judges have no right to be bullies," *supra* note 70.
132 In an interview on her retirement, Justice L'Heureux-Dubé described the *Mossop* decision, *supra* note 12, as her favourite judgment: see Cristin Schmitz, "Our one-on-one with Justice Claire L'Heureux-Dubé" *Lawyers Weekly* (17 May 2002) 18. She remarked that she had worked very hard on her dissent because the Court was addressing sexual orientation discrimination for the first time. In the *Mossop* case, Chief Justice Lamer cited three cases and no secondary sources in concluding the Canadian Human Rights Tribunal had erred in law by deciding the term "family status" could be read to protect same-sex couples from discrimination based on non-recognition of their families as families entitled to bereavement leave benefits. Justice La Forest cited no cases and no secondary sources in concluding Parliament intended the term "family status" to carry its "dominant" and "traditional" meaning. Justice L'Heureux-Dubé cited fifty-four cases and forty-three secondary sources in urging a deferential standard of review towards the Canadian Human Rights Tribunal's interpretation of "family status" and in concluding that its finding in favour of the gay complainant was not unreasonable.
133 John Jaffey, "High praise at symposium honouring retiring jurist" *Lawyers Weekly* (17 May 2002) 2.

134 *Ibid.*

135 Commenting on the omission of Justice Gonthier from their complaint to the Judicial Council against Justice L'Heureux-Dubé's *Ewanchuk* judgment, Gwen Landolt stated, "We have pretty well accepted that he is in the feminist camp, but he is more even-handed. And he did not write the decision. That is the difference. He just sort of tagged along." See Ohler, "Women's group turns tables," *supra* note 70.

136 Sampert, "Bitch on the Bench," *supra* note 52, points out that the *National Post* mentioned that the *Ewanchuk* decision was unanimous in only four of its twenty stories on the decision and its aftermath; the *Globe and Mail* noted the unanimity of the judgment in only one of twenty stories (at 129).

137 The Court's equation of discrimination with an abstraction called "dignitary injury" is generating utterly unpredictable outcomes contingent on individual judges' subjective views about when a legislative distinction legitimately injures the dignity of those it burdens. For an example of the dignity test's inconsistent outcomes, see *Lavoie v. Canada*, [2002] 1 S.C.R. 769. For comments on the non-predictiveness of recent jurisprudence, see Sheilah Martin, "Balancing Individual Rights to Equality and Social Goals (2001) *Can. Bar Rev.* 299, at 328–30; Donna Greschner, "Does Law Advance the Cause of Equality?" (2001) 27 *Queen's L.J.* 299 at 312–13; and Debra McAllister, "Section 15—The Unpredictability of the Law Test" (2003) *N.J.C.L.* 35.

Eighteen

## Outside/In: Lesbian and Gay Issues as a Site of Struggle in the Judgments of Justice Claire L'Heureux-Dubé

SHELLEY A.M. GAVIGAN*

### Introduction

I have been asked to address and assess the contribution of Justice Claire L'Heureux Dubé to lesbian and gay equality struggles, a contribution that justly has been explicated, analyzed, and celebrated elsewhere.[1] Indeed, after my research assistant had collected a dozen cases, and twice as many articles, her leave-taking was both ominous and sceptical: "With the topic you have given yourself, I don't know how you are going to find something new to say." Fair enough. For, indeed, what can be said of Justice L'Heureux-Dubé that has not already been said: of her fearlessness, her tenacity, her passion, her compassion, her indefatigability, her unflinching commitment to equality, and the fact she is not afraid of the "F" (for feminist) word, not to mention the "L" (for lesbian) and "G" (for gay) words, nor does she hesitate to challenge the "really Big F" (for Family) word. What more can be said? That she has never been afraid of bringing the outside in. That she starts with the experience of the "other"—the one or ones whose voices and experiences have not been welcome or well heard by the law. In the context of criminal law, she starts with the harm done and the experience of the victim (a challenge for many of us schooled in the sensibilities of the subjectivist tradition and attentive to the rights of the accused). In equality litigation, she starts with the experience of the equality-seeking group. When lesbians and gay men began taking their

lives to the Supreme Court, she was not afraid of what she saw. And, importantly, she incorporated the insights of feminism when she turned her mind to their claims.

### The Judgments

In the current context, one might be forgiven for succumbing to the temptation to adopt the generic "relationship recognition" or "equal families" gloss that is often invoked to describe the lesbian and gay struggles that have been or are currently before the Canadian courts. But, as I have argued elsewhere, these cases have been drawn from different social sites and legal contexts:[2] they have involved gays and lesbians as unionized workers in the public sector[3] and their right to human rights protection if they work in a non-unionized workplace in the quasi-private sector in Alberta.[4] Many "same-sex family" cases have transcended the conventional boundaries of family law and included claims to entitlement for social benefits[5] and survivors' benefits under public pension and insurance plans,[6] or challenges to adoption and child welfare legislation.[7] In fact, only one lesbian case in the "conventional" family law area reached the Supreme Court during Justice L'Heureux-Dubé's tenure on the Court: that of *M. v. H.*, which involved the fallout from a failed lesbian relationship and the claim by one for spousal support from the other.[8]

In rereading Justice L'Heureux-Dubé's judgments, I am struck by the consistency and clarity of her analysis when lesbian and gay issues appeared before her, whether in the context of entitlement work-related benefits (*Mossop*), social benefits (*Egan*), the right to human rights protection (*Vriend*), the definition of spouse in family law legislation (*M. v. H.*), or the policy of a Christian University to proscribe "sinful behaviours" such as homosexuality for the members of its students, faculty, and staff, and the response of the provincial accreditation body (*Trinity Western University*).[9] If, as one commentator observed, the Court "fumbled"[10] towards equality, it was not because Justice L'Heureux-Dubé ever dropped the ball, although one does imagine the scrimmage line—or the rugby scrum—when one reads the 4:4:1 split or 8:1 lopsided decisions. And yet, in a struggle that surely was not one for the faint of heart (in her words, the "battle for equality"),[11] Justice L'Heureux-Dubé appears to have been able to move the Court, when one considers the ground gained between her 1993 dissent in *Mossop* (concurred in by McLachlin J.) and the 1999 decision in *M. v. H.* (an 8:1 decision, with the

lone dissent on this occasion someone other than herself).[12]

In *Mossop*, the Supreme Court was confronted with a case under the *Canada Human Rights Act* involving the employer's denial of a federal civil servant's modest claim to one day of bereavement leave to attend the funeral of the father of the man with whom he lived. The collective agreement governing his employment permitted this form of leave in the death of designated family relations. His request was denied because the deceased man was not his father-in-law, not a member of his family. The federal human rights legislation did not prohibit discrimination on the basis of sexual orientation, thus Mossop claimed he had been discriminated against on the basis of his family status. A federal human rights tribunal had upheld his complaint, based on the evidence before it. But the federal government appealed this decision and it was left to the Canadian Human Rights Commission, and ultimately and more significantly, to intervening parties, to defend the tribunal's interpretation and decision in Mr. Mossop's favour before the Supreme Court.

Justice L'Heureux-Dubé urged her colleagues on the Court to respect the decision and jurisdiction of the administrative tribunal that had heard the matter. This position was going nowhere fast. Turning to the substantive issue, she analysed "family status" with the contextualized approach that she and Wilson J. had pioneered in their respective judgments, *Moge v. Moge*[13] and *R. v. Lavallee*.[14] Didi Herman presciently predicted the importance of L'Heureux-Dubé J.'s dissenting opinion in *Mossop* (1993) when she characterized it as "of greater interest, and, perhaps, "long term significance."[15] In contrast to the majority, her dissent explicitly adopted a "living tree" approach,[16] one less formalistic and more open to the entry of non-legal discourses.[17]

Justice L'Heureux-Dubé's dissenting judgment in *Mossop* revealed a sophisticated understanding of the complex and contradictory relationship of family and law, one that reflected a deep knowledge gleaned from what I think she would characterize as the "realities" of family law practice, her years on the bench, and a deep immersion in what she clearly regarded as the relevant scholarship. Her judgment urged a departure from the reliance and invocation of traditional understandings of the traditional family, what she characterized as the "unexamined consensus,"[18] and drew upon a wide range of feminist, lesbian, and other literatures to argue that law must shift to take into account the "lived experience of family."[19] She challenged the "unexamined" with illustrations that showed that within and without law, there were

a "multiplicity of definitions and approaches" to the family:

> The multiplicity of definitions and approaches to the family illustrates that there is no consensus as to the boundaries of family, and that of "family status" may not have a sole meaning, but rather may have varied meanings depending on the context or purpose for which the definition is desired. The same diversity of definitions can be seen in review of Canadian legislation affecting the "family". The law has evolved and continues to evolve to recognize an increasingly broad range of relationships. Different pieces of legislation contain more or less restrictive definitions depending on the benefit or burden of the law to be imposed. These definitions of family vary with legislative purpose, and depend on the context of the legislation. By way of example, one may be part of a family for the purpose of receiving income assistance under welfare legislation, but not for the purposes of income tax legislation.[20]

Justice L'Heureux-Dubé rejected the idea that the definition of family is inflexible and finite, determined and driven solely by authoritative "Law," offering instead an image of the relationship that bore the influence of law and society scholarship:

> ... the family is not merely the creation of law, and while law may affect the ways in which families behave or structure themselves, the changing nature of family relationships also has an impact on the law. ... Law and Family have long been engaged in an Escherian dialectic, each shaping the other while at the same time being shaped.[21]

Finally, she reminded her more conservative colleagues on the bench:

> It is possible to be pro-family without rejecting the less traditional forms. It is not anti-family to support protection for non-traditional families. The traditional family is not the only family form, and non-traditional family forms may equally advance true family values.[22]

Justice L'Heureux-Dubé's use of the term "dialectic" is enough to send shivers of delight up the back of any unrepentent socialist feminist; truly, how many cases has one read in which the term "dialectic" appears? And for those who would read her judgments as being perhaps informed by and leaning in the direction of "a postmodernist model of anti-discrimination law,"[23] she clearly understood how to deploy ideology as an analytic concept: "While it is arguable that the 'traditional family' has an ideological stronghold, it is clear that a large number of Canadians do not live within traditional families."[24] Relying on an early article by Didi Herman, which she had clearly read, Justice L'Heureux-Dubé made the decidedly un-postmodernist observation about the family: "The reality is, as Didi Herman writes ... that families are 'sites of contradiction'." ("Dialectic," "realities," "experience," "ideological"—used correctly —and "sites of contradiction"[25]—her occasional use of the language of intersectionality is not, in my respectful opinion, enough to place her on a pedestal of postmodernity, which, in any event, would invite deconstruction.)

As is well known, Justice L'Heureux-Dubé was presented with another opportunity to consider the legitimacy of the invocation of "the traditional family" in *Egan v. Canada*,[26] one of a trilogy of *Charter* equality cases,[27] which tested the opposite sex requirement for spouses in the federal old age security legislation. As I read these cases, the Supreme Court decided that the "traditional family's" patriarchal reach extended to include the "post-divorce family" but recoiled at the prospect of characterizing the forty-seven-year relationship of an elderly gay couple as "spousal"—that was simply too queer an idea for the traditionalists on the Court. However, and by a bare majority only, the Supreme Court saw its way clear to upholding the spousal claim of a woman in a common law heterosexual relationship.[28] More recently, in one of the last judgments in which Justice L'Heureux-Dubé participated, the Supreme Court made even more clear the narrow basis on which *Miron v. Trudel* was decided. In a Nova Scotia case, the Court rejected a woman's claim as a common law spouse to a share in family property and her challenge to the legislative definition of spouse.[29] As I have argued elsewhere, the closer one comes to property, the tighter the definition of spouse becomes.[30]

The result in *Egan* in the Supreme Court reminds one of the phrase coined by Kathleen Lahey in the 1980s: "equality with a vengeance."[31] It was a victory delivered in the embrace of loss. The Supreme Court of Canada unanimously decided that sexual orientation was an analogous ground of discrimination under section 15 of the *Charter of Rights and Freedoms*.[32] A slim

majority held that the "opposite sex" requirement for spouses under the federal *Old Age Security Act* violated the equality rights of Egan and Nesbitt, who had been living together since 1948 (before any of the justices of Supreme Court who heard their case had graduated from law school and been called to the bar). A differently constituted slim majority decided that the section 15 violation was a reasonable limit in a free and democratic society and hence saved under section 1 of the *Charter*.

Justice Sopinka justified his decision by characterizing the idea of same-sex spouses as "a novel concept" [perhaps for his brothers in the majority and for the federal government, but not for Egan and Nesbitt]. For Justice La Forest,

> marriage has from time immemorial been firmly grounded in our legal tradition, one that is itself a reflection of long-standing philosophical and religious traditions. But its ultimate *raison d'être* transcends all of these and is firmly anchored in the biological and social realities that heterosexual couples have the unique ability to procreate, that most children are the product of these relationships, and that they are generally cared for and nurtured by those who live in that relationship. In this sense, marriage is by nature heterosexual. It would be possible to legally define marriage to include homosexual couples, but this would not change the biological and social realities that underlie the traditional marriage.
>
> The marital relationship has special needs with which Parliament and the legislatures and indeed custom and judge-made law have long been concerned.[33]

Leaving aside the image of the shackled Ghost of Christmas past, and the small fact that this case was not about marriage, La Forest's judgment (and Gonthier J.'s dissent in the companion case, *Miron v. Trudel*),[34] revealed a breathtakingly conservative, procreation-driven view of marriage.

Justice L'Heureux-Dubé's approach to determination of an equality claim can be gleaned from her succinct statement in *Miron v. Trudel*: "I prefer to focus on the group adversely affected by the distinction as well as on the nature of the interest affected, rather than on the grounds of the impugned

distinction."³⁵ In *Egan*, she coined yet another phrase for which she is famous: "putting discrimination first."³⁶ Elaborating, she said, "This is not to say that the essential characteristics of the nine enumerated grounds are irrelevant to our inquiry. They are, in fact highly relevant."³⁷ But,

> We must remember that the grounds in s. 15, enumerated and analogous, are instruments for finding discrimination. They are a means to an end. By focusing almost entirely on the nature, content and context of the disputed ground, however, we have begun to approach it as an end, in and of itself.³⁸

She defined a "discriminatory distinction" as one that

> is capable of either promoting or perpetuating the view that the individual adversely affected by this distinction is less capable, or less worthy of recognition or value as a human being or a member of Canadian society, equally deserving of concern, respect, and consideration.³⁹

"It is important we ask ourselves" the following sorts of questions when considering the nature of the group affected:
- Is the adversely affected group already a victim of historical disadvantage?
- Is this distinction reasonably capable of aggravating or perpetuating that disadvantage?
- Are group members currently socially vulnerable to stereotyping, social prejudice, and /or marginalization?
- Does this distinction expose them to the reasonable possibility of future social vulnerability to stereotyping, social prejudice, and/or marginalization?⁴⁰

And the cautionary admonition was directed to the rule-bound and formalists:

> Equality and discrimination are notions that are as varied in form as they are complex in substance. Attempts to evaluate them

according to legal formulas which incorporate rigid inclusionary and exclusionary criteria are doomed to become increasingly complex and convoluted over time as "hard" cases become increasingly the rule than the exception.[41]

Needless to say, Justice L'Heureux-Dubé would have upheld Egan and Nesbitt's claim; she specifically rejected La Forest's reliance on "biological reality," which she characterized as "dangerously reminiscent of the type of biologically based arguments that this court has now firmly rejected."[42] And to sum up, she rejected Justice Sopinka's "novel approach" to section 1:

> There is a first time to every discrimination claim. To permit the novelty of the appellants' claim to be a basis for justifying discrimination in a free and democratic society undermines the very values which our *Charter*, including s. 1, seeks to preserve.[43]

The La Forest-Gonthier-Sopinka judgments were widely criticized, often in terms that emphasized their logical deficiencies and bald conservatism. For Bruce Ryder, "the reliance placed on 'biological and social realities' and 'fundamental values' to resist the logical implications of anti-discrimination principles by La Forest J. [in *Egan*] and Gonthier J. [in *Miron v. Trudel*] ... represents the most conservative contribution to equality jurisprudence by the Supreme Court since *Lavell*, *Bliss* and other infamous *Bill of Rights* decisions of the 1970s."[44] David Beatty also observed:

> After reading the judgments of La Forest and Sopinka no one can have any doubt that it was their personal beliefs about traditional family units (in the case of La Forest) and discrimination against gays (in the case of Sopinka) that explains why Egan and Nesbitt lost their case.[45]

Brad Berg echoed this assessment:

> The Justices led by La Forest steadfastly refuse to permit reexamination of the traditional definition of "spouse" that was represented by the impugned legislation. ... Unfortunately, wariness

of the novel may be only part of the story. In light of the logical contortions that had to be made in order to transform this pension case into a threat to heterosexual marriage, it seems impossible to escape the sad inference that what really motivated the La Forest judgment was profound heterosexism.[46]

In the long run, it is Justice L'Heureux-Dubé who has prevailed;[47] it is not for nothing that she has been described as the Supreme Court's "most advanced and sophisticated equity analyst."[48] Her influence on the Court has been substantial and is reflected in the Court's more recent decisions in *M. v. H.*[49] and *Law v. Canada (Minister of Employment and Immigration)*.[50] In *M. v. H.*, Cory and Iacobucci JJ., writing for the majority said,

> The exclusion of same-sex partners ... promotes the view that M., and individuals in same-sex relationships generally, are less worthy of recognition and protection. It implies that they are judged to be incapable of forming intimate relationships of economic interdependence as compared to opposite-sex couples, without regard to their actual circumstances. As the intervener EGALE submitted, such exclusion perpetuates the disadvantages suffered by individuals in same-sex relationships and contributes to the erasure of their existence.[51]

In *Law*, the Court unanimously emphasized the role of section 15 of the *Charter* in protecting those who are vulnerable, disadvantaged, or marginalized, as well as the importance of a contextual analysis that focuses on the perspective of those affected by the legislative distinctions.[52] Writing for the Court, Iacobucci J. emphasized the importance of a purposive approach to section 15 of the *Charter* and defined that purpose broadly:

> the purpose of s. 15(1) is to prevent the violation of essential human dignity and freedom through the imposition of disadvantage, stereotyping, or political or social prejudice, and to promote a society in which all persons enjoy equal recognition at law as human beings or as members of Canadian society, equally capable and equally deserving of concern, respect and consideration.[53]

## Beyond the Judgments

In *Trinity Western University (TWU) v. British Columbia College of Teachers (BCCT)*,[54] a case in which the Supreme Court had to consider whether the BCCT had jurisdiction to consider the discriminatory practices of TWU, a private Christian university, and whether the BCCT's decision to deny TWU's application for affiliation was justified. Trinity Western University had developed a teacher training program and, following some fits and starts in the process, sought approval to assume full responsibility for it. Students and faculty at Trinity Western University were expected to adhere to the "preferred lifestyle" articulated in a Community Standards document and to "refrain from practices that are biblically condemned"; these practices included "sexual sins including premarital sex, adultery, homosexual behaviour and viewing of pornography."[55] Faculty and staff were required to sign a document that included the prohibition of homosexual behaviour. At the heart of Justice L'Heureux-Dubé's dissenting judgment is a concern for lesbian, gay, and bisexual students who are forced to "modify their behaviour to avoid the impact of prejudice":[56]

> Most of the relevant evidence in this case is the reality of a hostile environment faced by homosexual and bisexual students. The courts by trespassing into the field of pedagogy, deal a setback to the efforts of the BCCT to ensure the sensitivity and empathy of its members to all students' backgrounds and characteristics.[57]

In the report of the case, the lists of cases and statutes that one would expect to be cited are cited. An impressive list of secondary sources is also set out: monographs bearing the titles *Gaylaw: Challenging the Apartheid of the Closet* and *Are We "Persons" Yet? Law and Sexuality in Canada*, together with articles published in academic journals that address the educational needs of lesbian and gay youth, silence in the classroom, and the "privileging of homophobic religious ideology." Not one of the authors cited is to be found in the majority judgment; it is only in the dissenting judgment of Justice L'Heureux-Dubé, in a case that went against her position 8:1, that these relevant scholarly authorities are considered.

Justice L'Heureux-Dubé is well known for referring to academic literature in her judgments. To the horror of some, she was as likely to cite the work

of academics, legal and otherwise, as she was legal precedents. She might try to persuade us that this was simply a reflection of the civilian tradition in which she was educated, practised, and served on the bench.[58] Indeed, I think it is safe to speculate that Justice L'Heureux-Dubé single-handedly introduced the work of a new generation of feminist and critical scholars—non-legal and legal—to the lexicon. As Sheila McIntyre notes in this volume, she cited these scholars as authorities![59] One encountered Susan Boyd,[60] Nitya Duclos-Iyer,[61] Jewelle Gomez,[62] Didi Herman,[63] Audre Lorde,[64] Adrienne Rich,[65] Bruce Ryder,[66] Kathleen Lahey,[67] Elizabeth Sheehy,[68] and former Chief Commissioner of the British Columbia Human Rights Commission, Mary Woo Sims,[69] in her judgments, to name but a few.

Justice L'Heureux-Dubé has been generous in her acknowledgement of the importance of academic research and scholarship:

> Our understanding of gender and other types of bias in the law as well as potential solutions to this problem has been greatly enriched by the theory and research examining gender differences observed in judicial decision making. This work is of unquestioned assistance in my own query ...[70]

But it would seem that on this methodological point, she often stood alone. Feminist, queer, and critical race legal scholars should acknowledge her support and integration of new forms of legal scholarship into her judgments. In this section, I want to reciprocate in kind. I am interested in Justice L'Heureux-Dubé's words in journals and her lectures to students—words that are not hitched to the wagon of litigation, tethered to a particular set of facts marshalled by lawyers, or focused upon a particular piece of legislation. As she herself has observed: "Judging can be described as the piecing together of a story which will never be more than partial and will reflect the legal rules which govern its telling."[71]

But a judge is more than the sum of her judgments. Here, I want to engage with three themes that have emerged in Justice L'Heureux-Dubé's lectures and publications: the interpretative lens of equality, the language of equality, and the challenge of inclusivity in legal education. Without suggesting that these themes are divorced from her judgments, it is instructive nonetheless to consider them as part of the contribution of her broader intellectual and legal agenda.

*The Interpretative Lens of Equality: "Putting Discrimination First"*

As I have suggested above, Justice L'Heureux-Dubé endeavours never to lose sight of the experience of the marginalized and disadvantaged. Her willingness to engage with and take up the research of critical scholars derives from her position that the law needs to move and to respond to new approaches to not so "novel" experiences of poverty and disenfranchisement. Rendering visible the complex forms of systemic inequality requires increasingly precise analytic tools because, as she quotes J.S. Mill, "domination always appears natural to those who possess it and the law insidious transforms the fact of domination into a legal right."[72] This is a task that requires that we move out of a comfort zone of common sense and, as she has written, that "we remove the well-worn shoes of unquestioned and often stereotypical assumptions."[73]

Justice L'Heureux-Dubé's commitment to a broad, flexible, and inclusive definition of equality is not an academic or abstract exercise. While she may not be the first feminist to articulate the following, one wishes more judges expressed and lived these words out loud:

> Equality must not only be part of our thinking, it must be part of our living. If we embrace equality and encourage others to do the same, we will be one step closer to creating a society in which you, your children and your children's children need not fear disempowerment and oppression.[74]

*The Language of Equality as a Mother Tongue*

In a series of public lectures and publications, Justice L'Heureux-Dubé has revealed her interest in linguistics[75] and spoken of "this language called equality":[76]

> I think that it is helpful to regard equality as a language like every other, with rules of grammar and syntax, nuances, exceptions and dialects. More importantly, language is more than a form of communication. It is an embodiment of the norms, attitudes and culture that are expressed through that language. Learning a language and learning a culture go hand in hand. ... it is dangerous to think we are fluent when we are not.

Our task is to revisit our underlying assumptions, to look beyond the four corners of the law, and to contemplate change where our examination reveals that the languages are inconsistent.[77]

I remain to be persuaded by this conceptualization of equality as a language, as a mother tongue. I prefer her use of the terrain of equality, the battleground—not because I find the metaphors of war more compelling, but because I believe that therein lies the material, the matter, the contexts of peoples' lives. The language of equality can be deployed in different ways, and to different purposes, as demonstrated no less than by Gonthier J.'s dissenting judgment in *M. v. H.*[78] We must not just talk the talk, we must also walk the walk—with others. And we must be prepared to "cultivate" the equality leaves and work the "terrain." Speaking the language of equality is essential to get the word out, but as Justice L'Heureux-Dubé herself has said, we must live equality.

### The Challenge of Inclusivity in Legal Education

Those of us who teach in law schools have had the opportunity to observe first hand the warm and open relationship Justice L'Heureux-Dubé enjoys with law students. They seem to represent her fondest hope for the future, and she does not hesitate to remind law professors that our responsibility to educate law students encompasses their minds and hearts. In articles published in the U.B.C. Law Review[79] and the Manitoba Law Journal,[80] Justice L'Heureux-Dubé quotes the words of the late Chief Justice Brian Dickson, on the aim of legal education. Although repeated in both articles, his words bear repeating here:

> The primary goal of legal education should be to train for the profession people who are first, honest, second, compassionate, third, knowledgeable about the law, and fourth, committed to the role of law and justice in our democratic society.[81]

Justice L'Heureux-Dubé reminds us that the late Chief Justice believed it to be

> essential that law schools, and indeed the entire legal profession, devote a great amount of attention and energy to studying

some of the deep social problems of our time—problems of poverty, inequality and the environment. If the legal profession as a whole is to help solve some of the seemingly intractable difficulties faced by the poor ... native people, other minorities, new immigrants, and others, its seems to me that the process must start in law schools.[82]

Compassion is not an "extra legal" frill, "but part and parcel of the nature and content of that which we call law."[83] Or it should be.

She also reminds us that the burden "to educate others" must not be placed on the shoulders of "a previously excluded group":

The energy and emotion involved for students from such a group to educate others in standing up for their right to speak, if in an environment where theirs are the only voices expressing such concerns, can serve all too readily to silence them.[84]

Thus, rather than asking whether women judges, women students, students with disabilities, or students of colour "will make a difference," she urges us to develop

ways in which those involved in teaching and administration at law faculties can help make this difference, by encouraging these students to speak, and at the same time, communicating an unfailing commitment on their own parts to equality and compassionate justice.[85]

And so, I conclude where I began, acknowledging with humility the courage, indeed fearlessness, and integrity of a jurist who simply would not be intimidated or brought to heel. This, perhaps more than anything else, is the lesson I draw from the manner in which Justice Heureux-Dubé has contributed to lesbian and gay issues in her judgments—how she has brought the outside in. In the pages of her judgments, lesbians and gays—students, youth, teachers, partners, workers, elderly couples, the poor—were treated with respect and dignity, as ordinary people leading noble lives, lives with value, and arguably at some personal cost to herself. It can't be easy to hold onto the

"1" in an 8:1 judgment with brothers on the bench implicitly casting aspersions on one's legal analysis. And yet, she never backed down.

I acknowledge this with humility because there is an important challenge in the legacy of Justice Heureux-Dubé for those of us involved in legal education. Our lesbian and gay students see themselves valued and respected in her judgments, but they continue to be a beleaguered, often invisible, community within our law schools. Her challenge to us, and that of Justice Dickson before her, is to welcome and nourish the *outside* in the legal academy, so that more of the *inside* can come out with confidence. She led by example.

### Endnotes

* I wish to thank Ed Yanoshota and Laura Westra for their research assistance and Elizabeth Sheehy for her invitation to participate in this.

1 See, e.g., Didi Herman, "'Sociologically Speaking': Law, Sexuality and Social Change" (1991) 2 J. Hum. Just. 57; Carl F. Stychin, "Novel Concepts: A Comment on *Egan & Nesbitt v. The Queen*" (1995) 6 Const. For. 101; Carl F. Stychin, *Law's Desire: Sexuality and the Limits of Justice* (London: Routledge, 1995); Douglas Kropp, "Categorical Failure: Canada's Equality Jurisprudence: Changing Norms of Identity and the Legal Subject" (1997) 23 Queen's L.J. 201; Kathleen Lahey, *Are We Persons Yet?* (Toronto: University of Toronto Press, 1999); Mimi Liu, "A 'Prophet with Honour': An Examination of the Gender Equality Jurisprudence of Madam Justice Claire L'Heureux-Dubé of the Supreme Court of Canada" (2000) 25 Queen's L.J. 417; Judith Keene, "Discrimination in the Provision of Government Services and s. 15 of the *Charter*: Making the Best of the Judgments in *Egan, Thibaudeau* and *Miron*" (1995) 11 J. Law & Soc. Pol. 107; Mary Eaton, "Patently Confused: Complex Inequality and *Canada v. Mossop*" (1994) 1 Rev. Const. Stud. 203; Robert Wintemute, "Sexual Orientation Discrimination as Sex Discrimination: Same Sex Couples and the *Charter* in *Mossop, Egan and Layland*" (1994) 39 McGill L.J. 429; Robert Wintemute, "Discrimination Against Same Sex Couples" (1995) 74 Can. Bar Rev. 682.

2 See S. Gavigan, "Feminism, Familial Ideology and Family Law: A Perilous Menage à Trois," in Meg Luxton, ed., *Feminism and Families: Critical Policies and Changing Practices* (Halifax: Fernwood Press, 1997); S. Gavigan, "Familial Ideology and the Limits of Difference," in Janine Brodie, ed., *Women and Canadian Public Policy* (Toronto: Harcourt Brace, 1996).

3 E.g. Karen Andrews, library worker and CUPE member, in *Andrews v. Ontario (Minister of Health)* (1988), 49 D.L.R. (4th) 584 (H.C.); Brian Mossop, federal government translator and CUPTE member, in *Canada (Attorney-General) v. Mossop*, [1993] 1 S.C.R. 554; Nancy Rosenberg, city employee and CUPE member, in *Rosenberg v. Canada (Attorney General)* (1998), 158 D.L.R. (4th) 664 (Ont. C.A.); Mary Woo Sims and Bill Dwyer, city employees and CUPE members, in *Dwyer v. Toronto*, [1996] O.H.R.B.I.D. No. 33 (QL); Michelle Douglas, member of Canadian Armed Forces, in *Douglas v. Canada* (1992), 98 D.L.R. (4th) 129 (F.C.T.D.).

4 Delwyn Vriend, high school teacher, in *Vriend v. Alberta*, [1998] 1 S.C.R. 493.

5 Egan and Nesbitt in *Egan v. Canada*, [1995] 2 S.C.R. 627,124 D.L.R. (4th) 609.

6 See, e.g., *Kane v. Ontario (Attorney-General)*, [1998] C.I.L.R 3526 (QL); *Canada (Attorney-General) v. Bigney*, [1998] F.C.J. No. 1336.

7 E.g., *K. (Re)* (1995), 23 O.R. (3d) 679 (Prov. Div.); *C.E.G. No. 1 (Re)*, [1995] O.J. No. 4072 (Gen. Div. Fam. Ct.); *C.E.G. No. 1 (Re)*, [1995] O.J. No. 4073 (Gen. Div. Fam. Ct.)

8 [1999] 2 S.C.R. 3. Her retirement from the Supreme Court means that Justice L'Heureux-Dubé will not have the opportunity to participate in the adjudication of the (paradoxically and simultaneously) most controversial and yet most conventional same-sex legal challenge currently wending its way up to the Supreme Court of Canada via the Ontario courts: the right to marry. See *Halpern v. Canada (Attorney General)* (2002), 60 O.R. (3d) 321, [2002] O.J. No. 2714 (Div. Ct.), currently on appeal to the Ontario Court of Appeal: see *Halpern v. Canada (Attorney-General)*, [2003] No. 720 and *Halpern v. Canada (Attorney-General)*, [2003] No. 730.

9 *Trinity Western University v. British Columbia College of Teachers*, [2001] 1 S.C.R. 772, [2001] S.C.J. No. 32.

10 Drawn from Brad Berg, "Fumbling Towards Equality: Promise and Peril in *Egan*" (1995) 5 N.J.C.L. 263.

11 Claire L'Heureux-Dubé, "Conversations on Equality" (1999) 26 Man. L.J. 273 at 280.

12 In his dissent Gonthier J. emphasized gender roles, a dynamic of dependence, and the biological reality of procreation: "In my judgment, the respondent M.'s claim fails because the legislation targets individuals who are in relationships which are fundamentally different from same-sex relationships. The legislation 'corresponds' to the actual need, capacity, and circumstances of the claimant and those of the group the legislation targets. As such, I find there is no 'discrimination' within the meaning of that term in s. 15(1) of the *Charter* on the facts of this appeal."

13 [1992] 3 S.C.R. 813 at 873: "In a family law context in which many assumptions are based on male norms and values, this technique may place the burden on the disadvantaged spouse to adduce evidence aimed at overcoming stereotypes or misplaced assumptions stemming from the lack of a shared reality between judges and parties. Placing the greater burden on the party less able to shoulder it raises, in my mind, concerns as to substantive equality. One vehicle by which courts may address this inequality is to demonstrate a greater willingness to share the financial and intellectual burden of bringing underlying assumptions in line with the realities of the party. In short, to do so they must contemplate a broader role for the doctrine of judicial notice."
14 [1990] 1 S.C.R. 852.
15 D. Herman, *Rights of Passage: Struggles for Lesbian and Gay Legal Equality* (Toronto: University of Toronto Press, 1994) at 138.
16 *Ibid.*
17 *Ibid.*
18 *Mossop, supra* note 3 at para. 114.
19 *Ibid.* at 627.
20 *Ibid.* at para. 117. Justice L'Heureux-Dubé was aided here by the Intervenors' Factum of Egale et al. See Gwen Brodsky, "Out of the Closet and Into a Wedding Dress? Struggles for Lesbian and Gay Legal Equality" (1994) 7(2) C.J.W.L. 523, Jody Freeman, "Defining the Family in *Mossop v. D.S.S.*: The Challenge of Anti-Discrimination Essentialism and Interactive Discrimination for Human Rights Litigation" (1994) 44(1) U. T. L.J. 41.
21 *Ibid.* at para. 119.
22 *Ibid.*
23 See, e.g., Kropp, "'Categorical' Failure," *supra* note 1 at 226–30.
24 *Mossop, supra* note 3 at para. 120.
25 *Ibid.* at para. 129.
26 *Supra* note 5.
27 The other two cases that, together with *Egan*, formed the trilogy were *Miron v. Trudel*, [1995] 2 S.C.R. 418 and *Thibaudeau v. Canada*, [1995] 2 S.C.R. 627.
28 *Miron v. Trudel, supra* note 27.
29 *Nova Scotia (Attorney-General) v. Walsh*, [2002] S.C.J. No. 84 (S.C.C.) (QL), with Justice L'Heureux-Dubé dissenting.
30 S. Gavigan, "Legal Forms, Family Forms, Gender Norms: What is a Spouse?" (1999) 14 Can. J. Law & Soc. 129–58.
31 Kathleen Lahey, "Feminist Theories of (In)Equality" (1987) 3 Wisconsin Women's Law Journal 5 at 15.
32 *Supra* note 5.

33 *Ibid.* per La Forest J. at 625 (D.L.R.).
34 *Supra* note 27.
35 *Ibid.* at 465.
36 *Egan, supra* note 5 at 637–38 (D.L.R.).
37 *Ibid.* at 638.
38 *Ibid.* at 635.
39 *Ibid.* at 638.
40 *Ibid.* at 639–40.
41 *Ibid.* at 642.
42 *Ibid.* at 650.
43 *Ibid.* at 652.
44 Bruce Ryder, "*Egan v. Canada*: Equality Deferred, Again" (1996) 4 C.L.E.L.J. 101 at 104. See also David M. Beatty, "The Canadian Conception of Equality" (1996) 46 U.T.L.J. 349 (who suggests at 355: "It would be hard to exaggerate how regressive the definition of discrimination that the La Forest-Gonthier coalition propose really is"); and Berg, "Fumbling Towards Equality," *supra* note 10 at 270.
45 Beatty, "Canadian Conception of Equality," *supra* note 44 at 374.
46 *Supra* note 10 at 274.
47 This confident assessment with respect to the recognition of same sex relationships and the definition of spouse should be tempered, in light of the more recent decision in *Nova Scotia v. Walsh, supra* note 29, concerning the unsuccessful claim of a common law spouse to family property.
48 Keene, "Discrimination," *supra* note 1 at 141.
49 [1999] 2 S.C.R. 3.
50 [1999] 1 S.C.R. 497.
51 *M. v. H. supra* note 49 at para. 73.
52 Claire L'Heureux-Dubé, "Introduction, Same-Sex Partnerships in Canada," in R. Wintemute and M. Andenaes, eds., *Legal Recognition of Same-Sex Partnerships* (Oxford: Hart, 2001) at 211.
53 *Law v. Canada (Minister of Employment and Immigration)*, [1999] 1 S.C.R. 497 at para. 88(4).
54 *Supra* note 9.
55 *Ibid.* at paras. 3, 4.
56 *Ibid.* at para. 91.
57 *Ibid.*
58 Claire L'Heureux-Dubé, "By Reason of Authority or by Authority of Reason" (1993) 27 U.B.C. L. Rev. 1.
59 Sheila McIntyre, "Personalizing the Political and Politicizing the Personal: Understanding Justice McClung and his Defenders" 313.

60 In *Gordon v. Goertz*, [1996] 2 S.C.R. 27.
61 *Mossop, supra* note 3; *Egan, supra* note 5.
62 In *Mossop*.
63 In *ibid.* at 633: "families are sites of contradictions."
64 In *ibid.* at 633–34: "we must recognize differences among [people] who are our equals ... and devise ways to use each others' difference to enrich our visions and our joint struggles."
65 In *ibid.* at 632.
66 In *ibid.* at para. 129.
67 In *Trinity Western, supra* note 9 at paras. 81, 91.
68 In *R. v. Seaboyer*, [1991] 2 S.C.R. 577; *R. v. Ewanchuk*, [1999] 1 S.C.R. 330, [1999] S.C.J. No. 10 (QL) at para. 82.
69 In *Trinity Western, supra* note 9 at para. 83.
70 Claire L'Heureux-Dubé, "Making a Difference: The Pursuit of a Compassionate Justice" (1997) 31 U.B.C.L. Rev. 1 at 2.
71 *Ibid.* at 5.
72 "Making Equality Work in Family Law" (1997) 14 Can. J. Fam. L. at para. 109.
73 "The Search for Equality: A Human Rights Issue" (2000) 25 Queen's L.J. 401 at 406.
74 *Ibid.* at 414–15.
75 See, e.g., Claire L'Heureux-Dubé, "The Legacy of the '*Persons Case*': Cultivating the Living Tree's Equality Leaves" (2000) 63 Sask. L. Rev. 390 at 391–92.
76 Claire L'Heureux-Dubé, "Conversations on Equality" (1999) 26 Man. L.J. 273 at 281.
77 "Making Equality Work," *supra* note 72 at para. 107.
78 *Supra* note 8.
79 "Making a Difference" *supra* note 70 at 1–18.
80 *Supra* note 76.
81 "Making a Difference," *supra* note 70 at 11; "Conversations on Equality," *supra* note 76 at 294.
82 "Making a Difference" at 11–12; "Conversations on Equality" at 295.
83 "Making a Difference" at 9; "Conversations on Equality" at 292.
84 "Making a Difference" at 13; "Conversations on Equality" at 296.
85 "Making a Difference" at 13; "Conversations on Equality" at 296–97.

Nineteen

## Rooms with "Traditional Views": Justice L'Heureux-Dubé and the Expansion of Interpretative Principles Related to Equality in the Context of Indigenous Rights

TRACEY LINDBERG

It may surprise you to know that I prepared for this discussion by looking for words in my language that have relevance to the discussion taking place today. After I did that, and thought for quite some time, I looked at what other people said about those words, and then examined the things people said about Justice L'Heureux-Dubé and her work and philosophies. It may also surprise you to know that only then did I review the case law that I thought important to this discussion. The reason why the case law is the last stop on this journey is that it is the least relevant, the least reflective of Indigenous understandings, and the least accessible portion of the discussion related to "law" for many Indigenous people. For many of us in our societies, to make sense of Canadian society, we need an interpreter. We need someone to interpret Canadian systems, laws, and principles. This is because the assumptions that you make, the understandings that you possess, and the knowledge that you impute into your own interpretative skills are informed by the place that you come from. For these to make sense, they must be interpreted in a way that is meaningful to the communities to whom they are presumed to apply.

The first reason the interpretative exercise is important is that the assumptions that underlie the laws, understandings, and judicial decisions of the Canadian judicial system are those best understood and presumed accurate by individuals who resemble the decision-makers. Comparing the

decision-making capacity of, decisions rendered by, and the legal precepts related by the Canadian judiciary allows us to examine the exclusivity of law, and in turn to appreciate truly the attempts to make law more inclusive.

The next reason that this interpretative exercise is important is to determine more accurately the sites of Indigenous intellectual traditions to determine the in/applicability of Canadian laws to Indigenous peoples. The end result is, of course, not only an examination of the notion of equality, but also a celebration of diverse understandings of the same.

Thirdly, this discussion is important as it addresses the actuality that is well-known to many of us who stand outside the Canadian judicial lines: the Canadian judicial system is not a pool within which we see ourselves reflected. For many of us, the court—much as the government of Canada—is perceived as outsider, foreign, and "other."

All of this relates to the work of Justice L'Heureux Dubé on several levels. This paper briefly examines the inclusion of difference and equality legal dialogue as an agent of change in Canada, focusing particularly on the Justice's patchwork of the Canadian social fabric based upon the notion of inclusiveness. Next, I will examine the impact that opening the door to the celebration of difference and the eradication of inequality may have for Indigenous peoples. Finally, I will conclude with a brief discussion of the import of social, cultural, and historical contextual understandings in the development of law in Canada.

What does equality mean, in the absence of a pattern of inclusiveness? What does egalitarian mean in a society where there has been prescriptive and judicially and governmentally mandated and/or sanctioned exclusivity, inequality, and unfairness? How can we truly address egalitarianism in a place where we have not even accepted responsibility for the oppression of many people living near to or within Canadian society?

These are hard questions, ones that have been answered without all of the information required to provide us with confidence in the answers. If we want answers with assurances of accuracy, we need to address not only the cadence of inclusiveness, but the language of representation. Not only do we need to be able to hear the "different voices" that Carol Gilligan refers to[1], but we must also prepare ourselves to learn or access new languages, old histories, and collective memories. It is simply not enough to acknowledge that inequality exists—for ascribing it a name or an understanding is also a priv-

ileged position. It is important for all peoples to be able to understand that the ability to name inequality and to adjudicate and assess the situations from which inequality results, without visiting or understanding the sites of the resultant oppression, prejudice, and "isms," is an incomplete journey. The voyage to equality includes stops at your own privilege, your own luxury of naming, and your power in judgment. As long as one is able to name an activity, action, or situation as "unequal," inequality exists. When someone who faces an activity, action, or situation that is "unequal" can name it and have the situation scrutinized and righted, there is access to equality. When you can identify unfair situations and have them resolved according to the standards of your community, then equality is not just accessible—it is achievable. The inequality is not merely in the actions directed at you, it is in having them adjudicated according to foreign ("different") standards and principles and not being able to name them yourself or have your own standards used to assess the inequality. When you can name and identify actions that perpetuate inequality according to your society's standards and the corrective action for the same is based on your society's standards, there is equality between your nation and other nations. With one as settler and the other Indigenous, acknowledging and entrenching these differential standards begins to create just societies.

There is, therefore, a great onus on those of us who get to label, name, and adjudicate to ensure that we share that obligation with those who are disempowered, oppressed, and affected most directly by labelling, naming, and adjudication. The onus is greater than impartiality. The responsibility is also larger than objectivity—which is seldom value-neutral and which often reflects the objectivity of the people who are situated in powerful decision-making positions. The obligation, in a *Neheyiwak* (Cree) context, is to make sure that you live your life in a manner that is responsible and that your relations can be proud of. The commitment to living your life in a manner in which integrity is integral to your decision-making is one that is fundamental to our understandings. By this meaning, it is a positive obligation to create a society within which equality and fairness can be expected by all peoples. It is a positive obligation, not a negative one (i.e., not creating unfair taxation schemes, state-sanctioned family designs, and male-dominated support and custody orders). It is a requirement that all people are treated with fairness and respect.

In this way, some of the work of Justice L'Heureux-Dubé has mirrored the teachings of Indigenous Elders.[2] She has, in her minority dissenting opinions and in her judgments, addressed the notion that we have an obligation to redress wrongs, review historic improprieties, and make amends for systemic and enduring unfairness. She has endeavoured to include the voices of those people who have not been heard, in a forum where she considers their evidence, their understandings, and their history an essential piece of the social fabric, most notably in the inclusion of women's voices in the creation of just relations.

In preparing this paper I had to review a few key terms to ground myself in the dialogue. My research took me to a Cree-to-English dictionary to determine the meaning of and comparable terms for equal, or equality. I had to ask someone who has more training than I do in our traditions, language, and understandings[3] to tell me about some of the principles that I am discussing today. No language came to me that was clearly comparable to the discussion about equality on a linguistic level. There were a few terms, however, that I think express the notions that are implicit within this dialogue. *Tapwewin* refers to speaking "the truth or with precision and accuracy."[4] *Manatisiwin* means respect.[5] *Kwayaskatisiwin* refers to honesty and fairness.[6] Respectful relationships are *miyo-wicehtowin* ("as symbolized by the laws governing relationships between cousins ...").[7] *Okiskinohtahew* is to conduct yourself in a manner that sets an example.[8]

We have an obligation to conduct ourselves in a manner that sets an example—perhaps this is a greater positive obligation than any concept related to equality as understood by Canadian law. Potentially, this is a doctrine from which many laws can stem.

What, then, is the obligation that citizens and decision-makers have in an Indigenous context? There is a Cree word that describes the measurement that approximates equality. The word, however, is not an interpretation of the principles that Canadian law hopes to emulate and entrench. It is not a word that translates easily into English. The English word "equal" is less precise than, say, Cree words that address inclusiveness (such as *miyo-wicehtowin*), the principles and rules that govern respectful conduct, and laws that establish the ways to live most balanced in the world. Equality as a doctrine that encompasses equal wealth (physically, spiritually, mentally) within differing parameters cannot be combined in a single word. The important point to take

from this is that if mere definitional comparisons cannot accurately address the richness of language and meaning, then not only are we obliged to examine the contextual underpinnings for the same, but if we want Canadian laws to reflect the richest and fairest understandings, we must also look to other sites of understanding to expand our knowledge.

All of us are limited by the language, the applied values, and the acknowledged power differential in this dialogue. Part of the difficulty is in recognizing and acknowledging that there is an absolute difference between awarding someone rights of equality and having equality awarded to you. These are different sites—those of empowered and disempowered, of namer and named, those who see that you are unequal and those who are deemed unequal. Equality means not only before the law, but also before your own laws. Subsumed in that word is the knowledge that we have not been treated fairly and that our laws have not been equally respected. It is not enough to require that we are treated the same as Canadian citizens under Canadian laws, for one brief look at our history will prove that there is no superficial equality for us in Canada (to say nothing of our citizenship in our own nations). The requirement that exists and the understanding that must be taken into account in Canadian jurisprudence must address our underlying understandings. In truth, we may not be equal—we may have legal systems and laws so elemental and advanced that they are in no way equal to those represented in Canadian systems. However, what we likely can agree upon is that we all have an obligation to be fair.

Acknowledgement that the laws of a nation should be applicable to the citizens of the nation is a requirement. The entrenchment of the understanding that all citizens must be included or reflected in the decisions that affect them is an excellent starting point. It may well be that all that we can hope for is the obligation of fairness in each of our own domains, mutual respect, and then a cross-pollination of ideas and understandings that we can share. Until that mutual respect for each other's laws is achieved, cross-pollination is going to be difficult, if not impossible.

There is a certain satisfying feeling when someone challenges the norm (normative, normal) entrenched in the Canadian legal traditions. We state that the person challenges "traditional thought." Despite the relegation to abnormality and the assessment that the traditional thought is mired in patriarchal and colonial understandings, as Indigenous peoples who are affected

by this challenge to "traditional thought," we must remind you of a few of our elemental and complex truths. Your response to the inadequacy and lack of representative capacity of the norm may also not be our norm. Your hard-won battles may be as foreign to us as the understandings and assumptions that littered the primary battleground. We are reminded, in this capacity, that the entrenchment of "traditional thought" is precisely what we desire. We patiently wait while our norms and our traditions are re-established and entrenched, acknowledged, and honoured.

For in this context, we are quite like Vriend, Thibaudeau, and Moge. We await someone who speaks our language, who understands that equality means inclusion, who knows that different stories, histories, and ways of knowing must be acknowledged and celebrated. We look for the acknowledgement that our stories and the standards that measure them may be completely different but that they are equal in that they deserve equal respect. The doctrine of equality of access, inclusion, or choice in the presence of different understandings and laws is a fundamental tenet. It refers specifically to the respect for understandings that are not the same as your own. If there is such a thing as equality, surely it must mean respect for laws and tenets that are as important as your own.

Justice L'Heureux-Dubé has facilitated this dialogue with her work in several cases, notably in *Moge, Egan,* and *Thibaudeau*[9].

In the *Moge* decision, several tenets familiar to Indigenous people are in evidence, including the notions that equity means taking into account different but equally valid and important roles in assessing the contributions men and women make to the family. The promotion of egalitarian notions of economic valuation of male and female contribution is very much entrenched in Indigenous principles of equality of the value of differing roles. As an aside, judicial notice of the formerly unnoticeable also blazes trails that were not publicly accessible.

As well, in the dissenting opinion in *Egan*, Justice L'Heureux-Dubé states that "[d]efining with accuracy and sensitivity the purpose of a particular right is, in short, the starting point for rights analysis."[10] The importance of this elemental understanding is deceptively simple. From an Indigenous rights perspective, sensitivity is referent to the previous statements that I have made about inclusiveness. For Canadian law to address Indigenous rights accurately, the sensitivity must exist to acknowledge the space required for that discussion to take place accurately. When discussing the fundamental

purpose of section 15 of the *Charter*, we have to broach the discussion of what "without discrimination" means in a language that those living in Indigenous societies and Canadian societies can both understand. Notably, the decision addresses the rights of groups as well as individuals. For those of us who live in nations and societies the basis of which is community and shared obligations, this discussion is relevant and begins to address the inclusion of our particulars. For many years, the requirement that rights dialogue take place in the first person singular dissuaded many of us from participation in the discussion. In this case as well, the reference to a subjective-objective standard begins to address the inclusion of Indigenous people in that formerly inaccessible definition of reasonable people.[11]

The dissent of Justice L'Heureux-Dubé in the *Thibaudeau*[12] decision is also notable in the area of Indigenous rights for several reasons. The notion of inclusiveness within the law and the doctrines governing law is once again addressed and the Justice opens the door wider to those treated unequally by the law. She says in this case: "A denial of equality does not necessarily require that all members of a group be adversely affected by the distinction. It suffices that a particular group is significantly more likely to suffer an adverse effect as a result of a legislative distinction than any other group."[13] Later in her dissent she also addresses systemic discrimination and says of this: "A system that materially increases the vulnerability of a particular group imposes a burden on that group which violates one of the four equality rights under s. 15."[14] For those of us mired in the systemic racism of the *Indian Act* and the proposed First Nations Governance legislation, the recognition that the burden placed on us is potentially a *Charter* violation is exceptionally important.

In all three cases that I have mentioned, Justice L'Heureux-Dubé has melted down and recast "The Master's Tools,"[15] replacing them with a toolbox. The toolbox was essentially created for the use of women who have found themselves discriminated against and disadvantaged as a result of the law. The particular attention paid to context, history, and inclusiveness has developed a toolbox that, I believe, can be filled with tools of our own making and that is available to all people who find themselves boxed in by Canadian law. With the toolboxes, we can build or rebuild our own models and borrow other tools as we deem their use necessary.

In an Indigenous rights context, one can point clearly to the usage of this toolkit of inclusiveness in Justice L'Heureux-Dubé's dissent in *R. v. Adams*[16] (a case regarding the right to fish) in which Indigenous traditional

fishing area rights met with Canadian judicial traditional understandings with respect to the Indigenous rights dialogue. Once again, her ability to include historical actualities and contemporary realities in her analysis enabled her to urge decision-makers not to look at the "frozen rights" of Indigenous peoples. Viewing our people as alive, contemporary, and capable of growth and change, she promoted the development of authentic and respectful representations of Indigenous people.

In addressing the modern-day realities of off-reserve Indigenous populations in the *Corbiere v. Canada* (Minister of Indian and Northern Affairs)[17] decision (a case adjudicating equality and voting rights for off-reserve Indigenous citizens), she promoted the inclusion of representations of Indigenous people by Indigenous people. In the dissenting judgment she addressed the stereotype of the monolithic and unidimensional Indigenous community and referred to the perspective of off-reserve citizenship. She relies on *Egan* with respect to the application of a subjective-objective perspective in the context of Indigenous citizens who perceive they are not accorded the same rights as other Indigenous citizens.[18] In doing so, she visits the particular historical, social, cultural, legal, and economic factors that created disadvantage within societies already perceived as not having been treated fairly in Canadian society. These, too, are a part of the toolbox that has become more and more accessible and increasingly useful to Indigenous citizens who wish to re-establish their own laws and/or participate in the Canadian legal system. No longer frozen in time nor viewed through an exclusive and unchanging lens, we see portions of our actuality float across the Canadian legal field of view.

The *Delgamuukw v. British Columbia*[19] decision of Justices La Forest and L'Heureux-Dubé demonstrates the need for movement towards the inclusion of Indigenous world-views in decision-making related to Indigenous peoples. In the discussion of the Aboriginal rights of the citizens of the houses affected by this decision, there arises a clear delineation between traditional judicial understandings related to Aboriginal rights and title and Indigenous traditional understandings related to Indigenous peoples' rights. The notable fissure between described and ascribed Aboriginal rights and Indigenous inherent rights is addressed in a statement that says, essentially, that Aboriginal title cannot be determined by looking to statutes or regulations related to reserve lands.[20] In my mind, this is the starting point for a shifting tide of interpretation. It is a point on which both the concurring justices and Indigenous citi-

zens can agree and it is a place where Indigenous peoples can situate themselves or elect to address the reasons why they cannot situate themselves in the Canadian justice system. It opens the possibility for dialogue on traditional territories and traditional understandings related to the same. I can tell you that it is a rare thing to see ourselves reflected in a Canadian judicial decision, but the inclusion of this understanding is an important one for many people.

The Canadian justice system is not at a place where inclusiveness is deemed essential, but the work of Justice L'Heureux-Dubé has clearly advanced the position that it is. Justice L'Heureux-Dubé has lived as o*kiski-nohtahew*—conducted herself in a manner that sets an example. By showing how women's concerns must be addressed in a respectful manner by all people she has provided a template for change for all of us not reflected in the Canadian norm to adapt and use for the advancement of our own concerns. The re-casting of the Master's Tools in a women's context has created a toolbox from which many peoples can construct and determine their own roles within the Canadian justice system. The inclusive nature of her work allows a space for those who wish to participate in the system to address realities and actualities of their existence. Her approach to the inclusion of context has been of exceptional importance. In an Indigenous rights context, the acknowledgement that Indigenous peoples' contextual understandings must be addressed can create room for addressing issues of Indigenous laws and justice (in whichever context our citizenship deems appropriate).

Justice L'Heureux-Dubé has said:

> In my view, the recognition that equality and discrimination are inextricably linked is an important one. It is indicative of an advanced and nuanced understanding of the values that underlie equality. For equality is not really about being treated the same, and it is not a mathematical equation waiting to be solved. Rather, it is about equal human dignity, and full membership in society. It is about promoting an equal sense of self-worth. It is about treating people with equal concern, equal respect and equal consideration.[21]

In her role as a Supreme Court Justice she has addressed these nuances and proposed that there may be differential values that must be equally respected. In my understanding of the principles upon which Indigenous

people have relied for our strength, the acknowledgement of difference and the equal respect for every society's values is a fundamental understanding. Perhaps in broaching this non-traditional (or traditional) dialogue in a traditional (or non-traditional) place—depending on your context—she has led us to a place where Indigenous and non-Indigenous people can begin to truly value and respect each other's positions in this discussion. She has led by example and all people—Indigenous and non-Indigenous—can learn from that example.

### Endnotes

1 Carol Gilligan, *In a Different Voice: Psychological Theory and Women's Development* (Cambridge: Harvard University Press, 1982).
2 This is not to suggest that Justice L'Heureux-Dubé is an Elder or has the training and understanding required to be an Elder in Indigenous traditions. However, the elemental and doctrinal marriage of respect and egalitarianism in much of her work and her commitment to fairness and parity is reminiscent to the author of the principled approach to law in an Indigenous context (most often discussed and best detailed by Elders in Indigenous communities).
3 My profound thanks to Harold Cardinal for his guidance and brilliant dialogue. While I was privileged to have this discussion with him, all interpretations of the same and any potential errors based upon it are completely my own.
4 Harold Cardinal and Walter Hildebrandt, *Treaty Elders of Saskatchewan: Our Dream is that Our Peoples Will One Day be Clearly Recognized as Nations* (Calgary: University of Calgary Press, 2000).
5 *Ibid.* at 32.
6 *Ibid.*
7 *Ibid.* at 33.
8 Rev. W.A. Watkins, in *A Dictionary of the Cree Language* (Toronto: Church of England in Canada, 1938), refers to this as *okiskino'tuhewao*, meaning a guide, a leader, a pilot, at 384.
9 *Moge v. Moge*, [1992] 3 S.C.R. 813; *Egan v. Canada*, [1995] 2 S.C.R. 513; *Thibaudeau v. Canada*, [1995] 2 S.C.R. 627.
10 *Egan v. Canada*, [1995] 2 S.C.R. 513 at 541.
11 *Ibid.* at 546. "A more appropriate standard is subjective-objective—the reasonably held view of one who is possessed of similar characteristics, under similar circumstances, and who is dispassionate and fully apprised of the circumstances."

12 *Thibaudeau v. Canada*, [1995] 2 S.C.R. 627.
13 *Ibid.* at 654.
14 *Ibid.* at 656.
15 Audre Lourde, "The Master's Tools," in *Sister Outsider* (Freedom, Ca.: The Crossing Press, 1984).
16 [1996] 3 S.C.R. 101.
17 *Corbiere v. Canada (Minister of Indian and Northern Affairs)* [1999] 2 S.C.R. 203.
18 *Ibid.*
19 *Delgamuukw v. British Columbia*, [1997] 3 S.C.R. 1010.
20 *Ibid.*
21 Claire L'Heureux-Dubé, "Conversations in Equality" (1999) 26 Man. L.J. 273–98 at 273.

Twenty

## Justice L'Heureux-Dubé: Dimensions of a Quintessential Judicial Leader

JUSTICE CORRINE SPARKS

Honouring the contributions of Justice Claire L'Heureux-Dubé to a feminist analysis of law is one of the most pleasant tasks that I have been asked to undertake. It is a rare honour and privilege to celebrate the multifaceted dimensions of the illustrious career of this judge.

Adjectives to describe the personality of this extraordinary person, this legal pioneer and mentor, are wide-ranging and include tenacious, compassionate, extroverted, effervescent, and yes, even feisty. I will comment later about her personal attributes and her profound humanitarianism.

Judging at the best of times can be an intensely stressful career. Yet some judges, like Justice L'Heureux-Dubé, encapsulate the role of an exemplary judge, raising the bar and providing much-needed motivation to the rest of us as judges, academics, and lawyers.

To be a good judge requires a high standard of knowledge, sophisticated interpersonal skills, deep compassion, sound articulation, and great patience. But outstanding jurists have extraordinary qualities that imbue them with leadership capacity. It is a gift: a unique combination of intellectual brilliance and innovation, coupled with an innate ability to relate to all humans in the rainbow of humanity. Justice Bertha Wilson calls it the ability to step into the skin of the litigant. Beyond this, however, these judicial leaders challenge our legal understanding of the cornerstones of the adjudicative

process, such as judicial impartiality and so-called judicial neutrality.

We know that there are various concepts of judicial impartiality in a pluralistic society. They have been classified as classical, relational, and situational by Professor Richard Devlin[1]. Professor Devlin would probably describe Justice L'Heureux-Dubé as adopting a situational approach to judicial impartiality and judging, as this type of approach is sensitive to feminism and racialization in society. This approach understands that justice is not blind but rather is aware of the broader social context while remaining somewhat detached. This approach utilizes the possibility of differential treatment as a mechanism to achieve equality within the confines of the *Charter of Rights and Freedoms*. We also know, with certainty, that various jurisprudential approaches will yield vastly different legal results.

When some judges think of a role model, they think of a judge who has never taken a different stand or a fresh approach to a particular legal scenario. Over the years, however, many judges, myself included, have steadfastly gravitated to those judges who have displayed courage, integrity, and dignity while utilizing the law as an instrument to create a more equitable society. Innovation is critical when faced with *stare decisis* and specific legal scenarios. Rhetorically, I ask, how would the law ever evolve as an instrument of social change if such judges were not part of the Canadian legal landscape?

In the persona of Justice Claire L'Heureux-Dubé we have had immeasurable good fortune in our beloved country. She has been a luminary and her legacy will be savoured for years to come.

I would like to address briefly four areas that have personally inspired me over the years as I watched the career of Justice L'Heureux-Dubé: her family law decisions; her self-assigned role as a great dissenter on the Supreme Court of Canada; her support of others in the legal profession; and her humanitarianism.

Justice L'Heureux-Dubé has penned innumerable key decisions, among them *R. v. Seaboyer*,[2] *R. v. O'Connor*,[3] *Young v. Young*,[4] *McKinney v. Guelph University*,[5] and *Moge v. Moge*.[6] Others from the academy will expound upon the far-reaching impact of these and other decisions as they emphasize her pedagogical and methodological approaches. Here, however, I would like to discuss briefly the decision in *Moge* with a view to highlighting Justice L'Heureux-Dubé's zest for family law as well as her feminist legal theoretical approach. Justice L'Heureux-Dubé practised family law before her appoint-

ment as the first woman to the Quebec Superior Court. During those years she undoubtedly observed many gender inequities upon separation and divorce. Her personality, together with her drive for equality, gave her the capacity not only to discuss the gender inequalities, but also to apply astutely the feminist theoretical approach to family law conflicts.

The methodological approach is pivotal in any legal analysis and it must be remembered that many of our colleagues on the bench, both male and female, are still using the classical approach, so aptly discussed and explained by Richard Devlin.[7] This is perhaps not surprising, as many members of the judiciary graduated from law school at the time when feminist legal theory and critical race theory were not even anticipated, let alone discussed. Today, however, we are dependent upon great jurists like Justice L'Heureux-Dubé to incorporate feminist and critical race theory as a key part of our jurisprudence.

In *Moge*, Justice L'Heureux-Dubé provided us with an excellent example of a feminist theoretical approach. This landmark decision, apart from the technical interpretation of sections 15 and 17 of the *Divorce Act*,[8] exemplifies the way in which the Court informed itself of the daily realities of women's lives after separation and divorce. With Justice L'Heureux-Dubé writing for the Court, there were lengthy quotations from social science literature, along with scholarly articles on this issue. Justice L'Heureux-Dubé noted that these studies were not new, but reinforced what was already known about the feminization of poverty, post-separation, and divorce. She encouraged trial judges like myself to take judicial notice of such studies, subject to other expert evidence that may bear on these findings, and to use them as background information. It is important that judges be aware of the social reality in which support decisions are experienced by women when engaging in an examination of the objectives of the *Divorce Act*.

Much more could be said about *Moge*, but I will leave family law and turn to my second area in the illustrious career of Justice L'Heureux-Dubé. Her role as a great dissenter is as legendary as her unique role on the Supreme Court of Canada. We all know that the role of a dissenter on a panel is not an easy one. In these challenging cases it requires a judge to evaluate her own principles and values; it requires tremendous courage to disagree and to write a compelling dissent. Yet Justice L'Heureux-Dubé has done this time after time. The law and thus society can never progress if there is always full una-

nimity. This is why a dissenting view is as important in a democratic society as it is on the bench. Life surely would be dull without a good and compelling dissent! We will all miss our great dissenter. Will the Supreme Court of Canada continue to be as exciting as it was when Justice L'Heureux-Dubé sat on the panel? Only time will answer that question.

Having said that, we know that our Canadian great dissenter is in the company of other outstanding jurists, such as Justice Thurgood Marshall of the United States Supreme Court. When reading his decisions today, we cannot help but be struck by the poignancy and the astuteness of his comments about the role of racial consciousness and racial inequities in American society. My point is this: dissents can be powerful and long-lasting. They pave the way not only for judicial innovation, but also for substantive societal change that will lead to future advancement under the rubric of human rights and the *Charter*'s section 15 equality guarantee. From her role as a great dissenter on the Supreme Court, we know Justice L'Heureux-Dubé is passionate, creative, principled, and, thank goodness, independent, in her reasoning and her analytical capacity. We are thankful for her wisdom, freshness, brilliance, and her ability to weave feminist theory and critical race theory into a so-called doctrine of black letter law.

I would also like to comment on the selflessness of Justice L'Heureux-Dubé. It is one thing to be closeted away writing judicial decisions, and even to have a cot placed in one's office to facilitate dedication to the job. However, it is another thing for a judge constantly to reach out to others. Justice L'Heureux-Dubé accepted her responsibility as a role model with grace and dignity, enthusiasm and zeal. It is not easy to attend conference after conference, especially when working long hours daily and sleeping on an uncomfortable cot! It is far easier to approach these commitments with a certain reticence. However, female members of the judiciary, particularly the International Association of Women Judges (IAWJ), can always count on Justice L'Heureux-Dubé for support and encouragement. She not only attends conferences, but understands the need for the IAWJ. This was not a debatable issue for her, as it has been for several other judges, both male and female.

Unknown to many is the encouragement that she has given to the Canadian Association of Black Lawyers (CABL). To my knowledge, she is the only Supreme Court of Canada justice to have attended a CABL conference. At the CABL conference several years ago I had the pleasure of serving as a

panellist with Justice L'Heureux-Dubé on the topic of judicial appointments. She may not remember this, as she has sat on many educational panels over the years, but I certainly do. At the conference, with budding black lawyers in attendance, she spoke eloquently, of course. However, two comments resonated with me and heightened my respect for this woman. First, we were discussing black appointments to the bench and, optimistically, she commented that the day will come when there will be a black justice on the Supreme Court of Canada. Even though many of you may not view this to be an earth-shattering claim, those struggling lawyers in the room picked up on this very powerful message and, in untold ways, it served to foster professional enthusiasm.

Second, on that same panel we heard from the president of the U.S. National Bar Association (NBA), which represents over 17,000 black lawyers and judges. The NBA president commented that her association did not support a certain judicial appointment. Justice L'Heureux-Dubé commented reflectively that black appointments are, of course, important to promote judicial diversity in a pluralistic society. But she went further and stated that we should be careful when we appoint a black person to the bench to *be* a "black judge." Having black skin does not necessarily mean that one will embrace racial consciousness. It does not mean that the person will be sensitive to racial issues or claim racial identity. In making these comments, Justice Claire L'Heureux-Dubé seemed to appreciate that being a black person has as much to do with life experiences as it does with skin colour. I think she was saying what many in the black community have been saying: having a black judge who has no, or a very restricted level of racial consciousness, will not serve the advancement of racial equity or, indeed, social justice. He or she may in fact impede the advancement of equality issues arising out of a particular case. We know the negative stereotypes that manifest in a racialized society. We also know that these racial stereotypes often manifest as discriminatory acts. However, it is important to be educated about the manifestations of these inequities, with a level of racial awareness and consciousness, in order to apply the pedagogical underpinnings of critical race theory.

Finally, rhetorically, I ask, how can a judicial leader emerge if she is not also a great humanitarian? Without deep human compassion and empathy, no one can reach greatness as a judge. Justice L'Heureux-Dubé relates to people. She relates to the oppressed and the repressed in society, the disenfranchised and the disempowered, and those who are diminished in Canadian

society. Adjudication is a perplexing process, but in order to be effective, relating to people is paramount. This woman is not afraid to show her humanity. She is a caring person who can relate to those in various stations in life, whether they be judge or janitor, because she sees more than the obvious, or the apparent: she sees their humanity. Here in the persona of Justice L'Heureux-Dubé is a unique woman who is strong and resilient, with a formidable character. This woman has faced indignities with dignity. She gives us all inspiration. Through her challenges we understand that when you are a fighter, an innovator, a humanitarian, and a great dissenter, you must stand tall for your principles. A female in a male-dominated profession can become a target. But what is perhaps most important is the grace with which she has met her personal and professional challenges. It is often said that these experiences make an individual bitter or better. Well, she became better. It is often said that these life challenges can reveal character. Well, she has demonstrated a warm and formidable character.

What has transpired over these past fifteen years is the making of a legal icon. Justice L'Heureux-Dubé, I convey my sincere wishes for your continued health and happiness, longevity of life, and no more restless nights on a less-than-comfortable cot.

### Endnotes

1 Richard F. Devlin, "Judging and Diversity: Justice or Just Us?" (1996) 20 Prov. Court Judges Journal 4.
2 *R. v. Seaboyer*, [1991] 2 S.C.R. 577.
3 *R. v. O'Connor*, [1995] 4 S.C.R. 411.
4 *Young v. Young*, [1993] 4 S.C.R. 3.
5 *McKinney v. Guelph University*, [1990] 3 S.C.R. 229.
6 *Moge v. Moge*, [1992] 3 S.C.R. 813 [*Moge*].
7 Devlin, *supra* note 1.
8 *Divorce Act*, R.S.C. 1985 (2d Supp.), c. 3.

# Contributors

**The Honourable Rosalie Silberman Abella** has been a judge on the Ontario Court of Appeal since 1992. She chaired the Ontario Labour Relations Board, the Ontario Law Reform Commission, and the Study on Access to Legal Services by the Disabled, and was a member of the Ontario Human Rights Commission, the Premier's Advisory Committee on Confederation, and the Ontario Public Service Labour Relations Tribunal. She was sole Commissioner and author of the 1984 federal Royal Commission on Equality in Employment, in which she created the term and concept of "employment equity," a new strategy for reducing barriers in employment faced by women, aboriginal people, non-whites, and persons with disabilities. The theories of "equality" and "discrimination" she developed in her Report were adopted by the Supreme Court of Canada in its first decision dealing with equality rights under the *Charter of Rights and Freedoms*. The Report has been implemented by the governments of Canada, New Zealand, Northern Ireland, and South Africa.

**Susan B. Boyd** is Professor of Law at the University of British Columbia where she holds the Chair in Feminist Legal Studies and is Director of the Centre for Feminist Legal Studies. Professor Boyd teaches courses in the fields of feminist legal studies and family law. She researches and publishes on feminist legal theory as well as on gender and sexuality issues in family law, especially child custody and access law. She is a long-standing member of the editorial board of the *Canadian Journal of Women and the Law*. She also works for law reform in family law and is a member of organizations that work for social change, such as the National Association of Women and the Law.

**Christine Boyle** is Professor of Law at the University of British Columbia where she teaches criminal law, evidence, and racism and the law. Formerly a member of the Bar of Nova Scotia, she is currently a member of the Bars of Northern Ireland (1973) and British Columbia (1995), and is associated with the firm of Smart and Williams in Vancouver. Her research interests lie in the fields of equality, criminal law, and evidence. She is active in test case equality litigation, currently with respect to the issue of male to female transsexual persons and women's groups. She is also active in the field of continuing education for judges and administrative decision-makers.

**Ena Chadha** is the senior litigation counsel at ARCH: A Legal Resource Centre for Persons with Disabilities. She is a graduate of the College of Law, University of Saskatchewan (1992) and was called to the Bar of Ontario in 1994. Prior to joining ARCH she was in private practice litigating in the areas of human rights, employment law, immigration, and refugee law. She holds a Certificate in Advanced Alternate Dispute Resolution and Mediation and is presently on the editorial board of the *Journal of Law and Social Policy*.

**Nathalie Des Rosiers** est présidente de la Commission du droit du Canada. Elle est professeure de droit en congé de la Faculté de droit – common law – de l'Université d'Ottawa. Mme Des Rosiers a été présidente de l'Association des juristes d'expression française de l'Ontario (AJEFO) et de la Canadian Law Teachers Association. Elle a été membre de la Commission d'appel de l'environnement de 1988 à 2000 et membre de la Commission de réforme du droit de l'Ontario de 1993 à 1996. Elle a reçu la médaille du Barreau du Haut-Canada en 1999 et l'Ordre du mérite de l'AJEFO en 2000.

**Shelley A.M. Gavigan,** a member of the faculty at Osgoode Hall Law School since 1986, teaches courses in criminal law, family law, poverty law, and children and the law. Professor Gavigan has twice served as the academic director of Osgoode's Intensive Program in Poverty Law at Parkdale Community Legal Services. She has worked as staff lawyer in legal clinics in Saskatchewan, and as director of complaints/compliance for the Saskatchewan Human Rights Commission. Her research interests include socio-legal history, criminal law, poverty law, and family law (with an emphasis on legal definition and regulation of familial relations).

**Reg Graycar** is Professor of Law at University of Sydney (Australia), and former full-time commissioner of the New South Wales Law Reform Commission (1998–2002). She is a member of the editorial boards of several journals, and has worked with the Australian Institute of Judicial Administration and a number of courts on their judi-

cial education programs. She is also a Director of Women's Legal Resources, Ltd., which manages the New South Wales Women's Legal Resources Centre and the Domestic Violence Advocacy Centre. Professor Graycar is the author of *The Hidden Gender of Law*, 2nd edition, 2002 (with Jenny Morgan), as well as numerous articles and books on gender and the law, feminist legal theory, and family law.

**Rebecca Johnson** clerked at the Supreme Court for Justice L'Heureux-Dubé in 1993, was a member of the Faculty of Law at the University of New Brunswick from 1995 to 2001, and joined the University of Victoria Faculty of Law as an associate professor in 2001. She has taught courses in constitutional law, civil liberties, criminal law, feminist advocacy, law legislation and policy, legal method, legal theory, and law and film. Her research and writing interests often draw her to the places where laws' discourses intersect with those of popular culture. Her current research projects concern nursing mothers and the saloon as a site of citizenship, and the role of reason and passion in the judicial dissent.

**Lee Lakeman** has been a collective member at Vancouver Rape Relief and Women's Shelter since 1978. She also represents British Columbia and the Yukon to the Canadian Association of Sexual Assault Centres. She wrote the 2003 report *Canada's Promises to Keep: The Charter and Violence Against Women* in which she records the work of ten sexual assault centres over five years. The report includes national research documenting the difficulties experienced by one hundred women when using the criminal justice system. In the report, she applies the promise of the *Canadian Charter* to the legal issues of violence against women. She celebrates the greater notions of equality found in anti-violence centres and local organizing against women's oppression. Both Lee and CASAC are available through www.casac.ca and www.rapereliefshelter.bc.ca.

**Yves Le Bouthillier** est professeur de droit de la Faculté de droit – common law – de l'Université d'Ottawa. Depuis juillet 2002 il occupe le poste de vice-doyen du programme de common law en français. Il enseigne en droit international, notamment le droit international de la personne et le droit international de l'environnement et dans des domaines connexes comme le droit de l'immigration et des réfugiés. Il s'intéresse également à la protection des minorités. Entres autres, il a été membre de divers organismes canadiens oeuvrant dans le domaine des droits linguistiques.

**Hester Lessard** joined the Faculty of Law at the University of Victoria in 1989 and became an Associate Professor in 1994. She teaches courses in constitutional law; law, legislation and policy; feminist legal theory; equality, human rights and social justice;

and legal process. Her past and current research interests include feminist critiques of constitutional rights, the construction of family relations under the *Charter of Rights*, and the role of rights-based strategies and discourses in achieving progressive social change for women.

**Tracey Lindberg** is the Director of the Centre for World Indigenous Knowledge and Research at the University of Athabasca. She is also an Assistant Professor of Indigenous Studies at Athabasca University and an instructor in the Native Law program at the University of Saskatchewan. Her principal interests are in the areas of criminal justice, Aboriginal law and justice, and traditional Aboriginal laws and understandings. She is a member of the Law Society of Saskatchewan and the Indigenous Bar Association. She is also a member of the editorial boards of the *Canadian Native Law Reporter* and the *Economic Development Journal*.

**Sheila McIntyre** joined the Faculty of Law at the University of Ottawa in 2003, after eighteen years in the Law Faculty at Queen's University. She is also the Director of the Human Rights Research and Education Centre at the University of Ottawa. Her teaching subjects have included public, administrative, constitutional, labour, and human rights law as well as feminist legal theory. She has been actively involved in test case litigation and in law reform initiatives designed to reduce systemic bias in Canadian law and legal institutions and to advance the equality of disempowered groups. Professor McIntyre's research has focused on systemic inequalities within universities, the application of equality law to sexual assault law and procedure, and feminist legal activism.

**The Right Honourable Chief Justice Beverley McLachlin** became, in 2002, the first woman to be appointed chief justice of the Supreme Court of Canada. She practised law before joining the Faculty of Law at the University of British Columbia in 1974. She became a Vancouver County Court judge in 1981, a British Columbia Supreme Court judge later that same year, a British Columbia Court of Appeal judge in 1985, and the first woman to be appointed chief justice of the British Columbia Supreme Court in 1988. She is chairperson of the Canadian Judicial Council, the Advisory Council of the Order of Canada, and the Board of Governors of the National Judicial Institute. She is also a member of the Privy Council of Canada.

**Mary Jane Mossman** is Professor of Law at Osgoode Hall Law School, York University, where she teaches courses on property law, family law, and gender and equality. She has published extensively in these areas, as well as on a variety of issues relating to legal aid and access to justice. She has also developed a number of courses

for law firms and government. Professor Mossman, a recipient of the Medal of the Law Society of Upper Canada and a holder of the Gordon Henderson Chair in Human Rights, recently received an Honorary Doctorate (LL.D.) from the Law Society of Upper Canada. She is currently involved in a family law reform project that brings together concerns about access to justice, gender equality, family ideology, and the law reform process in the context of complex economic changes in Canadian society.

**Elizabeth Sheehy** is a Professor in the Faculty of Law at the University of Ottawa. She has taught courses in criminal law and procedure, women and the law, commercial law, torts, and advanced studies in contracts and torts. She has acted as a consultant to the Department of Justice on women's issues in criminal law, the Women's Legal Education and Action Fund (LEAF), and the Canadian Association of Elizabeth Fry Societies on Judge Lynn Ratushny's Self-Defence Review. She has produced, with Jennie Abell, two volumes of a criminal law and procedure casebook that is in use in several law schools. She has also written articles on criminal law as it affects women, the *Charter*, and torts.

**The Honourable Corrine Sparks** was appointed to the Nova Scotia Family Court in 1987. In 1993 she served as a member of the Canadian Bar Association Gender Equality Task Force where, along with her other duties, she commissioned a study of Women of Colour in the Legal Profession. She has received the Frances Lillian Fish Women Lawyers' Achievement Award from the Nova Scotia Association of Women and the Law. She continues to preside at the Nova Scotia Family Court, where she adjudicates family-related disputes including conflict resolution for custody, access, and maintenance, as well as child protection and young offender matters.

**Ruth Sullivan** is professor of Law at the University of Ottawa. Prior to attending law school, she taught English literature and composition for several years at Concordia University in Montreal. She served as clerk for Chief Justice Laskin at the Supreme Court of Canada. Professor Sullivan's primary interests are administrative law, statutory interpretation, linguistics, legal drafting, and legal theory. She has worked in the Legislation Section and the Regulations Section of the Department of Justice and directed the Graduate Program in Legislation and Legal Drafting.

**Claire F.L. Young** is Professor of Law at the University of British Columbia. In 1999, she held the Dunhill Madden Butler Visiting Chair in Women and the Law at the University of Sydney, Australia. She has consulted with the Department of Finance and several international organizations on tax policy issues. Currently, she is working on the Gender Responsive Budget Project as a member of the Joint Commonwealth

Secretariat and the International Development Research Centre research team, based in London, U.K. She has co-authored two books and written numerous articles on tax law and policy. Her other research interests include feminist legal theory and sexuality and the law.

**Margot Young** is an Associate Professor in the Faculty of Law at the University of Victoria. This past year, she has been the Walter S. Owen Visiting Chair in Law at the University of British Columbia. She teaches constitutional law, civil liberties and the law, feminist legal theories, and social welfare law. Professor Young is currently Chair of the British Columbia Public Interest Advocacy Centre Board and is also involved with a number of non-governmental groups working on issues of women's economic equality and justice. Professor Young's research interests are equality theory and law, the evolution of the welfare state, social and economic rights, and comparative constitutional law.